UNDEREXPOSED

EDITED BY COLIN JACOBSON

Vision On Publishing

Based on an idea by
Index On Censorship

In association with
Getty Images

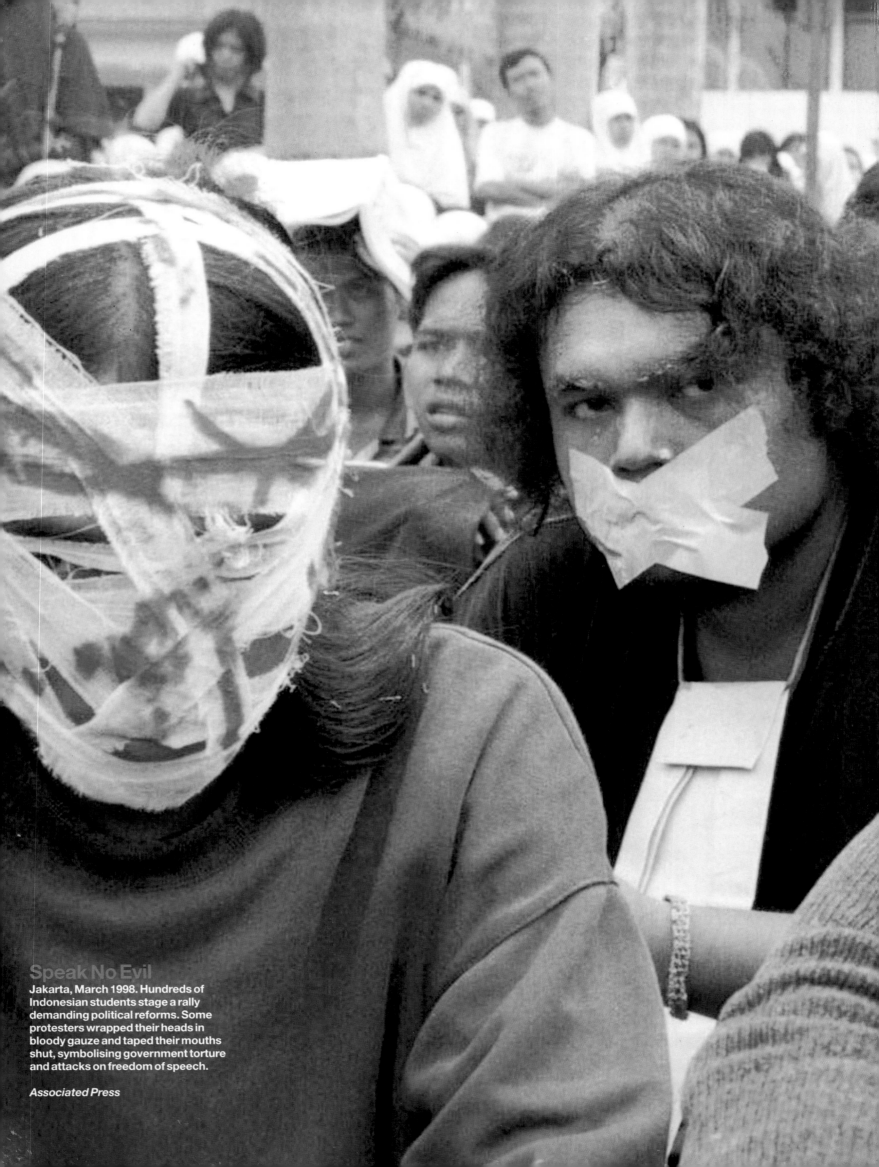

Speak No Evil

Jakarta, March 1998. Hundreds of Indonesian students stage a rally demanding political reforms. Some protesters wrapped their heads in bloody gauze and taped their mouths shut, symbolising government torture and attacks on freedom of speech.

Associated Press

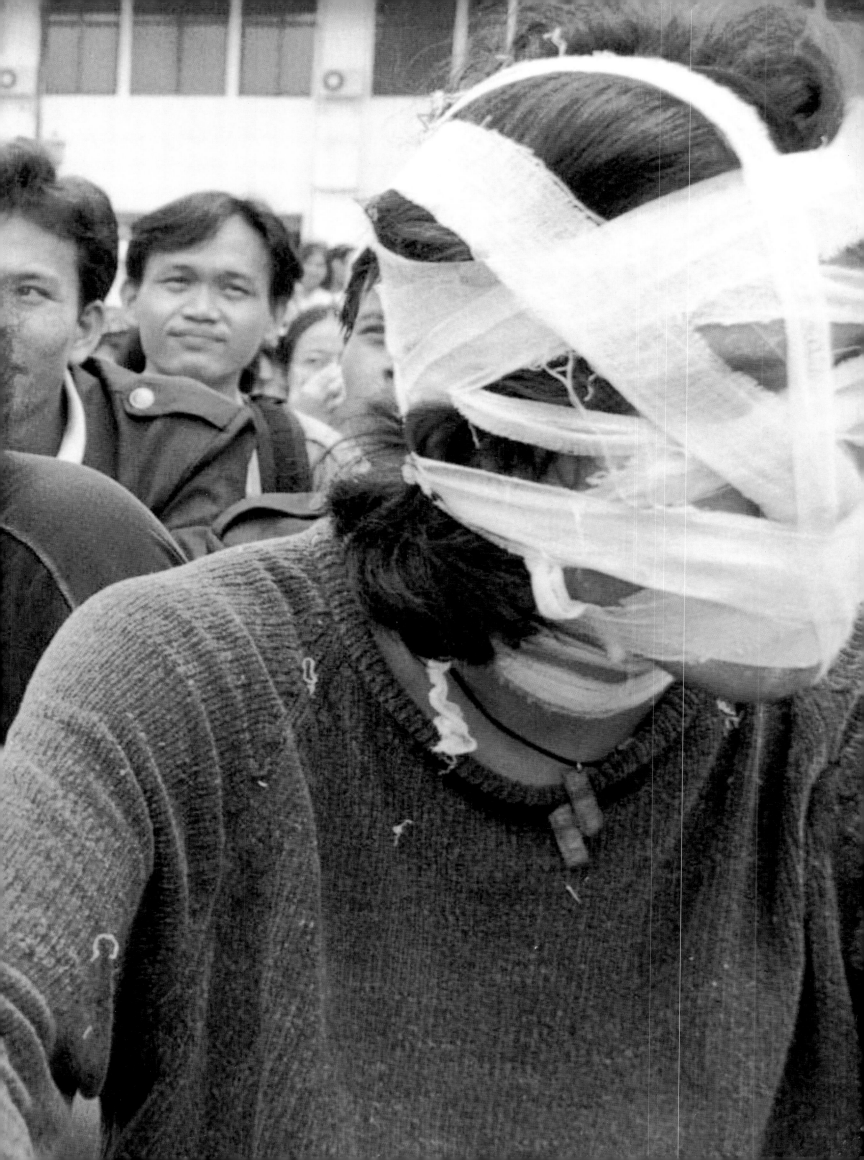

Introduction
Colin Jacobson

Almost a century ago, the documentary photographer Lewis Hine wrote:

"While photographs may not lie, liars may photograph. It becomes necessary then to see to it that the camera we depend on contracts no bad habits."

"Censorship" is a disturbing concept, usually referring to the act of someone in authority who prevents us from reading or hearing certain words or seeing certain images. By implication, it can also mean we are persuaded to accept phoney material as genuine or consider a distorted context as the supposed truth.

Traditionally, censorship is associated with scheming politicians and government officials who plot to hide crucial facts from a gullible public. Years later, when historians and journalists pore over newly released official documents, we discover another version of history.

Underexposed, based on the original concept by Index on Censorship (vol 28, 6/99), investigates some of the most glaring examples of photographs which have been banned, doctored, suppressed or manipulated in order to dupe the viewer.

There are less obvious forms of control. How often have government-inspired visual messages persuaded the populace not to be alarmed at certain threats to its health or welfare? How many times have editors banned the use of a disturbing image, not on the basis of its journalistic significance but because it might upset the sensitivities of their readers? How often has a vocal and influential minority in society dictated to the majority what may be looked at in culture and the arts? How many family picture albums have glossed over the mysterious woman standing behind Uncle Arthur?

Nearly all of human experience has now been privatised and commercialised; politics, washing powder, show business, sport, leisure and religion are sold in exactly the same way. *Underexposed* discusses the sneaky agenda at work within the advertising and public relations industries in which photographic representation and distribution are strictly controlled and monitored.

Underexposed looks at the way in which shifting cultural values and norms affect what is acceptable or unacceptable in photography, and relates this to insidious forms of self-censorship which are so destructive to genuine journalism and communication.

In recent times, a convenient myth has entered the debate. The public, it is alleged, do not want to be shown too much about the distressing consequences of their leaders' decisions. Readers wish to be entertained, not overwhelmed with harsh reality. Censorship "by omission" has infiltrated the media as publications have progressively shied away from serious stories about the world. In the mid-1980s, the acting editor of the left-of-centre *London Observer* pulled a magazine cover image by Sebastaio Salgado featuring a severe drought in Mali on the pretext that it might disturb readers enjoying themselves on the beach during August Bank holiday (in the event, the holiday weekend was washed out by rain). It was replaced with a fashion photograph.

In France, recent legislation has made it extremely difficult for publications to use reportage photographs in which people are identifiable, because of the risk of a lawsuit. An absurd example of the consequences appeared in *L'Express* magazine in July 2000. A prominent story about the pleasures of life on the beach at cap d'Agde was accompanied by innocuous colour photographs in which every visible face had been digitally altered to an unrecognisable smudge. Many French publications now routinely illustrate stories on social or documentary issues with static pictures posed by models to avoid the risk of prosecution.

In these post-modern times, we have to be sensitive to our own prejudices and cultural assumptions when we come to interpret images. As Adam Phillips points out in his thought-provoking article on page 153, "The photography is propaganda if we immediately know where we are with it". A certain degree of confusion or ambiguity is not necessarily dangerous if we are challenged to think about the issues involved and worry about the context. Photographs have an important function to fulfil as the agents of discomfort. If we are not disturbed by certain aspects of our nation's visual history, we are either extremely complacent or looking at the wrong pictures.

The surprising thing is not that censorship and manipulation of photography goes on, but how easy it is to do and how often people get away with it. In *Pictures on a Page*, Harold Evans argues passionately for a more sophisticated approach to the understanding and critical evaluation of photojournalism, applying the same kind of rigorous assessment given to written text. Lip service is frequently paid to the awesome power of the photograph, but there is little general discussion about the enormous strengths and pitfalls of visual journalism. The furore over pictures of captured Taliban "illegal combatants" (or were they "prisoners of war"?) held by the Americans in Guantanamo Bay, Cuba in January 2002 underlines how essential it is for the context and meaning surrounding photographs to be made clear.

Underexposed does not claim to be definitive. The selection of pictures is inevitably limited and subjective. For instance, no examples of Stalin's notorious doctored photographs are included because this has been comprehensively covered elsewhere. It is an attempt to broaden the debate about censorship into areas where hidden agendas, be they conscious or subconscious, deliberate or accidental, malign or well-meaning, all work on our perception of the world and our interpretation of what is going on. It is hoped that this book, by telling the stories behind visual history, will make a contribution to better understanding.

In the current digital revolution, communicators are realising more than ever what a powerful tool they have at their disposal. Never before have so many people been bombarded with so much visual imagery from so many directions. *Underexposed* reminds us that we have to be alert to false messages sent out by those who want us to get the wrong end of the stick.

Contents

6 Don't Look Now
Photographs the public weren't supposed to see

"They all of them, censors and manipulators, testify to the power of the still image."

Harold Evans

Big Brother is in good company. Many worthy people have joined the thought police in the suppression of images. Malcolm Browne's snapshot of a Buddhist priest immolating himself in a square in Saigon was considered unfit for America's breakfast tables by the editors of the *New York Times*. That was a misjudgement on their part, even by the taste buds of the time. The event testified to the Buddhists' sense of outrage at their persecution by the Saigon government. It was truly incredible. Many people could hardly believe the report that a priest had burned himself alive. The video was even more compelling, even if some thought the flames were a kind of circus magic.

There was an excuse for the caution of the *Times* editors. Violent images shock; readers make a fuss and cancel their subscriptions. In the Gulf War, the *Observer* in London published a gruesome photograph of an incinerated Iraqi staring sightlessly from his truck. The editor was inundated with protests. Again, I think he was right to publish. The Gulf War had been presented as some kind of clean war where laser technology removed the pain. As a Syracuse editor said of the *Times* suppression of the Saigon image, an editor who would not use that picture would not have run one of the Crucifixion.

Are there any sensible limits? I think there are. I would not have published the photographs of Jayne Mansfield's head severed from her body in a car crash, nor the corpse of Lee Harvey Oswald stitched up after the autopsy. The test I applied as an editor was whether the violence or obscenity portrayed had a social or historic significance and, if it did, whether the shocking detail was necessary for a proper understanding of the event.

So I have occasionally been an unrepentant censor. What is the difference between this kind of censorship and government control? Well, in a pluralistic press it is not so much censorship as discrimination. One editor's decision does not amount to suppression. Another editor can take a different view. The *National Enquirer* had no hesitation in publishing Oswald on the pathologist's table. Editors have to decide whether the shock is worth the offence, and it is a useful calculus. A government edict is altogether a different matter. While the rules suggested are helpful, they leave room for discretion, for the special case that no legislator can envisage. A law of the kind the French government has proposed, banning photography at specific occasions, is inflexible. *Content* magazine recently canvassed opinions on the notion of banning photography at funerals in the light of intrusion on the Kennedy family following the death of John F Kennedy Jr. As editors pointed out, if that prohibition had existed when his father was assassinated the world would never have seen the memorable image of John Jr giving a salute to his father.

In World War II, I might have hesitated to publish the images of charred bodies after the German bombing of Coventry out of deference to the relatives. Those pictures were suppressed by the government as damaging to morale, and in national crisis that is an argument that deserves some respect – but not too much. The people ought to have a clear idea of the sacrifices being made, of what is being done in their name. When authority moves to suppress it is usually an indication that they have little confidence in their actions – precisely the moment when a more informed debate can avert catastrophe. Governments were too ready to suppress pictures from the trenches in World War I. It was a stupid war, and the sooner everyone realised it the better. Both sides, busily suppressing, were of course only too ready to manipulate opinion by publicising the enemy's "atrocities".

Propaganda has to be met by propagation of the truth. Tom Hopkinson, the editor of *Picture Post*, was fired because he wanted to publish photographs during the Korean War that his ownership judged "anti-western". They showed North Korean prisoners, some only 12 years old, roped together and in obvious fear for their lives. It is true that these pictures were helpful to the North Koreans – but by caption or photography an objective editor would have been entitled to remind readers that both sides were cruel.

But a publication that strives to be "balanced" at all times is treading dangerous ground. I remember the arguments advanced against publication of the photographs Ron Haeberle had taken at My Lai. It was 18 months before they became available. Viewing them with the editors of the *Sunday Times* colour magazine, I reached two conclusions: that we had to check out the authenticity and then, if satisfied, we not only had a right but a duty to publish. They were inconvenient for "our side", but essential to corroborate an appalling story. We recognised that they would offend or upset, but the overwhelming necessity was to document the tragedy.

Today an even bigger problem for photography is the ease of manipulation with the computer. Senator Tydings, Joe McCarthy's main early critic, was famously killed in his reselection campaign by scissor work with two photographs that made him appear chummy with the leader of the American Communist Party. As David King and others have documented, the Stalinists, too, have always been expert at this kind of trick, especially in visual liquidation.

They all of them, censors and manipulators, testify to the power of the still image.

© *Index on Censorship. Harold Evans is the author of* Pictures on a Page *and* The American Century. *He is vice-chairman and editorial director of the* Daily News *and* US News and World Report, *and former editor of the* Sunday Times *and* The Times *of London.*

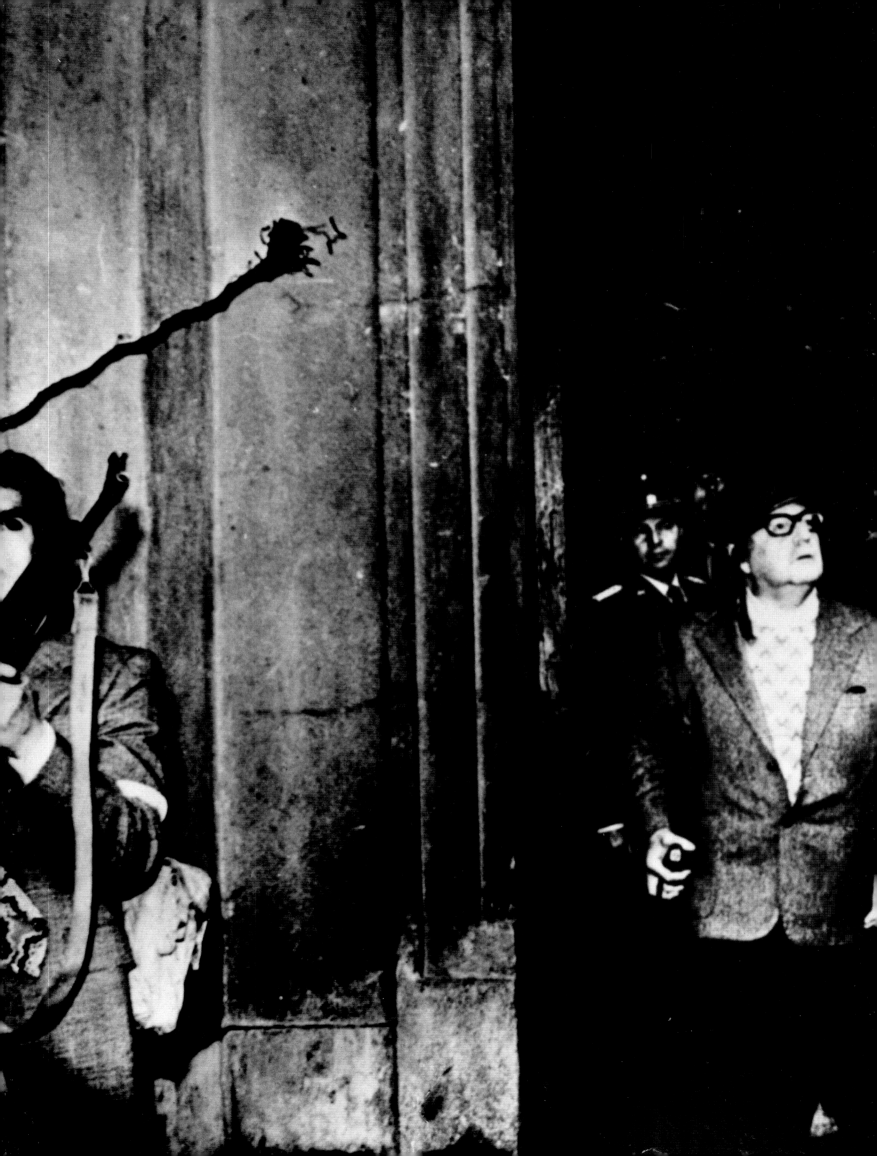

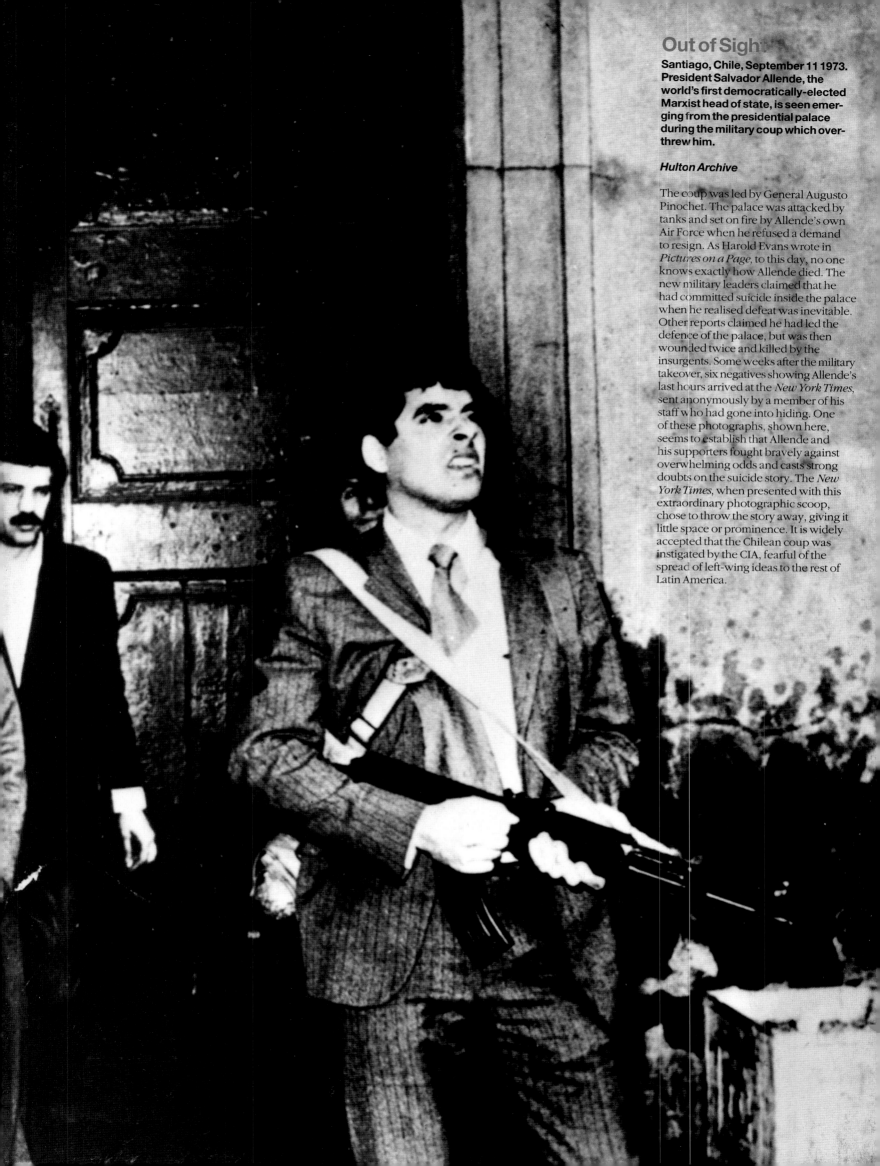

Out of Sight

Santiago, Chile, September 11 1973. President Salvador Allende, the world's first democratically-elected Marxist head of state, is seen emerging from the presidential palace during the military coup which overthrew him.

Hulton Archive

The coup was led by General Augusto Pinochet. The palace was attacked by tanks and set on fire by Allende's own Air Force when he refused a demand to resign. As Harold Evans wrote in *Pictures on a Page*, to this day, no one knows exactly how Allende died. The new military leaders claimed that he had committed suicide inside the palace when he realised defeat was inevitable. Other reports claimed he had led the defence of the palace, but was then wounded twice and killed by the insurgents. Some weeks after the military takeover, six negatives showing Allende's last hours arrived at the *New York Times*, sent anonymously by a member of his staff who had gone into hiding. One of these photographs, shown here, seems to establish that Allende and his supporters fought bravely against overwhelming odds and casts strong doubts on the suicide story. The *New York Times*, when presented with this extraordinary photographic scoop, chose to throw the story away, giving it little space or prominence. It is widely accepted that the Chilean coup was instigated by the CIA, fearful of the spread of left-wing ideas to the rest of Latin America.

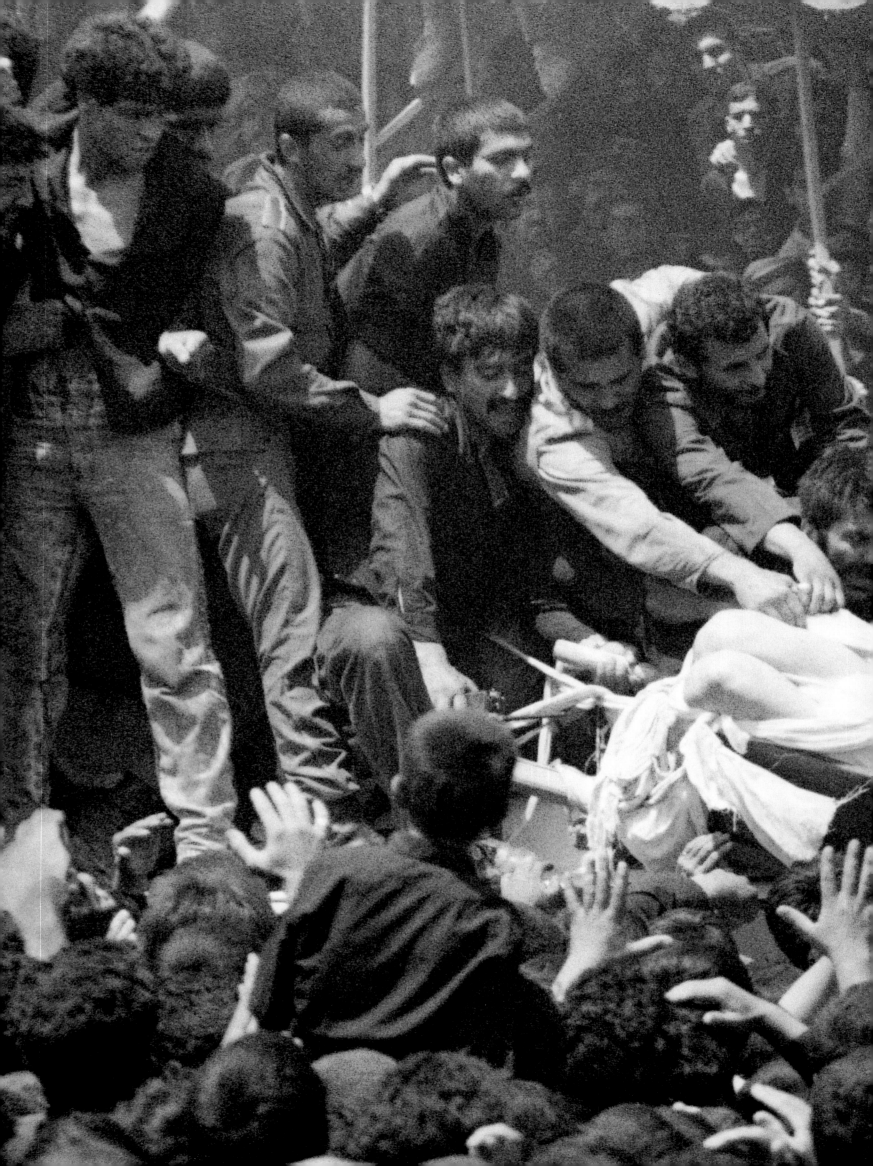

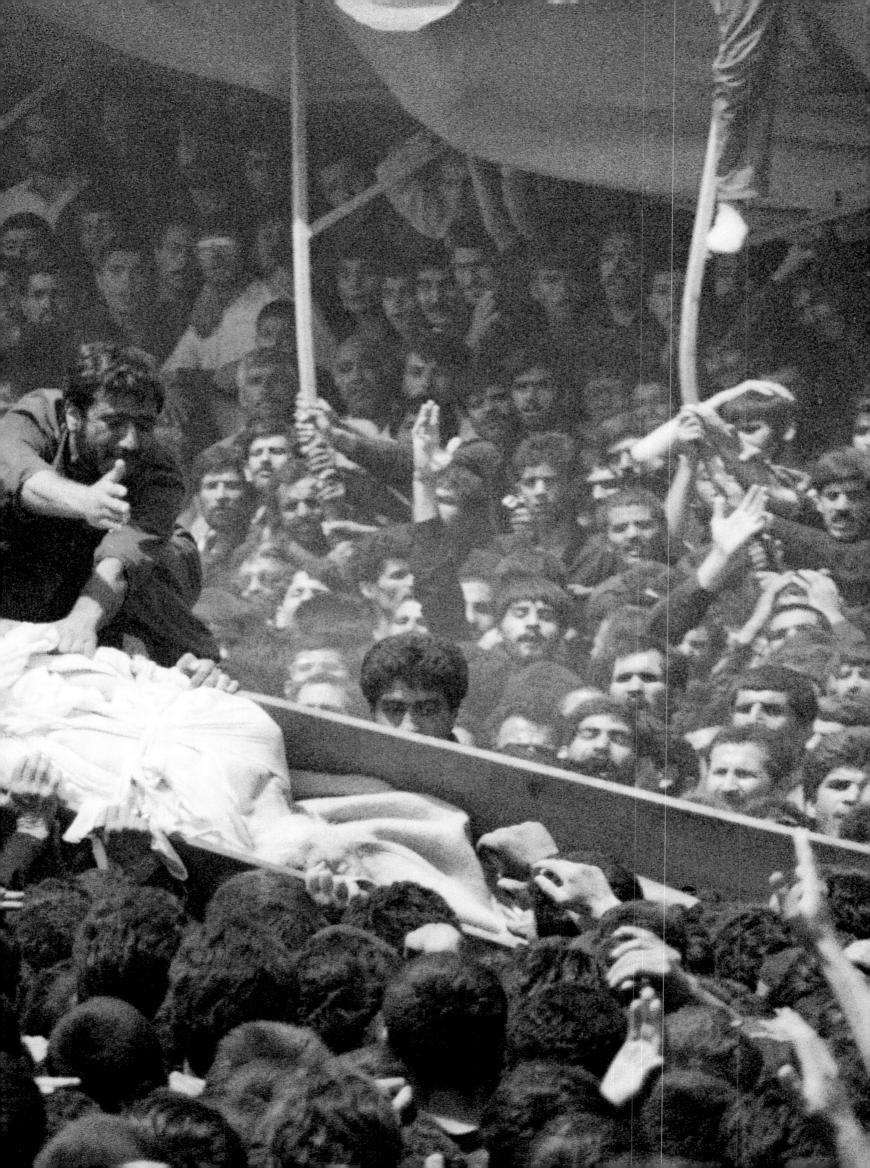

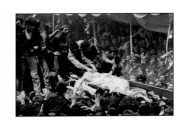

Passion Play

◀ Tehran, Iran, June 4 1989. The funeral of Ayatollah Khomeini, attended by an estimated two million mourners. Reverence for the former spiritual leader all but disappeared in the frenzy of the event, as those closest tried to strip clothes from the body as a memento. The Islamic authorities attempted to confiscate and destroy all photographs showing the Ayatollah's semi-naked corpse, but this was one of the few images smuggled out of the country and gleefully published in the West.

Anon

The website danielpipes.org describes the atmosphere at the funeral: "The death of Ayatollah Ruhollah Musavi Khomeini on June 4 was mourned by millions of his followers with an extravagance that surprised even the Iranian authorities. Time and again, funeral plans were disrupted by gigantic mobs unwilling to give way to either schedules or politicians. The scene in Tehran was one of unrelieved chaos. In the traditional manner, men pounded their chests and flagellated themselves with chains. Some sacrificed sheep and some shouted: 'We wish we were dead, so not to see our beloved iman dead.' Others ran 25 miles to the cemetery. The grave dug for Khomeini's body was occupied by mourners who refused to leave. Fire trucks sprayed water on mourners in an effort to keep them from fainting in the intensity of the June heat and the press of humanity. According to official sources, 10,879 people were injured, 438 were taken to hospital, and eight died in the crush to view Khomeini's body. In the cemetery, mourners climbed on buses to catch a better glimpse of the body, and in one case the roof of a bus collapsed, injuring those sitting inside."

Soldiers of God

Bolivia, 1990. Army leaders parade with a religious icon of Our Lady of Peace. This photograph, underlining the close relationship between the church and the military in Latin America's turbulent history, was part of a banned exhibition of photographer Carlos Reyes-Manzo's work. It was to have been held in Chile in 1992 at the Catholic University in Santiago to mark the 500th anniversary of Columbus' arrival in Latin America. Reyes himself was imprisoned in Chile for two years, from 1974 to 1975, and then exiled during the Pinochet regime. The university authorities maintained that his work, highlighting the theme of suffering and destruction which had taken place in the region since Columbus' arrival in 1492, was against the spirit of the celebrations. He received a letter informing him that "regrettably it will not be possible for us to hold the photographic exhibition as had been anticipated... it is definitely set apart from the spirit in which events related to this issue are taking place".

Carlos Reyes-Manzo/ Andes Press Agency

> "Regrettably it will not be possible for us to hold the photographic exhibition as had been anticipated... it is definitely set apart from the spirit in which events related to this issue are taking place."

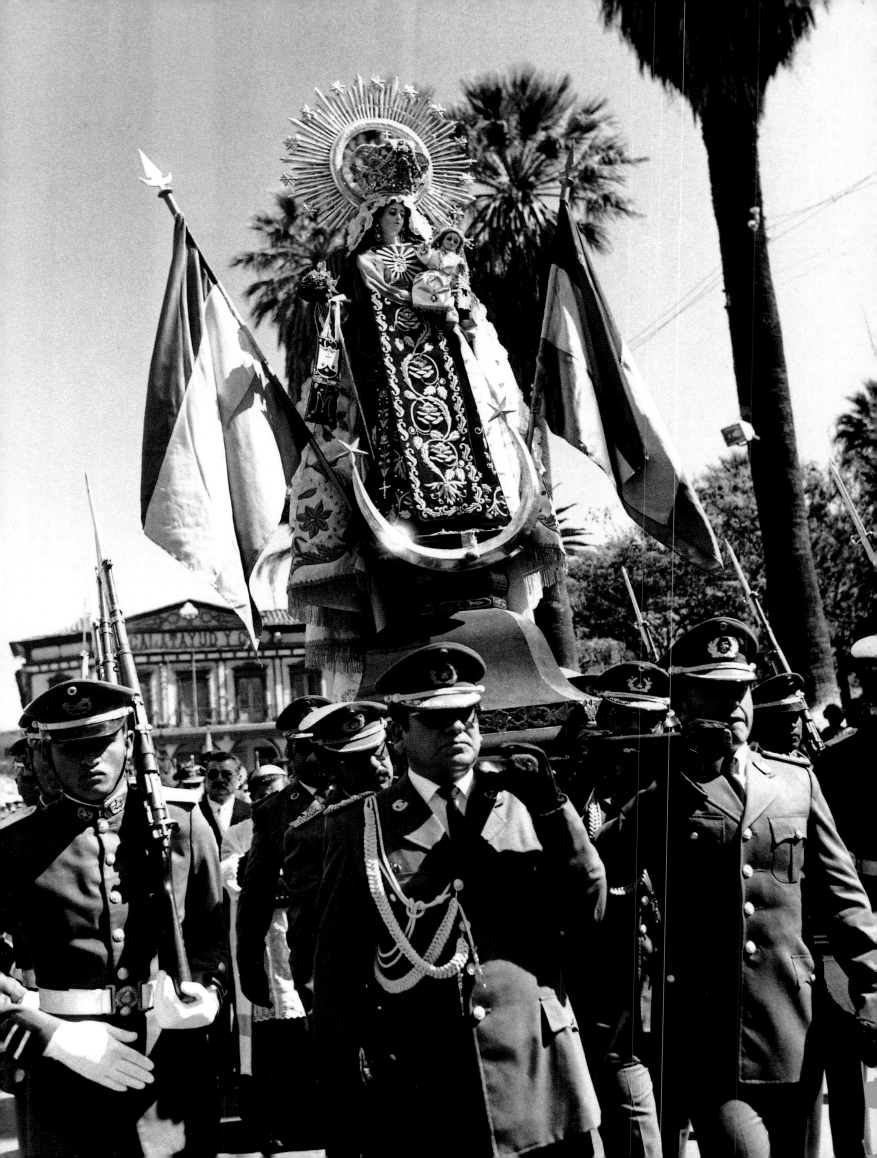

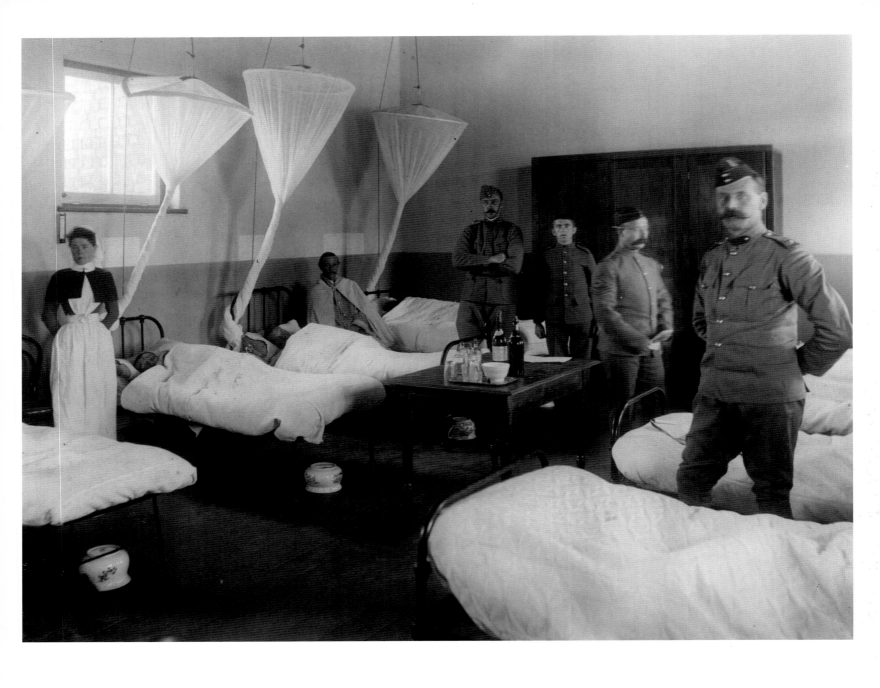

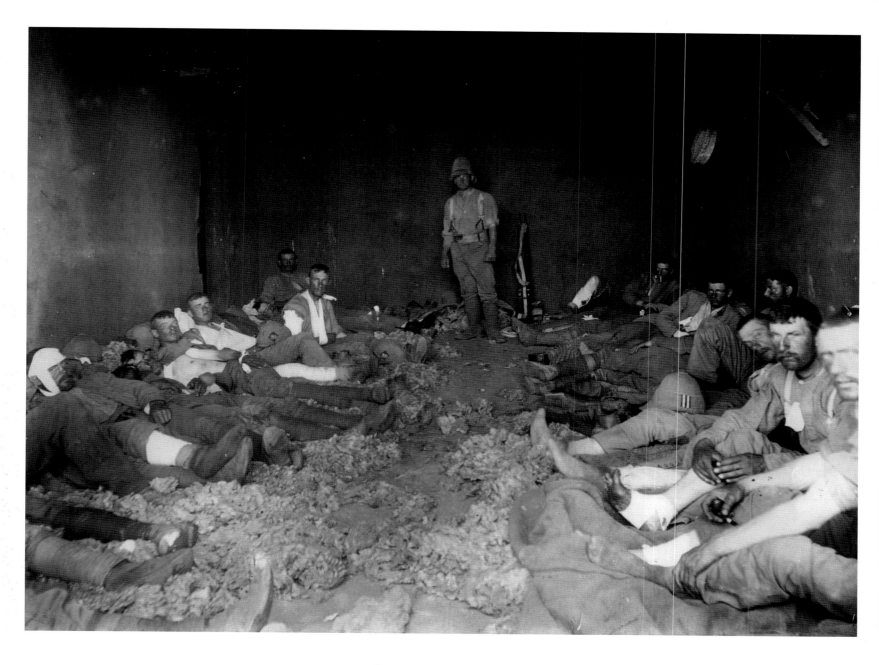

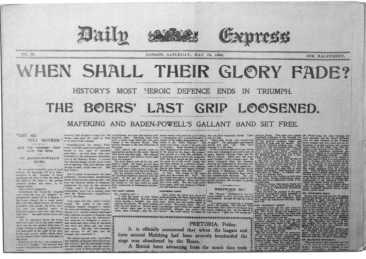

"Week after week, the British public was regaled with lists of Boers killed, Boers wounded, Boers made prisoners, Boers surrendered... but the war went on."

Cassell's History

Home Truths

Rheinhold Thiele was an early war photographer who did not flinch from showing the reality of conflict. His photograph of British wounded resting in a filthy wagon house (above) contrasts starkly with the idealised propaganda version taken in a hospital many miles away from the front line (left).

Hulton Archive
Front page courtesy John Frost Newspaper Archives

"The whole talk was of death – who died yesterday, who lay dying today, who would be dead tomorrow."

British Made

South Africa, 1899-1902. A prototype concentration camp, developed by the British during the second Boer War.

Hulton Archive

In an attempt to persuade the Boer guerrilla army to surrender, the British Army evacuated and destroyed farms to cut off supplies to the fighters. They seized thousands of Boer women and children for "security reasons" and locked them up in special camps. The conditions were extremely bad, with little food and no medical facilities, and enteric fever was rife. An English visitor recorded:

"The whole talk was of death – who died yesterday, who lay dying today, who would be dead tomorrow." 28,000 Boer women and children perished in these camps, far more than their soldiers killed on the battlefield; the fever also killed many British soldiers. Over 50,000 Africans who worked for the Boers perished in separate camps as well. The British public were protected from seeing what was being done in their name, and were fed a diet of heroic images of British forces in action.

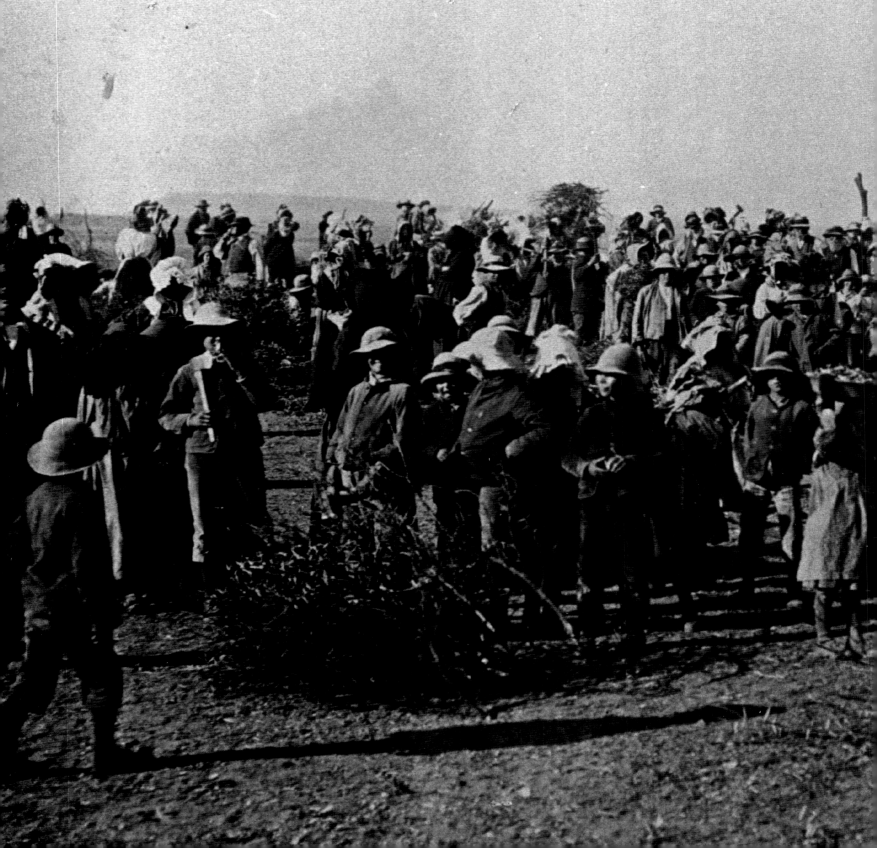

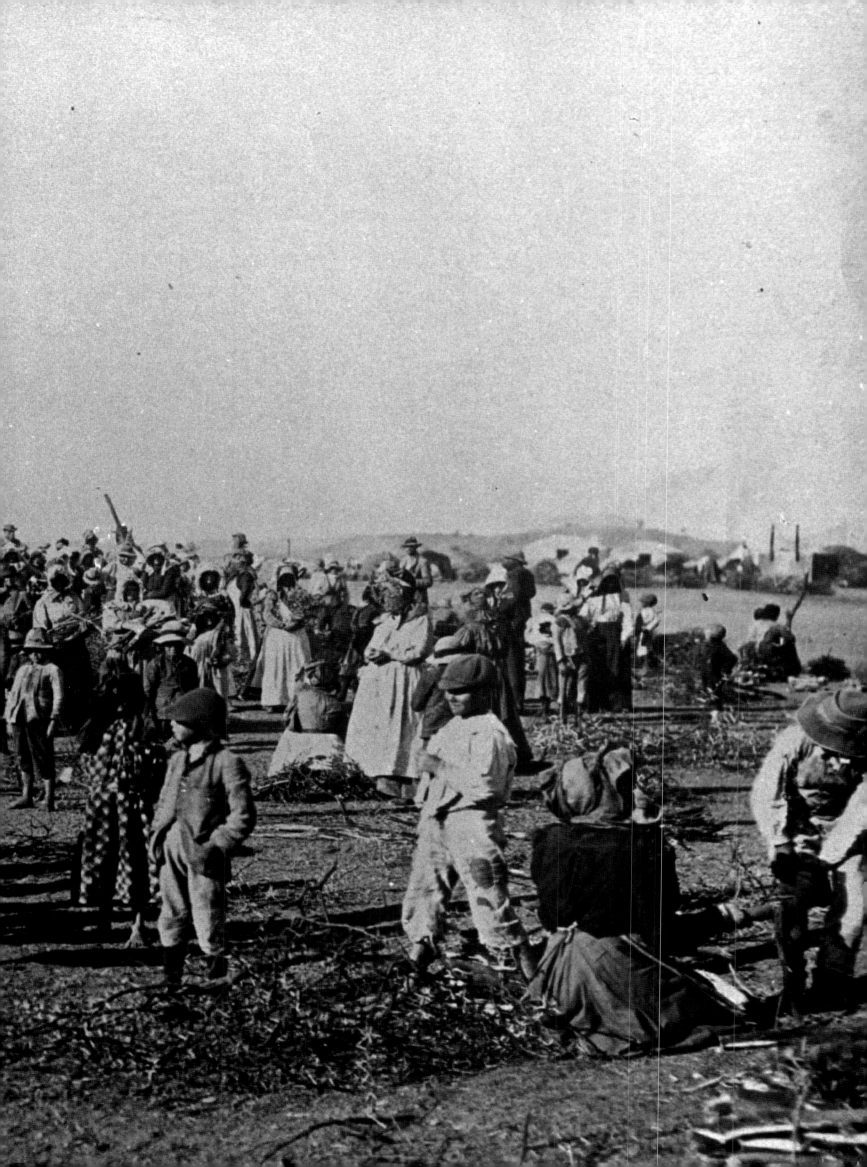

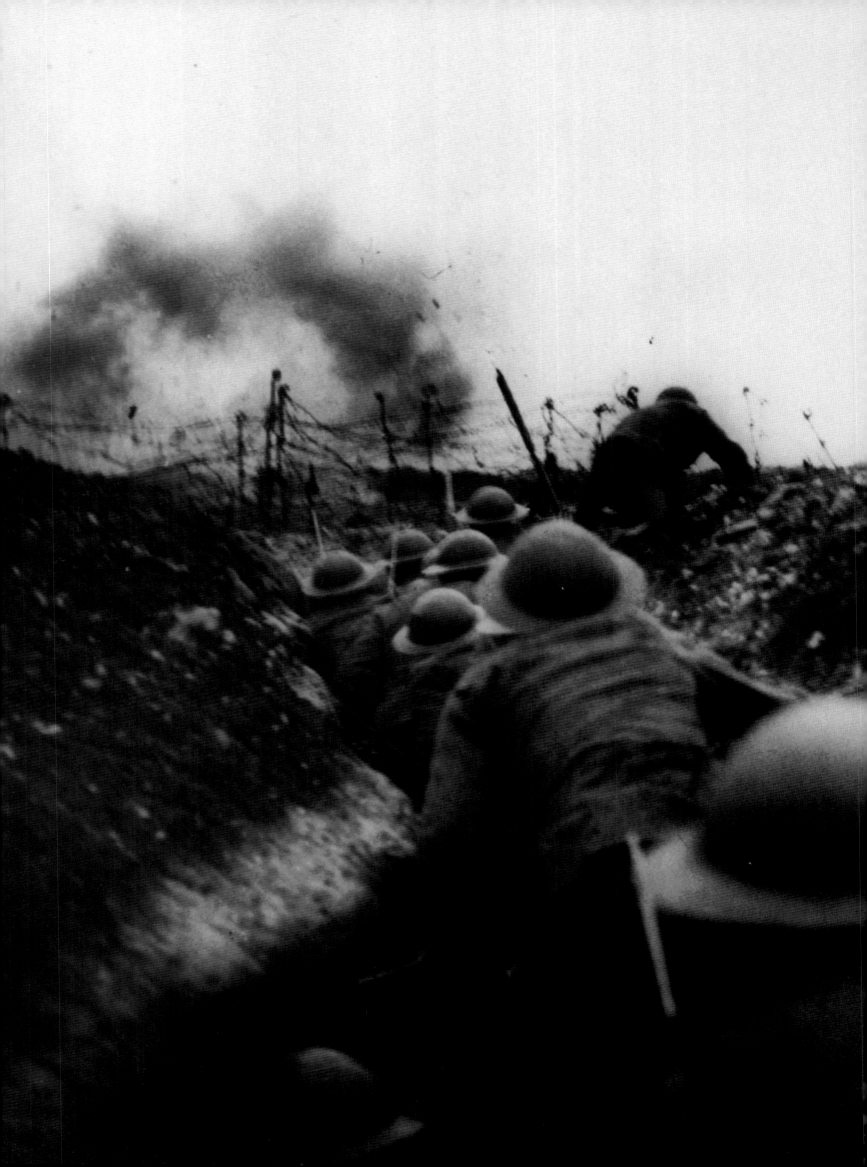

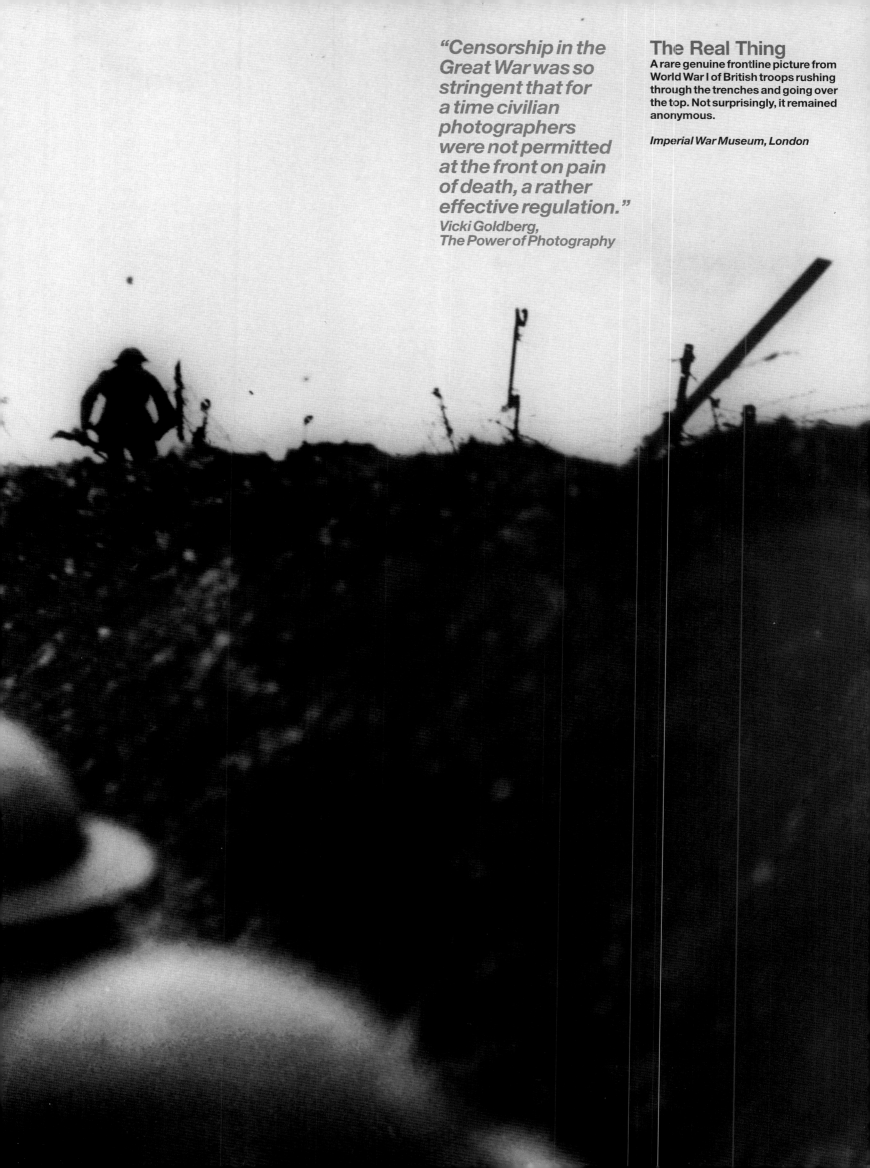

"Censorship in the Great War was so stringent that for a time civilian photographers were not permitted at the front on pain of death, a rather effective regulation."
Vicki Goldberg,
The Power of Photography

The Real Thing
A rare genuine frontline picture from World War I of British troops rushing through the trenches and going over the top. Not surprisingly, it remained anonymous.

Imperial War Museum, London

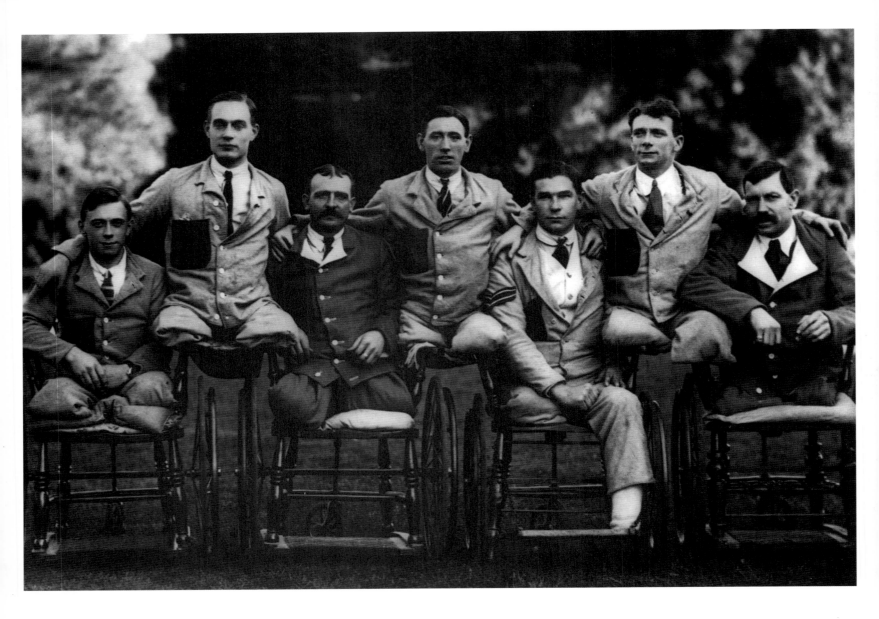

Counting the Cost

(Above left) London, 1918. A group of British amputees from World War I convalescing at Roehampton Military Hospital. Only gradually did the social cost of the war sink in, and the realisation that a whole generation of young men were maimed or dead.

(Above right) Western Front, 1917. Dead German soldiers lying in a trench.

Imperial War Museum, London

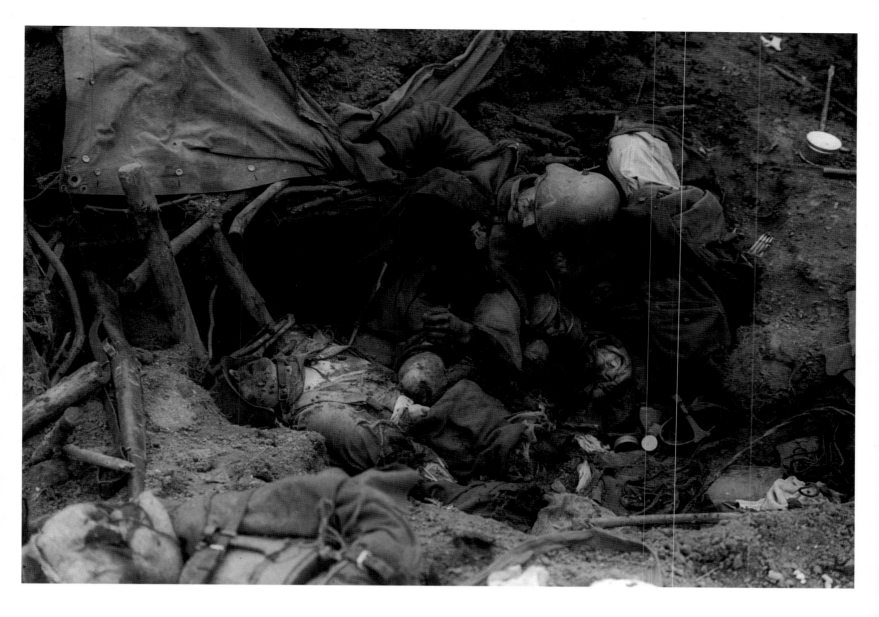

During the Great War, the British government used the Defence of the Realm Act to impose an extreme system of censorship. As Jane Carmichael points out in *Photographs of the First World War*, few disturbing images were allowed past the censors while the war was going on and the British public were largely protected from the harsh realities of life in the trenches. Newspaper proprietors and war correspondents, including photographers, collaborated willingly with this form of control and accepted the need to disseminate propaganda. Few photographs exist which show the reality of war for British troops and the savagery of the hand-to-hand combat.

Significantly, those photographs held in the Imperial War Museum which do convey the full horror are usually of German troops. Even disturbing pictures of enemy casualties were frequently banned, presumably on the assumption that an intelligent audience could make the required mental leap from what was happening to the enemy to what might be happening to their own side.

A survivor of the Great War, Stuart Cloete, recalls a memory from 1916 when he witnessed a dreadful accident: a heavy ammunition carriage inadvertently drove over a line of injured soldiers. They "sat up as the wheels went over them and burst like grapes". Pictures and reports of these kinds of incidents did not find their way into the contemporary press. Years after the war, one British officer described being on a burial party after the Battle of the Somme in 1916: "As you lifted a body by its arms and legs, they detached themselves from the torso, and this was not the worst thing. Each body was covered inches deep with a black fur of flies, which flew up into your face, into your mouth, eyes and nostrils as you approached. The bodies crawled with maggots... We stopped every now and then to vomit... The bodies had the consistency of Camembert cheese. I once fell and put my hand through the belly of a man. It was days before I got the smell out of my hands." (George H Roeder Jr, *The Censored War*)

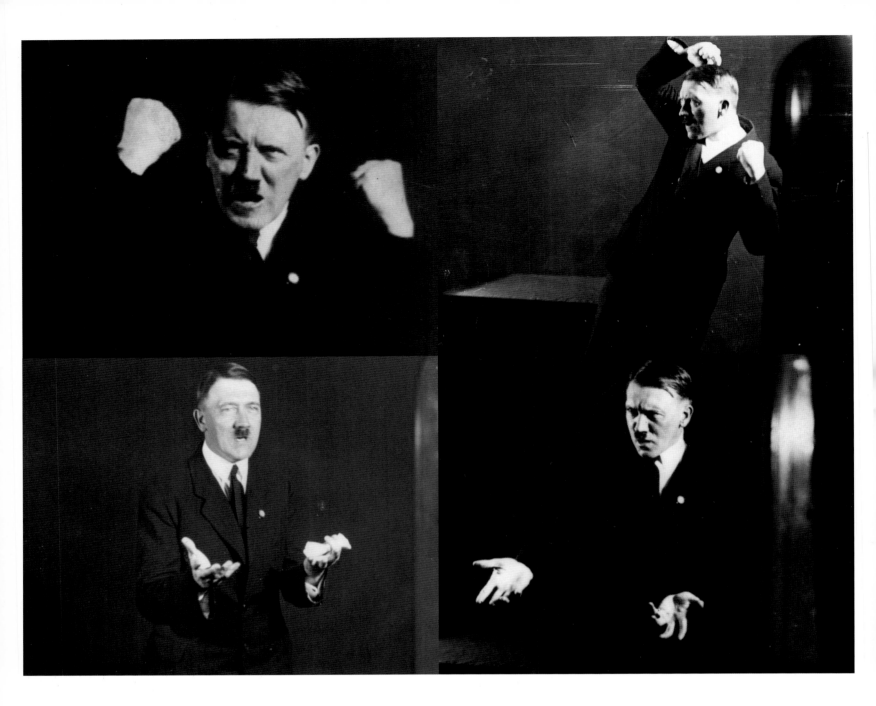

The Great Pretender

Germany, 1925. Adolf Hitler rehearses supposedly spontaneous gestures while listening to a recording of one of his speeches, soon after he had written his political manifesto, *Mein Kampf*. Taken by his personal photographer, Heinrich Hoffman, who accompanied him everywhere, the photographs explode the myth of Hitler's natural hypnotic, demagogic skills. Subsequently, Hitler ordered Hoffman to destroy the negatives; fortunately for posterity, Hoffman disobeyed. Such absurd images, had they been widely seen at such an early stage of Hitler's political career, may well have pricked the balloon of his shaky credibility.

Hulton Archive

It is seldom appreciated how rich Hitler was. Writing in the British magazine *New Statesman*, Julia Pascal points out that by the time he died, 8 million copies of *Mein Kampf* had been sold, making him a multi-millionaire. He boasted that *Mein Kampf* sold more copies worldwide than any book apart from the Bible, which was hardly surprising since 6 million copies were bought by the state and handed out to German newlyweds as a marriage present. The book was extremely explicit about Hitler's plans for the Jews, the disabled and those deemed "racially inferior", which tends to undermine widespread claims permeating post-war Germany that nobody knew what Hitler was planning to do.

Hitler originally wanted to call his masterpiece *A Four-and-a-Half Year Struggle Against Lies, Stupidity and Cowardice*, but was persuaded by his publisher to adopt the snappier title of *Mein Kampf* ("My Struggle").

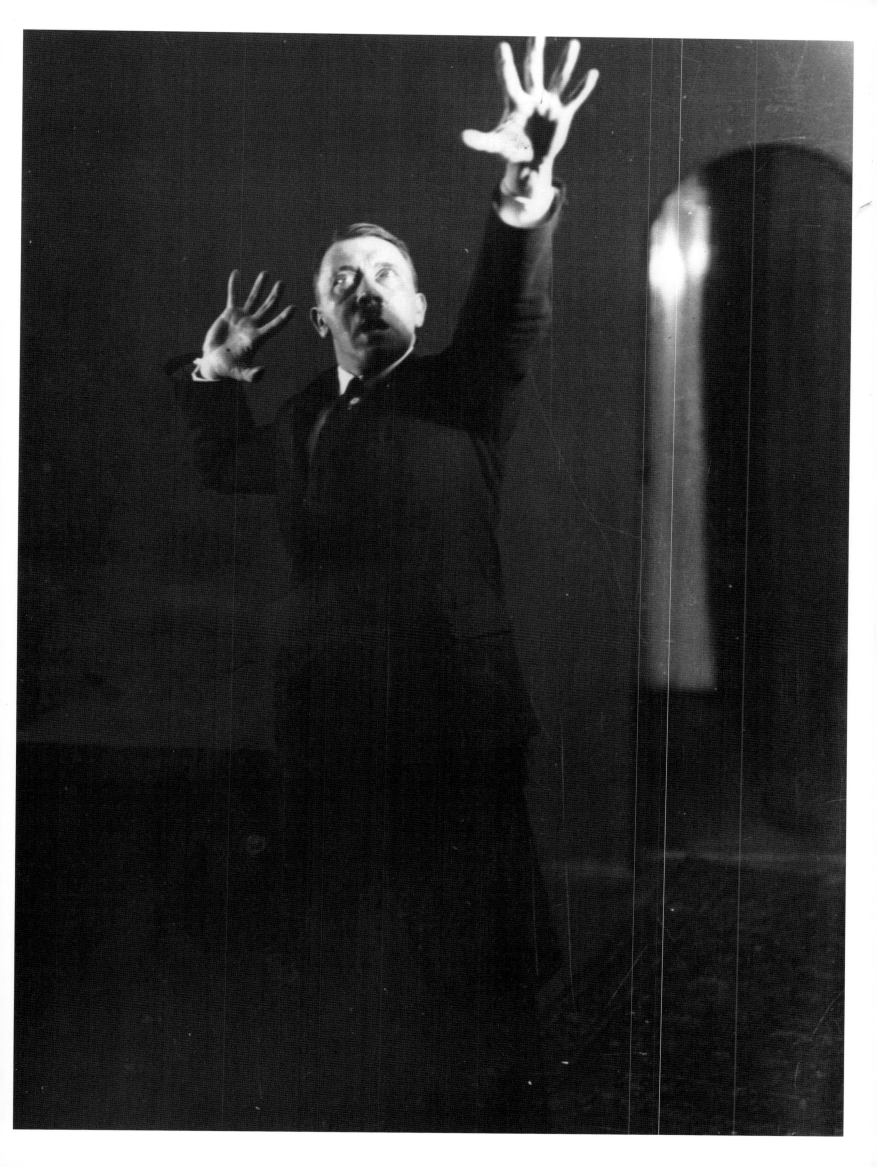

London's Burning

March 8 1945. The aftermath of one of the last German V2 "doodle-bug" rocket attacks on London before the end of World War II.

(This page and overleaf)
Hulton Archive

380 people were killed in the Farringdon Market area in the centre of the city, just over a hundred yards from the offices of *Picture Post*. A photographer and reporter from the magazine were on the scene before the dust had settled, but the censors killed the story, believing the images would demoralise war-weary Londoners. It was not until 1948 that the photographs were finally published (overleaf).

In 1944, British censors banned the hit US song "I Heard You Cried Last Night" because a man crying was "not a good thought at the present time".

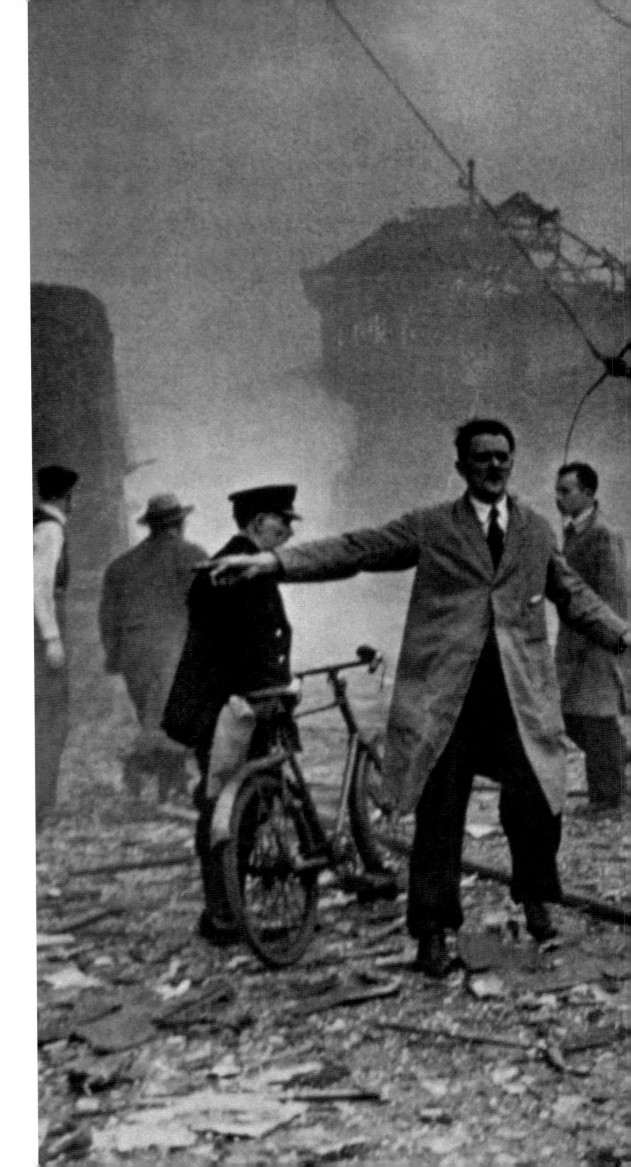

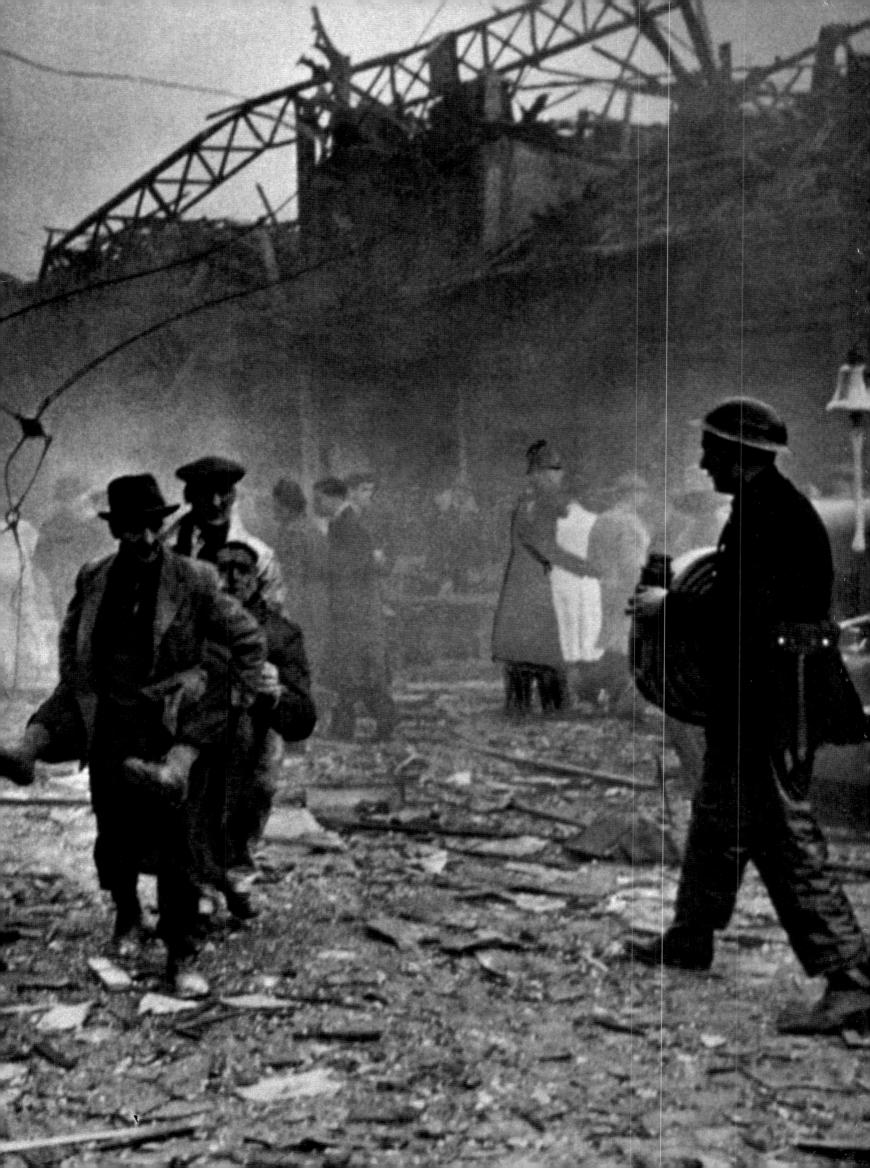

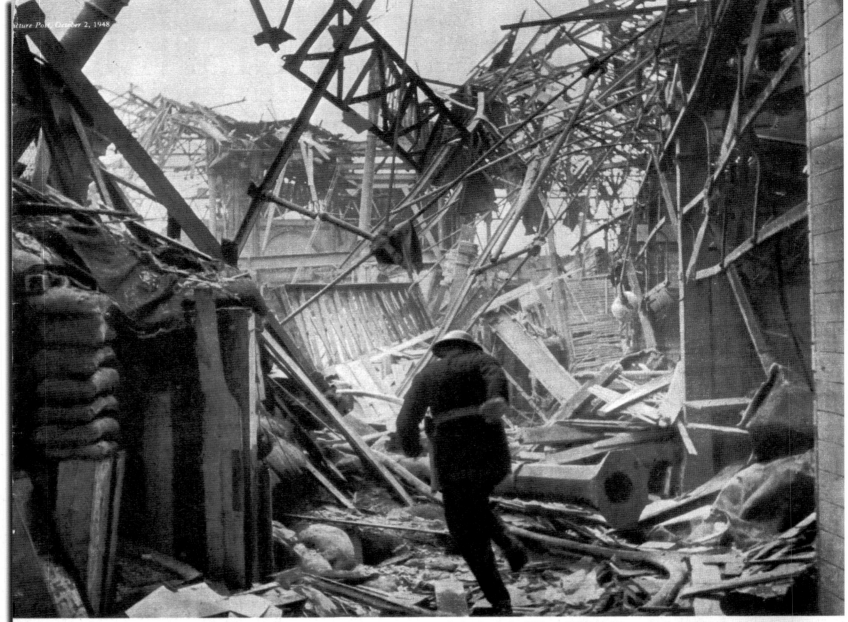

A Blow from a Dying Enemy: One of the Last, and One of the Worst, Bomb-Scenes of the War

A V2 rocket has just fallen on the Farringdon Market, not much more than a hundred yards from Picture Post office in Shoe Lane. Our photographers were on the scene before the dust had settled. Several hundred people who were there that morning did not see the end of the war on London.

ONE STORY WE COULDN'T TELL

Photographed by HAYWOOD MAGEE & FRANCIS REISS

Our office is in a cluster of buildings surrounded by acres of bomb-sites. Here is the record of one 'near-miss,' untold before because of war-time censorship.

AT two minutes to eleven, on the eighth of March, 1945, the war was nearly over for most of us. The last doodle-bug base had been captured, and I can still remember how it felt to get into the bath that evening without having to consider what an unsatisfactory place the bath would be to be blown up in. A day or two later, with aerial peace beginning to be taken for granted, we heard with a sick feeling a very loud explosion.

Next day, all London was speculating. And wish-fulfilment gave the greatest number of votes to the theory that a gasometer had exploded in Chiswick. We were soon to know better, and in a day or two, V2 had to be acknowledged, for it had certainly arrived.

At that minute, on that March morning, the names of some three hundred and eighty people were 'on it.' On one of the last of the rockets, and one of the worst. It fell on the Farringdon Market, at the junction of Farringdon Street and Charter-house Street, at the busiest hour of the day. Outside the meat and fish and poultry shops, and along the

Continued overleaf

Smoke and Dust Darken the Spring Sky

Passing civilians, shopkeepers, men from the trolley-bus maintenance shops, all dropped whatever they were doing and ran to the market to help wherever they could.

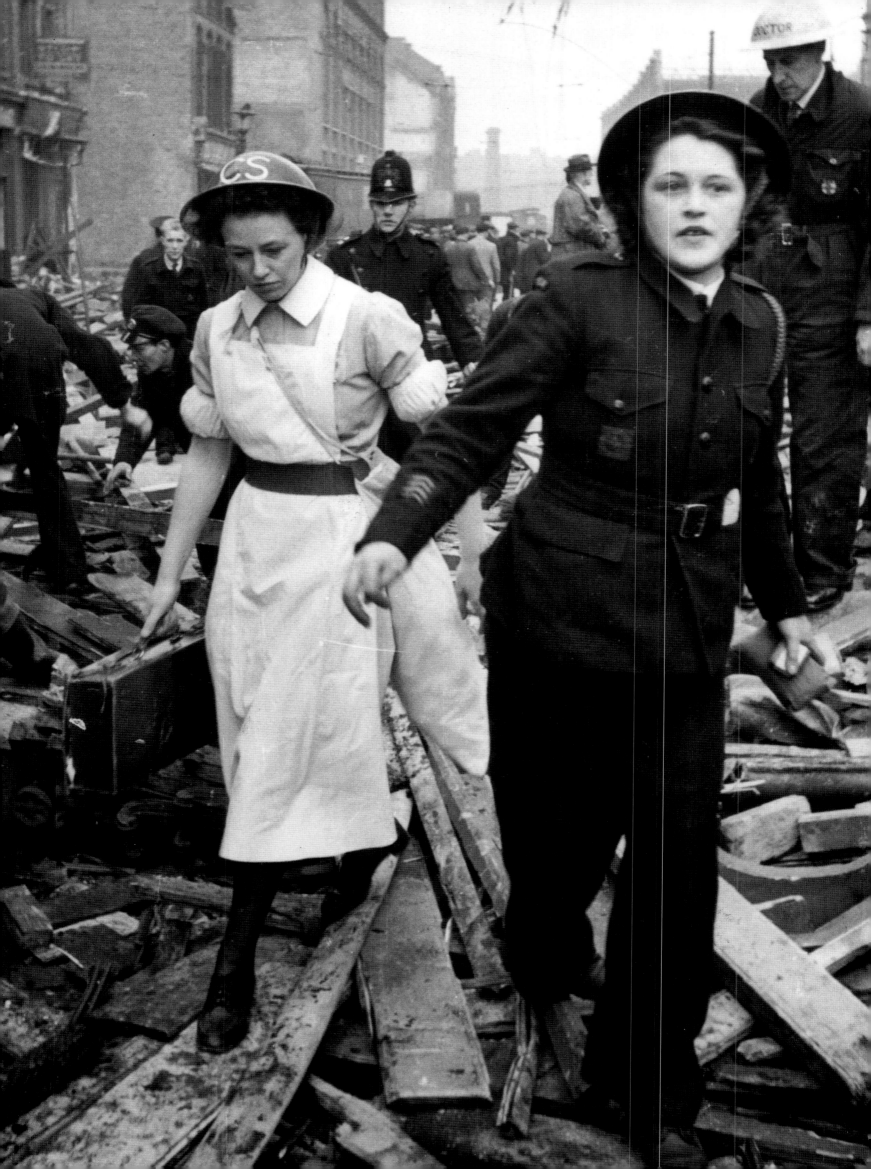

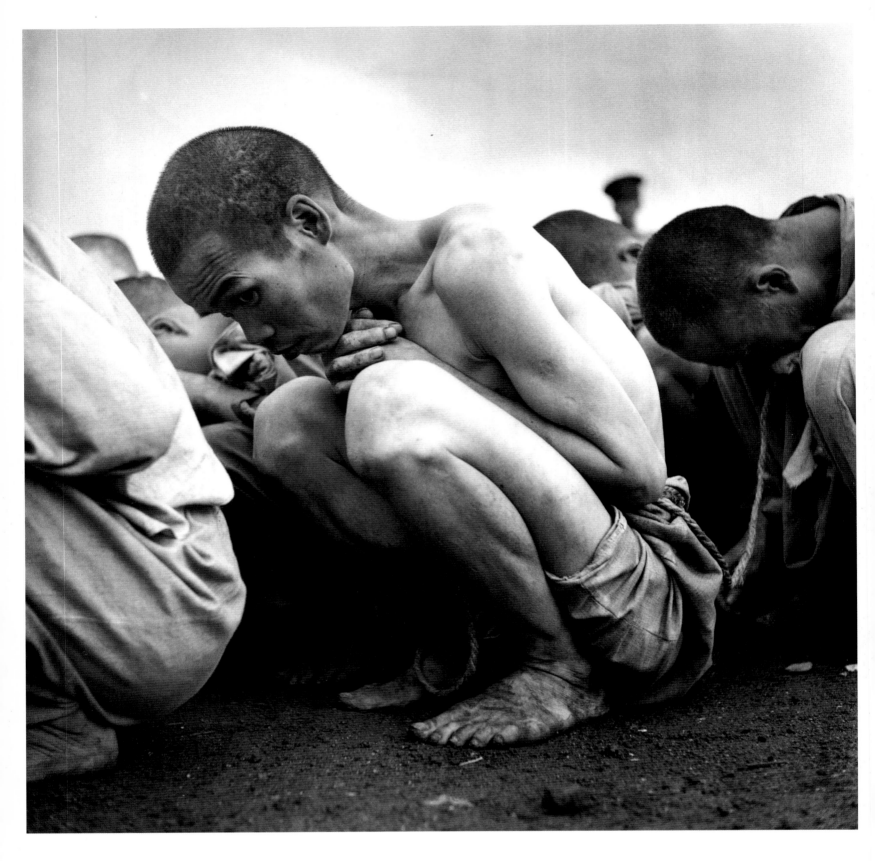

Proprietorial Power

South Korea, 1950. At the height of the Korean war, suspected opponents of the South Korean regime, which was supported by the Western Allies under the flag of the UN, were rounded up as political prisoners and accused of being supporters of communist North Korea.

Hulton Archive

Prisoners on both sides were treated brutally but little evidence of South Korean atrocities appeared in the Western press. This photograph was part of a story taken by Bert Hardy for the British magazine *Picture Post*, with text by the distinguished journalist James Cameron. The proprietor of the magazine, the pro-establishment Sir Edward Hulton, banned the hard-hitting report because he felt it undermined the anti-communist war effort. It was also rumoured that he feared the article would scupper his chances of a knighthood (which he eventually received). The editor of *Picture Post*, Tom Hopkinson, refused to go along with Hulton's order to pull the article and was sacked. The story (right) was never published.

James Cameron wrote: "I had seen Belsen but this was worse. This terrible mob of men – convicted of nothing, untried – South Koreans in South Korea, suspected of being 'unreliable'. There were hundreds of them… skeletal, puppets on a string, faces translucent grey, manacled to each other with chains, cringing in the classic Oriental attitude of subjection, the squatting foetal position, in piles of garbage… around this medievally gruesome marketplace were gathered a few knots of American soldiers photographing the scene with casual industry."
(Halliday and Cummins, *Korea, the Unknown War*)

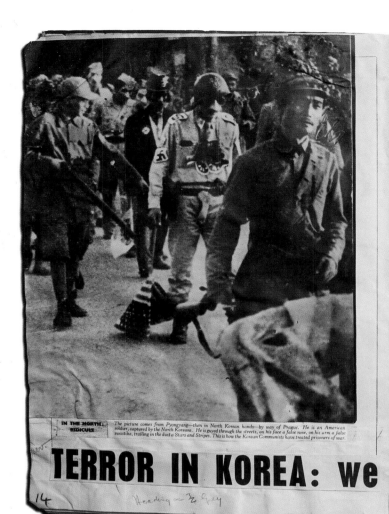

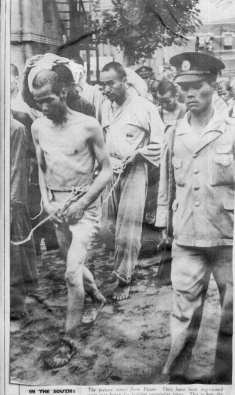

James Cameron is now home. We publish his final article written in Korea because we believe that the cause of the United Nations is best served by recognising some of the ugly things which have been happening under its flag. We believe that once these things are known, U.N. will certainly take vigorous action to see that they are not repeated. That is why we have sent the text and pictures to the General Secretary of U.N. and to Mr. Kenneth Younger, who leads the British delegation at Lake Success.

WE were on our way through the station compound at Pusan, on a lowering day of rain, when we came on the sight that, more than anything else in that unlovely country, made us realise that the corrupting hand of Korea had reached out for us at last. A month before we would have been aghast; it was shocking then only to feel it commonplace.

In photographing this incident, and publishing the photographs, we knew we might possibly be accused of damaging the cause of the United Nations in Korea; it was a chance we were ready enough to take, knowing that we have the support of the U.N. officials themselves, together with that of all democrats still left in Korea.

The pictures should tell the whole story in terms of a human abasement in which we, specifically, have a shareholder's responsibility. There is not much need for me to do more than explain that these are political prisoners of the South Korean Government—I must repeat the South Korean Government, for whose integrity both U.S. and British troops, with the immense moral backing of the United Nations, have been fighting. Nor the North Koreans, whose system traditionally operates in this vicious fashion. They are South Korean civilians whose crime—or alleged crime, since they have not yet had the formality of a trial—is that they are possible opponents of the Synghman Rhee régime. They have, for a variety of reasons and by a variety of people, been denounced or accused—not yet necessarily convicted—of being politically unreliable, 'potentially Communist.' They have been in jail now for indeterminate periods—long enough, we can say, for lack of official information, to have reduced their frames to skeletons, their sinews to strings, their faces to a translucent, terrible grey, their spirit to that of cringing dogs. They are roped and manacled. They are compelled to crouch in the classic Oriental attitude of subjection in pools of garbage. They clamber, the lowest common denominator of personal degradation, into trucks with the numb air of men going to their death. Many of them are.

The spectacle is utterly mediaeval. Among the crowds drifting indifferently around, a few bystanders take snapshots, grinning.

These things have to be said. The U.N. delegation in Korea, to whom I wrote in protest, said:
Continued overleaf

Continued overleaf

IN THE NORTH: RIDICULE *The picture comes from Pyongyang—then in North Korean hands—by way of Prague. He is an American soldier, captured by the North Koreans. He is guyed through the streets, on his face a false nose, on his arm a false swastika, trailing in the dust a Stars and Stripes. This is how the Korean Communists have treated prisoners of war.*

IN THE SOUTH: THE CORD *The picture comes from Pusan. They have been imprisoned since war began for holding unpopular views. This is how the Korean anti-Communists treat some political prisoners.*

TERROR IN KOREA: we appeal to U.N.

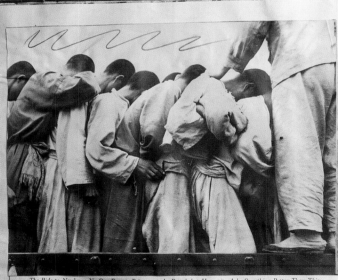

The Ride to Nowhere: No One Expects Prisoners to be Petted, but Humanity Asks Something Better Than This
Unlike cattle, they are roped together. They do not know where they are going. They do not know if they will ever come back. Marked on the truck was the Allied Star, which should become a guarantee of fair treatment.

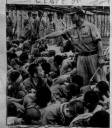

The Men in the Market-place
In the middle, a South Korean guard. In the background, more guards. All around, shaven heads.

"We wish you would try to do something about it; we can't"—an attitude that was not hostile, even if it was supine and futile. The International Red Cross said: "It's shameful, but there you are; everyone knows that the United Nations here means the Supreme Command Far East, and that means the U.S. Army, and that means General MacArthur, and he's in Tokyo."

Of all the melancholy considerations brought about by this war-that-isn't-a-war, this must surely be the most disheartening. In the practical sense, of course, this campaign is a 100 per cent. MacArthur show, militarily and politically. Nevertheless in all the pious announcements, and likewise in the minds of men, it is a United Nations show if it is anything, and the flag is our flag, too. Yet barbaric scenes like these were permitted to take place, cynically, in the most public place possible, under the United Nations, with all our supervisors claiming they are unable (because they haven't tried) to stop the excesses of a domestic Government that is about as democratic and high-principled as Caligula's Rome.

Our South Korean allies are an amiable enough people, afflicted with a savage police, who have the Asiatic conception of technical justice, the administration of suffering, and the rights of men who might be guilty. If it were indeed their war, it would be deplorable; as it is our war it is intolerable.

It is ridiculous and immoral to shrug it off and say: "You know what these people are," when firm action from the military commanders could stop it. They know, because they have told me, that they are perfectly aware of what goes on, the imprisonments without trial, the 'processing of suspects,' the beatings-up, the tapings of thumbs to the terminals of field-telephones, and they say: "We are pretty busy with other things."

I would like to know what other things are more important to the outcome of this struggle than the maintenance of clean hands on one side at least, the avoidance of handing to the enemy precisely those propaganda weapons he can best use. In every war atrocity begets atrocity; to keep it under cover would presume some sort of conscience about it, to display it openly suggests a carelessness and psychological idiocy that surely ill becomes the first fight ever undertaken in the name of *international* justice and principle.

This is dispiriting to write, and hurtful, and damaging to some very very brave men who are sweating out the war in less cosy and powerful places than the rear-echelon and the United Nations Base Office. Yet it seems important to say that if the difference between the thing we are fighting for and the thing we are fighting against is allowed to become academic to the point of invisibility, then let us hand over our publicity now to the Kremlin, which at least handles hypocrisy like an expert.

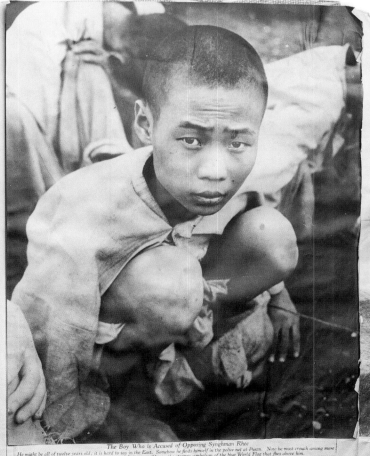

The Boy Who is Accused of Opposing Synghman Rhee
He might be all of twelve years old; it is hard to say in the East. Somehow he finds himself in the police net at Pusan. Now he must crouch among more experienced enemies of the State, wondering, possibly, on the strange symbolism of the blue World Flag that flies above him.

Ghost in the Machine

February 26 1991. An Iraqi soldier burnt to a cinder at the wheel of his vehicle on the road to Basra at the end of the Gulf War. Allied pilots relentlessly attacked the demoralised Iraqi troops as they retreated in a convoy of a thousand vehicles; some of the pilots referred to it as a "turkey shoot". Unofficial estimates put the number of dead at between 400 and 2,000.

Kenneth Jarecke/
Contact Press Images

"A newspaper that tells only part of the truth is a million times preferable to one that tells the truth to harm its country."
British tabloid newspaper
The Sun

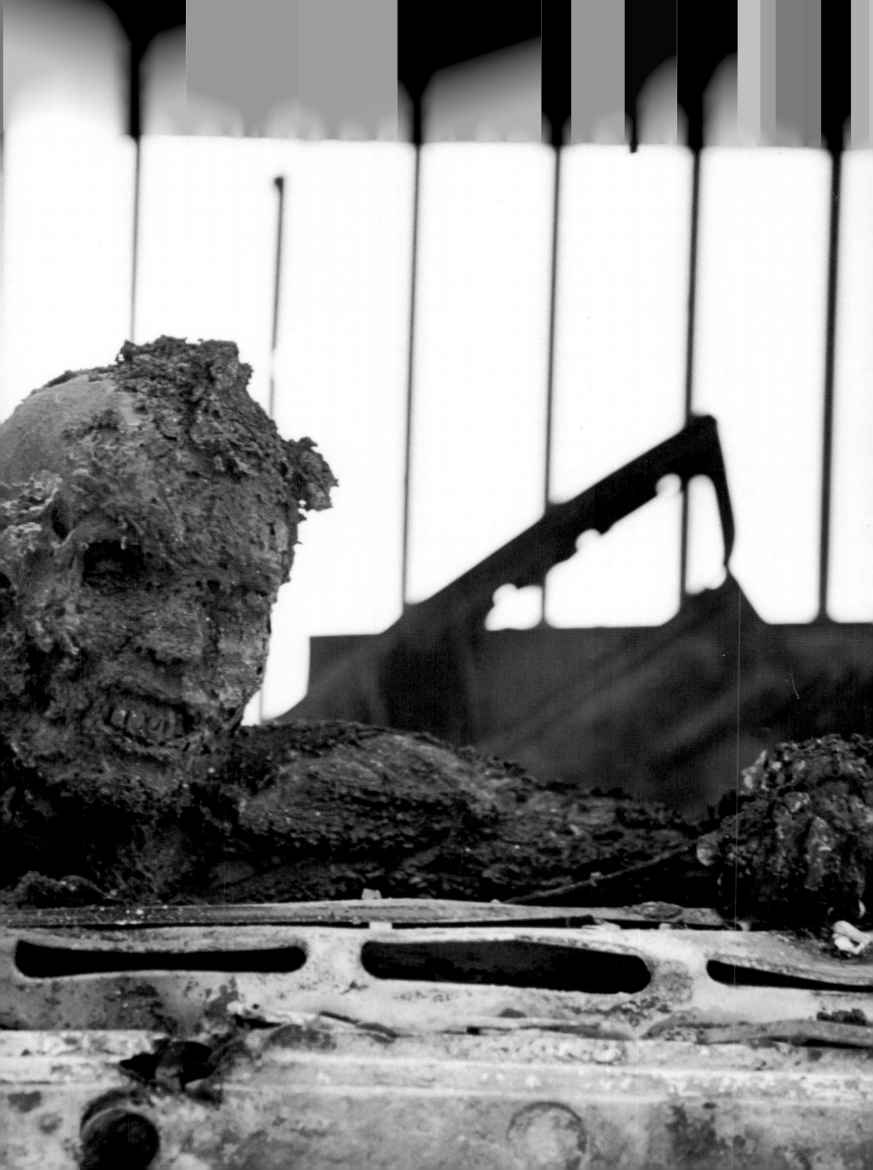

◄ On February 1, 1943, during World War II, *Life* magazine published a famous Ralph Morse photograph of a screaming, helmeted Japanese skull perched on a burnt-out tank. Many readers complained but the editors responded: "War is unpleasant, cruel and inhuman. And it is more dangerous to forget this than to be shocked by reminders."

The US government was more aware of the way in which photography could support the war effort than their British counterparts. In 1943, *Life* magazine's editors argued with the censors that some of the realistic pictures coming back from the war should be published to make the American public more patriotic: "Why should the home front be coddled, wrapped in cotton wool, protected from the shock of the fight? If Bill had the guts to take it, we ought to have the guts to look at it, face-to-face." President Roosevelt was finally persuaded, and *Life* published one of the first pictures of US dead on a beach in New Guinea. Public reaction was overwhelmingly favourable and sales of bonds to pay for the war effort soared. As George H Roeder Jr wrote in *The Censored War*, "The tough pictures which had been withheld to keep morale high were now brought out of hiding for the very same reason, and this time they did a better job."

Half a century later, in a very different climate, Ken Jarecke took this photograph, one of the very few images to emerge from the Gulf War showing the horrors of war from the enemy's point of view.

Jarecke was working on assignment for *Time* but the magazine did not publish it. Associated Press, the US international news and picture agency, transmitted the image to their New York office but the editors there killed it. An AP spokesman said, "Newspapers will tell us, 'We cannot present pictures like that for people to look at over breakfast.'" Contrary to their attitude in 1943, *Life* magazine declined to publish Jarecke's picture; originally it was designed over a two-page spread to appear the week after the war ended, but the photograph was killed at the last moment. The managing editor apparently described the photograph as the "stuff of nightmares" and cited the effect it would have on children as his reason for rejecting it. Eventually, the image appeared in *Time*'s end-of-year special, but when an all-time best of *Life* publication appeared a couple of years after the Gulf War, the picture was used thumbnail-size on the publisher's page with a note from the editor.

The only publication to print this image as a news photograph was the London *Observer* on March 3 with the caption "The real face of war", although they chose not to run it on the front page; perhaps because it was a few days after the event, perhaps because of its shocking effect. The *Observer*'s picture editor defended its use in the *British Journal of Photography*, suggesting the picture established that "war is disgusting, humiliating and degrading, and diminishes everybody".

The Gulf War was presented to the world as a squeaky-clean technological masterpiece and the public were not encouraged to associate computer-controlled, laser-directed weapons with subsequent human carnage. Jarecke has gone on record as deploring "censorship by omission" as the most prevalent form of censorship at work in the "free" world. "No one would touch my photograph. The excuse was that it was too upsetting, that people don't want to look at that kind of thing any more. The truth was that the whole US press collaborated in keeping silent about the consequences of the Gulf War and who was responsible." (*Reporting the World: John Pilger's Great Eyewitness Photographers*)

Jarecke feels betrayed by the US press. In a TV interview he spoke of how he had "risked his life to do his job, for nothing. If the US is tough enough to go to war, it should be tough enough to look at the consequences". (*Decisive Moments*, BBC Television)

In his book *Body Horror*, John Taylor quotes a journalist from the London *Daily Express*, Chris Buckland, who wrote that despite an unprecedented bombing campaign, "not a single body has yet been photographed, and not a single injured soldier seen on TV... This absence shrouded the war in mystery, and encouraged suspicions that the public were being misled."

Many things were strange about this war, including the casualty lists. Of the 16 British troops who died, nine were killed by "friendly fire" from the Americans, who mistook British Warrior armoured vehicles for retreating Iraqis. 148 Americans also died, 35 of whom were killed by their own side. In spite of boasts of technological precision, Allied military officials blamed these unfortunate incidents on the featureless terrain of the battlefield, the need to fight in rain and darkness and the long range of the weapons. "Our goal was not to kill people, our goal was to destroy the Iraqi army," said President George Bush's National Security Adviser. The total number of Iraqi casualties seems clouded in mystery. At one point, General Schwarzkopf, commander of the UN alliance, let slip, "We must have killed 100,000," whereas official US government estimates were much lower, at between ten and thirty thousand. "The increasing refusal to be clear about military deaths implies that the number of Iraqi soldiers to be killed had ceased to be central and had become beside the point or even theoretical." (John Taylor, *Body Horror*)

Survival Instinct

In 1957, a decade after its foundation, the celebrated international photo co-operative Magnum was faced with an unenviable conflict of loyalties which led to them censoring one of their own stories about an FLN training camp in Algeria.

Photograph by Kryn Taconis/Magnum

In his book *Magnum*, Russell Miller discusses the background to this intriguing story. Kryn Taconis was a Dutch photographer passionately concerned with humanitarian issues – he had been a Resistance leader in Holland during the German occupation. He joined Magnum in 1955. Two years later, he made contact with members of the FLN, the Algerian freedom fighters who were seeking independence from France. This was a nasty war, involving many atrocities. French settlers in Algeria were being targeted by nationalists and often hacked to death. The atmosphere in France itself was very tense and paranoid concerning their North African colony.

Taconis was promised access to the rebels' military operations in Algeria. He was extremely excited by this prospect and hoped to get his picture story published in time for an important UN debate on Algerian independence to be held in September 1957. He spent a week with the FLN forces, but little happened which he could photograph. He went on a night raid but it was too dark to take pictures; a supposed ambush of a French convoy in the mountains never happened because the convoy did not arrive.

So Taconis left Algeria without any real conflict photographs, although he did have a journalistic scoop on the training of the FLN, a story which would be bound to upset the French authorities. French newspapers and magazines which tried to publish articles sympathetic to the Algerian cause were routinely censored. In the Paris office of Magnum, everyone was extremely nervous about the Taconis story, especially Henri Cartier-Bresson, co-founder of the agency. "The 'Algerian question' was the cause of great political tension at that time," writes Miller. "Cartier-Bresson became convinced that the agency risked being closed down, or even bombed by right-wing extremists, if it went ahead with publication." In this atmosphere, Magnum decided to send out the photographs anonymously, without an agency or photographer's credit.

Initially, Magnum Paris was concerned that the photographs should not be seen anywhere in France, but eventually great pressure was put on Taconis to withdraw the story completely. A majority of Magnum members agreed with this approach and Taconis reluctantly went along with it, though he wrote a hurt letter to his colleagues regretting their lack of courage and warning that such an act of censorship could seriously affect the agency's credibility. Afterwards, he resigned from Magnum a disillusioned man.

Henri Cartier-Bresson confirmed: "[Taconis] was very upset, very upset. So were we, but it was not possible because in those days one would have had a plastique [bomb] through the door."

Marc Riboud, a senior Magnum member, concurred: "Was it reasonable for the whole future of Magnum to be put at risk for one story? We were all against the war in Algeria, but it was a very emotive subject at the time. Everyone was worried about reprisals."

A few months earlier, Cartier-Bresson had given a magazine interview in which he said: "We have great responsibility and must be extremely honest with what we see. The photographer must not censor himself while shooting… Everybody in Magnum has full liberty… Nobody in Magnum decides for the other what he should do." (Russell Miller, *Magnum*)

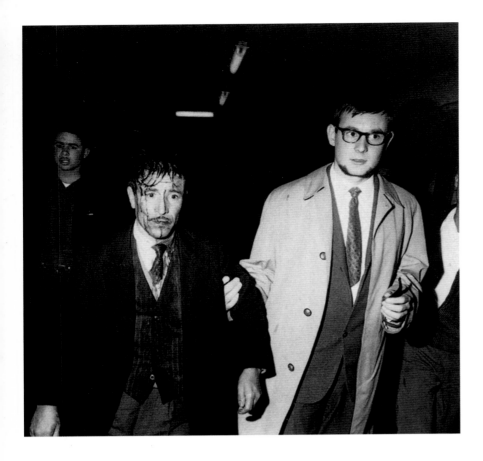

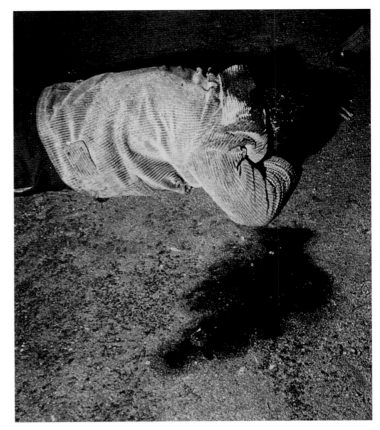

Blood in the Seine

On October 17, 1961, over 30,000 Algerian nationalists defied a curfew and took to the streets of Paris in a peaceful protest against infringements of their civil rights. The Paris police reacted with extreme violence. The number of Algerians injured or killed that day is still shrouded in mystery.

Elie Kagan/courtesy fonds Elie Kagan – BDIC, Paris

The Paris police chief, Maurice Papon, later to be found guilty of crimes against humanity during World War II, ordered riot police to break up the demonstration, allegedly with instructions to "shoot on sight". Prior to commanding the Paris police, Papon coordinated military and civil forces in east Algeria, and torture and summary executions were a daily part of his "pacification" programme.

From 1958, Papon's police started to crack down on the Algerian community in Paris. Two weeks before the massacre, during a funeral for a policeman killed by a member of the FLN, Papon declared that every act of violence against his men would be repaid tenfold. On October 5, 1961, the police unilaterally imposed an illegal curfew on all Algerians. In this atmosphere of tension and mistrust, false rumours were spread claiming that more French policemen had been killed by the FLN.

Several witnesses confirmed that the crowd participating in the October 17 demonstration, which included women and children, was peaceful, but the police started shooting anyway to "protect themselves". From then on, the police chased anyone who seemed to have a North African appearance; they arrested 10,000 people and transported them to a detention camp. Others, it is alleged, were beaten up or killed in the streets of Paris and the suburb of Nanterre and many bodies were thrown into the Seine. By nightfall, the streets were spattered with blood. Official figures released at the time stated that just two people had died. Over 25 years later, in 1997, this figure was revised upwards to "several dozen". Eyewitnesses told a different story. Forty years on, nobody knows for sure how many Algerians died; estimates range from 32 to around 200.

Strenuous efforts were made to destroy evidence after the event. Police confiscated all the film they could find, and there are suggestions that newspapers collaborated with this censorship, including the editor of the communist *L'Humanité.*

Much of the worst violence took place behind police lines or in police stations, and at night it was easy for the police to spot a camera flash and intimidate the photographers.

However, a courageous left-wing photojournalist, Elie Kagan, managed to hide his film before the police searched him, collecting it later it when things had calmed down. His photographs remained largely unpublished for many years, and as recently as 1996, copies of the Algerian newspaper *Liberte* which printed the photos were confiscated by French customs in Lyons.

In Nanterre, Kagan came across a badly injured man covered in blood, lying next to a dead man (above centre). He took some photographs and then drove the man to hospital (right). Kagan testified that the man was still alive at that time. Later, he discovered from records that the same man's body had been delivered to the morgue by a police car (cause of death was identified as severe fractures of the skull). Witnesses confirmed that the police rounded up many of the badly injured from hospitals but no one knows what happened to them after that. Many years later, the family of the dead man identified him from Kagan's photographs.

Parisians seemed largely unconcerned about the dreadful events unfolding in their city. Kagan himself referred to the "complete and total indifference of the French people". Even when two Parisians carried a wounded Algerian to a pharmacy, a policeman reacted: "Why are you bothering with these scum? Let them crawl away and die."

Athough a few of Kagan's photographs were printed at the time in *L'Express* magazine, October 17 1961 remained a piece of hidden history. None of the dead were ever registered officially, and as recently as 1999 Papon rejected the authenticity of Kagan's evidence in *Le Monde* newspaper: "Elie Kagan's photographs? I don't believe them, they're just a montage."

Official records of the events were hidden away and complaints against the police were never investigated. Papon remained chief of police until 1967. De Gaulle resisted calls for a parliamentary inquiry. In 1962, a general amnesty pardoned all crimes committed in combatting the "Algerian insurrection". Jean-Luc Einaudi, author of a book on the events based around Kagan's photographs, commented: "The massacre has been allowed to disappear forever from our collective memory." It was Channel 4, a British TV company, which made the first major documentary about the events. Until recently, most of the French press treated this extraordinary event in their capital city with a resounding silence.

Kagan died in 1999, but in October 2001 many French publications marked the 40th anniversary of this tragedy by embarking on new investigations of the events, relying heavily on his photographic evidence.

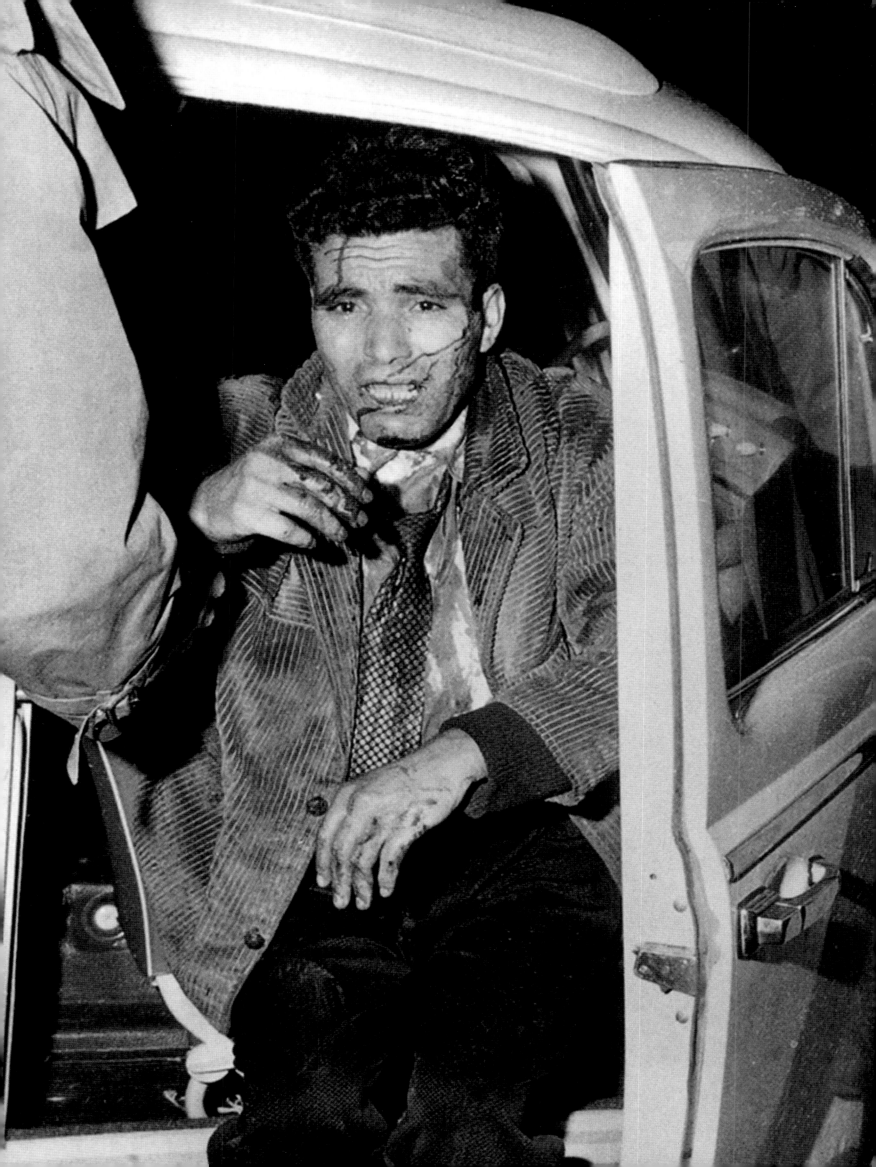

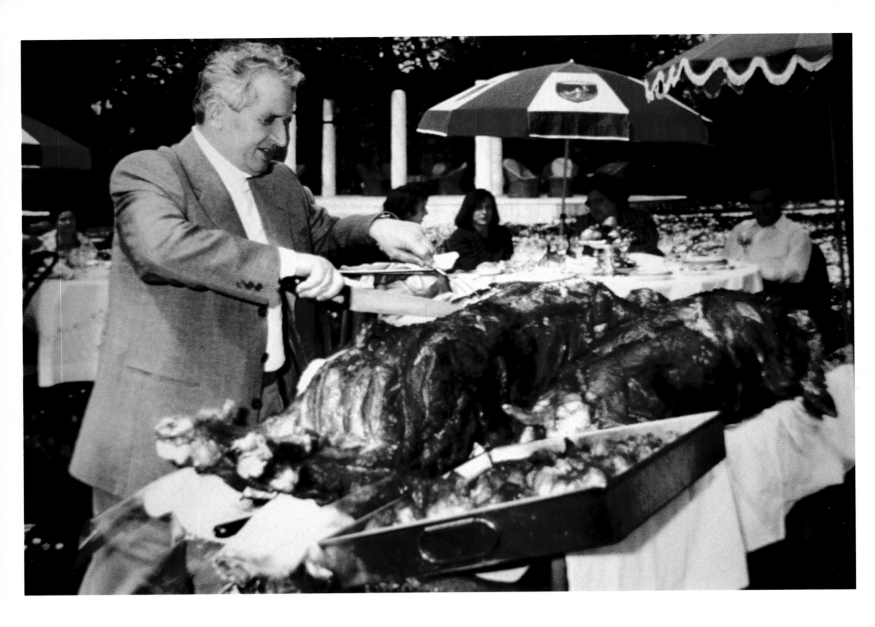

The Good Life

Nicolai Ceaucescu instituted a brutal reign of terror in Romania from 1974 to 1989, backed by his notorious Securitate secret police. Like many dictators, he appointed members of his family to high office, including his wife Elena, whom he made deputy Prime Minister and Minister of Culture. He became the darling of the West, persuading them that he was independent from the Soviet Union, so much so that he was welcomed by the British Queen on a state visit and given an honorary knighthood. At the same time, he managed to convince the Soviet Union that he was a hardline communist fully in control of the party and state.

Corbis/Sygma

With the collapse of communism, Ceaucescu's days were numbered; he was arrested, tried and quickly executed along with his wife on Christmas Day 1989. Journalists reporting on the civil war in Romania were shocked by the social conditions they found, and even more so when they discovered a family photo album in the Presidential palace depicting the high life the Ceaucescus had enjoyed while their people suffered extreme deprivation.

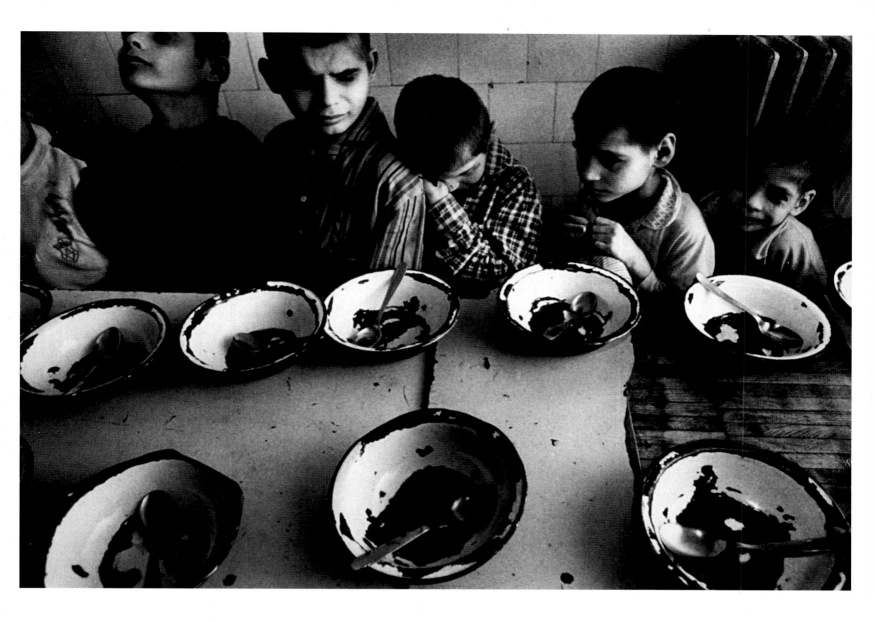

Waifs and Strays

Romania, 1990. Starving orphans faced with chipped and empty plates. Shortly after the fall of Ceaucescu's regime, visiting journalists uncovered the appalling conditions in state-run orphanages housing thousands of abandoned children. The plight of these forgotten children moved hundreds of western families to adopt orphans.

Mike Abrahams/
Network Photographers

Ceaucescu embarked on a maverick policy of rapidly increasing the Romanian birth rate. Women had to have at least five children before they could qualify for birth control. This was part of his bizarre plan to increase the population of "pure" Romanians and build a "robot work force" out of "impure" children born to the minority Hungarians, Bulgarians and gypsies. However, in the harsh economic realities of the country, it soon became normal for all Romanians to abandon unwanted children to state-run orphanages, irrespective of their ethnic origin. Ceaucescu continued to believe it was only the "impure" children who ended up in these grim places and so decreed that food, blankets, medicine and clothing should not be wasted on them.

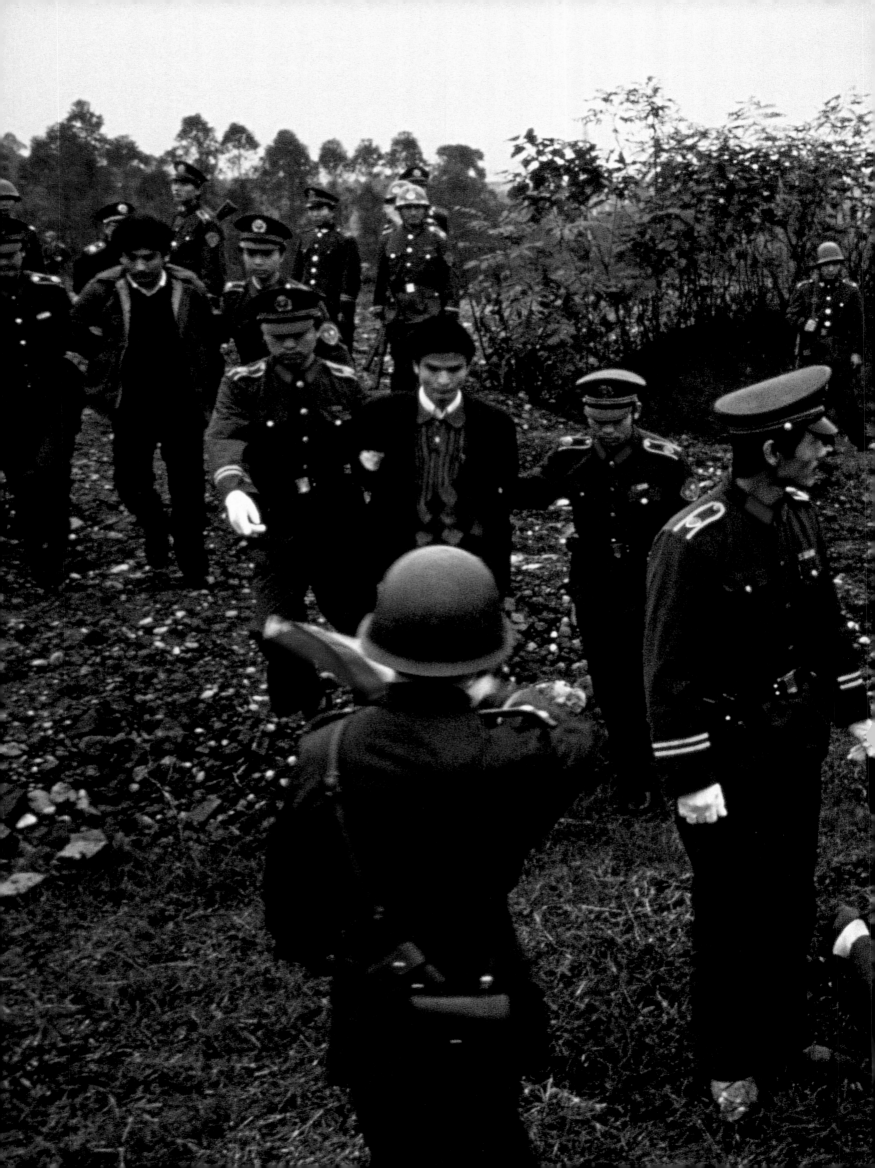

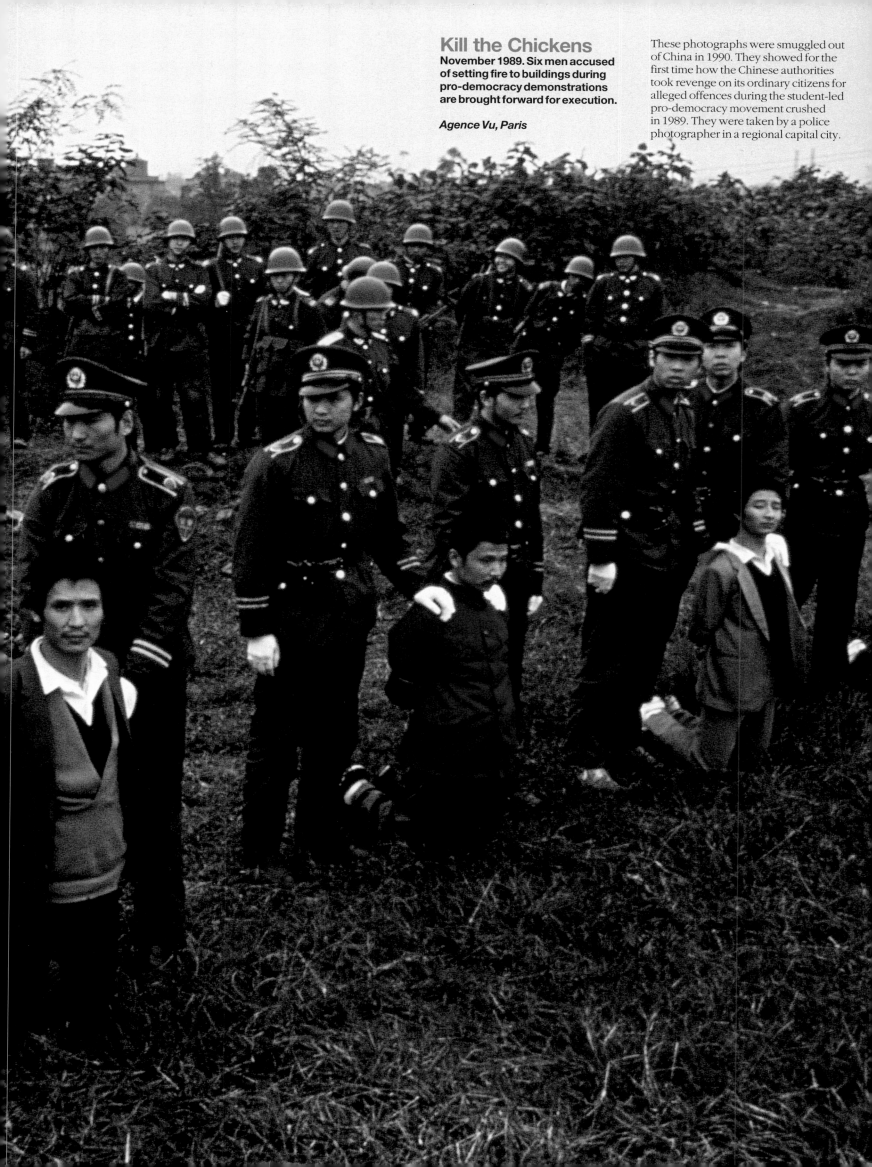

Kill the Chickens

November 1989. Six men accused of setting fire to buildings during pro-democracy demonstrations are brought forward for execution.

Agence Vu, Paris

These photographs were smuggled out of China in 1990. They showed for the first time how the Chinese authorities took revenge on its ordinary citizens for alleged offences during the student-led pro-democracy movement crushed in 1989. They were taken by a police photographer in a regional capital city.

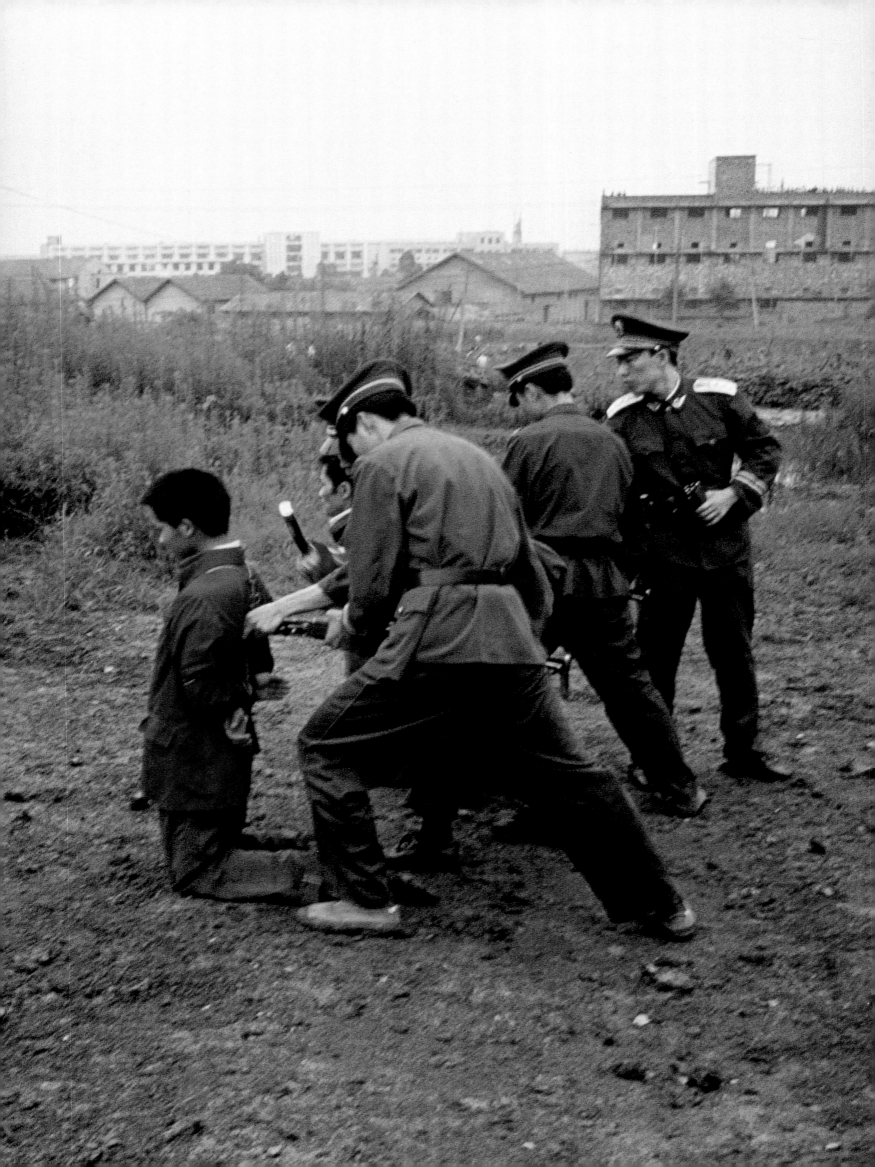

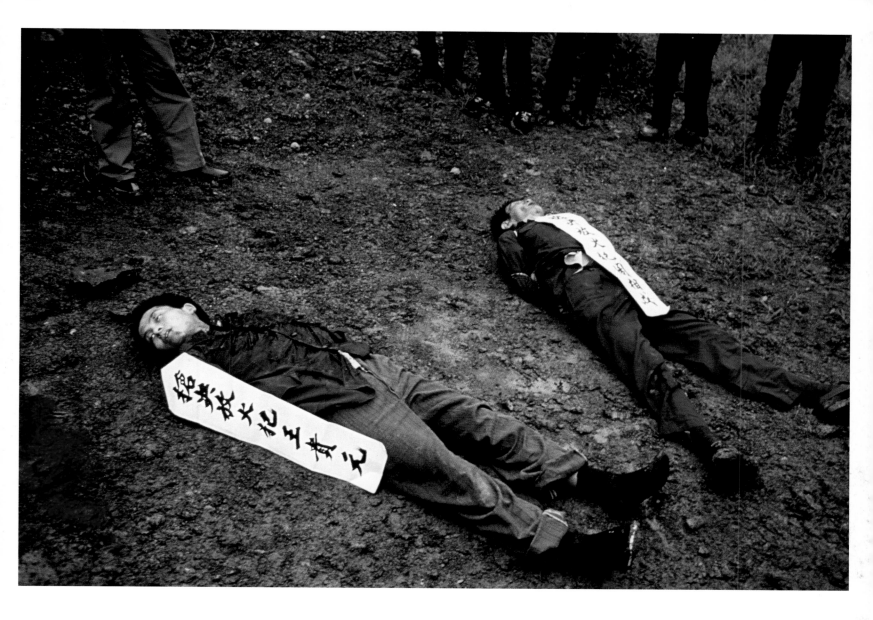

(Left) July 1990. Wang Kweiyuan, an unemployed labourer, and Chou Xiangchen, a street trader, both accused of arson, kneel to await execution after a summary trial.

(Above) Labels indicating their crimes were placed against their dead bodies for the benefit of official photographs.

Agence Vu, Paris

Writing in Britain's *Independent Magazine*, Peter Popham described how such executions were carried out: "Each prisoner was led by his executioner to a spot near the foot of the bare slope and required to kneel. The soldiers pressed the barrels of their rifles against the backs of the condemned men and then, when another soldier let his red flag drop, fired a single shot into the victim's heart. Both men fell forward. Chou died at once. Wang's executioner must have missed the mark, however, because Wang writhed on the ground as the blood gushed from his mouth. Another soldier stepped forward and kicked him to hasten the loss of blood and thus his death... Afterwards the corpses were taken to the police crematorium. Even if the next-of-kin were informed, it is likely that they were too frightened to collect them."

According to Amnesty International, hundreds of activists were executed in the months following the events in Tiananmen Square in June 1989. However, by 1990, the authorities were targeting "hooligans" and "parasites", relatively uneducated people uninvolved with the main student protests. Chinese dissidents believed that thousands of fringe protestors all over the country were killed in the manner photographed here, underlining the Chinese proverb: "Kill the chicken to scare the monkeys." In other words, victimise a few easy targets to terrify more elusive opponents of the regime.

Chinese law allows for seventy capital offences, ranging from murder to theft, corruption and political offences. Ammesty International estimates that 18,000 criminals were executed in China during the 1990s.

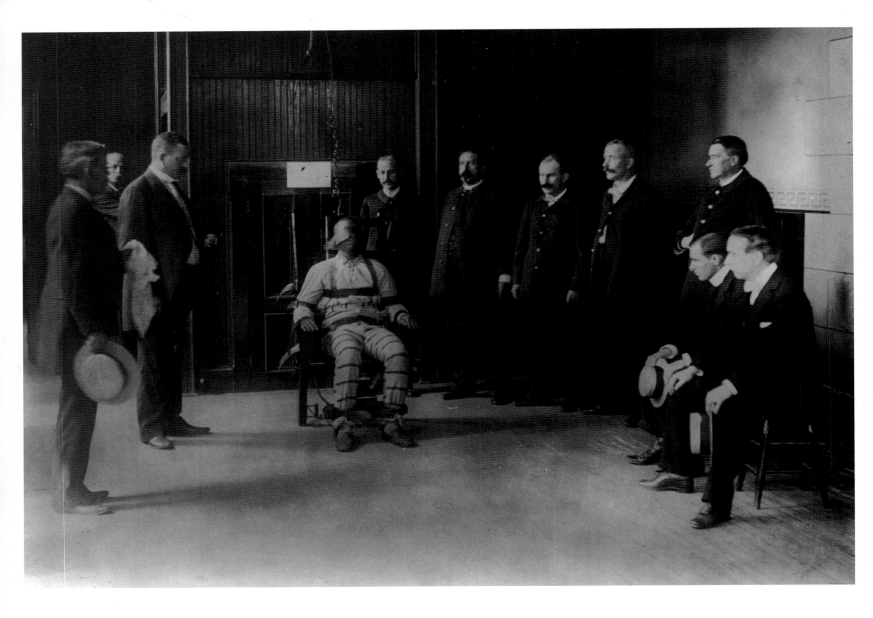

Armchair Retribution

(Above) Sing Sing prison, New York, circa 1900. An African-American prisoner strapped into the electric chair is observed by white American witnesses and guards before the moment of electrocution.

Hulton Archive

(Right) Florida, US, 1999. Almost a century later, Allan Lee Davis, 54, was executed by the state for a triple murder committed during a robbery 17 years earlier. He was electrocuted by a replacement apparatus for "Old Sparky", which had been taken out of service after a previous execution during which foot-long flames burst from the dying man's head. Reacting to Davis' unexpectedly bloody end, Florida's Governor Jeb Bush, brother of President George W Bush, is said to have remarked that "the (new) chair functioned as it was designed to function, and we're comfortable with that".

The photograph is part of a series taken by a witness. They appear on an official website but have not been published in print in the US, so as not to disturb the certainties of those who advocate capital punishment.

www.openrecords.org/specials/ execution.html

No other country in the world uses electrocution as a means of execution, and only four states in the US – Florida, Alabama, Georgia and Nebraska – require electrocution to be the sole means of execution. In 1999, following Davis' execution, lawyers for Thomas Provenzano, another death row inmate, filed for a stay of execution because of the electric chair's malfunctions. The lower, circuit court concluded that the electric chair does not constitute cruel or unusual punishment. Among the court's findings of fact was that "execution inherently involves fear, and it may involve some degree of pain. That pain may include pain associated with affixing straps around the head and body to secure the head and body to the electric chair. However, any pain associated therewith is necessary to ensure that the integrity of the execution process is maintained." Florida's Supreme Court upheld the findings of the circuit court, albeit with some dissenting judges, and rejected the motion that the state's use of electrocution was "unconstitutional because it violates the evolving standards of decency that mark the progress of a maturing society".

Reviewing previous executions, two dissenting judges commented: "The prisoner was engulfed in smoke and flames when the switch was pulled. The head of one prisoner [Tafero] was burned and charred, his face was licked by flames, and his eyebrows, eyelashes, and facial hair were burned; his head also was gouged and made raw with wounds. The head of another [Medina] was burned and charred and his face was scalded. In the third botched execution [Davis], the prisoner suffered blood flowing from his nose and pooling on his chest; he was likely asphyxiated at least partially prior to electrocution, and he attempted to scream or yell after his airway was occluded; he too was burned on his head, face, and leg."

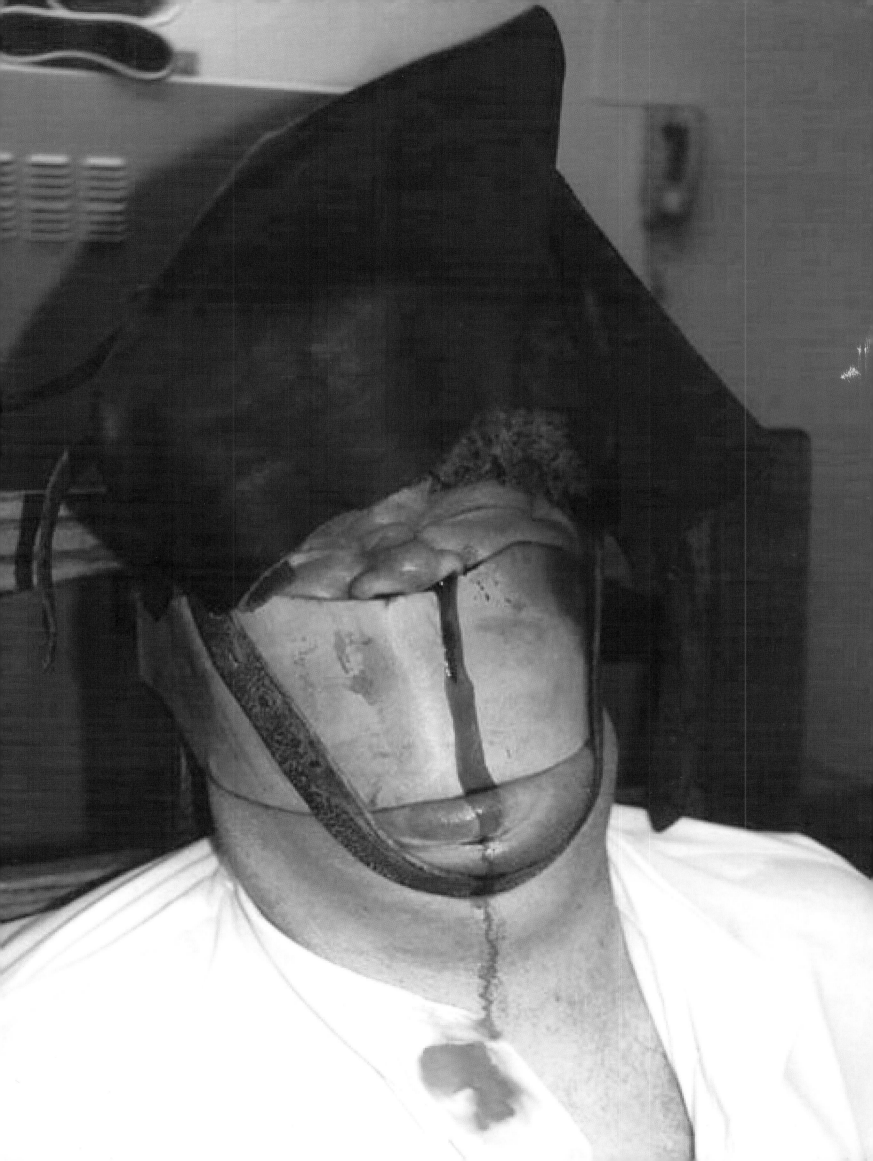

44 Restricted Vision
Censorship
in action

"*I wouldn't tell the people anything until the war is over and then I'd tell them who won.*"

US military censor

Fear and Loathing

Roger Hutchings

November 17 1994. A Turkish army Chinook clatters across the open sky towards Diyarbakir air base. As its shadow passes over the shantytown, I stoop behind a wall to keep out of sight. This is a miserable place – a stony slope on a bleak hill on the outskirts of Diyarbakir, where a slum city has risen up from the mud to house Kurds driven from their rural homes by the war against the PKK, the Kurdish guerrilla movement. It's a place of fear and intimidation, surrounded by watchtowers.

The light is failing. I decide to go back to my hotel.

Two men are sprawled on the sofa in the foyer and show an unwelcome interest in me. They are undoubtedly plain-clothes policemen and seem to be considering whether to arrest me. I climb the stairs to my room and see that someone has been poking through my things. Certain that at very best I am going to have my films confiscated, I hide them in a rolled blanket, pack hurriedly and leave by the back stairs for the Turkish Airlines office to buy a ticket for the evening flight to Istanbul.

I return to collect my gear and leave with a colleague, Jonathan, for the airport, hoping to get away without being detained. Journalists are unwelcome in south-east Turkey and subjected to constant harassment, threats and detention. (Local journalists who antagonise the authorities through sympathy for the Kurdish cause fare worse – they are often charged under the emergency laws or simply "disappear". In the offices of the newspaper *Ozgur Gundem*, a display of nine photographs of imprisoned or missing journalists bears chilling testimony to this.)

The police have left the foyer and as the taxi pulls away, the snap and pop of a nearby gun battle accompanies our escape. (I later read that sixteen suspected "rebels" were killed after being staked out in an apartment block.)

The flight to Istanbul leaves in two hours – an eternity given that the police are on our case. Diyarbakir airport is an uncomfortable place to hang out – it is frequented by policemen, soldiers, spies, general busybodies and a sprinkling of bona fide travellers. The most discreet place to wait is a small bar. I order a vodka tonic and look about anxiously. A man hunched over the counter shuffles closer to us and says in English, "You're journalists, aren't you? You were in Bismil yesterday."

I am taken aback. Here one grows accustomed to being watched but it is unnerving to be confronted in this way. Pure coincidence or something more sinister? We had indeed been in Bismil the previous day. That's where the picture of the man being searched was taken, on a back road which we always used to avoid the police. We drove round a blind bend straight into the checkpoint. It confirmed my suspicion that our driver was an informant. We were accused of trying to make contact with the "outside people", as the security forces call the PKK guerrillas. I shot one frame with my Leica concealed under my jacket. Astonishingly (since this camera is so quiet), the policeman in the photograph heard the shutter trip and screamed in fury that photography was prohibited. He ordered us into our car and told us to follow him. "We are going to the terrorist police," Jonathan said as I slipped him the roll of film. "It might be very unpleasant." In fact, we were taken to the regular police station where the commanding officer recognised Jonathan from a previous visit. To the dismay of the twitchy cops from the checkpoint, we were questioned, cordially given tea and despatched to Diyarbakir with a warning not to come back.

Who was the man in the airport? I have no idea. I shrugged off his questions and we left for the departure lounge. To my surprise, we left Diyarbakir unhindered.

But as we walked away I felt his eyes on my back, and the voice of the young human rights activist we had met earlier in the week passed through my mind: "You can ring me, but remember this is 1984 – they are always there, always listening, always watching."

I sparred with the security forces for two years before my luck ran out. I went back to Diyarbakir in March 1995 to cover the Kurdish New Year. Observance of the occasion was banned, so it was a potentially explosive situation. Dissent was expressed by lighting bonfires using car tyres, which produced dramatic pillars of black smoke.

I drove to Cevazi, a dismal area near Diyarbakir prison (known locally as the "University of Terrorism"). Many displaced Kurds lived there in awful conditions, spied on by government thugs and shifty armed types sporting sunglasses and bomber jackets. I shot a couple of rolls of film surrounded by a sullen crowd. I felt uneasy and decided to leave. Mehmet, my interpreter, agreed: "Let's go, Roger. It's dangerous here." Some of the crowd started throwing clods of mud at us, which surprised me as I had rarely experienced animosity from Kurds. They may have been scared – people who talked to the foreign media were often picked on by the police.

I was about to start the car when a man opened the passenger door and gripped Mehmet by the throat. Two others signalled for me to get out. I knew the type – shiny rayon suits, shoes in tasteless hues, stony eyes, pinched mean faces, swaggering officious bearing – definitely secret police. I got out of the car reluctantly and held up my press card. One of them snatched it and threw it into the road, lunging for my camera with his other hand. I pulled it back and he punched me on the side of the head, sending me reeling, while two other men set about me, cursing in voices thick with anger and contempt. Someone pulled my ankles away from behind and I crashed headfirst into the road, curling into a ball as the garish shoes flailed at my head.

I was lying face-down, focusing on the scuffed toe-caps of one of my assailants. Mehmet was talking throughout, trying to placate them, telling them I was an important guest, telling me to stand up, telling me we had to leave. "We can't," I said. "The fat one has taken the car key." It was standard practice at checkpoints to take the ignition key. This cop was violent and stupid; he denied it and rounded on me with renewed spite, searching my pockets as if to prove me a liar. To my frustration, he found and took the film hidden in my photographer's vest. Finally, he fumbled in his own pocket and produced the car key. We stood there for a moment, not sure what to do, and became aware of the large crowd that had gathered to watch our humiliation. Mehmet pulled my arm: "They say we must go or they will kill us."

Amnesty International estimate that four million Kurds have become refugees because of the war in east Turkey.

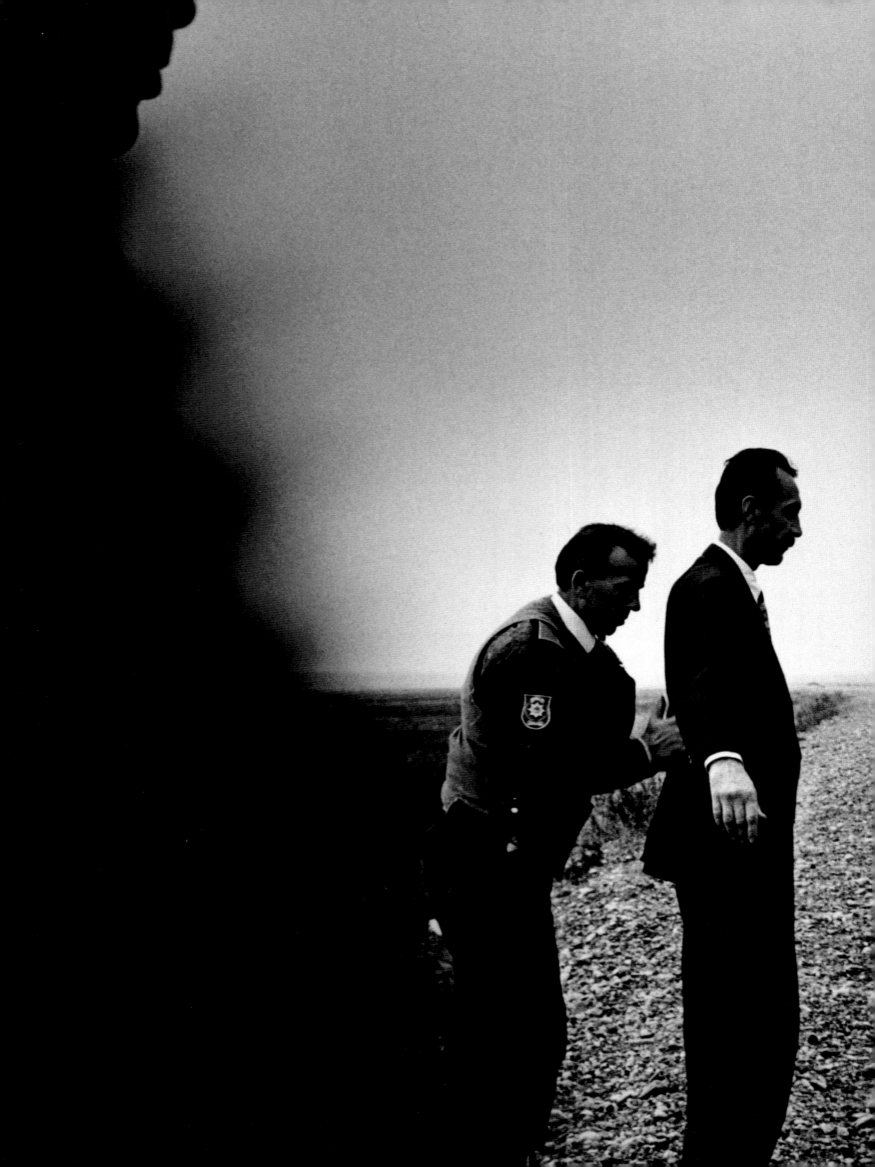

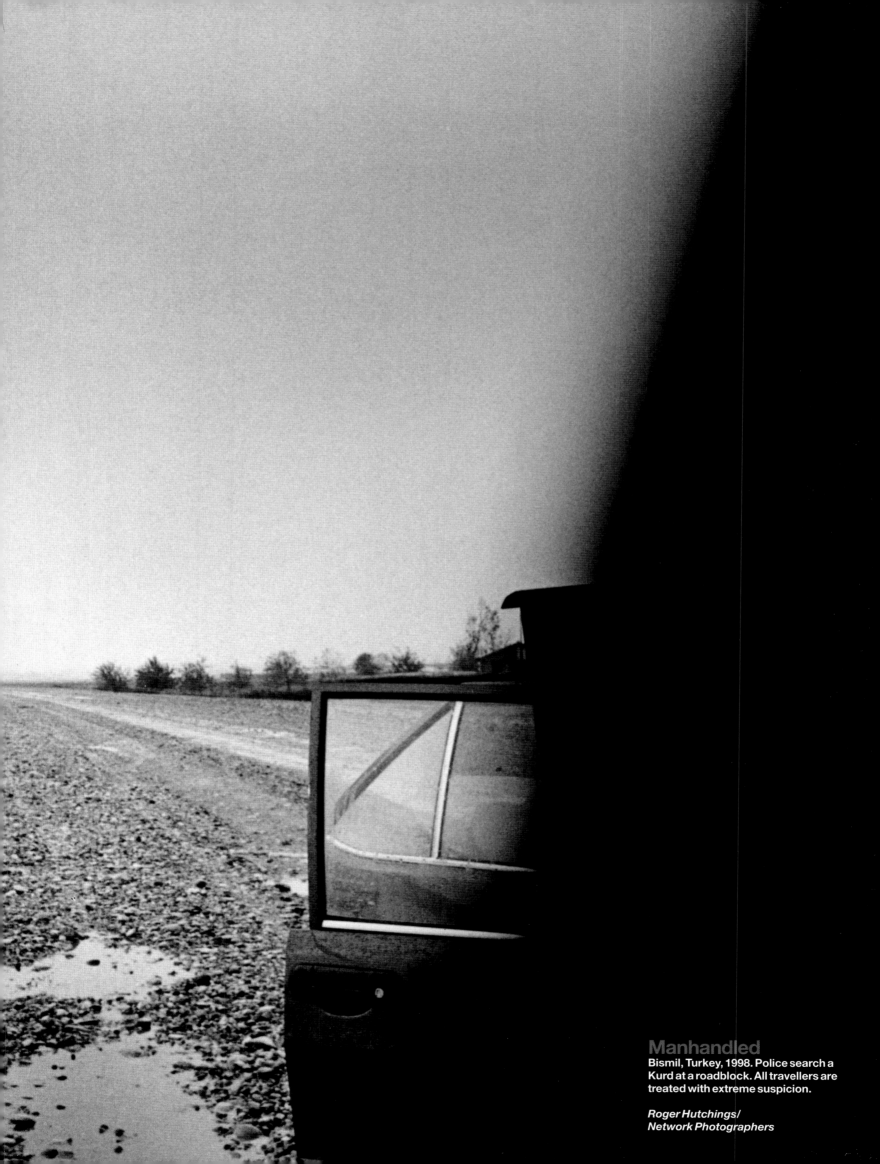

Manhandled

Bismil, Turkey, 1998. Police search a Kurd at a roadblock. All travellers are treated with extreme suspicion.

Roger Hutchings/
Network Photographers

Ominous Presence

Diyarbakir, Turkey. Turkish police make their presence felt at a political rally.

Roger Hutchings/ Network Photographers

"We are going to the terrorist police," Jonathan said as I slipped him the roll of film. "It might be very unpleasant."
Roger Hutchings

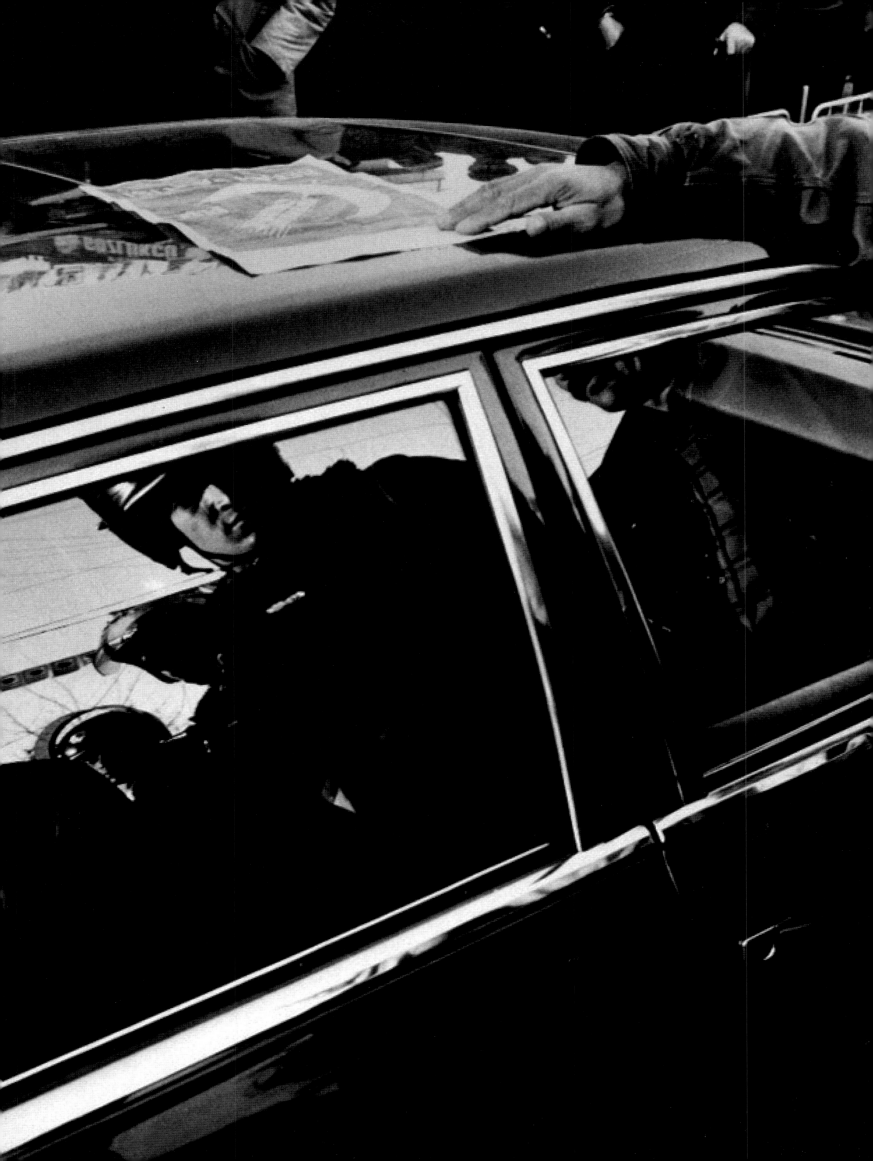

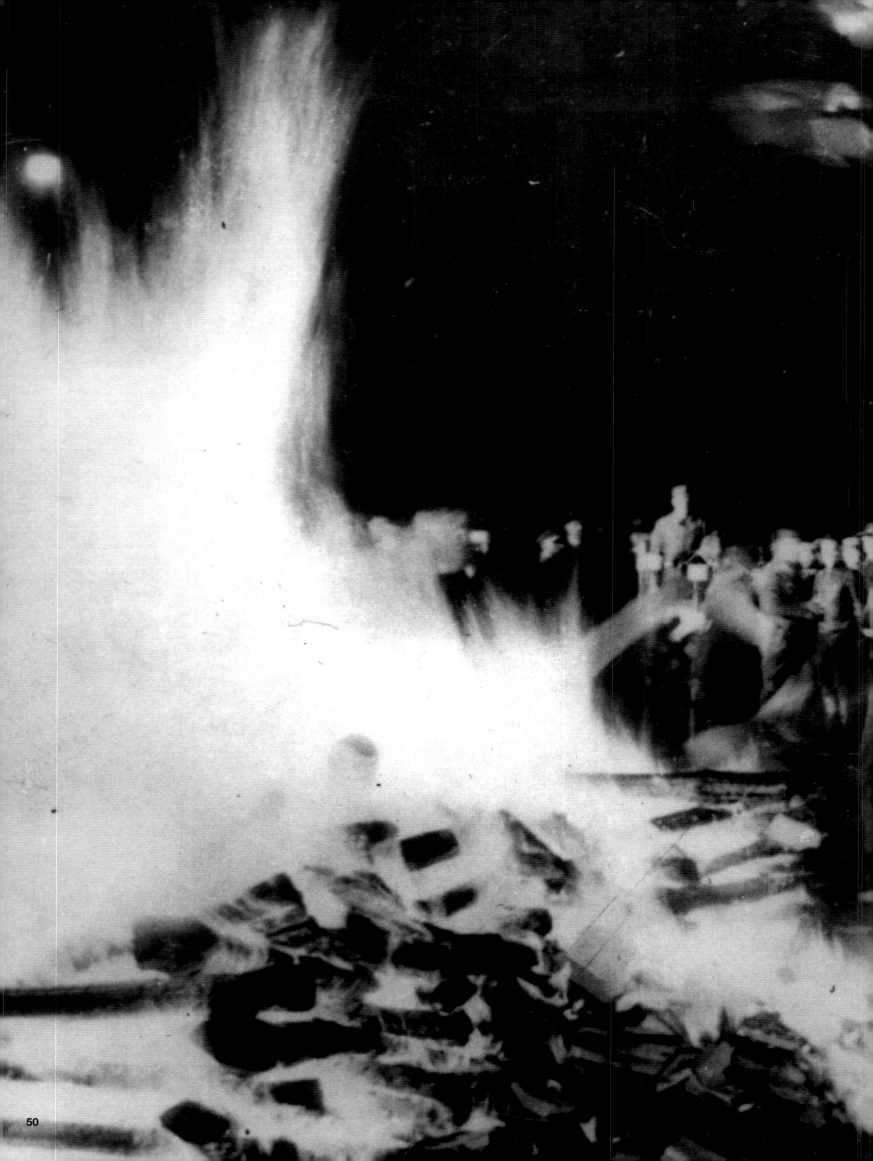

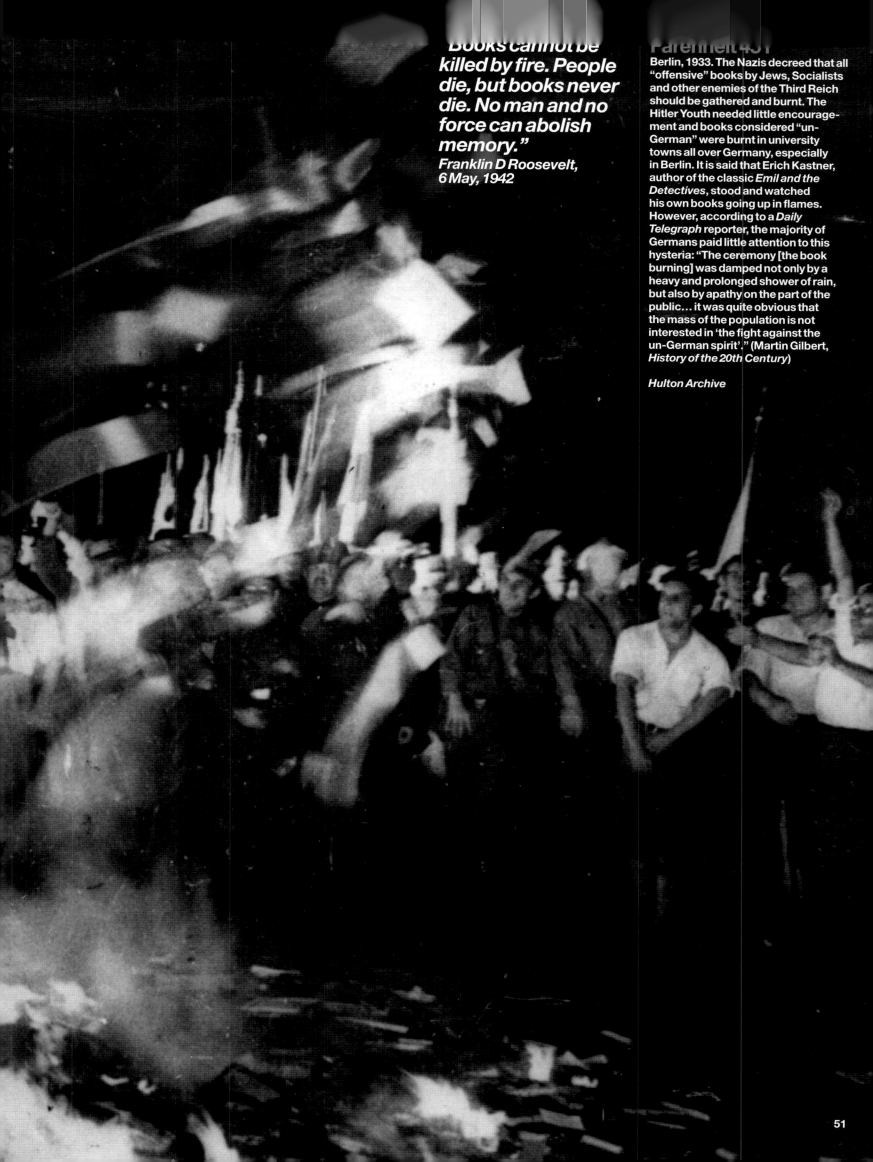

"Books cannot be killed by fire. People die, but books never die. No man and no force can abolish memory."

*Franklin D Roosevelt,
6 May, 1942*

Fahrenheit 451

Berlin, 1933. The Nazis decreed that all "offensive" books by Jews, Socialists and other enemies of the Third Reich should be gathered and burnt. The Hitler Youth needed little encouragement and books considered "un-German" were burnt in university towns all over Germany, especially in Berlin. It is said that Erich Kastner, author of the classic *Emil and the Detectives*, stood and watched his own books going up in flames. However, according to a *Daily Telegraph* reporter, the majority of Germans paid little attention to this hysteria: "The ceremony [the book burning] was damped not only by a heavy and prolonged shower of rain, but also by apathy on the part of the public… it was quite obvious that the mass of the population is not interested in 'the fight against the un-German spirit'." (Martin Gilbert, *History of the 20th Century*)

Hulton Archive

Smash and Grab

(Below) Nizhny Novgorod, USSR, 1935. A demolition gang pose for a team photograph in front of the newly-destroyed Giorgievsky Church. Over 50,000 churches were smashed under the regimes of Stalin and then Kruschev in an attempt to eliminate the influence of Christianity.

Nizhny Novgorod City Museum/ Dimitriev Photo Archive/ Endeavour Group UK

(Right) China, 1966. During the height of the hysteria of the Cultural Revolution, Red Guards enthusiastically destroy the 2,000-year-old shrines of Confucius. This antagonism to any alternative ideology or religion resulted in widespread destruction of temples and holy places all over China and Tibet.

Xinhua News Agency, Beijing/ Endeavour Group UK

Tyrannical governments throughout history have sought to eliminate symbols of those beliefs that threaten their power base. By removing the physical manifestation of religious faith, communist powers thought they could wipe out religion's inherited memories and traditions. Significantly, religion has never been stronger in many parts of the former Soviet empire.

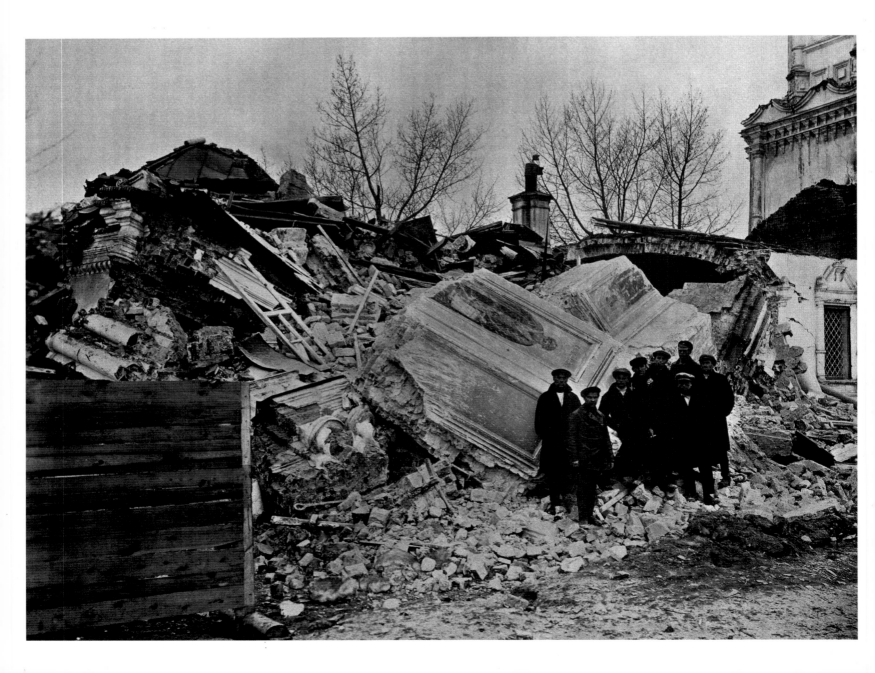

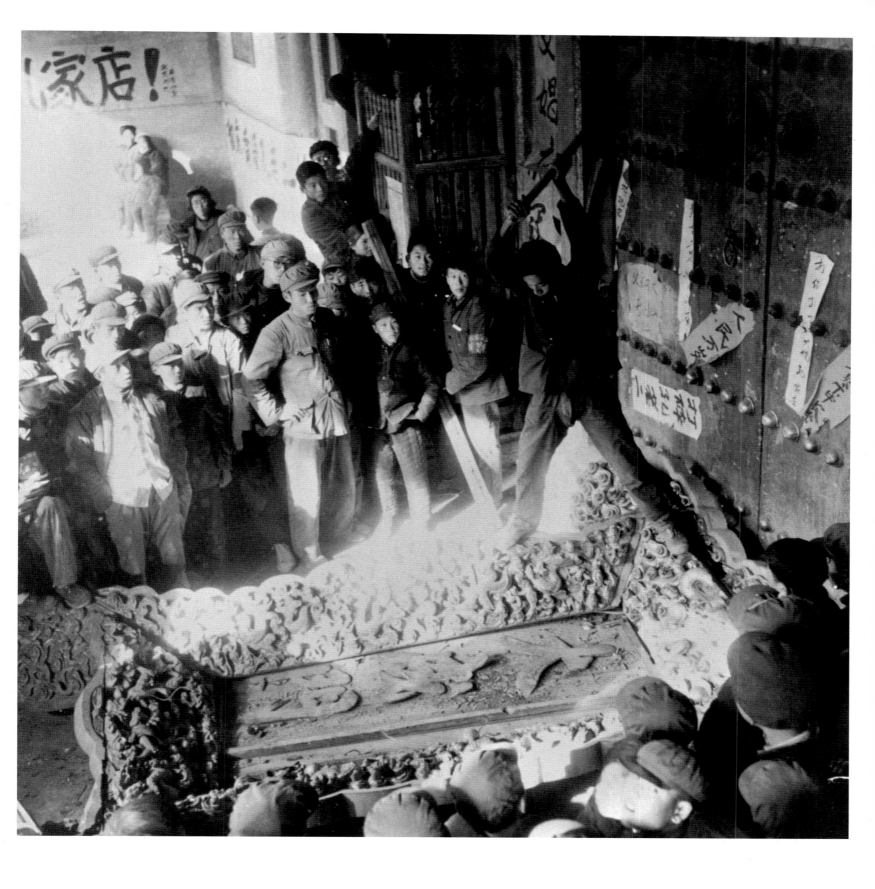

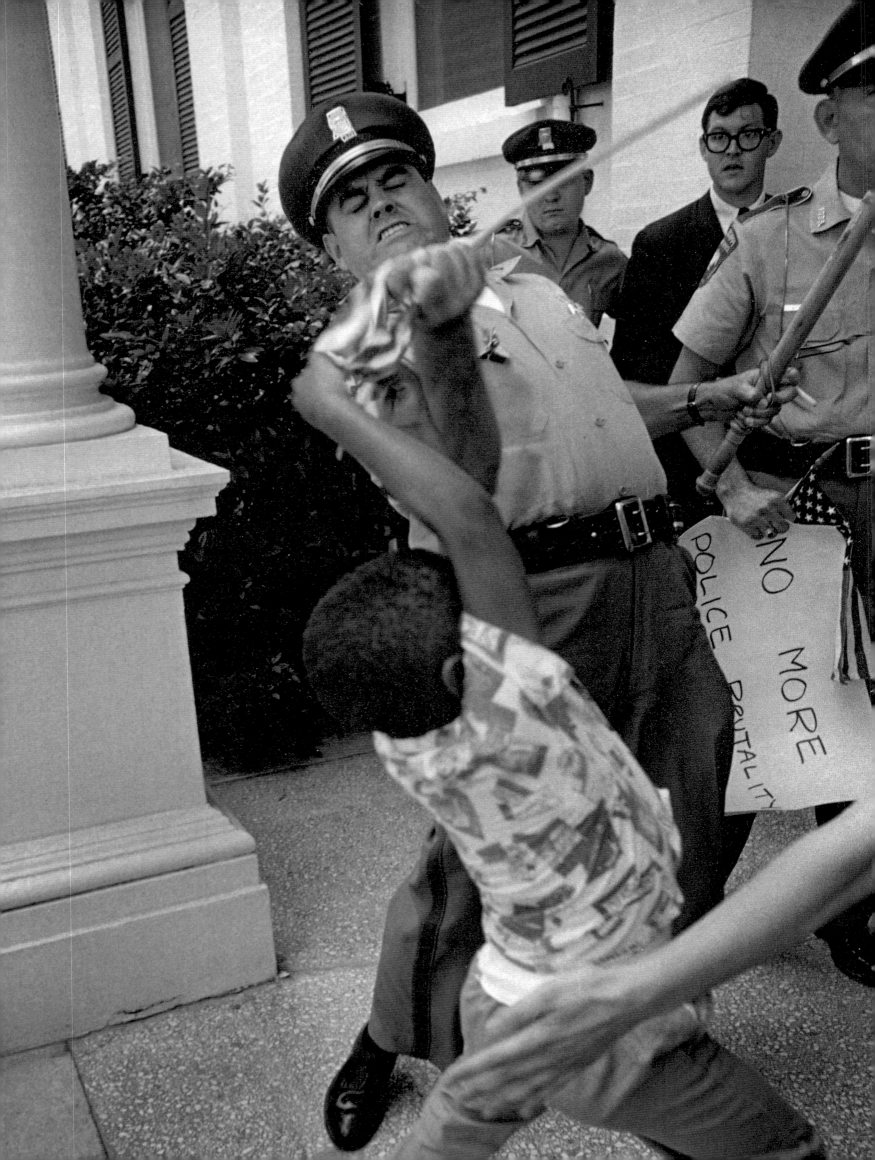

Child Minder

Jackson, Mississippi, USA, 1965. An ironic image from the civil rights protest era as a white policeman rips an American flag away from a young black boy during a political demonstration.

Matt Herron

Matt Herron describes the events that surrounded this photograph, which won a prize in the World Press Photo contest of 1965: "The picture was taken at the side entrance to the Governor's mansion on Capital Street in Jackson in the summer of 1965. The boy is Anthony Quinn, aged 5. His mother, Mrs Ailene Quinn of McComb, Mississippi and her children were trying to see Governor Paul Johnson; they wanted to protest against the election of five Congressmen from districts where blacks were not allowed to vote. Refused admittance, they sat on the steps. The policeman struggling with Anthony is Mississippi Highway Patrolman Hughie Kohler. As Kohler attempted to confiscate the flag, Mrs Quinn said: 'Anthony, don't let that man take your flag.' Kohler went berserk, yanking Anthony off his feet.

In the South during the civil rights movement, the American flag was a potent symbol of support for racial integration (and support for federal law). Southerners who believed in racial segregation displayed Confederate flags instead. People were pulled from their cars by policemen and beaten simply for displaying an American flag on their license plates. So the simple act of a small child carrying an American flag represented defiance of Mississippi law and custom.

Anthony and his mother were arrested and hauled off to jail, which was a cattle stockade at the county fairground, since the city jails were already full of protesters. The Quinn protest was organised by COFO (Council of Federated Organisations), an umbrella organisation responsible for most civil rights activities in the state. Today Anthony lives in Florida. I believe he is a lawyer. His mother died recently, and when Patrolman Kohler died a number of years ago, his obituary in the *Jackson Daily News* referred to this photograph and mentioned how Kohler regretted that moment 'for the rest of his life'."

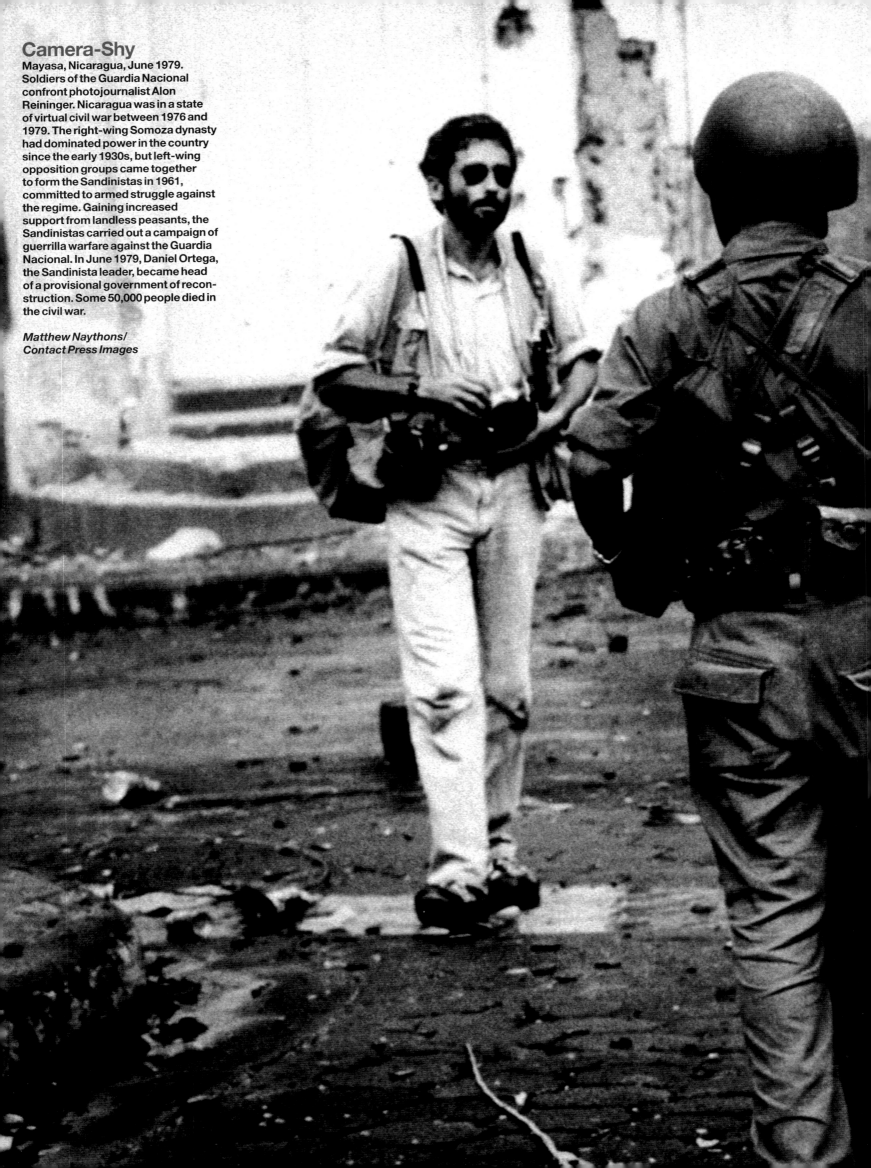

Camera-Shy

Mayasa, Nicaragua, June 1979.
Soldiers of the Guardia Nacional
confront photojournalist Alon
Reininger. Nicaragua was in a state
of virtual civil war between 1976 and
1979. The right-wing Somoza dynasty
had dominated power in the country
since the early 1930s, but left-wing
opposition groups came together
to form the Sandinistas in 1961,
committed to armed struggle against
the regime. Gaining increased
support from landless peasants, the
Sandinistas carried out a campaign of
guerrilla warfare against the Guardia
Nacional. In June 1979, Daniel Ortega,
the Sandinista leader, became head
of a provisional government of recon-
struction. Some 50,000 people died in
the civil war.

Matthew Naythons/
Contact Press Images

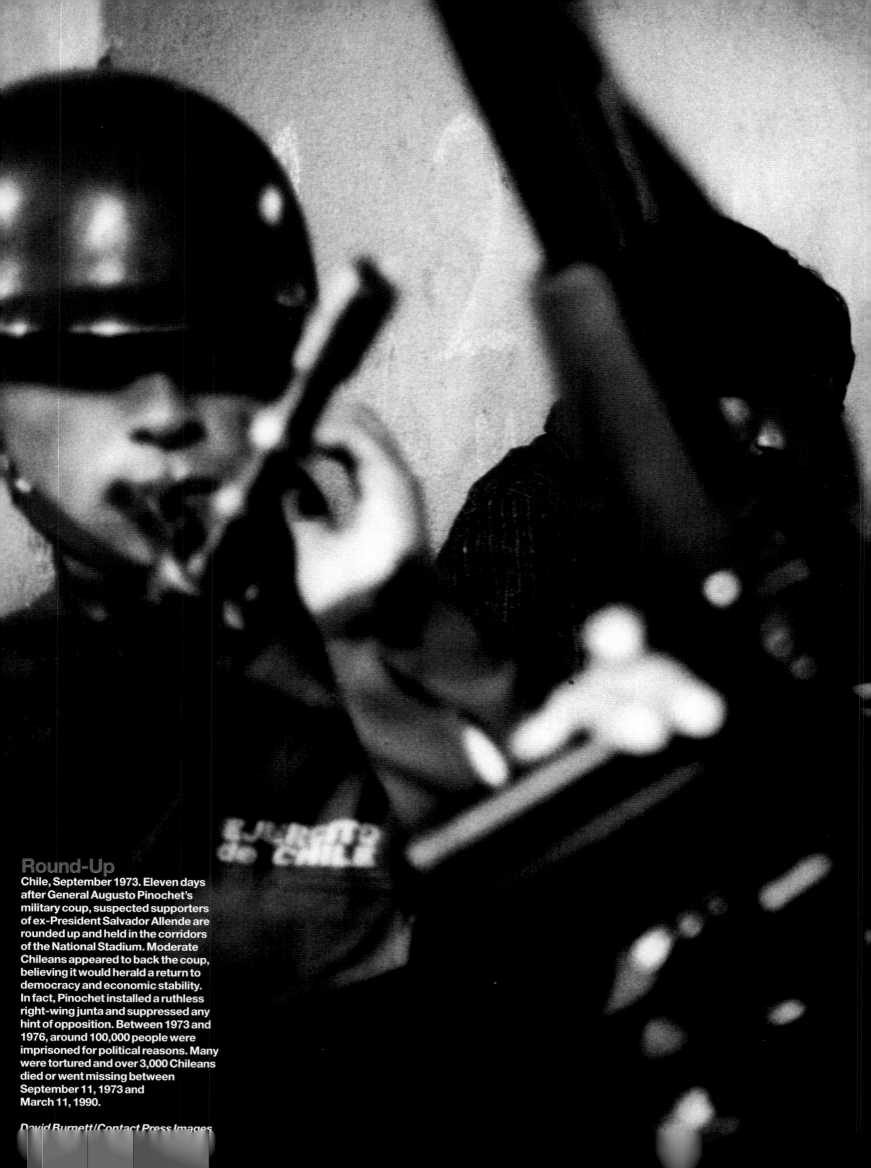

Round-Up

Chile, September 1973. Eleven days after General Augusto Pinochet's military coup, suspected supporters of ex-President Salvador Allende are rounded up and held in the corridors of the National Stadium. Moderate Chileans appeared to back the coup, believing it would herald a return to democracy and economic stability. In fact, Pinochet installed a ruthless right-wing junta and suppressed any hint of opposition. Between 1973 and 1976, around 100,000 people were imprisoned for political reasons. Many were tortured and over 3,000 Chileans died or went missing between September 11, 1973 and March 11, 1990.

David Burnett/Contact Press Images

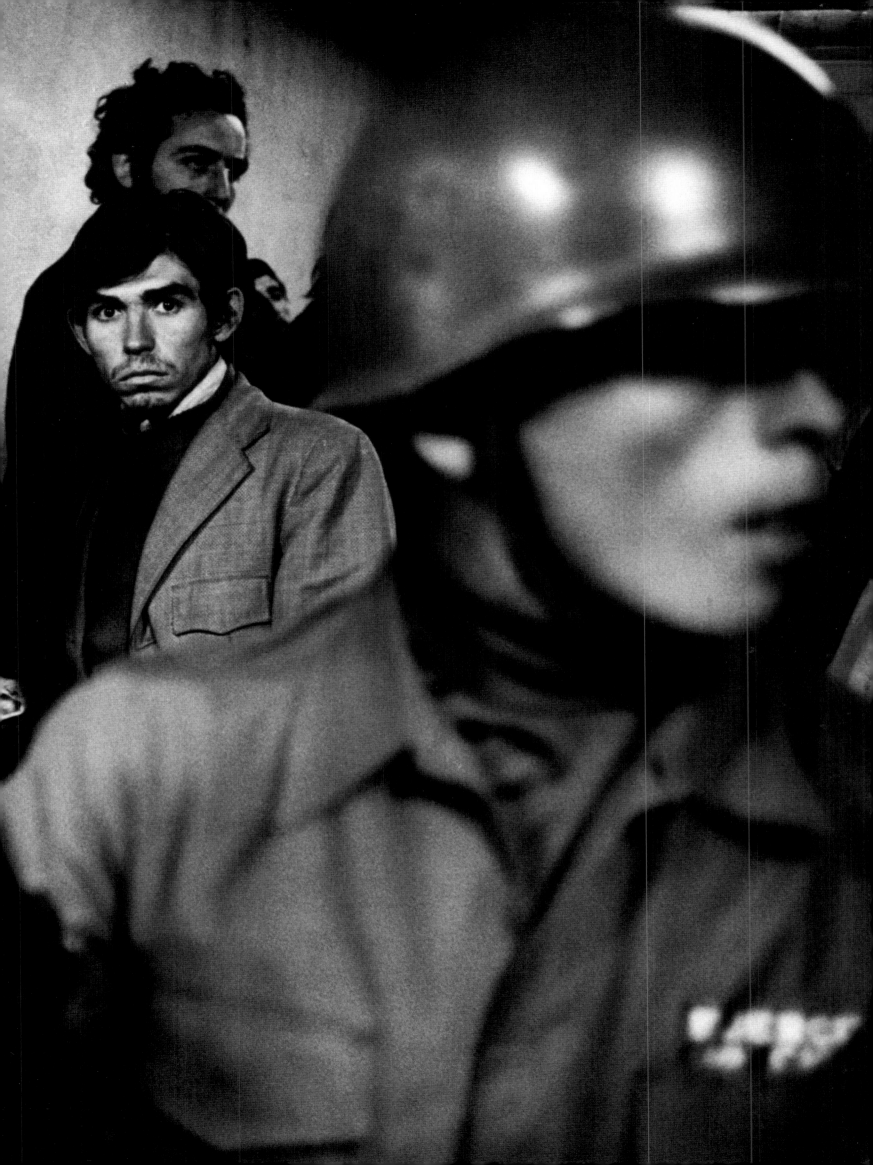

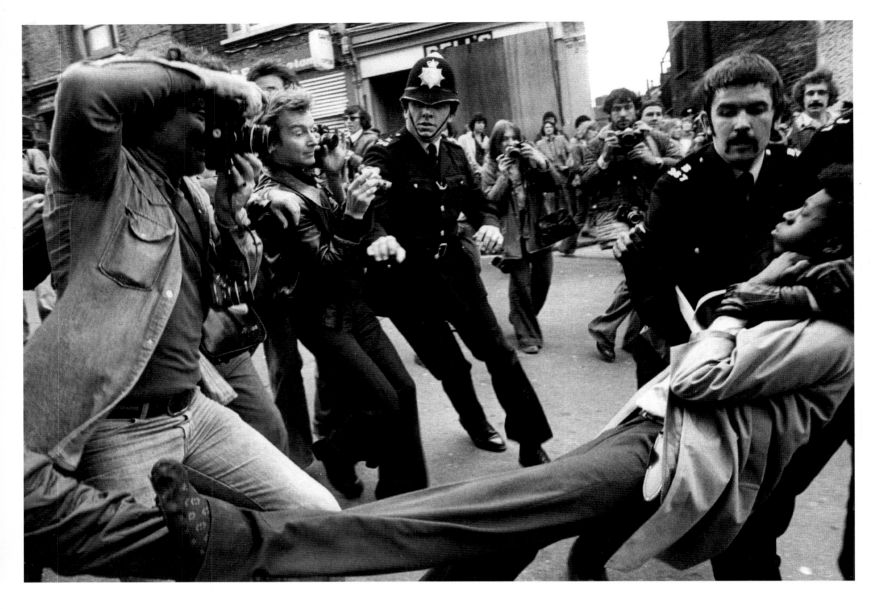

Long Arm of the Law

London, 1977. Press photographers close in as a policeman arrests a young black demonstrator protesting against a National Front march. A second officer seems intent on preventing photojournalists from recording the scene.

John Hodder/Observer/ Hulton Archive

The experiences of David Hoffman, a London-based freelance photojournalist, underline the often uneasy relationship which exists between photographers and the police in the UK.

In May 1989, Hoffman had a run-in with a certain Police Constable Terence Way, Constable 698 N, which led to a court case in which he successfully sued the Metropolitan Police and received £25,000 in compensation. After many legal hearings, meetings, letters and general wrangling, the police offered to settle Hoffman's claim without admitting any formal liability.

The incident took place in London while Hoffman was covering a demonstration protesting against Salman Rushdie and his book *The Satanic Verses*. Hoffman had press accreditation fully recognised by the Metropolitan Police. PC Way initially pushed him out of the way, threatening him with arrest and accusing him of inflaming the situation. Hoffman took a discreet photograph as this happened. Diplomatically, he walked some way away but continued to photograph another incident nearby. Suddenly, PC Way rushed towards him, smashing his camera into his face; the camera flew off and injured an Asian man standing close by.

Way then sauntered off and was about to join another group of policemen when Hoffman approached and took a picture of him. Way grabbed hold of Hoffman, placing him under arrest for disorderly conduct. Subsequently, at the police station, the charge became obstruction and assault on a police officer; later still, it was reduced to obstruction alone. Whilst in the police van Way wanted to take the film. Hoffman refused but had in any case already removed the significant roll of film from the camera.

Unknown to the police, Hoffman had crucial evidence on his film that won him the case. The photograph of PC Way included his wristwatch which clearly showed the time as being 15 minutes after the alleged time of arrest; Hoffman was in a place where he could not have been had Way been telling the truth.

Apologists for a rigorous view of law and order might argue that PC Way was acting under pressure, in a volatile and uniquely passionate atmosphere (Islamic death threats not being a part of British social fabric prior to the Rushdie affair). Hoffman feels that there is a tacit policy within the British Home Office, responsible for police matters, to make the act of demonstrating and reporting so unpleasant as to significantly reduce numbers attending and thus covering such events. To a greater or lesser extent, this approach is working, since

Hoffman himself, a seasoned observer of numerous political and civil rights marches, now chooses not to go to certain events – he feels that police behaviour makes attending pointless because he is unlikely to obtain useful pictures.

Hoffman sees this as part of an ongoing and developing strategy. During National Front marches in Bermondsey in 2001, the police formed two layers of protection as human shields, wearing yellow Day-Glo jackets, so it was virtually impossible to take any photos. On a number of ecological demonstrations in the UK, the press were expected to remain in designated areas and were treated as demonstrators if they chose to move around freely to get their stories. During the London visit of the Chinese Premier, Jiang Ze Ming, in 2001, police buses were placed strategically between the press and the demonstrators, which effectively prevented photographers from taking successful pictures. The Free Tibet Society took action against the police and received an apology and a promise of better behaviour in the future but, according to Hoffman, nothing has changed.

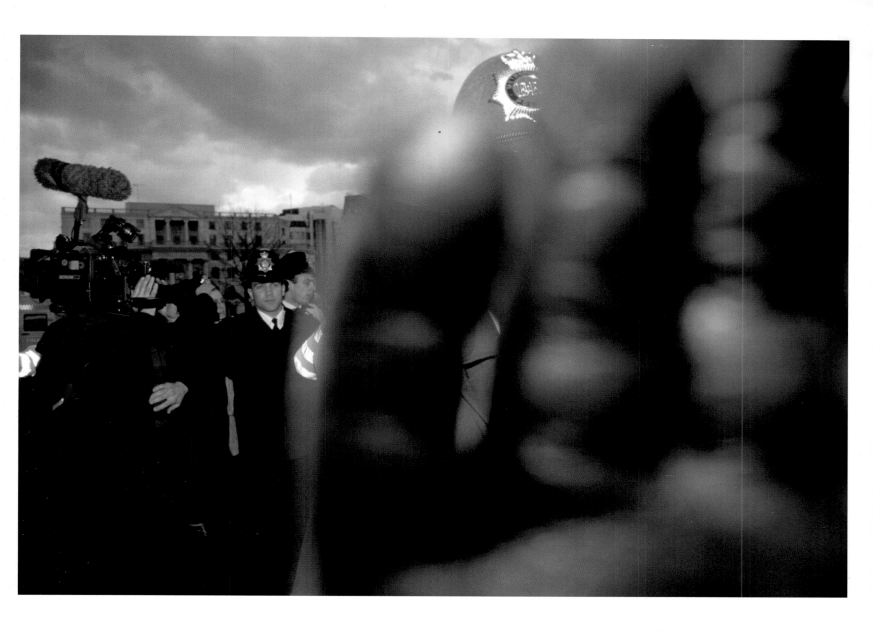

News Blackout

**Trafalgar Square, London, April 1997.
A police officer's hand covers David
Hoffman's lens during a joint demonstration of striking Liverpool dockers
and Reclaim the Streets protestors.
Police also prevented TV crews from
filming police actions against the
demonstrators. During the events, riot
police attacked and injured a number
of accredited press photographers.**

David Hoffman

 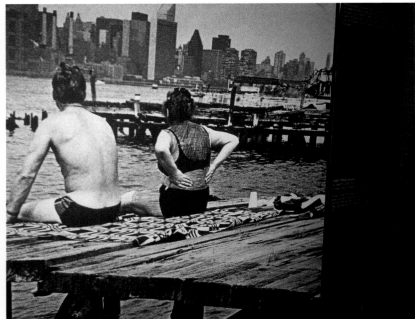

Cover-Up

The World Press Photo Foundation, based in the Netherlands, organises the best-known annual contest of international press photography. Following the judging of this competition, an exhibition of the winning photographs travels the world, and an annual book is widely distributed. It is a guiding principle of the Foundation that the exhibition and book should be accepted in their entirety and that political or cultural sensitivities should not be allowed to influence what is shown in particular countries or regions.

However, in Iran some 12 years ago, World Press Photo did allow a degree of cultural censorship, believing that it was important for the exhibition to take place in Tehran. Here, an amateur photographer recorded examples in which parts of the photograph were covered up. Offending areas of women's skin have been scratched over by hand on two of the exhibition prints (above) while masking tape has been stuck over bare breasts and kissing mouths in the others (above right). In the event, a World Press spokesman confirmed that "no pictures were omitted from the exhibition, the content of the pictures was not harmed and all the photographers whose work was involved gave their consent. The censorship was restricted to a clearly visible masking of nudity and social behaviour offensive to the Iranian authorities".

Ben ten Berge

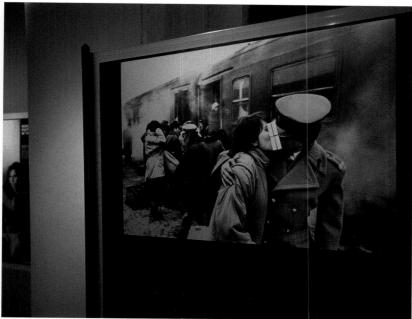

Árpád Gerecsey, formerly managing director of the World Press Photo Foundation, recalls some other attempts to censor the book and exhibition around the world:

"In 1990, the winning photograph, taken by Charlie Cole, was of the lone student confronting a line of tanks during the Tiananmen Square events. The exhibition did not take place in Beijing because of 'unclear formalities', according to the Chinese authorities. For us, this was clearly an act of silent political censorship. Over the past few years, while negotiating a Chinese edition of the World Press book, the Chinese publishers have always made it clear that they reserve the right to remove images due to issues of 'administrative policy'. As a result, there has been no Chinese version of the book.

In Iran in 2001, although the Iranian Ministry of Culture and Islamic Guidance had signed a document stating we would be allowed to show the whole exhibition, they attempted to remove two images (the final 100-metre women's final at the Sydney Olympics and the bomb attack in Moscow); both of these showed uncovered female body parts. After an open discussion with all parties involved, the pictures were allowed to stay.

In 1999, the exhibition in Ankara was cancelled although it had already been shipped to Turkey. The Turkish authorities objected to an image of Palestinians manhandling an Israeli soldier, saying it was putting a friendly neighbouring country in bad light. Interestingly enough, a few months later, the chairperson of the Turkish Chamber of Commerce at the European parliament approached me at the opening of the exhibition in Brussels, asking whether the show would also be in Turkey. When I told her what had happened, she was furious, agreeing with me that with a censorship policy like this, Turkey would never gain entry to the EU.

In the USA and Iceland, in cities where the exhibition is shown in public places, such as shopping malls, we've had serious and ongoing discussions about those images which convey explicit violence. Two main arguments are usually put forward: 'I do not want to be confronted with these images', and 'I do not think these images are appropriate for my children'. The facts that these images are used in newspapers and magazines worldwide, and that anyone can see as much violence on a TV screen as in the World Press Photo exhibitions, do not seem to help as counter arguments. It is my feeling that there is a stronger outcry by small minority groups against certain images than there was a number of years ago, and that such objections have a much greater impact on local exhibition organisers nowadays. Large groups of visitors are prevented from seeing images – important images – because a small number of people object to them. There is a serious threat to photo-journalism here, maybe even more serious than the political ones we face."

64 Making Choices
**Confronting or
avoiding the issue**

*"We have... become our own
thought police; but instead of
calling the process by which we
limit our expression of dissent
and wonder 'censorship', we
call it 'concern for commercial
viability'."*

David Mamet

Death of the Photographer Philip Jones Griffiths

Just because writing on papyrus replaced carving hieroglyphics on stone, it cannot be presumed that each new form of communication will consign the previous one to the dustbin. Today, we have a variety of media existing in somewhat uneasy symbiosis, with the unified aim of misleading us while amusing us. TV, radio and publishing get along just fine as we, the audience, get collectively dumber.

As always the Golden Rule applies: those with the gold rule, for the most part, the means of communication. What we get to think and know about the world is firmly in the hands of a few. They exist to misinform us, whether it's *National Geographic*, who can claim to have "educated" what is now the world's largest population of parochial ignoramuses, or US television, whose coverage of the Gulf War meant, according to University of Detroit researchers, that the more you watched, the less you understood. Surely no one is naïve enough to believe that the great media conglomerates exist to inform us about the truth. Information is selectively gathered and packaged for our amusement and titillation, for a truly informed public is antithetical to the interests of modern consumer capitalism.

Historically, the role of photography in this structure has presented a problem. People believe photographs – it's the reason we have them, not drawings, in our passports; and why the police use a camera to record a crime scene. We need to see photographs, for they offer proof of reality. This authenticity often jars with the interests of the opulent few, so the spin-meisters of obfuscation are called upon to apply their talents.

In the past, their techniques were somewhat heavy-handed. Photographs were cropped to alter their meaning, mis-captioned to mislead and retouched when necessary. In the Soviet Union, the faces of Stalin's enemies vanished from old photographs. Here in Britain, magazines such as *Picture Post* regularly "assembled" photographs from strips taken from other pictures. Many of the great iconic images of the past have turned out to have been manipulated. Eugene Smith, heralded as America's greatest photographer, is best known for his story on life in a Spanish village. Not only did he orchestrate his pictures, using the people as models, but in one famous picture of a wake, when a woman found him more interesting than the body, out came the bleach and ink in the darkroom, redirecting her eyes towards the corpse. Not perhaps a serious occurrence, but a solid nail in the coffin of photographic veracity.

But the "doctoring" of images was always considered a bit risky – for the original might turn up to haunt the perpetrator. The selective choice of subject matter may better illustrate the predilections of the proprietor.

My first insight into this was the coverage of a huge CND protest rally at Aldermaston by *The Times*. A plane with their photographer aboard arrived a good hour after the meeting was over and the crowds gone. Next morning's paper showed a picture of a few stragglers, implying a poorly-attended event. For me, a more egregious example was *The Telegraph*'s photographer who, during the last pit closure in the Rhondda, cajoled one miner into kneeling on the ground so that he could "get the background right". The picture appeared the next day with the caption, "Down, and finally out!"

Since those days, faking has enjoyed a quantum leap with the advent of computerised manipulation. Now, with digital cameras, there is no "original" to compare. There is nothing to stop anyone resolving the Kennedy assassination by inserting Ladybird Johnson on the grassy knoll with a smoking gun in her hand. Fraudulent practice is easy and detection difficult, and photography will never be the same again. We are probably the last generation that will accept the integrity of the photograph.

In the meantime, television has become the dominant visual communication medium. Not because it's been embraced as the purveyor of truth, but because it supplies the pabulum we have been taught to crave. No one expects much veracity in the world of info-tainment. Truth has become superfluous. For those of us working in the magazine world, we plod on with the usual encouragements: "Lively pictures, everyone happy!" "No gore, our advertisers don't like it!" And my favourite: "Fresh colour, please!"

In a perfect world, the photographer would be handed a ticket and dispatched to some situation with the assurance that his or her interpretation would be eagerly awaited by those readers anxious for edification.

Alas, the world is far from perfect. Today the photographer is sent off to illustrate the preconceptions, usually misconceptions, of the desk-bound editor – an editor biased not by any knowledge of the subject but by the pressure to conform to the standard view ordained by the powers that be. Any deviation from the "party line" is rejected.

The stark truth is that the media have abandoned "stories" – the "stories" repeated around the countless campfires enrapturing mankind since the dawn of history. Today they are deemed unreliable because they stem from what we really do and think, from our real experiences, rather than the externally imposed homogenised admass culture.

Photography may be on its last legs, but those of us with cameras round our necks will still keep running.

© Philip Jones Griffiths 1999. Philip Jones Griffiths is a former president of Magnum Photos. He has been a photographer since 1961.

"Assasination is the ultimate form of censorship."
George Bernard Shaw

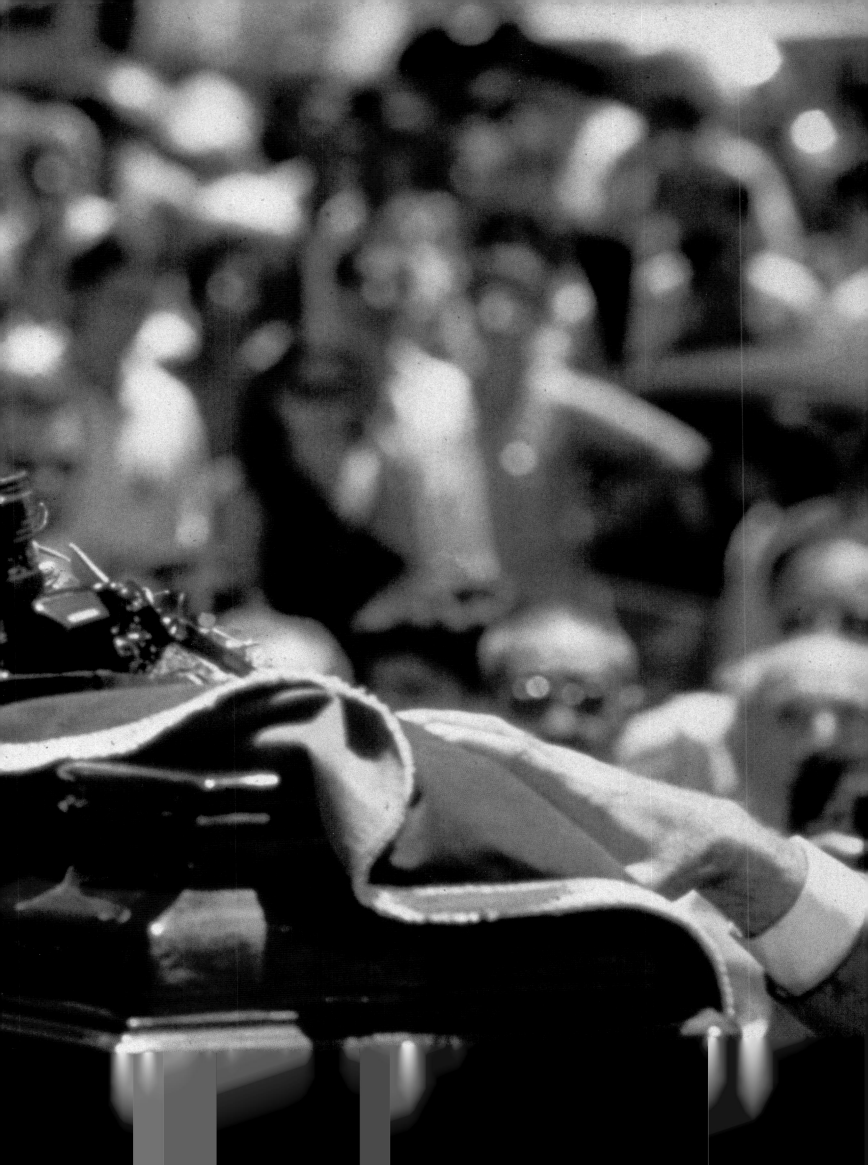

Silent Witness

Buenos Aires, Argentina, 1997.
Funeral of photojournalist Jose
Luis Cabezas, killed by Argentine
security forces.

*Editorial Atlantida/Getty Images
News Service*

*"I have discovered
that almost every
belief that we hold
collapses under
scrutiny – the 'truth'
is often simply a tool
that serves someone
else's purposes."*

Garden Party

(Right) Northern Ireland, 1973. The
incongruities of life in an urban war
zone. Photojournalists make choices
as to the story they will tell. Some
images, such as this, may tend to
subvert the messages of those in
authority, or undermine perceived
realities. Philip Jones Griffiths wrote:
"I have travelled to over 140 countries
trying to make sense of it all. I have
discovered that almost every belief
that we hold collapses under scrutiny
– the 'truth' is often simply a tool that
serves someone else's purposes."

*Photograph by Philip Jones Griffiths/
Magnum*

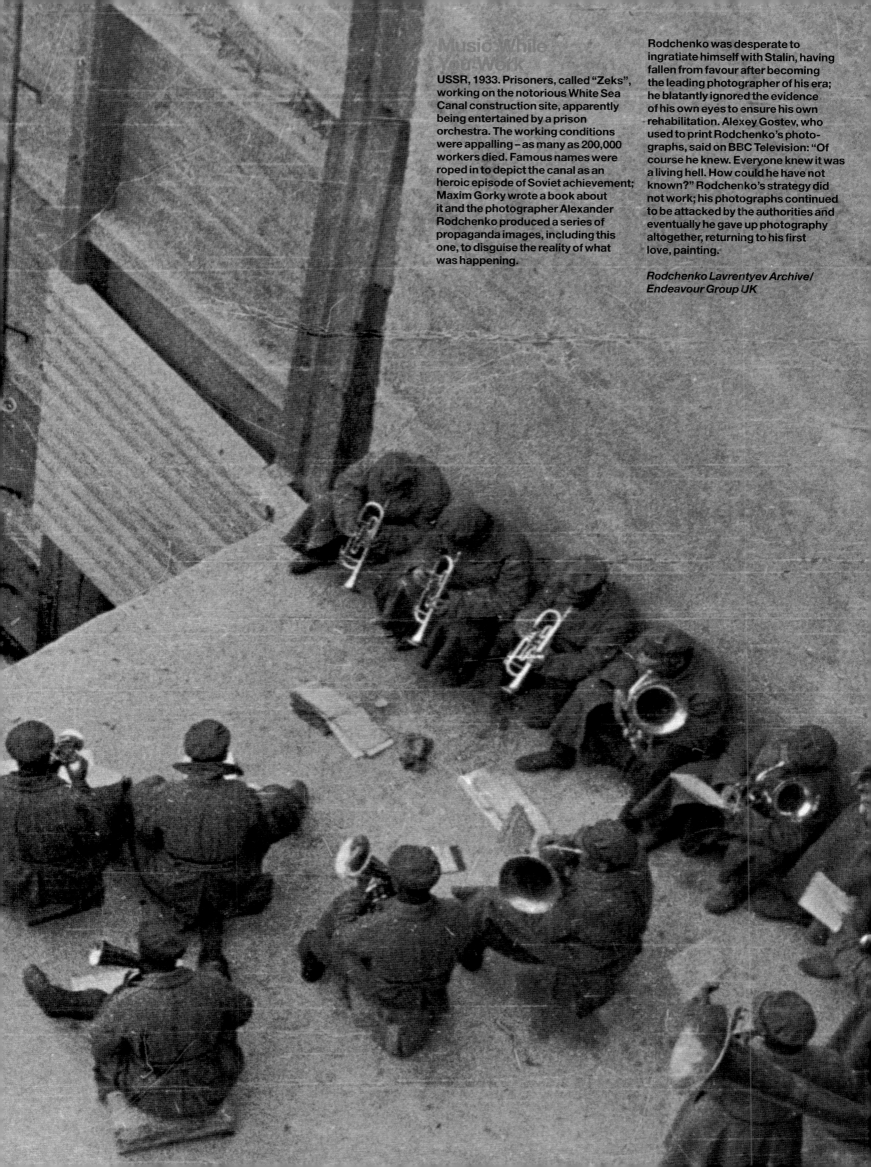

Music While You Work

USSR, 1933. Prisoners, called "Zeks", working on the notorious White Sea Canal construction site, apparently being entertained by a prison orchestra. The working conditions were appalling – as many as 200,000 workers died. Famous names were roped in to depict the canal as an heroic episode of Soviet achievement; Maxim Gorky wrote a book about it and the photographer Alexander Rodchenko produced a series of propaganda images, including this one, to disguise the reality of what was happening.

Rodchenko was desperate to ingratiate himself with Stalin, having fallen from favour after becoming the leading photographer of his era; he blatantly ignored the evidence of his own eyes to ensure his own rehabilitation. Alexey Gostev, who used to print Rodchenko's photographs, said on BBC Television: "Of course he knew. Everyone knew it was a living hell. How could he have not known?" Rodchenko's strategy did not work; his photographs continued to be attacked by the authorities and eventually he gave up photography altogether, returning to his first love, painting.

Rodchenko Lavrentyev Archive/ Endeavour Group UK

In 1930, Stalin ordered the construction of a massive canal between the Baltic Sea and the White Sea, one of the grand projects of his Five Year Plan. He entrusted the overseeing of this to his much-feared secret police, the OGPU (forerunners of the KGB).

The OGPU trawled Stalin's burgeoning labour and prison camps for slave workers for this canal: peasants who had been deported as Kulaks, political opponents of the regime and even loyal Communists who found themselves exiled for no good reason in the paranoid atmosphere of the times. Workers were given false promises of political rehabilitation in return for their labour.

When the canal was finished, Stalin took a celebratory boat ride along it with OGPU chiefs. He is said to have been pleased to see giant portraits of himself on the canal banks. A generation later, the British historian Martin Gilbert recalled his first encounter with the White Sea Canal: "It was a bright, cold winter's day, and the canal presented an idyllic scene, with frost-covered trees lining its bank. Nothing could have been further removed from the scenes of torment that must have been visible on those same canal banks 63 years earlier." (Martin Gilbert, *A Descent Into Barbarism – A History of the 20th Century, 1933-1951*)

Hungry as a Wolf

The Volga, USSR, 1921. This photograph was taken during one of the great famines that swept through Soviet Russia under Stalin. This couple were photographed with human body parts and bits of human flesh. They were accused of having killed their victims.

Slava Katamidze Collection/ Hulton Archive

Stalin's policy of enforced collectivisation of the rural economy helped to bring about catastrophic famines in the Ukraine between 1928 and '29, and in 1932. To achieve collectivisation, Stalin waged a brutal war against the "Kulaks", those well-off (or not-so-well-off) peasants who owned their own land. He characterised them as evil and lower than human. "They looked on the so-called 'Kulaks' as cattle, swine, loathsome, repulsive: they had no souls; they stank; they had all the venereal diseases; they were enemies of the people and exploited the labour of others," wrote the Soviet writer Vasily Grossman, quoted in Martin Gilbert's *History of the 20th Century*. Kulaks were forcibly evicted from their land; millions died in mass executions. Others were left to wander the countryside dying of famine, and others still were deported to labour camps in the frozen wastes beyond the Arctic Circle – thousands of women, children and the old perished on the journey. The novelist Vladimir Tendryakov, a witness to the fate of the Kulaks in the northern Russian town of Vokhrovo, wrote:

"In the station square Ukrainian Kulaks, expropriated and exiled from their homeland, lay down and died. One got used to seeing the dead there in the morning, and the hospital stable boy Abram would come along with his cart and pile the corpses in.

Not everyone died. Many wandered along the dusty, sordid alleyways, dragging dropsied legs, elephantine and bloodlessly blue, and plucked at every passer-by, begging with dog-like eyes.

In Vokhrovo, they had no luck: the inhabitants themselves, to receive their ration, had to stand in the bread queue all night." (Martin Gilbert, *History of the Twentieth Century*)

A report published at the time provided strong evidence of cannibalism and included a photograph of man who had allegedly eaten his sister. Vasily Grossman was more adamant: "There were people who cut up and cooked corpses, who killed their own children and ate them. I saw one. She had been brought to the district centre under convoy. Her face was human, but her eyes were those of a wolf." (Brian Moynahan, *The Russian Century*)

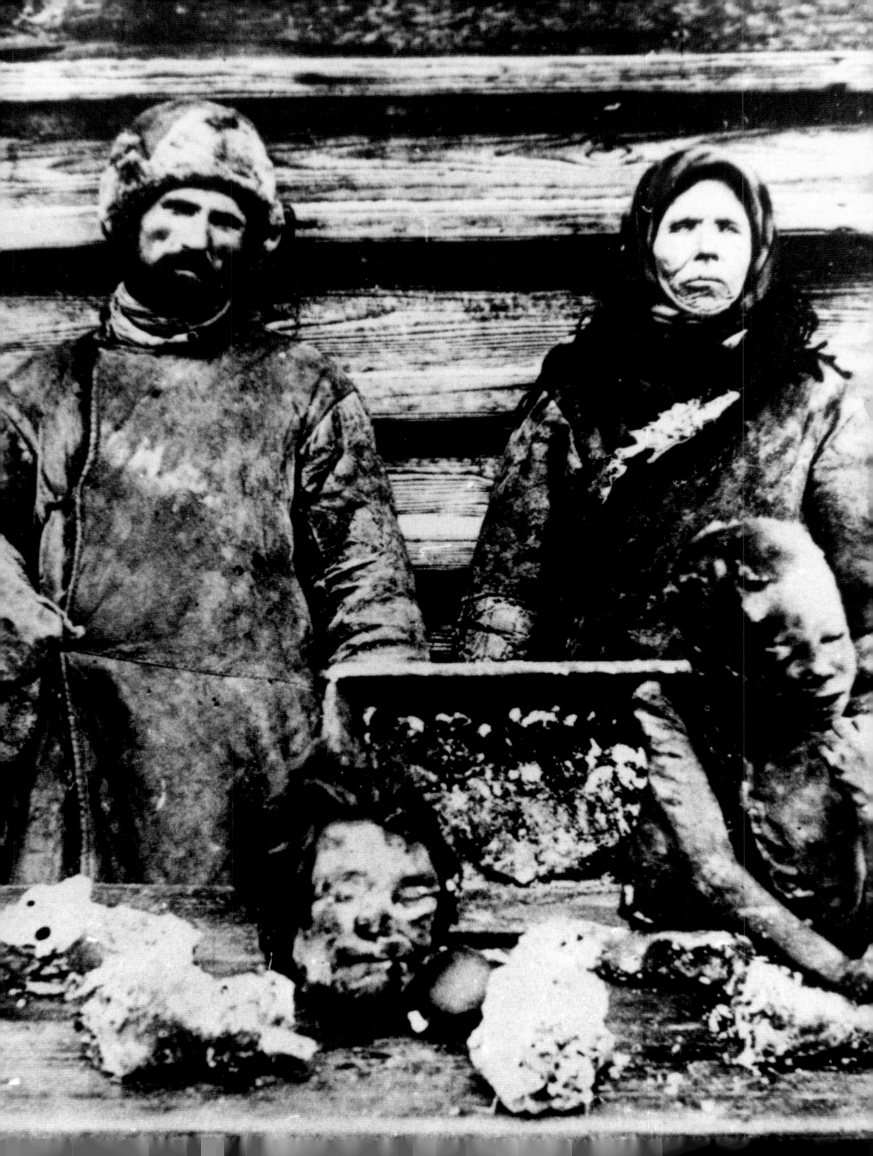

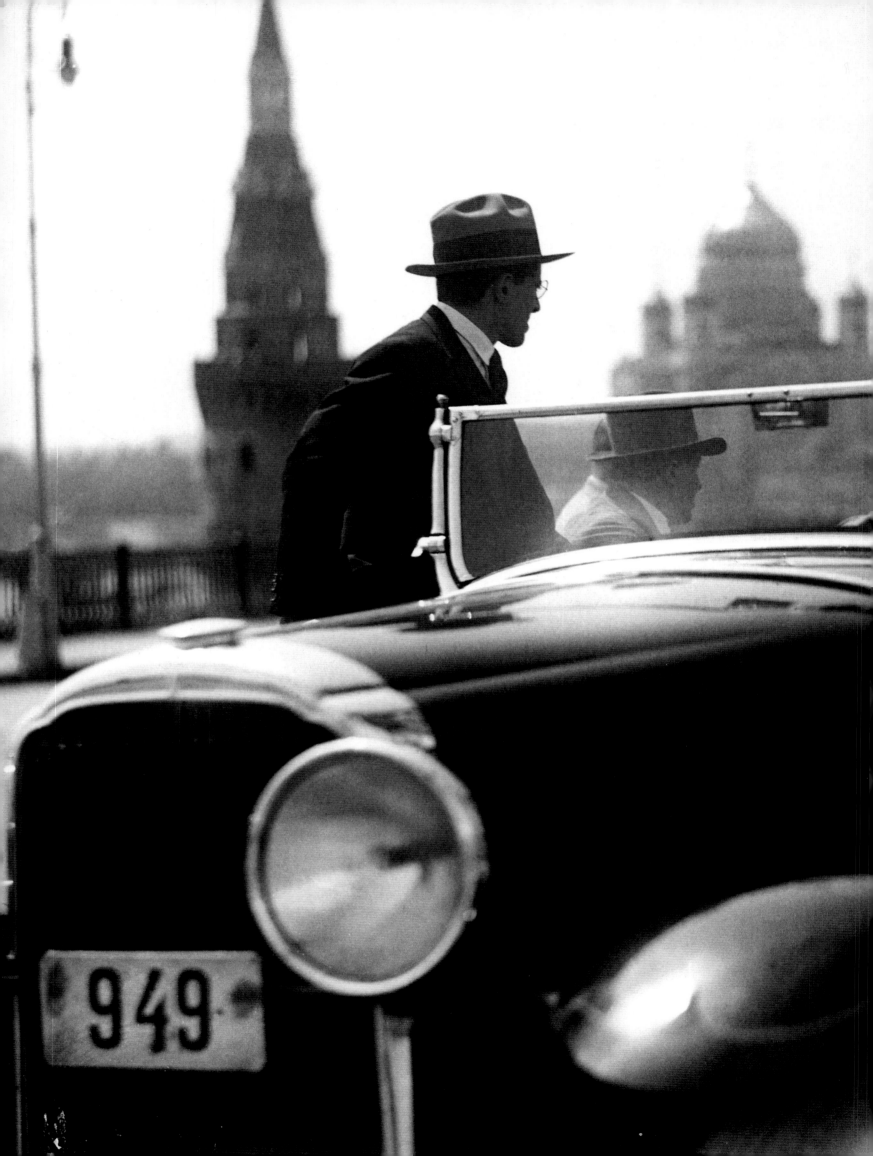

Rose-Tinted Spectacles

Western sympathisers with the Soviet cause, such as George Bernard Shaw, refused to acknowledge that millions were dying of starvation in the Soviet Union. Shaw, seen here being driven through Moscow in 1932 during the height of Stalin's collectivisation policy, chose to believe the Soviet propaganda machine.

Russian State Archive of Film and Photographic Documents, Krasnogorsk/Endeavour Group UK

In a letter to *The Times* of London, he proclaimed that "tales of a half-starved population dwelling under the lash of a ruthless tyrant" were nonsense. He talked of "crowds of brightly-dressed well-fed happy-looking workers".

A *New York Times* journalist, Walter Duranty, writing in November 1932, asserted that "there is no famine or actual starvation nor is there likely to be". (Brian Moynahan, *The Russian Century*)

Official figures from Soviet sources in 1990 estimated that four million peasants died in the Ukraine alone; some Western historians put the figure higher, at around five million.

> *"Freedom is the right to tell people what they do not want to hear."*
> George Orwell,
> The Road to Wigan Pier

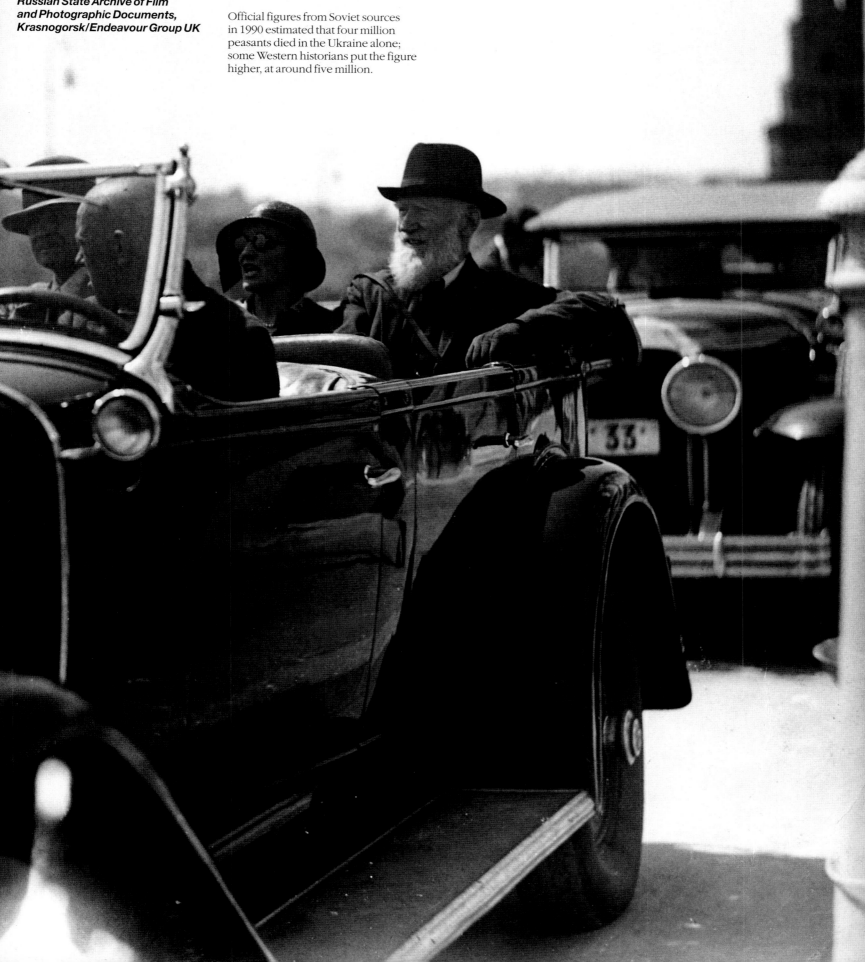

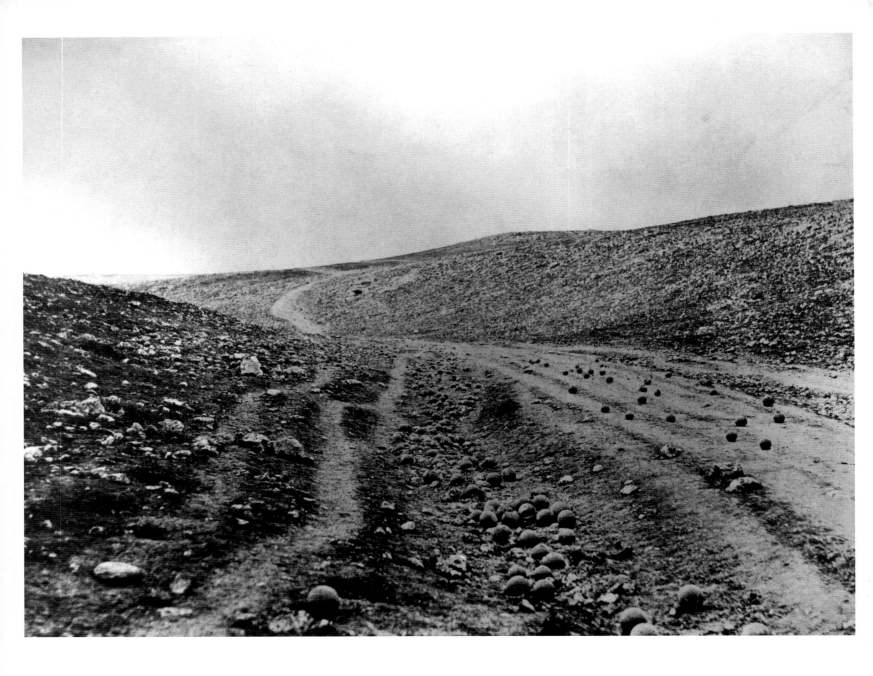

Postcards from the Crimea

(Above) October 1854. Cannonballs lying in the "Valley of Death", the innocuous scene as viewed by Roger Fenton after the disastrous Charge of the Light Brigade in which almost 500 British troops were mown down.

(Right) Fenton's cosy representation of life at the front.

Hulton Archive

"At ten minutes past eleven our Light Cavalry Brigade advanced… At thirty-five minutes past eleven not a British soldier, except the dead and dying, was left in front of the Muscovite guns."
William Howard Russell, The Times of London, November 14 1854

Fenton was an unsuccessful painter who founded the Royal Photographic Society. Public confidence in the conduct of the Crimean War was shattered by the decimation of the Light Brigade, and by critical reports from war correspondent William Howard Russell of *The Times* concerning the conditions of British troops. Fenton was encouraged to take his camera to Crimea, probably by Prince Albert (who called Russell "that miserable scribbler") and he set about sanitising the war through his images. Excellent though his photographs were, they completely distorted the reality of the situation, showing tranquil and convivial social scenes.

Fenton himself described in a letter what things were really like: "We came upon many skeletons half buried. One was lying as if he had raised himself upon his elbow, with still enough flesh left in the muscles to prevent it from falling from the shoulders. Another man's hands and feet were out of the ground, and shoes on the feet and the flesh gone." However, not one of his pictures even hinted at such horrors.

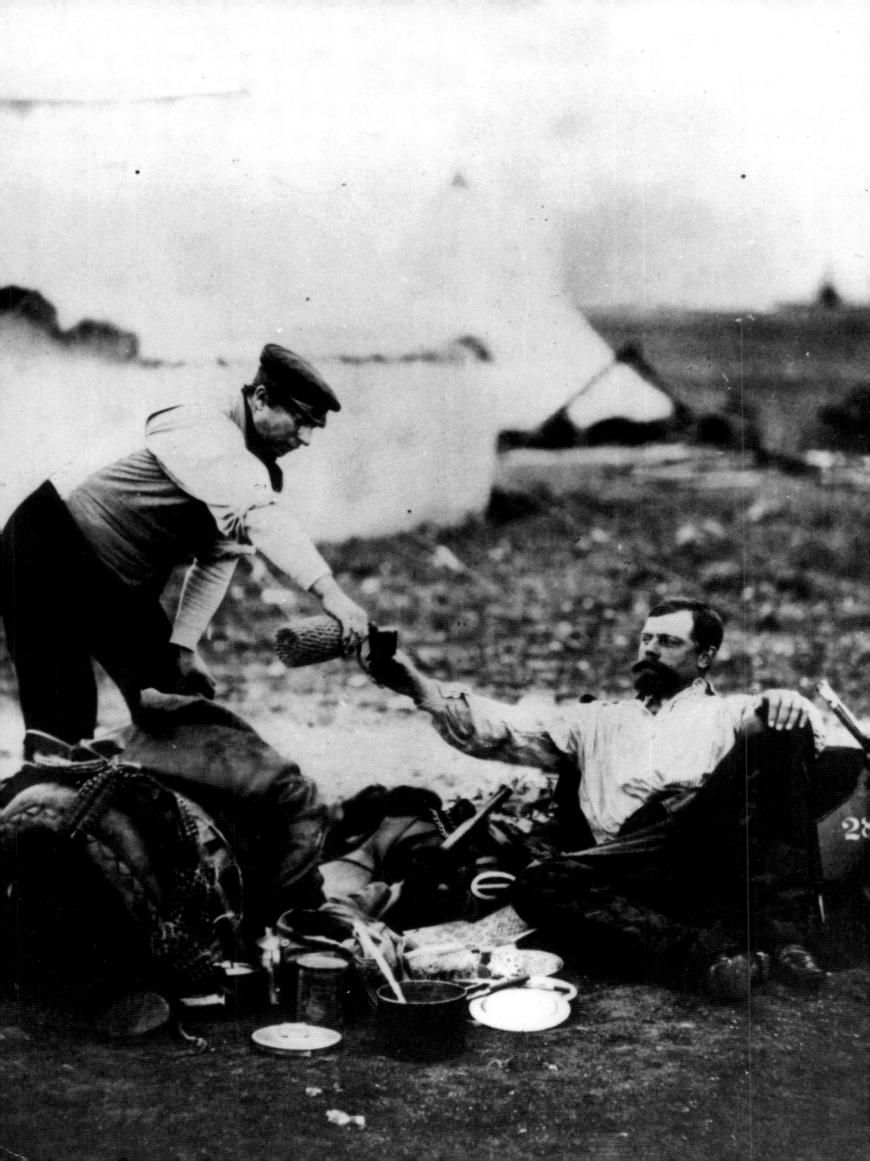

Learning the Lesson Two rival political groups, the African National Congress (ANC) and the Pan African Congress (PAC), were leading opposition to South Africa's system of apartheid. A large crowd of unarmed protestors, including women and children, congregated in the township of Sharpeville near Johannesburg to demonstrate against the infamous "pass laws" which controlled the black population's freedom of movement and access to jobs. The day before, the PAC leadership declared: "We are not going to fight, insult or provoke the police in their lawful duties. Nobody is carrying knives or any dangerous weapons tomorrow." When the crowd approached the local police station, the police opened fire.

Sharpeville proved to be a watershed in South Africa's internal politics; the ANC and PAC were banned and as a result resorted to violence as the only effective answer to white oppression. A year later, South Africa withdrew from the British Commonwealth, declaring itself a republic. The white minority had no intention of following the example of Great Britain and France, who were in the process of giving their African colonies independence under black governments.

Ian Berry, who joined Magnum two years after Sharpeville, was the only photojournalist present at this massacre. Another photographer from the *Rand Daily Mail* newspaper did arrive after the event and photographed the dead bodies. Berry was on the staff of *Drum* magazine, a celebrated publication aimed at a black audience in South Africa. *Drum* was edited by Tom Hopkinson (later Sir Tom) and owned by maverick character Jim Bailey. Hopkinson was a distinguished journalist who had edited *Picture Post* magazine in the UK in its heyday. Bailey was a good-looking war hero whose father had been a mining magnate but whose own politics were on the liberal side. *Drum* had published a number of social exposés in the past.

Hopkinson knew an exclusive when he saw one and responded with great excitement to Berry's pictures, editing an impressive layout of the story. But Bailey stepped in and refused to allow the story to be run; he was scared that the white authorities would close down the magazine. For Hopkinson, this was a terrible case of déjà vu; in 1954, he had been fired from *Picture Post* for refusing to suppress a story about maltreatment of communist prisoners during the Korean War (see page 28).

Hopkinson advised Berry to send the photos to a London agency, which then sold them for premium rates to the leading international magazines of the day – *Life*, *Paris Match* and *Stern* – who went to town on the story. Ironically, these magazines were available in South Africa, yet the leading home-based journal did not run the pictures and they have in fact never been published in a South African publication.

Incredibly, those wounded protestors who survived were charged with police obstruction. At the subsequent inquiry into the shootings, Berry's photographs became central evidence, emphatically disproving police claims regarding the number of rounds shot and the position of the police.

Ian Berry recalls: "Some time later, I received rather a large cheque from the picture agency and, as I was a staff photographer, I decided I had better give the money to Bailey, even though I had been on my day off when I took the pictures. I was expecting to receive a decent share, but I heard nothing from him. I finally asked him about the matter; he claimed to have forgotten all about it and handed me a cheque for £20.00. I handed it back to him, suggesting he should buy himself a Christmas present, and then I resigned."

Humphrey Taylor, at the time assistant editor of *Drum*, was with Ian Berry at Sharpeville. In 1999, the London *Observer Magazine* published his account of the events. He described the atmosphere before the shootings as being like a "Sunday outing". "Some kids waved to the policemen sitting on the Saracens [armoured cars] and two of the policemen waved back… One of the policemen was standing on top of a Saracen, and it looked as though he was firing his Sten gun into the crowd. He was swinging it around in a wide arc from his hip as though he were panning a movie camera. Hundreds of kids were running too. One little boy had on an old black coat, which he held up behind his head, thinking perhaps that it might save him from the bullets."

The police claimed they were in desperate danger because the crowd were stoning them. Yet only three policemen were reported to have been hit by stones and more than 200 Africans were shot down. The police maintained that the crowd was armed with "ferocious weapons" which littered the area after they fled. Tyler said, "I saw no weapons, although I looked very carefully and afterwards studied the photographs of the death scene."

The police commander, Colonel DH Pienaar, said of Sharpeville: "It started when hordes of natives surrounded the police station. If they do these things, they must learn their lesson the hard way."

Front page courtesy John Frost Newspaper Archives

Daily Mirror

TUES
MAR. 22
1960

2½ᵈ ★ No. 17,500

FURY IN SOUTH AFRICA

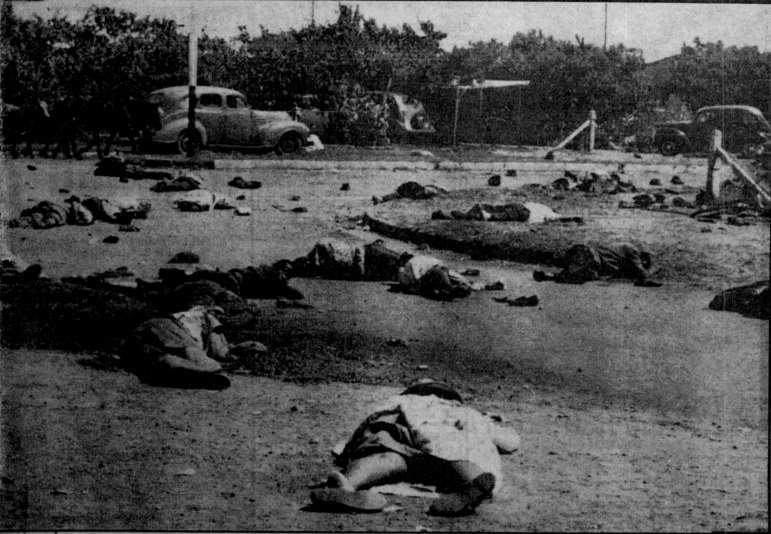

LIKE a battlefield. . . . Some of the 56 Africans killed and 162 wounded sprawled in a street after police had opened fire with rifles and sten guns at Sharpeville, near Johannesburg, South Africa, yesterday.

Women and children were among the victims. *Now turn to Back Page.*

56 SHOT DEAD
162 WOUNDED

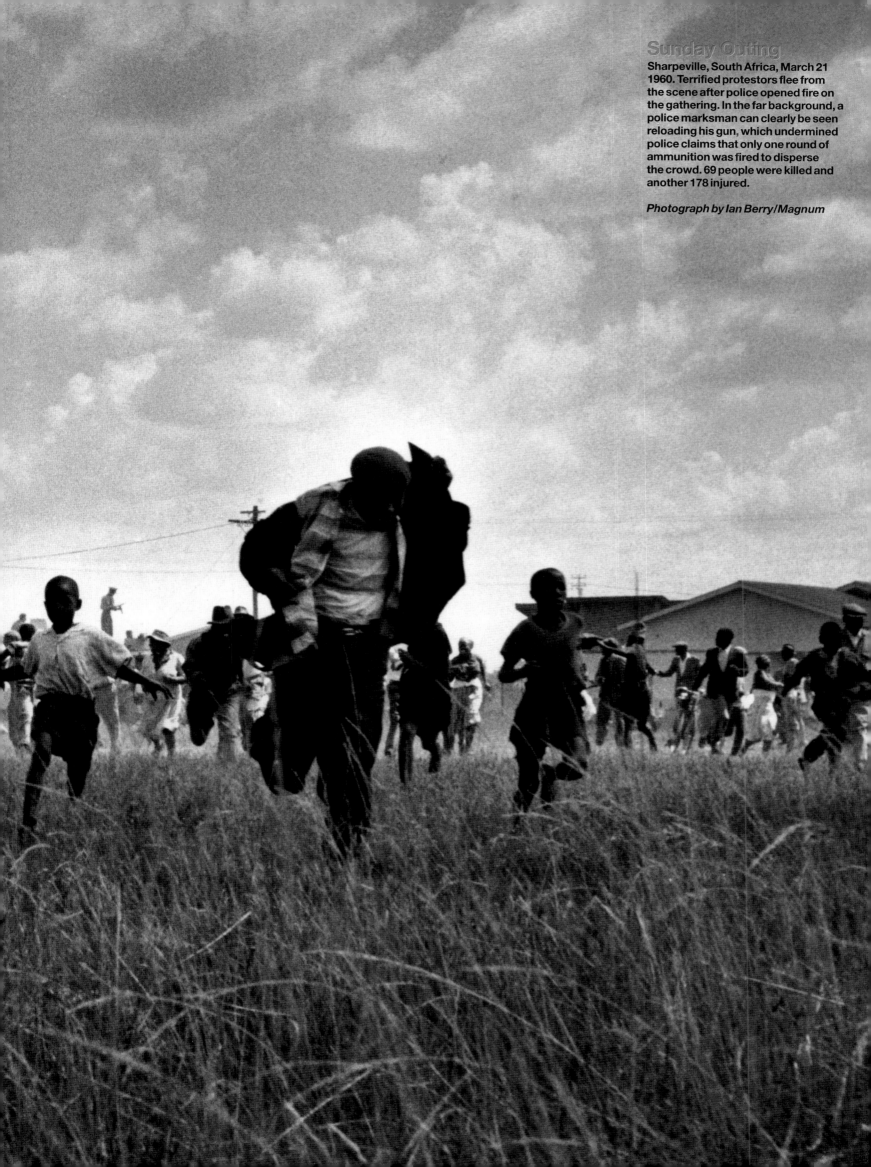

Sunday Outing

Sharpeville, South Africa, March 21 1960. Terrified protestors flee from the scene after police opened fire on the gathering. In the far background, a police marksman can clearly be seen reloading his gun, which undermined police claims that only one round of ammunition was fired to disperse the crowd. 69 people were killed and another 178 injured.

Photograph by Ian Berry/Magnum

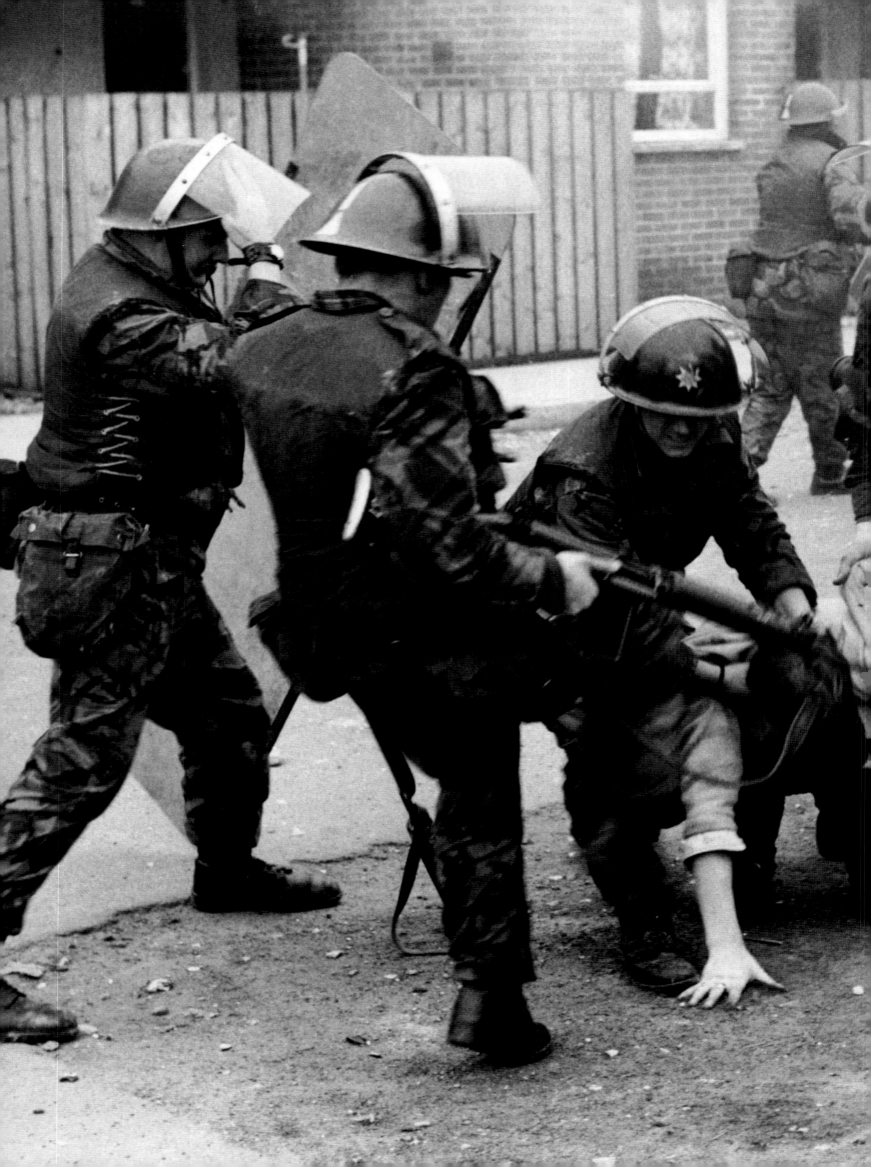

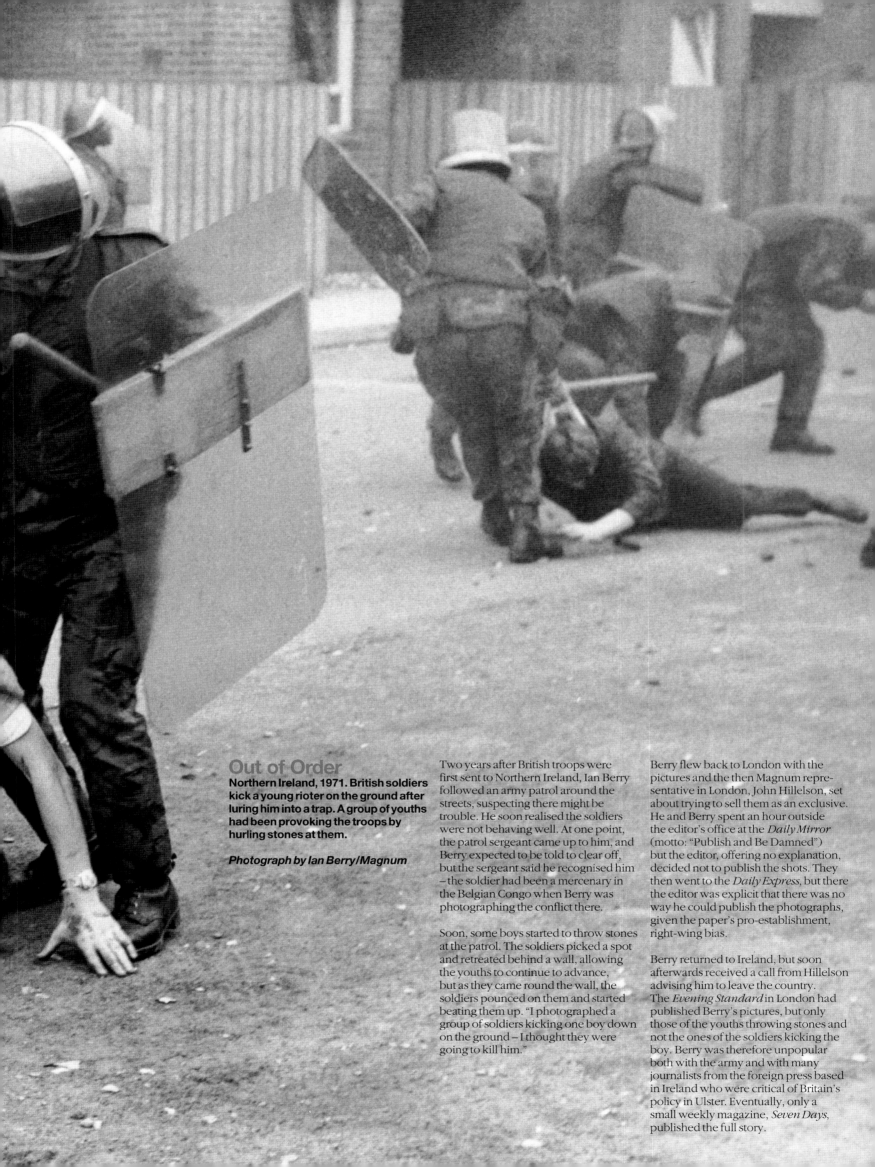

Out of Order

Northern Ireland, 1971. British soldiers kick a young rioter on the ground after luring him into a trap. A group of youths had been provoking the troops by hurling stones at them.

Photograph by Ian Berry/Magnum

Two years after British troops were first sent to Northern Ireland, Ian Berry followed an army patrol around the streets, suspecting there might be trouble. He soon realised the soldiers were not behaving well. At one point, the patrol sergeant came up to him, and Berry expected to be told to clear off, but the sergeant said he recognised him – the soldier had been a mercenary in the Belgian Congo when Berry was photographing the conflict there.

Soon, some boys started to throw stones at the patrol. The soldiers picked a spot and retreated behind a wall, allowing the youths to continue to advance, but as they came round the wall, the soldiers pounced on them and started beating them up. "I photographed a group of soldiers kicking one boy down on the ground – I thought they were going to kill him."

Berry flew back to London with the pictures and the then Magnum representative in London, John Hillelson, set about trying to sell them as an exclusive. He and Berry spent an hour outside the editor's office at the *Daily Mirror* (motto: "Publish and Be Damned") but the editor, offering no explanation, decided not to publish the shots. They then went to the *Daily Express*, but there the editor was explicit that there was no way he could publish the photographs, given the paper's pro-establishment, right-wing bias.

Berry returned to Ireland, but soon afterwards received a call from Hillelson advising him to leave the country. The *Evening Standard* in London had published Berry's pictures, but only those of the youths throwing stones and not the ones of the soldiers kicking the boy. Berry was therefore unpopular both with the army and with many journalists from the foreign press based in Ireland who were critical of Britain's policy in Ulster. Eventually, only a small weekly magazine, *Seven Days*, published the full story.

Damned If You Do & Damned If You Don't

Dacca, East Pakistan, December 1971. During the Bangladesh War of Independence, Bengalis rose up in defiance of the East Pakistan Muslim state. The Indian army captured east Pakistan towards the end of 1971, assisted by soldiers of the Mukti Bahini, the Bengali guerrilla army. During a celebration rally, victorious Bengalis started to attack and kill terrified prisoners in full view of international journalists and photographers. Some walked away in protest, but others stayed to record the grisly events.

(Right) Penny Tweedie was convinced the violence was being orchestrated for the benefit of the media. This is one of the last pictures she took before leaving in disgust.

Penny Tweedie/Panos Pictures

(Far right) Other news photographers felt they had a duty to tell the story.

William Lovelace/Daily Express/ Hulton Archive

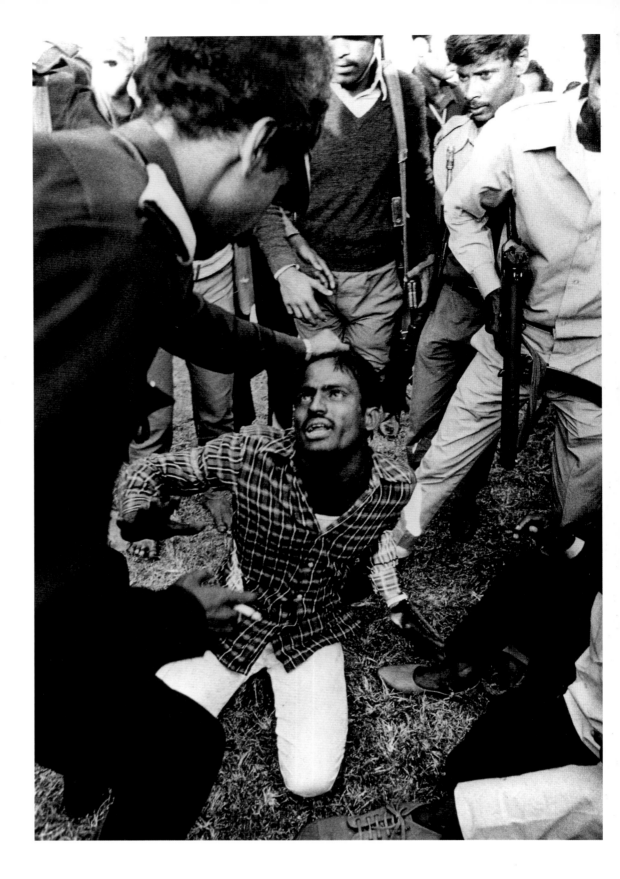

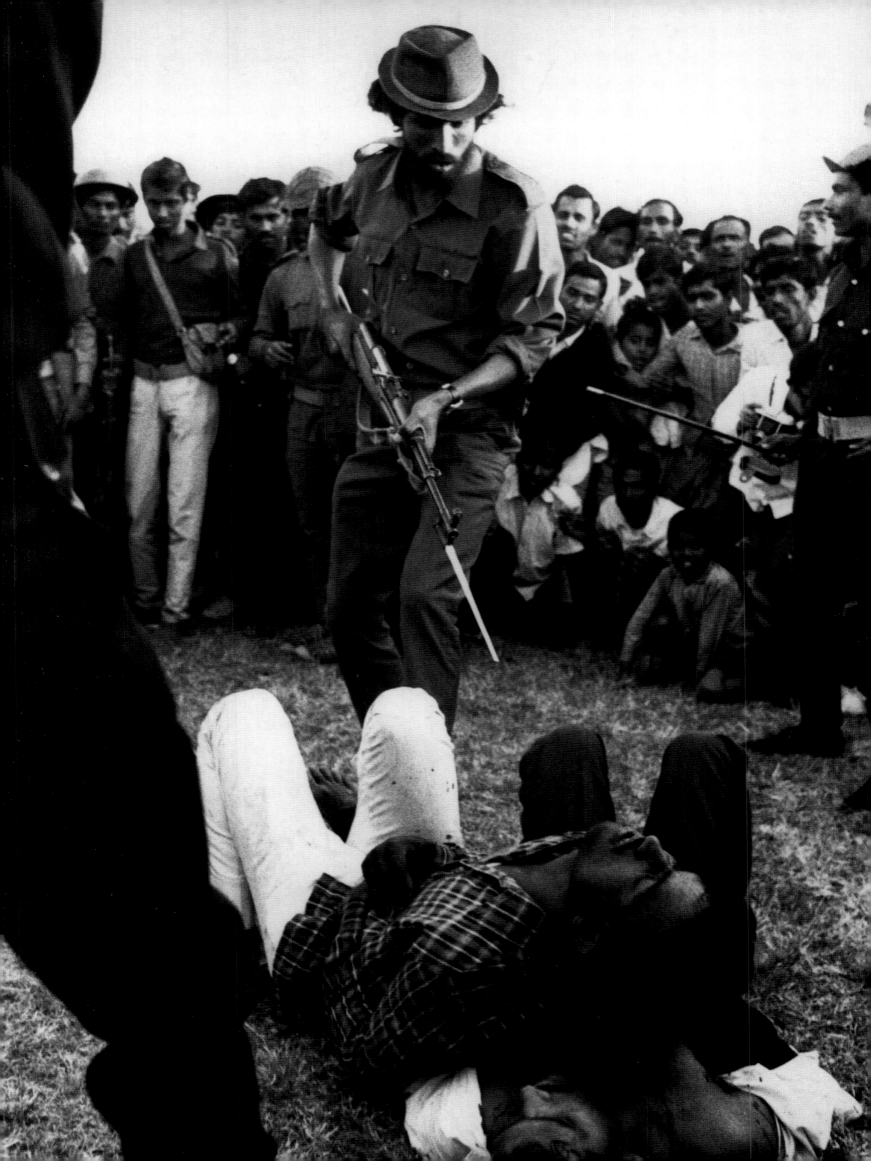

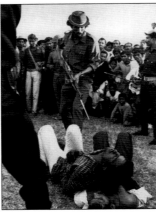

Those photographers who stayed to witness the killings were heavily criticised by some fellow photographers and press commentators. Marc Riboud of Magnum described the event as "an invitation to a massacre", implying that the murders were being carried out for the benefit of journalists. Harold Evans, in *Pictures on a Page*, suggested that photographers had received an invitation to a "photo opportunity".

Horst Faas, one of the photographers who photographed the killing, now a senior editor with Associated Press in London, emphatically repudiates this claim: "I was a news photographer, working for AP, a wire agency. I arrived in the area at 3.00 am and had nowhere to stay and so I just happened to hang around. There never was any premeditated invitation. It had been a gruesome, awful day; I had been working for 16 hours witnessing killings and death all around but I didn't realise this was going to continue when I came to the rally. Tiger Saddiqui, leader of the Mukti Bahini, had been addressing his supporters for hours on end. Suddenly, I saw a truck arrive with prisoners tied up in the back of it – they were thrown to the ground brutally and roughed up. Then Saddiqui stepped down from the platform and delivered the first bayonet stab to one of the prisoners. Other people joined in and it quickly became a kind of bloodthirsty ballet; the prisoners were dead or dying on the ground and the crowd were closing in around us. The atmosphere was getting very agitated and threatening and along with the two or three other journalists, I decided to push my way out."

Faas went to Calcutta with his film, which had to pass the Indian military censors. They blocked all the bayoneting pictures but allowed him to transmit scenes of torture, burnings with cigarettes, beatings and so on. These made a huge splash in the British press. 24 hours later, all his film arrived in London and the newspapers followed up with more huge stories, this time showing the actual killings taking place.

Faas remains unapologetic for his actions. Referring to accusations of callousness, Faas responds: "I always maintained that many photographers and newsmen walked away that evening not 'in protest' but because the rally was dragging on without much happening and it was getting dark. Some wanted to file what they already had. Others just missed the murders, like my colleague from United Press International, Peter Skingley, who had a hell of a time explaining it to his photo desk, as did a few British newspaper photographers who left while the *Daily Express* photographer stayed on."

The two most experienced photographers present, Faas and the Frenchman Michel Laurent, decided to pool their photographs: "We were both very upset. What we had witnessed was too awful, too gruesome, too close-up. We decided not to take any financial benefit from this work." In 1972, they jointly won the prestigious Pulitzer Prize in the US for their photographs.

Much later, Faas met Harold Evans at an international photography event and assured him that that there had been no prior invitation to the killings. Evans revised his view in *War Stories*, a publication for the Newseum in Washington DC, in 2001. He quoted Marc Riboud, one of those who had walked away in disgust: "Prime Minister Indira Gandhi said that the publication of the murder photos had so shocked and embarrassed Indian authorities that severe orders had been issued to stop such incidents." "Still," writes Evans, "I remain troubled that the Pulitzer board was, by inference, criticising the photographers who walked away."

Penny Tweedie, one of the photographers who chose to walk away, explained the events from her point of view:

"Saddiqui and members of the Mukti Bahini were making endless speeches in Bengali. I couldn't understand a word so I wandered around to the back of the podium and came across five young men roped together. As I raised my camera, a guard hit one of the prisoners with a rifle butt. When I asked what was going on, he didn't reply. The prisoners were very young, just boys, and one of them pleaded, 'Help us.' Suddenly, they were dragged to their feet into the stadium. People stood up and began singing prayers with their hands close to their faces. I noticed that some were crying. Then the Mukti Bahini started to attack the five boys. All the other photographers gathered around shooting pictures as the boys were taunted and hit with rifle butts by their captors – no one was trying to stop it.

I began to get an awful feeling that this was all being staged for us, the media, orchestrated by the flamboyant Tiger Saddiqui. The boy at my feet was looking desperately at me, terrified, and I saw one of the militia brandishing a bayonet. I turned to Marc Riboud and said, 'This is being done for us. We've got to stop it.' He felt the same; so did Richard Linley from ITN. We stepped back from the action and Linley protested openly and tried to talk to Saddiqui, but got no sense out of him. The three of us called to the other photographers to back off, and we walked away towards the stadium gate. We later returned to find four of the boys dead on the ground. Someone said they had been collaborators.

I went back to the hotel where I was staying, and some of the photographers who had missed the event started quizzing me, wanting me to share my film. I didn't feel much like talking about it as some of them had abused me, calling me a coward for walking away and refusing to listen to my point of view. A few months later, when Horst Faas and Michel Laurent shared the Pulitzer Prize, a British TV programme invited myself and another photographer to discuss the incident. Once again, I was criticised for not staying to record the atrocity. The clear implication behind this attack was that I was a weak woman, which is absurd given my track record, but at least I was able to put my point of view.

It was a gut reaction on my part. I did what I felt was right at the time. If all the photographers had walked away, would they still have killed the prisoners? I still don't know the answer to that."

Tweedie is sceptical about claims that the killing photographs were crucial in influencing world opinion and putting political pressure on Indira Gandhi. "There had been enough awful pictures coming out of this war already for the world to know that terrible things were going on."

A further development in this story took place in Bangladesh recently. In January 2001, Shahidul Alam, a photographer who also runs Drik Picture Library in Dacca, organised a major photographic exhibition called *The War We Forgot*. This covered all aspects of the Bangladesh War and included the photographs by Horst Faas and Michel Laurent. The National Museum, which was hosting the exhibition, objected to the pictures of the killings, so Alam withdrew the whole show in protest against this form of state censorship, moving it instead to the Drik premises. In February 2001, Drik launched a website on human rights with leading Bangladeshi journalists providing the content. Less than 24 hours later, the Bangladesh Telegraph and Telephone Board (BTTB) blocked all Drik's outgoing telephone connections, including voice, fax and data lines, without any prior warning. The BTTB denied this had anything to do with Drik's activism in the field of human rights but maintained that the services could not be restored until "investigations" had taken place. Though services were partially restored after seven months, the new government again blocked the lines, but did restore local outgoing lines soon afterwards. By early 2002, Drik was still unable to make international calls.

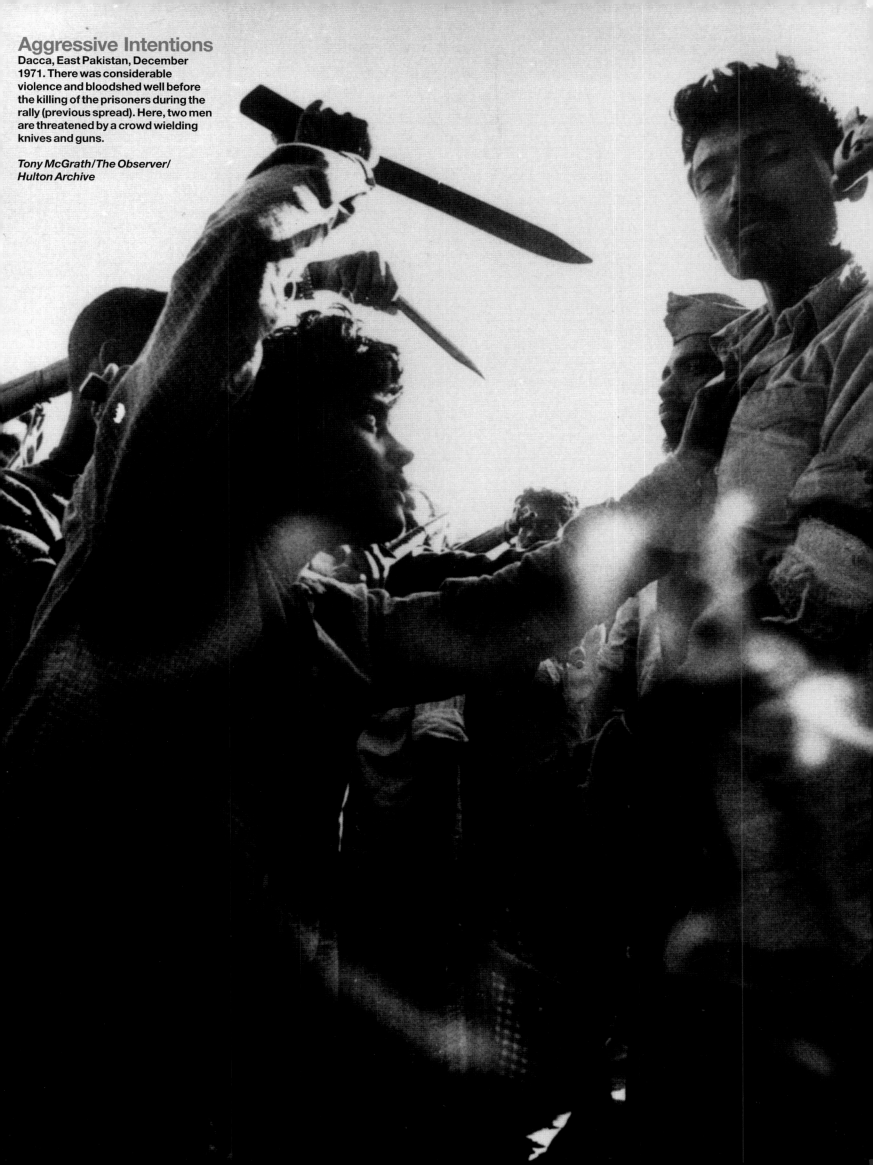

Aggressive Intentions
Dacca, East Pakistan, December 1971. There was considerable violence and bloodshed well before the killing of the prisoners during the rally (previous spread). Here, two men are threatened by a crowd wielding knives and guns.

Tony McGrath/The Observer/ Hulton Archive

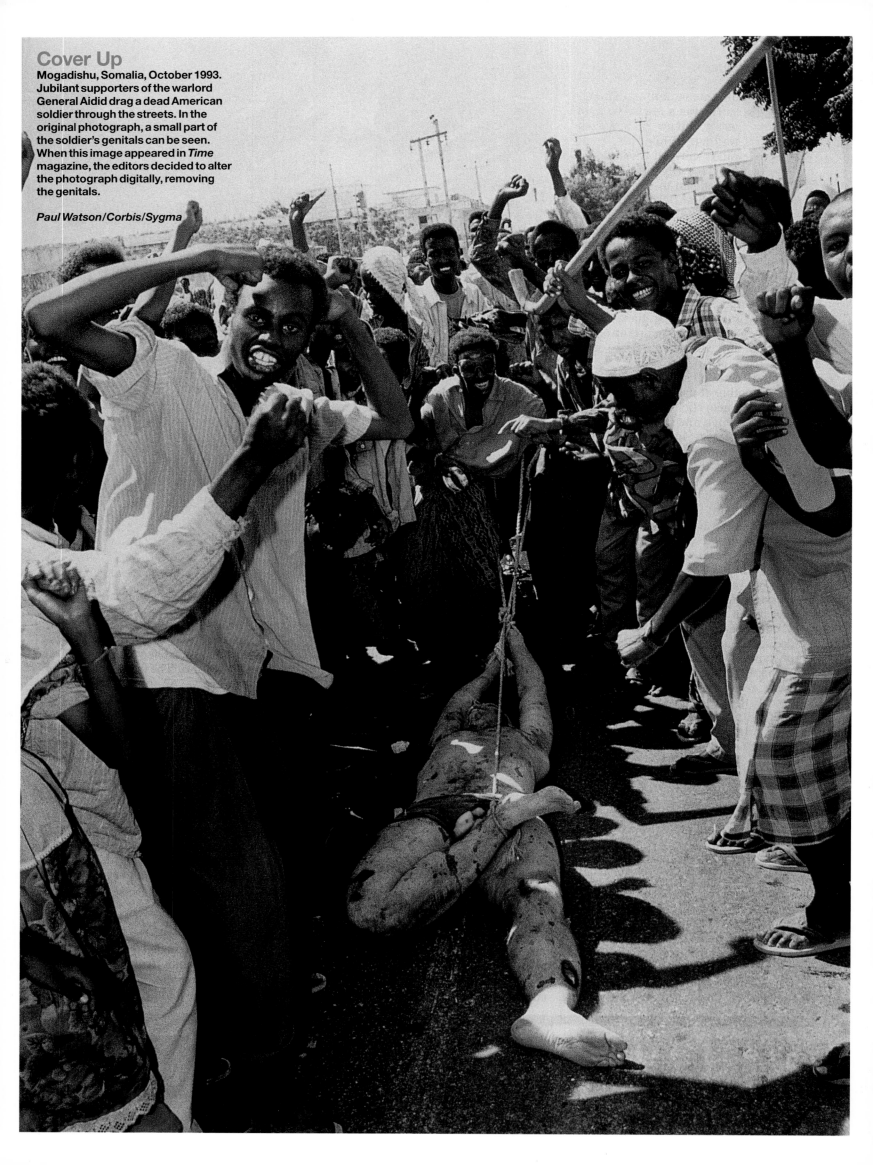

Cover Up

Mogadishu, Somalia, October 1993.
Jubilant supporters of the warlord
General Aidid drag a dead American
soldier through the streets. In the
original photograph, a small part of
the soldier's genitals can be seen.
When this image appeared in *Time*
magazine, the editors decided to alter
the photograph digitally, removing
the genitals.

Paul Watson/Corbis/Sygma

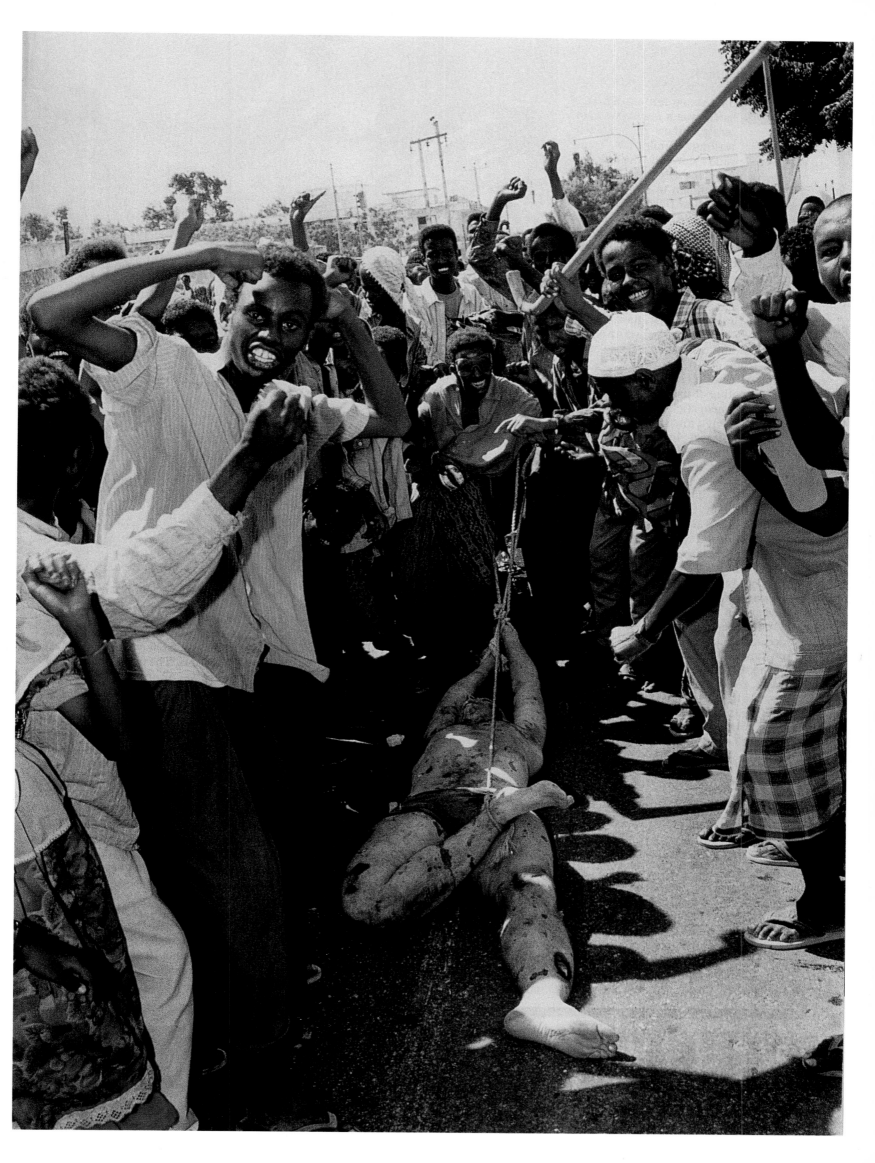

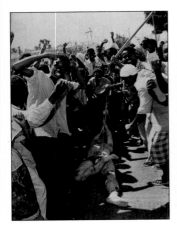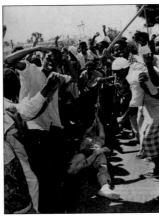

Playing Safe

(Right) Mindful of the likelihood that his full-length picture of the dead American soldier would not be published, Paul Watson hurriedly returned to the scene to take this half-length photograph. "AP told me later that they have a strict policy against altering images and therefore probably wouldn't have handled the full-body shot because of the genital problem. I'll never know if they would have done so if I hadn't sent them a second, more palatable, choice."

Paul Watson/Corbis/Sygma

◄ On December 4, 1992, President George Bush Sr announced that American troops would be sent to Somalia to assist UN relief efforts. ABC news reported on December 6 that "the anarchy in the country makes it almost impossible for the relief workers to do their jobs, which means that everyone is waiting for the US to arrive".

On October 3, 1993, 18 American soldiers were killed in a fierce battle with supporters of the warlord General Aidid. *Newsweek* claimed that 300 to 400 Somalis were killed in the same battle and 700 to 800 injured. No images of the Somali dead were shown in US media outlets.

It is difficult to exaggerate the shock waves this image sent through the soul of America. Taken by Paul Watson of the *Toronto Star*, it is an uncanny visual echo of a famous picture of American whites lynching a black man in 1931.

Paul Watson, now South Asia Bureau Chief of the *Los Angeles Times*, gives the background to how the photograph was taken and what happened afterwards:

"The image *Time* used is different from the one that was widely distributed by the Associated Press [right].

I had no way to transmit the pictures from Mogadishu. So I had to do a deal with AP, under which they agreed to meet an aid flight at Nairobi and transmit my pictures to Toronto for free. After that, they could then do whatever they wanted with any of the images.

I warned the Nairobi bureau chief that some of the images – perhaps all of them – were probably too graphic for AP, but stressed that he should move everything to the *Star* so that I could try to persuade the editors there to publish the photographs.

The first picture I shot was a full-body image of the mob beating the US airman's corpse, and I realised that his underwear was slightly askew, exposing a tiny portion of his genitals. At times like this, certain voices guide a person's behaviour. I was reminded of an old photographer friend during a trip to Sudan years earlier. He had shot a picture of naked boys running along a riverside, and I remarked that it must be a great picture.

'They'll never print it,' he said. 'Why not?' I asked. 'Because their penises are showing,' he replied.

That brief conversation flashed through my mind in the seconds after my two Somali bodyguards, armed with assault rifles, pushed me back into the car because the crowd had started to threaten us. I bolted from the car and followed the mob as they made a left turn with the corpse. It was in those few seconds that I shot the second half-body picture that the AP later moved to its subscribers. If you look at both pictures, you can see the eyes in this second image are a lot meaner, and focused on me, in part because I'd defied the first order to leave.

AP told me later that they have a strict policy against altering images and therefore probably wouldn't have handled the full-body shot because of the genital problem. I'll never know if they would have done so if I hadn't sent them a second, more palatable, choice.

Soon after that half-body picture was public, Sygma agency in New York bought magazine rights on the full-body picture.

Time bought the image from Sygma and I saw that it had been digitally touched up days later when a journalist arriving in Mogadishu showed me a copy of the magazine. In print, the underwear now covered all of the 'offending parts'.

It's very telling that the decision was made to censor something considered sexually offensive, while the outrageous violence of desecrating a corpse is deemed safe for the general public's consumption. Of course, I'm grateful the pictures were printed at all – I doubted they would be. But the US wasn't seeing the whole, ugly truth of what was happening in Somalia, and I risked my life to show that American troops were on the front lines of a war that was going wrong."

Stephen Mayes, a director of photography, comments: "*Time*'s manipulated picture exposes the sensitivities of a nation that is militarily strong enough to confront one dead soldier, but morally too insecure to risk the exposure of a single genital, even in such a non-sexual context. What exactly was the purpose of the exercise – could it have been to protect the dead man's family? This would be a hard case to argue with a picture so inherently grotesque. If it was to protect readers from offence, it would raise the more profound question about what could be judged to be so offensive about genitals that is not offensive about killing."

Time carried no reference to the manipulation, which is unusual since the magazine had introduced the term "digitally-altered composite" into its picture credits. Mayes concludes that the world's leading news magazine had stepped into the murky territory of making judgements about "acceptable" visual censorship.

Michele Stevenson, *Time*'s director of photography, explains the situation from the magazine's perspective: "There was a great deal of discussion about whether to run the whole picture or the cropped version. Since the whole scene had been running on television for many days before we published, our editors felt that it was now a familiar scene and one we should publish; and that our readers should be aware of how bad the situation had become in Somalia. (We are often criticised for running pictures of dead soldiers or civilians from other cultures; people write and say, 'You wouldn't run those pictures if they were of dead Americans.') At the same time, it was felt that we should run the whole picture but retouched (by us, not AP) for the dignity of the man and his family – the original image would have offended even more than the slightly altered one."

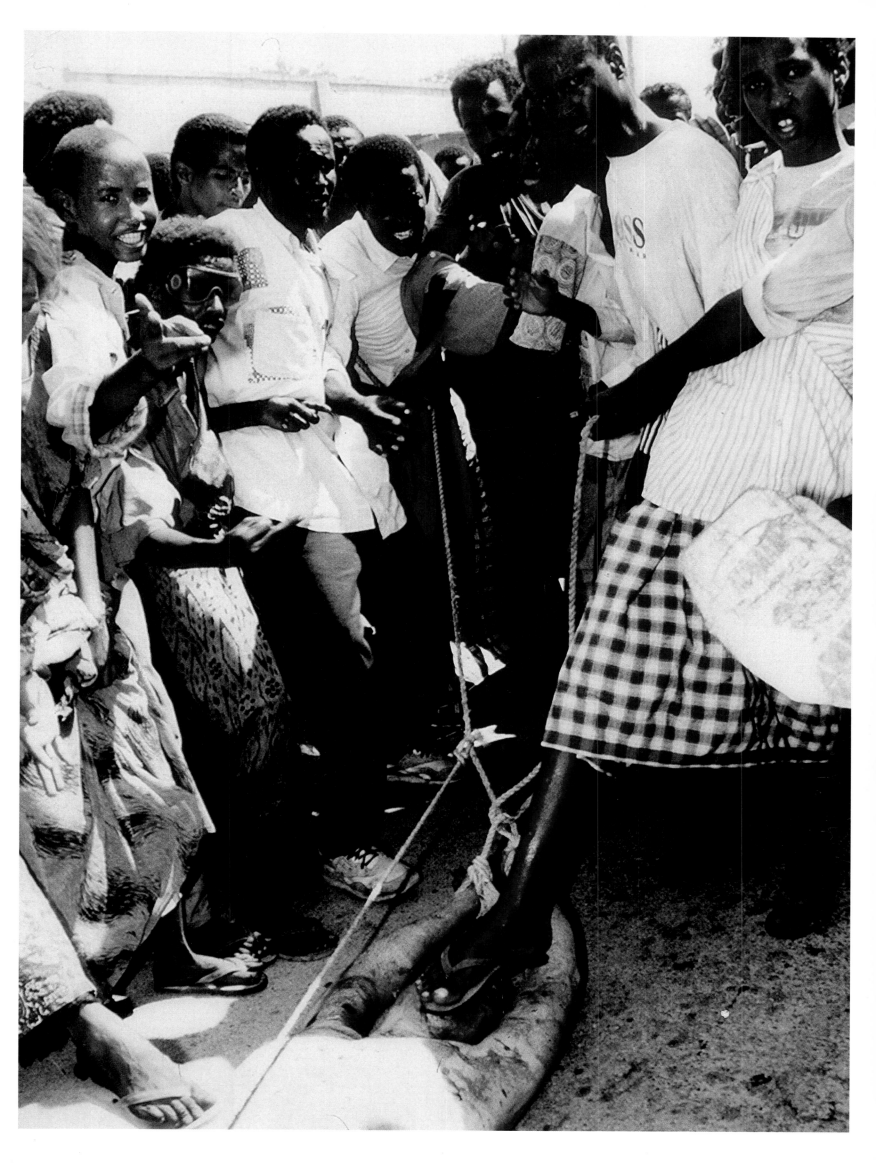

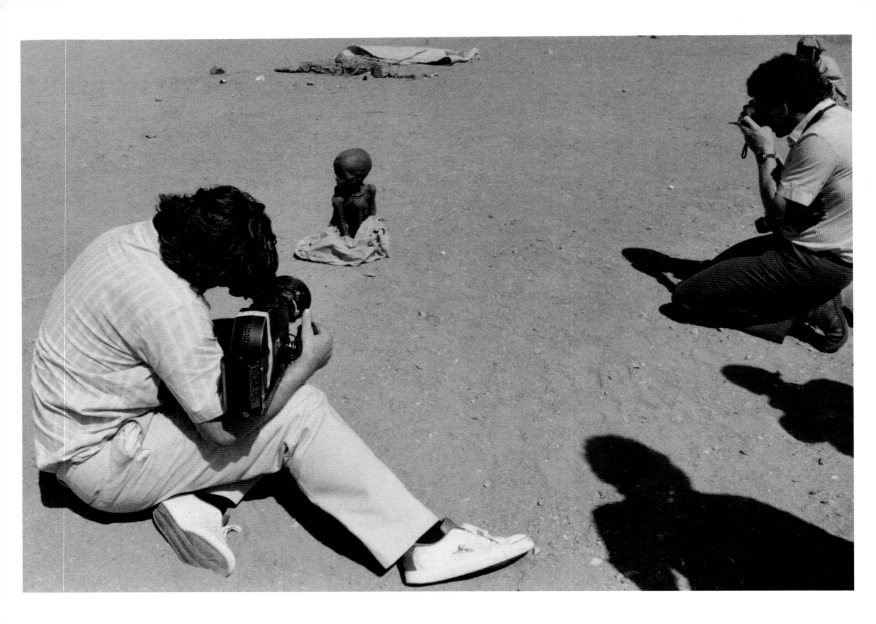

Media Victim

Red Sea Hills, Sudan 1984. In 1984, famine was afflicting many Sudanese, including the nomads of the northeast, whose grazing lands had dried up. Nomadic Hadendowa tribespeople came out of their traditional areas to seek work and food in the towns. They set up a temporary camp by the side of the main paved road from Khartoum to Port Sudan. The camp was mainly inhabited by women, children and the elderly; the men were away looking for casual work. When a British television crew and accompanying UNICEF staff members appeared at the camp, the people brought out one of their most afflicted children for the cameras to demonstrate the hardships they faced.

Wendy Wallace

Western perceptions of the Third World, especially its many natural and man-made disasters, have been heavily influenced by media coverage. All too often the visual images presented have reinforced stereotypes, portraying refugees and civilians as helpless victims powerless to influence their own future. This is the easy way out for photographers and filmmakers because it offers "strong", familiar pictures – suffering mothers and babies in the iconic tradition of Madonna and child, or, as here, the hapless, isolated and vulnerable child on its own. It is important to consider whether such culturally-induced perceptions, however well-intended, serve any real purpose other than to act as fund-raising propaganda; journalistically, do they show us or tell us anything we do not already know? Do they help us to a better understanding of the situation of those photographed or the reasons that such conditions have come about? Do they allow us to relate more easily to the "felt" life of those caught in the view-finder? Or do we just respond with a ritual "How awful!" and turn the page?

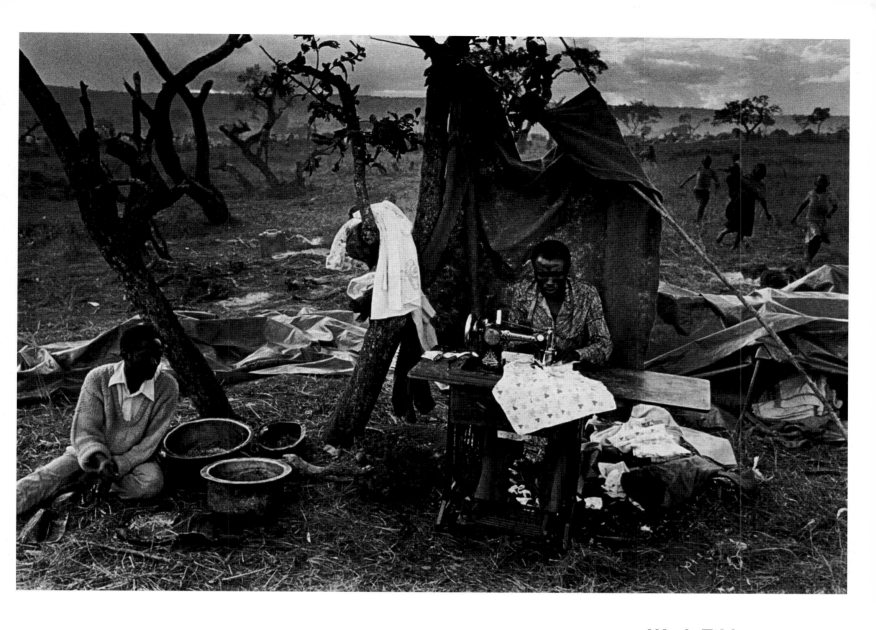

Work Ethic

Tanzania, 1994. In a camp for civilians escaping the Rwandan civil war, a refugee has set himself up a repair business with his sewing machine. Here, rather than concentrate on visually familiar images of squalor and hardship, the photojournalist has looked for a situation that expresses the survival instinct. The intelligent surprise factor may well touch readers in a way that a predictable litany of woe will not.

Witold Krassowski/
Network Photographers

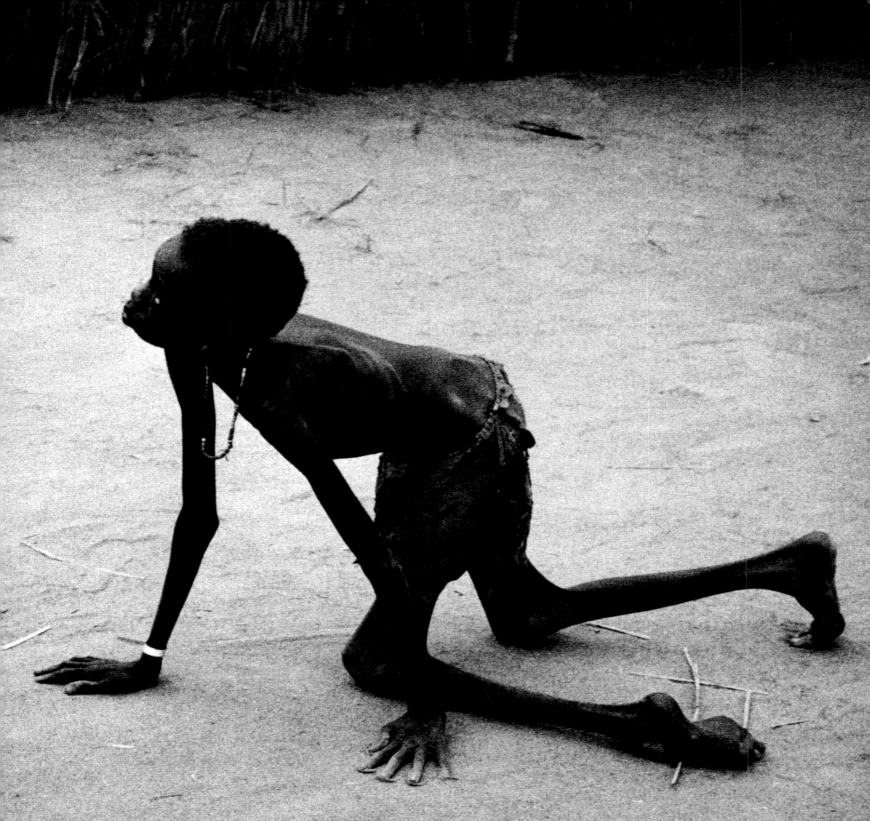

Food Theft

Tom Stoddart, a British photo-journalist, visited southern Sudan in 1998. Between 1983 and 1993, 1.3 million people in the Sudan died of hunger, disease or violence, mainly because of the civil war between the Arab and Muslim-dominated government in the north of the country and the mostly Christian, animist, black rebels in the south. A number of well-researched reports have accused the government of carrying out an almost genocidal war against the south, including aerial bombardment, ethnic cleansing, torture and execution, indiscriminate placing of landmines and forcible conversion to Islam. Above all, say the critics, the Muslim government is using famine as a weapon of war.

Tom Stoddart/IPG

In 1998, perhaps in reaction to world pressure, the Sudanese government allowed a new round of aid to be delivered to the south. Stoddart travelled to a camp at Ajiep with Medicins Sans Frontières where more than 100 people were dying every day; a situation worse than that in the Horn of Africa at the time of Live Aid. He took this disturbing photograph of a crippled boy who had queued for hours for food, only to find it robbed from him by a fit man who strides confidently away.

Stoddart received some criticism for this image; people asked why he did not intervene in the theft. He responded, "I am a photographer, not a policeman or an aid worker. All I can do is try to tell the truth as I see it with my camera." Maybe the same critics should have been asking, "Why is this going on? Why have successive Western governments allowed this savage civil war to continue unabated? Why is there a conspiracy of silence among them and the Western aid agencies about the large amount of food and grain which disappears from the camps and appears for sale in the market places of Sudan and its neighbouring countries?"

This is an unresolved dilemma facing the international aid organisations. If the robbers aren't given their cut, they will not let the aid shipments get through, and more starving will die.

Stoddart feels that the picture works well as a symbol of Africa's problems as a whole – the big man with the stick rules. The image along with two others used together in the London *Guardian* generated around £150,000 in donations to charity.

Holding Back

Mission hospital, Zimbabwe, 1993. The wife and relatives of an Aids patient react with grief just as he dies of a seizure. The doctor is standing at the right.

Gideon Mendel/
Network Photographers

Gideon Mendel is a South African photojournalist based in London who has built up an impressive body of work on Aids in Africa. His photography has been at the forefront of efforts by many non-governmental organisations to raise world awareness of the devastating extent to which HIV has gripped the whole continent of Africa.

In November 1993, shortly before the first World Aids Day, Mendel visited a small, remote mission hospital in Zimbabwe in which a high proportion of the patients had Aids. Even at that time, non-governmental organisations were estimating that something like 20 per cent of the adult population of Zimbabwe had HIV. The UN Aids organisation's most recent estimate is that 40 million people worldwide are HIV positive, 28 million alone in sub-Saharan Africa, and that 8,000 people per day are dying from the disease.

In the course of photographing such a sensitive subject, especially in those African countries that are still reluctant to recognise or discuss Aids for what it is, Mendel has faced situations which forced him to question the ethics of his journalism. Discussing this photograph, Mendel wrote:

"On the last day of my stay, I unwittingly photographed the death of a patient with Aids. I had begun to photograph the man as his wife started to lift him from the bed, to change his position. He then had a seizure. I carried on photographing, not realising until afterwards that he had died."

When he did realise, Mendel stopped photographing the anguished response of the man's wife and relatives, feeling that his presence as a photographer was too intrusive. However, the Swiss doctor, seen here at the right of the picture, remonstrated with him, chiding, "Go on, man. Do your job." Subsequently, the doctor got into trouble with the Zimbabwe government for not clearing the matter with official channels, but he clearly believed the world should witness what he was seeing daily.

Mendel continues: "It has become one of the conventions of photojournalism that one can photograph illness and suffering, one can photograph bodies and funerals, but that photographing the moment of death is not allowed. Had I intruded on a sacred moment?"

After much thought, I decided that these pictures, too, should be published. If the task I had set myself was to tell the story of Aids in Africa, I could not shy away from the cruel fact that Aids leads to death. I hope this image, and others like it, help to convey the tragedy caused by Aids. One death affects a family, a community, a society. This is a tragedy which is being repeated across Africa many times every day."

Overcoming this instinct for caution, Mendel requested, and was granted, permission to publish his photographs by both the family of the patient and the hospital, provided they did not appear in Zimbabwe. When Mendel's photographs were published in Britain's *Independent* magazine, the editorial team expected a shocked response from readers. In fact, the only letter of protest came from the Zimbabwe High Commissioner, who questioned the magazine's judgement and asked the rhetorical question: "Would you have published such a photograph of a man dying if the patient had been in Britain rather than Zimbabwe?" Mendel's own view is that the Zimbabwe government were more concerned about the threat to tourism and were in complete denial of the problem in their country – their response to Aids has been woefully inadequate.

This experience in Zimbabwe and others like it have had a profound effect on Mendel's method of working. In retrospect he regrets that he did not carry out any interviews with the wife and family of the dead man. He was concerned almost exclusively with the visual storytelling at that time, but now sees himself less as a photojournalist and more as an activist. He is increasingly engaged with the people he meets and photographs, allowing their voices to reflect their experiences of Aids and hoping to raise widespread awareness through his work.

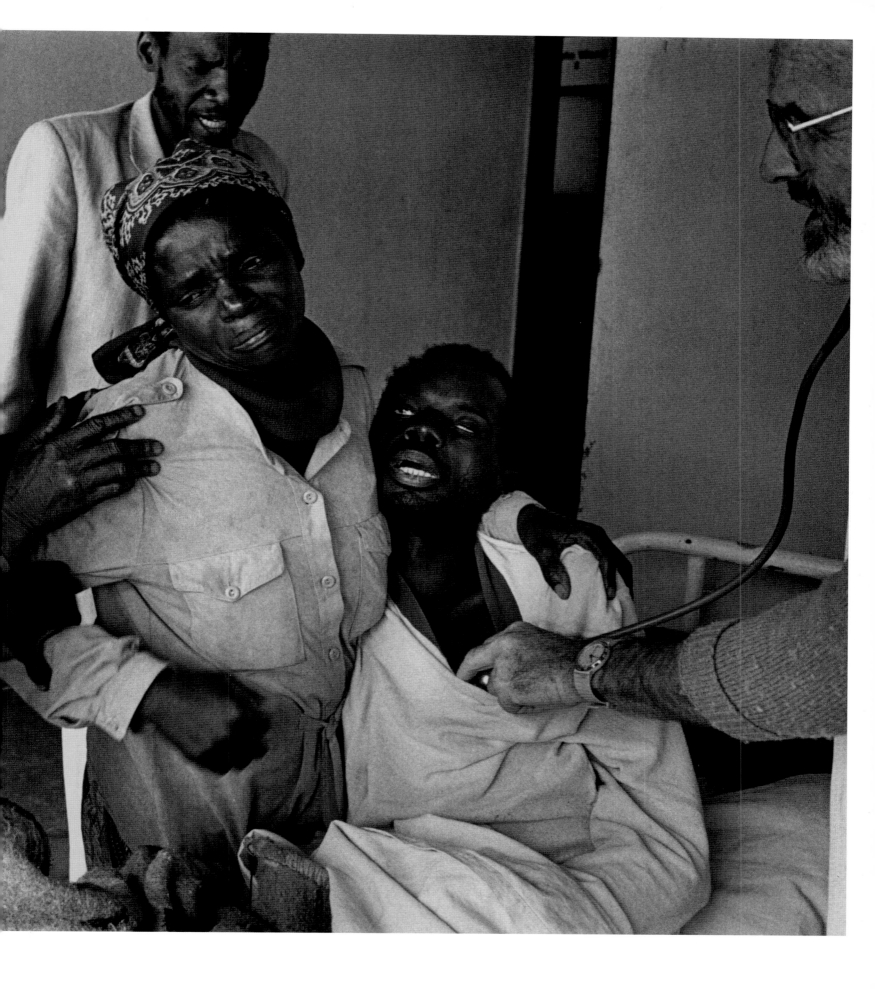

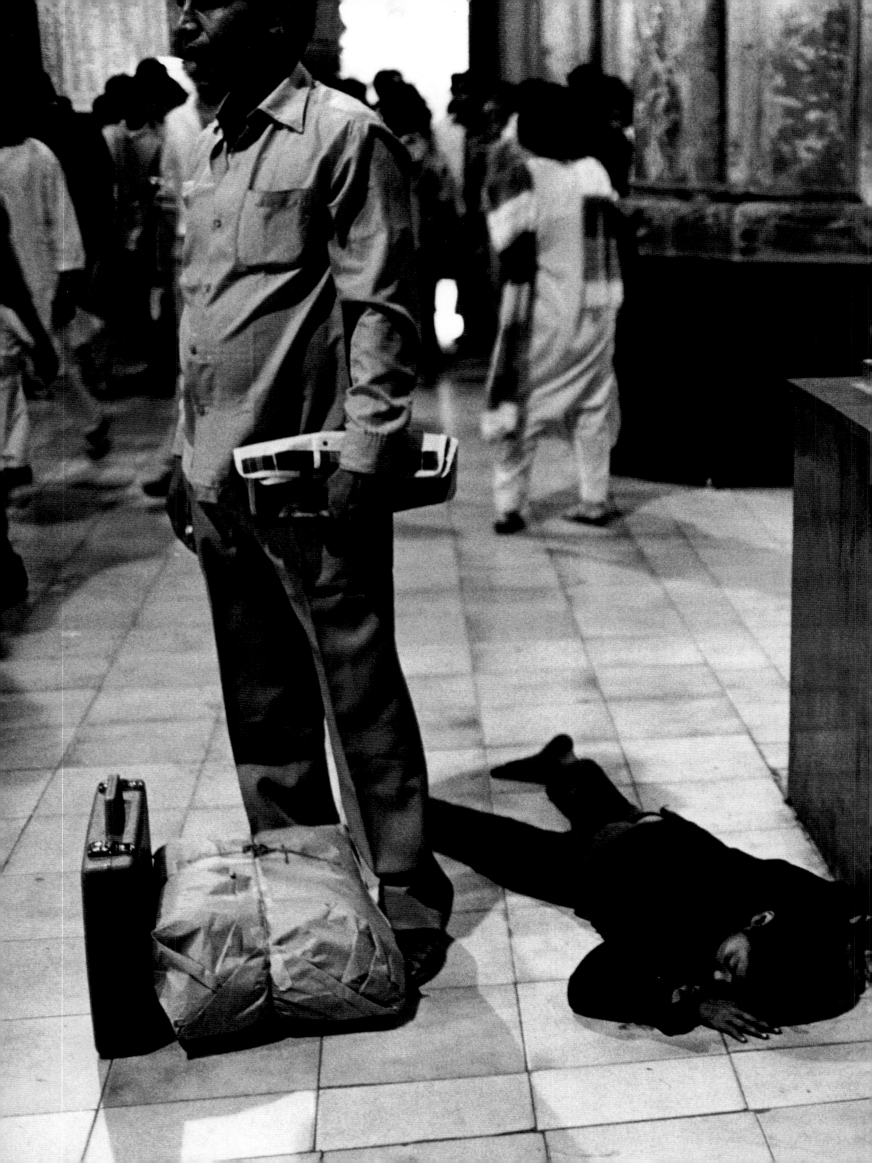

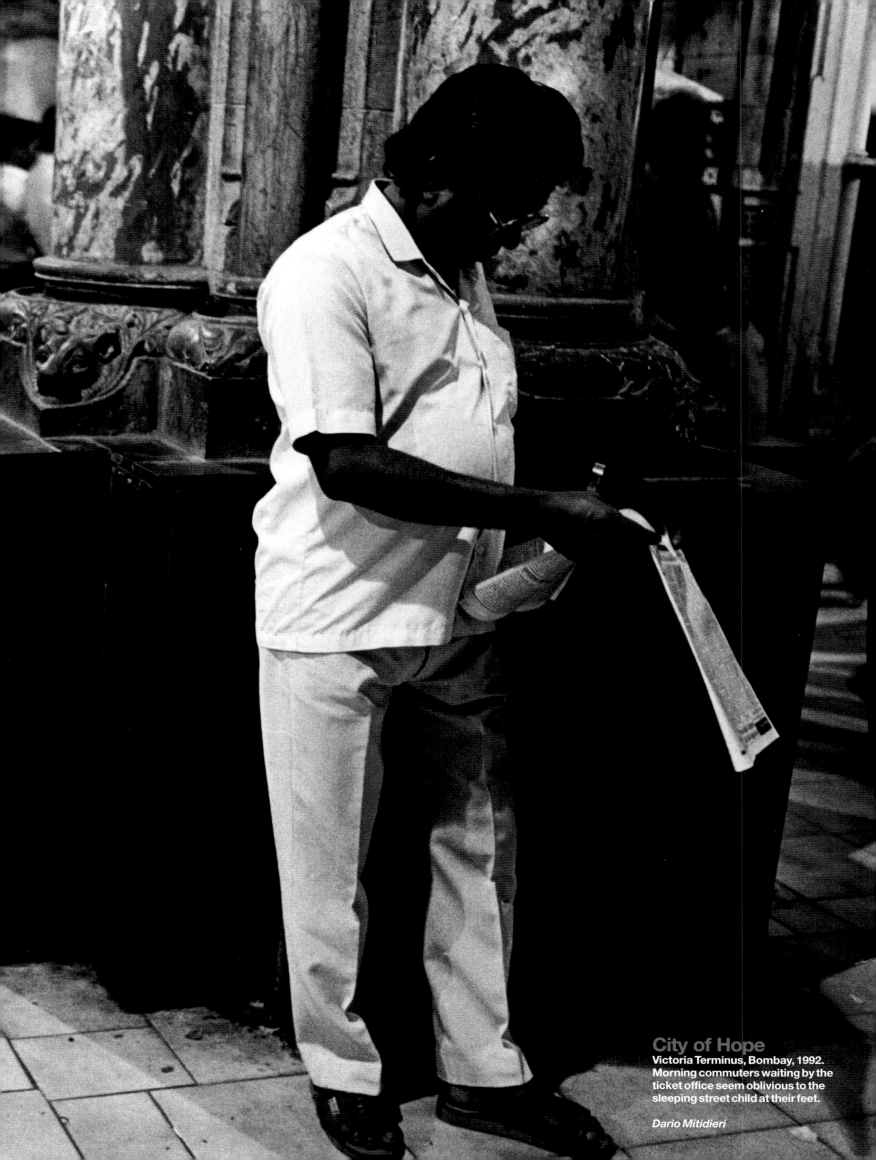

City of Hope
Victoria Terminus, Bombay, 1992. Morning commuters waiting by the ticket office seem oblivious to the sleeping street child at their feet.

Dario Mitidieri

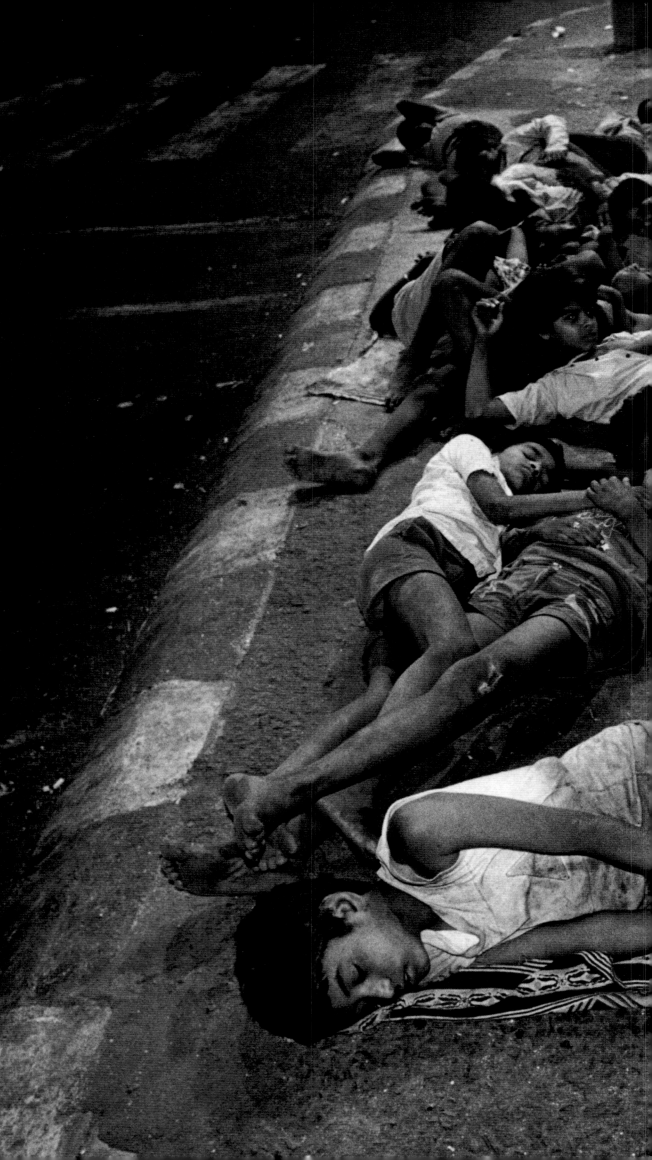

Safety in Numbers
Bombay, 1992. The Victoria Terminus street children huddle together for protection outside the station.

Dario Mitidieri

In the early 1990s it was estimated that there were 35,000 street children in Bombay. Five years on, their numbers had grown to around 100,000 and they were getting younger and more vulnerable all the time.

Satish, aged 12 and crippled, had been on the streets for 4 years: "I ran away from home because my father was a drunkard. I didn't have a mother. My father wouldn't let me go to school. He used to beat me. I will never go home but I very much want to go to school."

The photographer Dario Mitidieri worked with the street children on and off for over a year with the help of the W Eugene Smith Grant in Humanistic Photography. He encountered a great deal of resistance from the authorities and even from social workers, who resented the bad publicity and alleged he was exploiting the children.

"He was accused of making money out of the poor children, as if there were not easier ways for a prize-winning photographer to make money than to grapple with filth and disease, contagion and corruption," wrote Firdaus Kanga in his introduction to Mitidieri's book, *Children of Bombay*. "Again and again, he was asked to go away by authorities and ordinary people alike. How dare he take pictures of India and Indians which did not portray us as the vanguard of the developing world, a land of hydro-electric projects and shining shopping malls?!"

The middle class and rich of Bombay seem unable to acknowledge that the street children are there because of urban poverty and ignorance. They prefer to look on the problem as a fact of life and see the children as an irritant and a nuisance. When Dario Mitidieri's exhibition opened in Bombay, a middle-aged woman accosted him: "Dario, I hate your photographs. This is not what I expected to see. I suppose I just didn't know. This is a reality that I have tried to ignore all my life and now here it is in front of me. Now I'm getting older and I have a lot of free time. Maybe I should do something for these children."

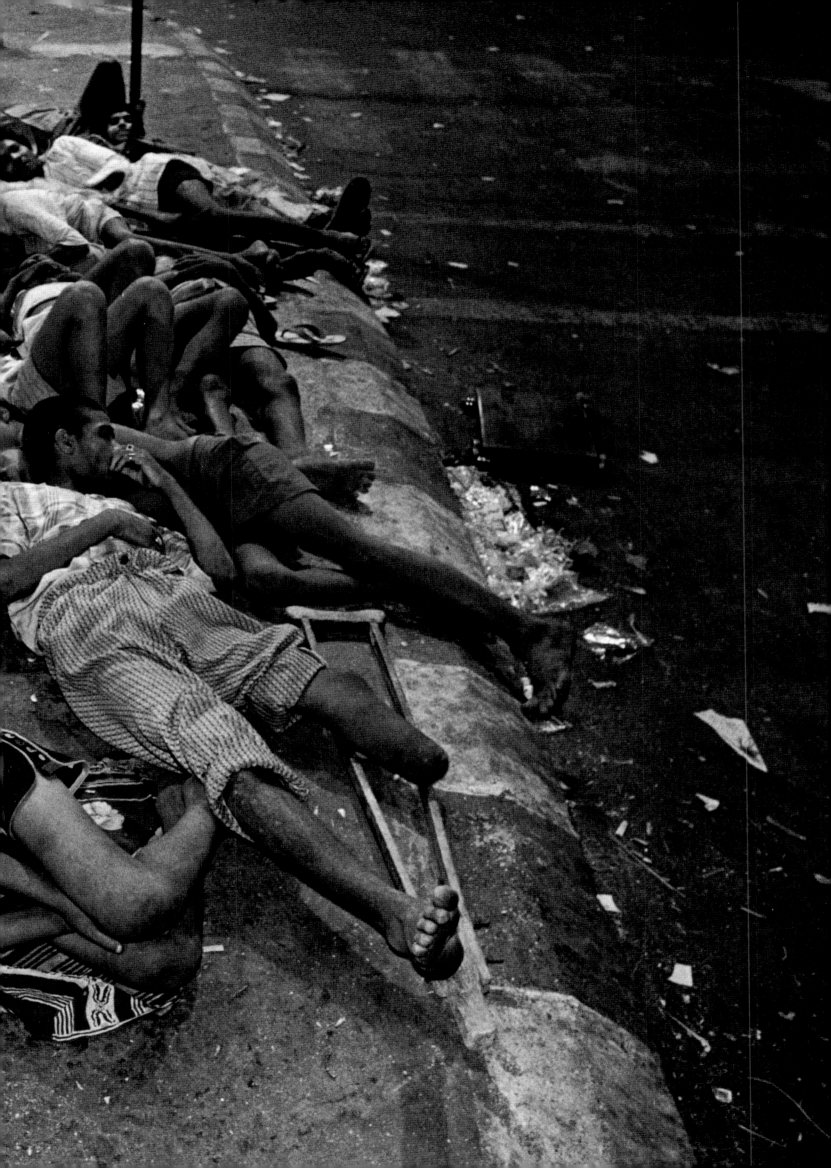

*"Propaganda is a soft weapon;
hold it in your hands too long,
and it will move about like a
snake, and strike the other way."*

Jean Anouilh

Danny Schechter

Photojournalism has always had an edge in shaping how we understand world events: impactful images become the private movie we screen in our minds to help us extract meaning from what we see.

Clearly, images can be, and often are, not what they seem to be. In the age of airbrushing and digital enhancement, when colours and backgrounds can be punched in electronically and undetectably, how trustworthy are images? Advertisers and governments alike are shameless manipulators, from the first heroic socialist realist posters celebrating the "New Soviet Man" that defined one form of propaganda, to the far more carefully constructed advertising campaigns that base their images on psychological probing and focus group research.

Look around. You cannot escape the visual assault – on the streets, in the tubes and subways, in books and magazines and in the news. What's true? Ask the editor of the US news magazine who darkened the face of OJ Simpson on the cover because he wanted it clear that Simpson was a black man. Ask the many official ministers of information and PR experts who daily sanitise their clients with photos chronicling deceptive stories and heroic accomplishments. It's all here for you to see, and to marvel at the techniques utilised throughout this century to twist the truth and bend the facts.

There are the acts of deliberate commission; the fudged, the faked, the phoney caption and the old atrocity posing at the new. They can be hard to detect and dissect and we need to be vigilant. Somehow, with the passage of time, that task becomes simpler. We now know what really happened, or so we think, and so can pass judgement on the distortions and manipulations of an earlier era. When we see Hitler goose-step into history on those grainy archival films from 70 years ago, we ask ourselves why it wasn't obvious to all, including the German people, that he was a fraud. Charlie Chaplin realised that early on, but millions were captivated by the carefully pumped-up portrait that he created to promote the mystique of fascism. Perhaps it's just that brainwashed eyes never see.

But the Führer was then. What's now? Goebbels had nothing on the modern practitioners of public relations and political consulting who specialise in the stealth-packaging of politicians and the sale of what passes for their original ideas. The manipulators' trick book has expanded with state-of-the-art refinements tethered to the most powerful media machine in history. Our global TV system is truly a weapon of mass distraction. The commissars used images to mobilise classes and spread ideology. Today, so-called "free market"-driven propaganda has been commercialised and corporatised. Its goal is to depoliticise society and privatise all experience. Its organising slogan is even more seductive: "Shut up and shop." Its images are used for branding products and consumers alike. How else to explain the logos plastered on our clothing that have turned us into human billboards? These images bury political culture in a swamp of consumer choice.

The media sin of omission diminishes our world. The media today is like the frog in the well looking up to see a tiny circle of sky above him, and he thinks that's all there is. In the US, we've had a 50 per cent cut in foreign news – the canvas of coverage is shrinking even as globalisation makes world news vital. Deep in our well, we sing "We are the world" and believe it.

Soundbites substitute for substance and "bang-bang" footage is all we're given of complicated conflicts that are presented with little context or background. CBS News and the *New York Times* asked Americans about Bosnia after four years of nightly coverage. "Who lives in Sarajevo?" was the question. 59 per cent answered "The Serbs"; 25 per cent said they didn't know. Thus the overwhelming majority of viewers who were exposed to the daily dose of horror had little clue as to what the war was about, who was fighting whom, or who even lived there.

Pictures can lie – and liars use pictures. Images have become their own image-ology. We need to hold the visual media to the same standards of accuracy and credibility as the print media.

© Index on Censorship. Danny Schechter is executive editor of Globalvision's www.mediachannel.org, and author of the recently published News Dissector *(Akashic Books) and* Falun Gong's Challenge to China *.*

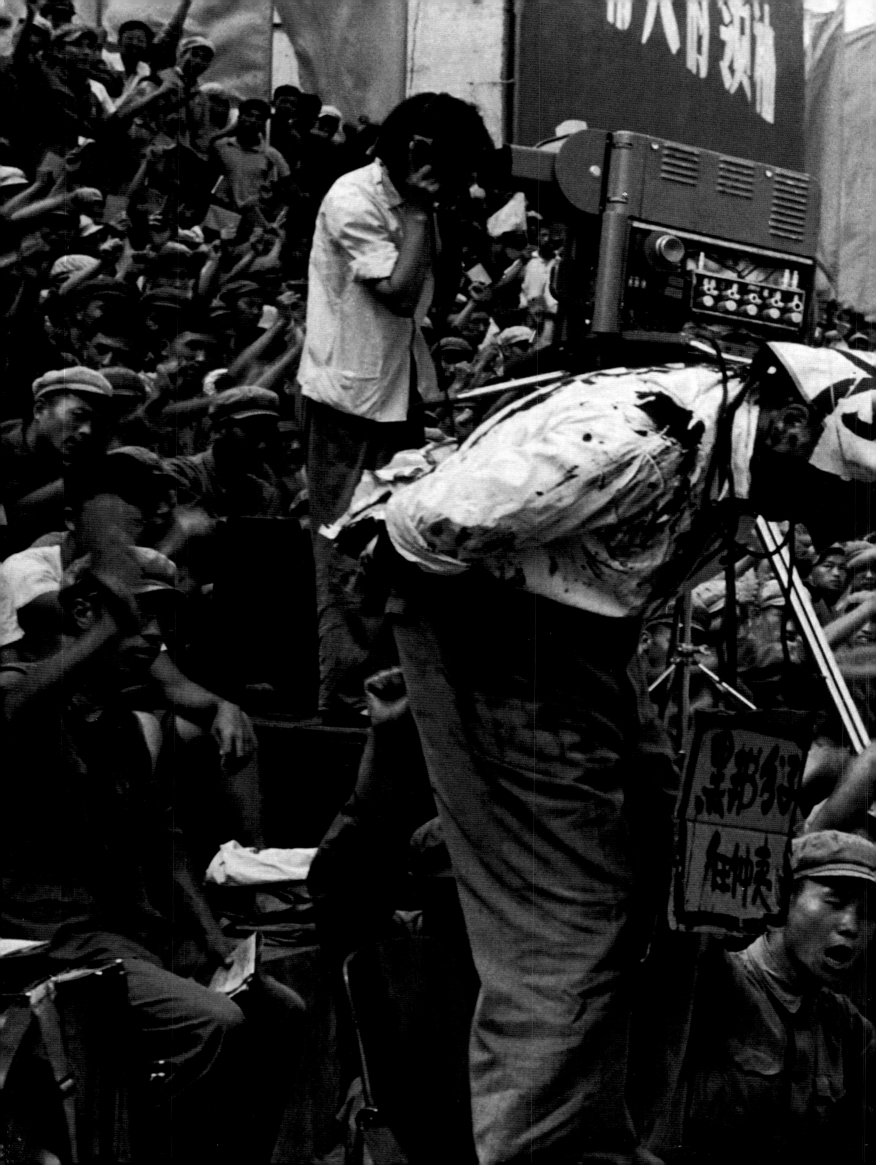

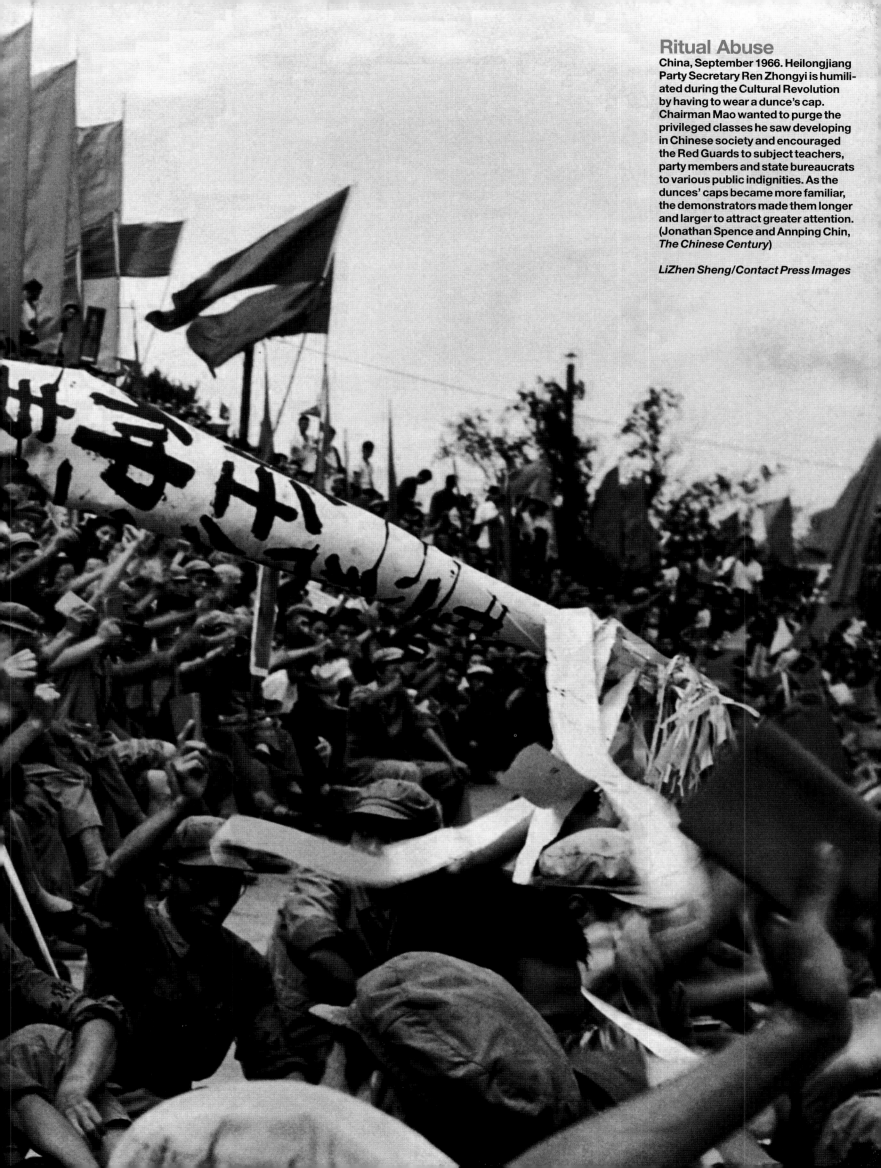

Ritual Abuse

China, September 1966. Heilongjiang Party Secretary Ren Zhongyi is humiliated during the Cultural Revolution by having to wear a dunce's cap. Chairman Mao wanted to purge the privileged classes he saw developing in Chinese society and encouraged the Red Guards to subject teachers, party members and state bureaucrats to various public indignities. As the dunces' caps became more familiar, the demonstrators made them longer and larger to attract greater attention. (Jonathan Spence and Annping Chin, *The Chinese Century*)

LiZhen Sheng/Contact Press Images

Reds Under the Bed

Oklahoma, US, 1965. This poster shows civil rights leader Martin Luther King Jr allegedly in the front row at a communist education centre. From the early 1960s, the FBI maintained heavy surveillance on King until his assassination in 1968. They were convinced that elements within the American Communist Party, financed by funds from the Soviet Union, were attempting to infiltrate the civil rights movement and manipulate King. In the tense atmosphere of the Cold War, this poster was part of a campaign to portray him as a threat to national security.

Hulton Archive

J Edgar Hoover, director of the FBI, fuelled the fire of paranoia in the US about the fears of Soviet world domination: "Communism is in reality not a political party, it is a way of life. An evil and malignant way of life. It reveals a condition akin to a disease, that spreads like an epidemic and, like an epidemic, a quarantine is necessary to keep it from infecting the nation." A communist-turned-FBI informer proclaimed about his former colleagues: "They are lying, dirty, shrewd, godless, murderous, determined… an international criminal conspiracy."

In 1950, President Truman had been advised to triple the defence budget after US spy planes detected evidence that the Soviet Union had acquired the atom bomb. In the same year, the Committee on Un-American Activities became the vicious tool of Senator Joseph McCarthy; for 4 years, he and his cronies tyrannised whole sections of the American people with an anti-communist witch hunt which included Hollywood actors and scriptwriters, academics and government officials. In 1950, he claimed that he had a list of 207 communists working in the State Department; by 1954, he was out of control, alleging that even the US Army was riddled with communists. Finally discredited, he died of alcoholism in 1957.

McCarthy's extraordinary rise to power was possible because of the climate of fear; as one contemporary newsreel warned, "The bull's eye of the enemy's target is you, your family, your home."

Under a Chinese Cloud

Tibetan pilgrims prostrate themselves along a traditional prayer route in Lhasa, oblivious to a truckful of Chinese soldiers.

Manuel Bauer/Lookat Photos/ Network Photographers

The year 2000 saw the 50th anniversary of China's "liberation", or "invasion", of Tibet. Tibet suffered heavily during the Cultural Revolution (1965-68). The Chinese government labelled Tibetan Buddhism a disease, to be eradicated through communist indoctrination. An estimated 1.2 million Tibetans were killed and 6,000 monasteries destroyed. There was a gradual liberalisation during the 1980s, with an open admission from Beijing that the Communist Party had made serious errors in the region.

As a result, there was a period of economic reform. Tibet was opened up to tourism and some monasteries were rebuilt. The Chinese invested heavily in the region's infrastructure and intensified its exploitation of an area rich in natural resources, including timber, precious metals and, significantly, one of the world's largest uranium deposits.

In 1989, Chinese troops resumed action in Tibet, quelling separatist demonstrations. Martial law was rigorously imposed and hundreds of people were rounded up and tortured, including nuns and monks, according to human rights groups.

Nervous at the possibility of further revolts, the Chinese government has intensified its policy of neo-colonial settlement, so much so that Tibetans now form an ethnic minority in their own country. Whilst many Tibetans welcome the modern conveniences the Chinese have brought in, they complain that many of their own people face unemployment while the Chinese settlers enjoy relative prosperity.

The Communist Party has vowed to eliminate the Dalai Lama's influence from every sphere of Tibetan society, suppressing religious activities and even appointing religious representatives. At the same time, Lhasa, the capital city, is facing further "modernisation", which in practice means destroying much traditional Tibetan architecture, building ugly uniform housing blocks and introducing discos, gambling and prostitution. A young Tibetan father lamented: "Tibet will look like a part of China within 10 years. Already my own children watch Chinese television and live in a Chinese flat; if they're lucky, they will end up working for a Chinese company."

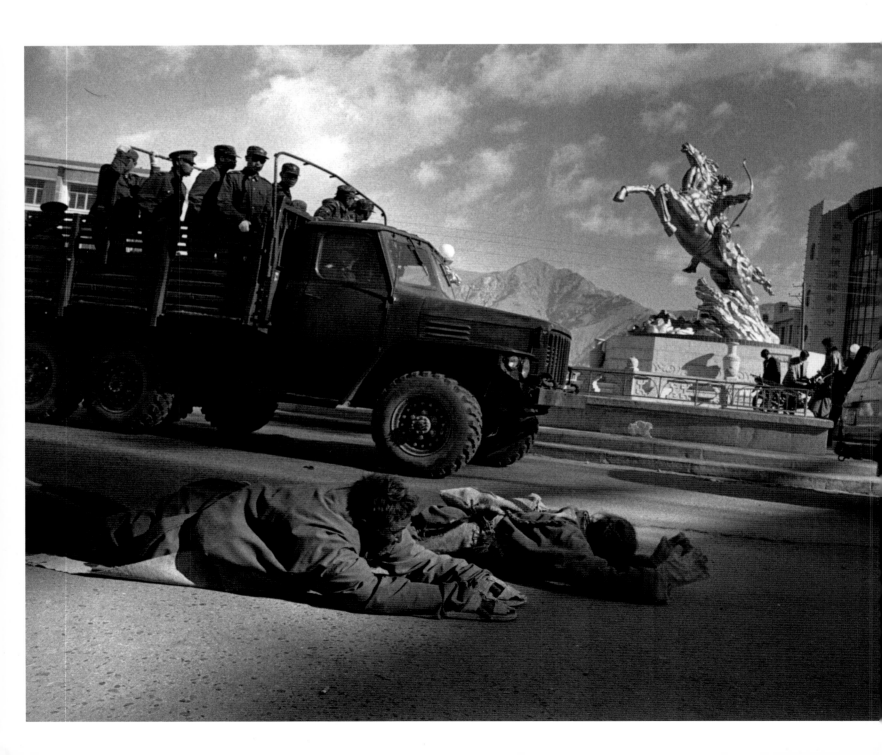

Sweetness and Light

Beijing, 1954. The Dalai Lama and the Panchen Lama stroll with Chairman Mao three years after thousands of Chinese troops had occupied Tibet and forcibly integrated it into the People's Republic of China.

Xinhua News Agency, Beijing/ Endeavour Group UK

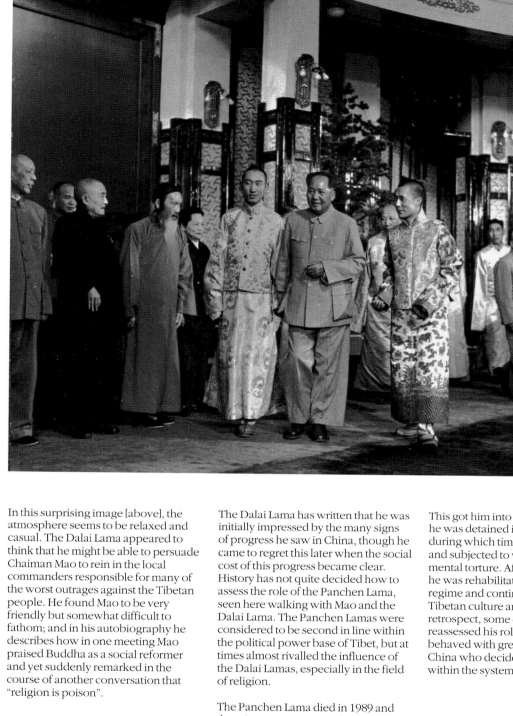

In this surprising image [above], the atmosphere seems to be relaxed and casual. The Dalai Lama appeared to think that he might be able to persuade Chaiman Mao to rein in the local commanders responsible for many of the worst outrages against the Tibetan people. He found Mao to be very friendly but somewhat difficult to fathom; and in his autobiography he describes how in one meeting Mao praised Buddha as a social reformer and yet suddenly remarked in the course of another conversation that "religion is poison".

The Dalai Lama has written that he was initially impressed by the many signs of progress he saw in China, though he came to regret this later when the social cost of this progress became clear. History has not quite decided how to assess the role of the Panchen Lama, seen here walking with Mao and the Dalai Lama. The Panchen Lamas were considered to be second in line within the political power base of Tibet, but at times almost rivalled the influence of the Dalai Lamas, especially in the field of religion.

The Panchen Lama died in 1989 and there is controversy over his current reincarnation. He was brought up in China and many people felt he became something of a communist puppet. After the Dalai Lama fled to India, the Panchen Lama stayed on in Tibet, effectively becoming head of the Tibetan "autonomous government" and causing many Tibetans to view him as a traitor. He felt, however, that he was doing more good by staying on and trying to resist China's attacks on Tibetan culture. He soon realised he was being sidelined by the Chinese and was merely a nominal head of the country. In 1962 he wrote a damning critique of Chinese policy in Tibet, pointing out that things had gone seriously wrong.

This got him into deep trouble and he was detained in China for 15 years, during which time he was maltreated and subjected to various forms of mental torture. After the death of Mao, he was rehabilitated by the Chinese regime and continued to try to defend Tibetan culture and autonomy. In retrospect, some commentators have reassessed his role, suggesting he behaved with great courage as a critic of China who decided to make his stand within the system.

Anonymous Icons

The Farm Security Administration was set up in the US during the depression years of the 1930s to document the harsh social conditions faced by rural Americans. Supporters of Franklin D Roosevelt's New Deal were well aware of the power of photography in influencing public opinion. Headed by the energetic Roy Stryker, the FSA hired some of the country's leading photojournalists, including Dorothea Lange, Walker Evans and Ben Shahn, to travel the country and record the struggles of farmers and "Okies" (migrant workers). Between 1935 and 1943, some 270,000 photographs were taken for the FSA in an attempt to put a human face on the economic crisis. The photographers wanted to change the world and influence social policy.

Hulton Archive

Lange's *Migrant Mother*, taken in 1936, is one of the best-known photographs of all time. Lange was driving home after an assignment when she saw a camp of migrant workers. She felt she had taken enough photographs that day, but on an impulse turned round and went into the camp. She took very few frames without speaking and then left. The next day, her striking image appeared on the front page of the *San Francisco News* and became instantly famous. Some readers sent food to the camp where the woman had been photographed but she and her family had moved on.

The image has come to symbolise the plight of women not just at that time in America, but more universally, in all times of social hardship. Its iconic status is enhanced by the fact that few people even know or care who the actual woman was.

Lange herself has confirmed that she avoided asking the woman's name. She wanted the photographs to tell not just a personal story, but also to symbolise the stories of hundreds of other migrant families: "I saw and approached a hungry and desperate mother, as if drawn by a magnet. I do not remember how I explained my presence or my camera to her, but I do remember she asked me no questions… I did not ask her name or history." Lange's desire to influence American opinion was very obvious: "The good photograph is not the object, the consequences of the photograph are the object."

When the identity behind an iconic face is explored, interesting contradictions can emerge. In fact, the famous photograph was of Flora Thompson, then aged 32, of Cherokee Indian descent and mother of 7 children. Lange used her skills as a former society portrait photographer, framing the chosen photograph to echo the long tradition in Western art of the Madonna and child, overlaid with the American virtue of endurance in the face of adversity. She deliberately omitted Thompson's other children, especially the oldest teenage girl. The visual message was skilfully constructed to appeal to Middle America and to avoid eliciting the response that what the migrant workers needed was birth control rather than welfare.

Even Flora Thompson's body language in the photograph is deceptive. What seems to be a dignified placement of the hand on her chin turns out to have been an habitual nervous gesture she made at times of anxiety.

Flora Thompson's children joined the middle class in a classic case of American upward social mobility, and Flora went to live with one of her daughters. She died in the early 1980s, apparently still quite bitter about her famous image; she felt it had been used, seen and endlessly sold around the world without any benefits coming to her. According to her daughters, she tried to have publication of the photograph stopped after it first appeared but was told that this was impossible as it was in the public domain.

The unashamedly propagandist agenda of the FSA was underlined by Stryker's peculiar habit of punching holes in negatives which he did not feel were "on message" or up to standard. Admittedly, he would often consult with the photographers about this, but such a crude method of de-selection would send shudders down the spines of modern photojournalists who are well aware that what may seem boring or irrelevant today can become extremely pertinent tomorrow.

After the US entered World War II, Stryker changed his tone, instructing his photographers: "We must have at once men, women and children who appear as if they really believed in the US. Get people with a little spirit."

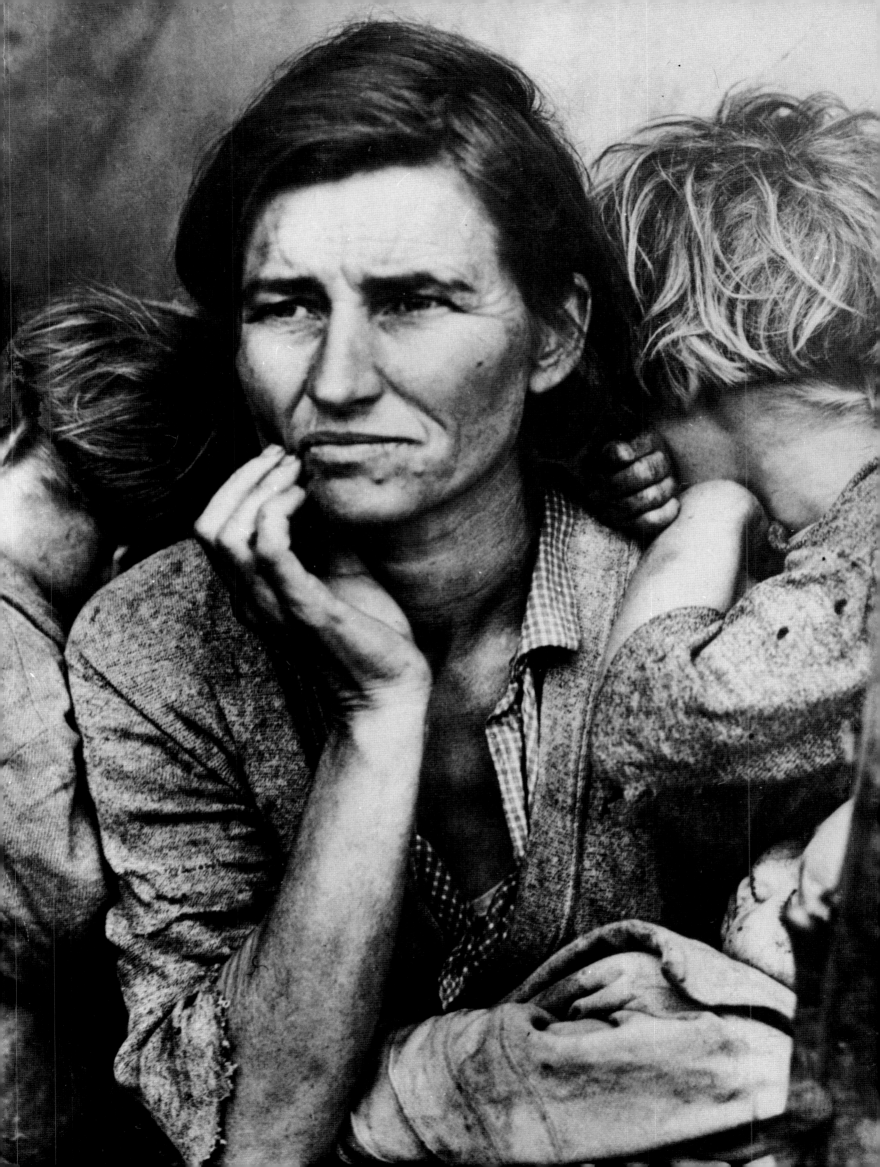

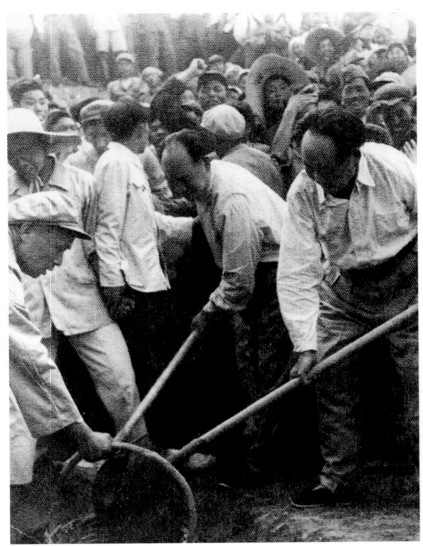 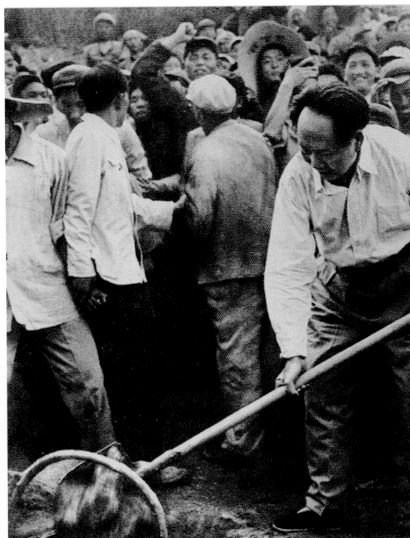

Hard Labour

May 1958. Chaiman Mao digging at the construction site for the Ming Tombs Reservoir. In the first photograph (top left), he is accompanied by Peng Zhen, secretary of the Beijing Communist Party and a veteran of Mao's revolution. Peng fell out of favour in 1966 and was purged. In the second photograph (top right), he has been made to "disappear".

Endeavour Group UK

As Jonathan Spence and Annping Chin recount in *The Chinese Century*, Mao visited the reservoir site close to Beijing and engaged in some token digging: "He soon started sweating, so stopped for tea, and then did not return. His doctor commented: 'It is the only time in the 22 years I worked for him that Mao engaged in hard labour.' Yet Mao told senior Party members, in reference to this very project, 'Officials, no matter who, big or small, should all participate in manual labour as long as they are able.'"

Family Values

Beijing, China, 1951. Chairman Mao relaxes in his Zhongnanhai compound; an image designed to establish a paternal and caring image. He is chatting to his eldest daughter Li Min (centre), born on the Long March to his second wife – his first wife was killed during the earlier civil war. The other girl is his daughter Li Na, born to his third wife, the ambitious and scheming Jiang Qing, who became one of the "Gang of Four". The boy is Mao Yuanxin, son of Mao's younger brother, who died along with Mao's only other brother in the civil war. Mao's personal physician, Dr Li, whose book revealed Mao's promiscuous lifestyle, wrote that Li Na was "caustic, mean... downright rude", whereas Li Min was "honest, simple... polite but not very bright".

Xinhua News Agency, Beijing/Endeavour Group UK

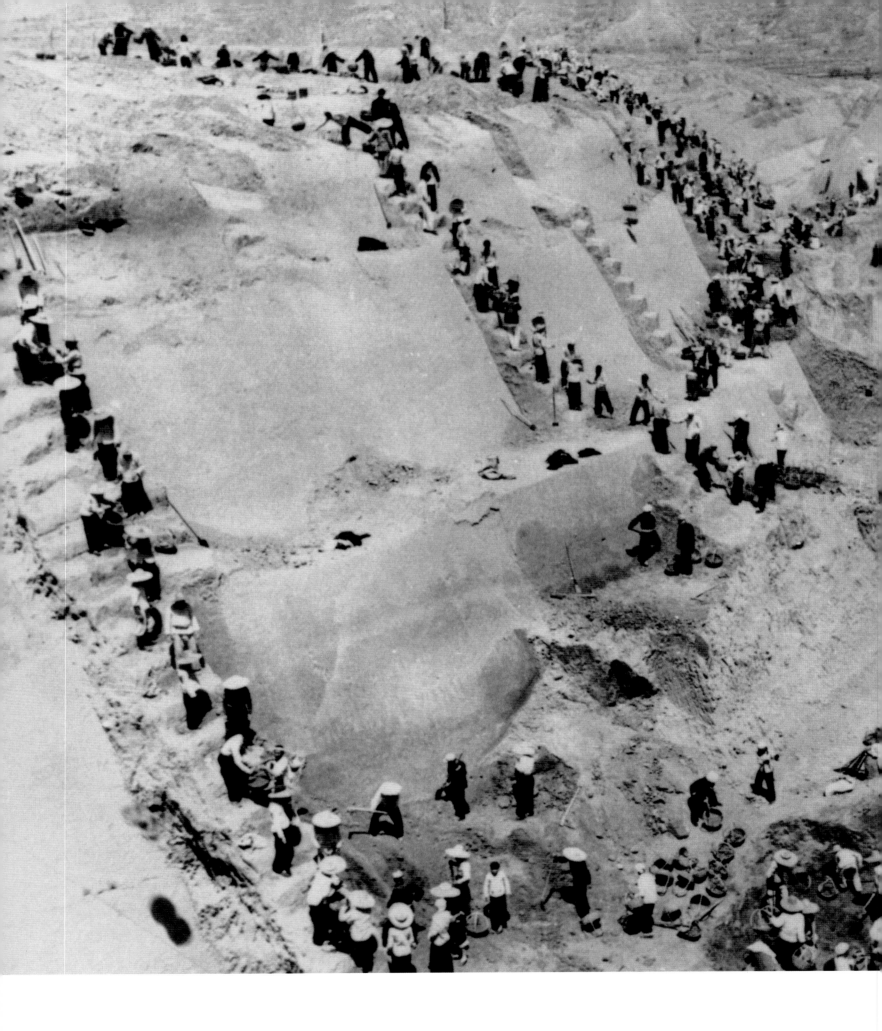

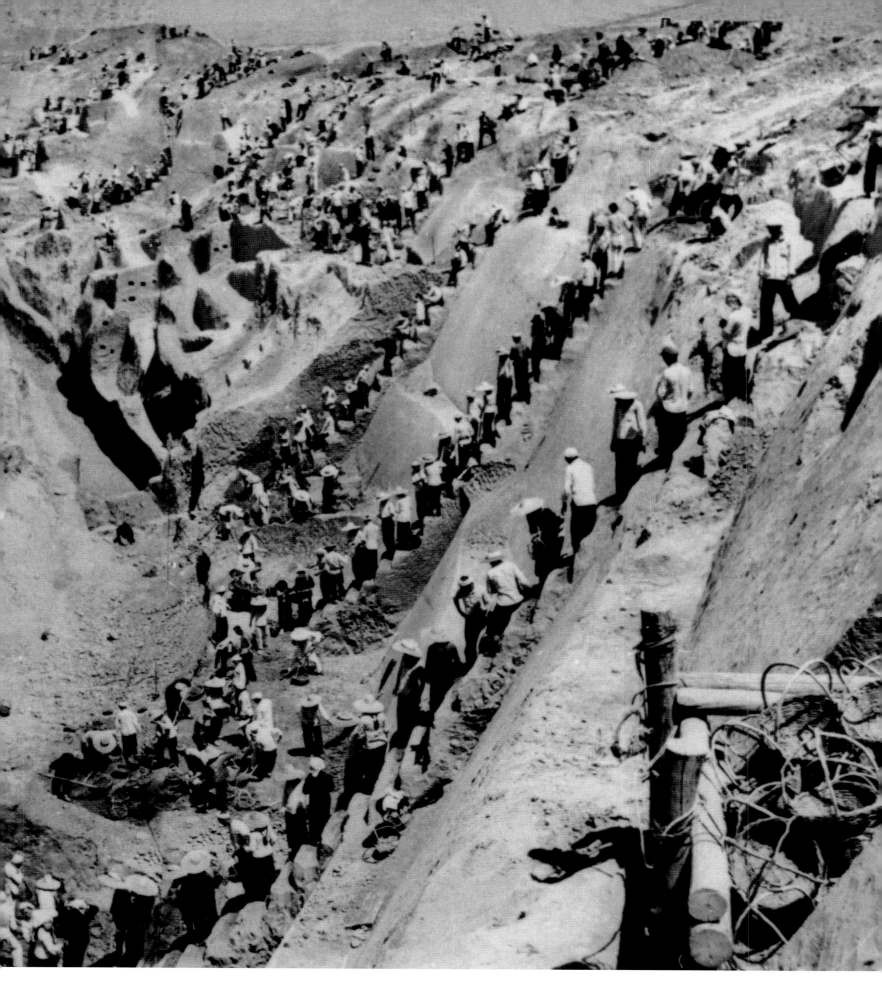

Great Leap Forward

Jiangxi province, China. In 1958, Chairman Mao ordered the establishment of massive communes in rural China in an effort to increase productivity. In this "Great Leap Forward", hundreds of thousands of labourers were used on giant projects to make up for the lack of mechanisation. Many intellectuals and supposed critics of the Party were forced to work in the countryside. Here, on a canal and irrigation project, local workers moved five million cubic feet of soil. The human cost of such schemes was enormous; malnutrition and starvation were rife. Mao began to realise what he had started.

In a remarkably frank speech to Party leaders, he said, "Half of China's population will die; and if it's not half, it'll be a third or 10 per cent... If you don't lose your jobs, I at least should lose mine." (Jonathan Spence and Annping Chin, *The Chinese Century*) *Xinhua News Agency, Beijing/ Endeavour Group UK*

Country Matters
Soviet Union, 1936. A lyrical country scene in Stalin's dacha at a time when the Russian people were being subjected to an intense reign of terror. While Stalin works on official papers, his daughter Svetlana sits on the knee of Lavrenti Beria, soon to become head of the fearsome NKVD secret police, forerunners of the KGB. In 1991, the KGB itself estimated that 42 million Soviet citizens died during Stalin's paranoid rule between 1928 and 1952.

Russia State Archive of Film and Photographic Documents, Krasnogorsk/Endeavour Group UK

Embargoed

Moscow, 1922. Five years after Lenin's revolution in Russia, the leaders of the secret police, the infamous Cheka, dedicated themselves to a ruthless form of protection of the Soviet state. Here, Felix Dzerzhinsky, recently appointed head of the Cheka, sits with his cronies in the notorious Lubyanka. The photograph was stamped "Not to be reproduced" at the time. Most of those in the photograph became victims of their own successful methods. Only Dzerzhinsky and his successor, Menzhinsky, died of natural causes; most of the others were liquidated.

David King Collection

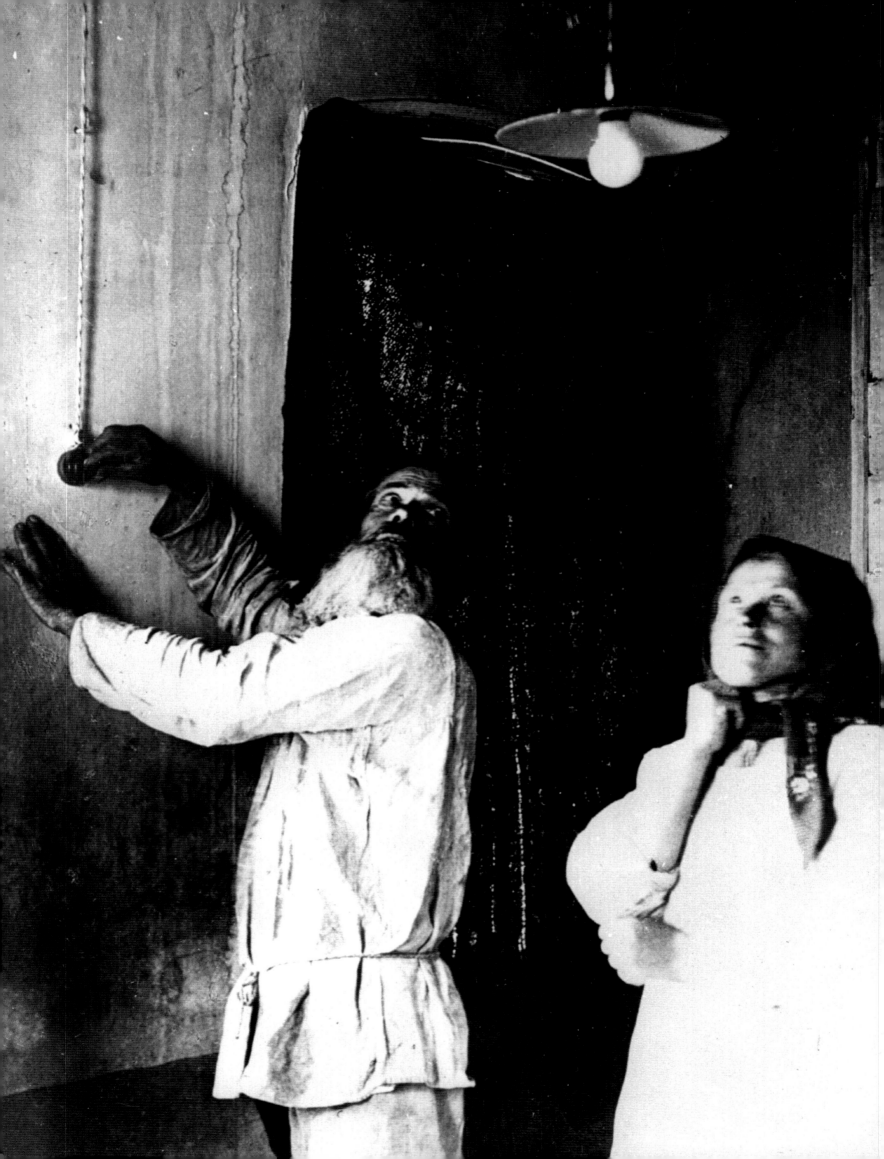

Photo Opportunity
(Left) A Soviet propanganda photo-
graph, taken by Arkady Shaikhet in
1926, extolling the virtues of rural
electrification programmes.

*Slava Katamidze Collection/
Hulton Archive*

(Above) Glasgow, UK, 1999. Queen
Elizabeth II takes tea with the
McCarron family in their housing
association home. After the death
of Princess Diana and the resulting
national outcry over the future of the
British monarchy, the Royal Family
sought to shed its aloof image with
such visits.

David Cheskin/Associated Press

Theatre of the Absurd

Germany, 1940. The bizarre manifestation of grotesque self-delusion – German "scientists" measure the size of a man's nose and a monkey's ear in "Aryan race determination tests" to prove the evolution and existence of the Master Race. People suspected of being Jewish were required to undergo such humiliating ordeals at the hands of the Nazis.

Hulton Archive

The Nazis adapted Darwin's theory of "survival of the fittest" to the evolutionary process, using it to formulate plans to ensure racial purity and a healthy human population. This was designed to eliminate "non-Aryan" peoples. The pseudo-scientific measurement and classification of physical characteristics such as noses, hair and eye colour were designed to produce a desirable racial type.

Hitler's plans to eradicate the Jews had been well publicised in his book, *Mein Kampf*. By the 1930s, the Nazis were obligingly providing English translations of their anti-Semitic posters slapped up on Jewish shops and businesses, but few people outside Germany took the visual evidence seriously.

In 1935, Britain signed a treaty permitting Germany to rebuild its naval strength. A French journalist fumed: "Does London imagine that Hitler has renounced any of the projects indicated in his book, *Mein Kampf*? If so, the illusion of our friend across the Channel is complete."

Recently declassified documents from the US National Archives show beyond reasonable doubt that the British and American governments were aware as early as 1941 that the Nazis intended to eradicate the Jews of Europe. Even earlier, British code-breakers had deciphered German messages which showed that mass killings of Polish and Russian Jews were taking place in Nazi-occupied territories. There is no indication that the Western Allies acted upon this information by warning potential Jewish victims or even disseminating the knowledge they had acquired.

> *"The broad mass of a nation will more easily fall victim to a big lie than a small one."*
> *Adolf Hitler*

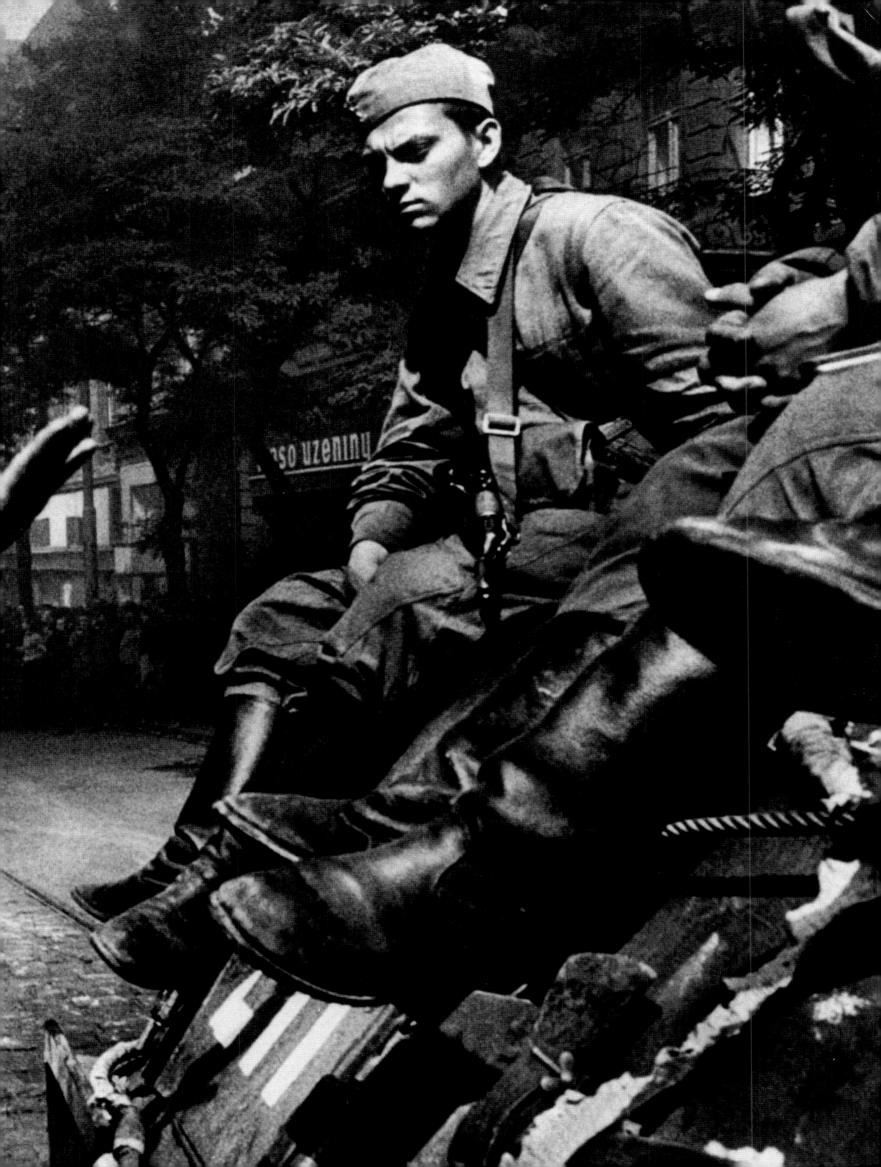

Russian Roulette

◀ **Prague, Czechoslovakia, August 1968.**

Photograph by Josef Koudelka/Magnum

In April 1968, Alexander Dubcek, recently appointed First Secretary of the Communist Party, initiated a programme of reform that came to be known as "socialism with a human face". He introduced an element of political democracy and personal freedom; censorship was abolished, political prisoners were freed and some non-Communist political groups were legalised. Dubcek took pains to persuade Brezhnev, the Soviet leader, that Czechoslovakia would remain loyal to Communism and to the Soviet Union. Dubcek and Brezhnev appeared to have struck a deal early in August, but the Russians were playing a canny game.

On August 18, the Kremlin decided to invade Czechoslovakia. Soviet Defense Minister Andrei Grechko declared to the Soviet Politburo and military leaders: "The invasion will take place even if it leads to a third world war."

During the night of August 20, a force of 500,000 Soviet troops, accompanied by token forces from Poland, Hungary, Bulgaria and East Germany, invaded Czechoslovakia without warning. The Czech army, faced with overwhelming odds, was ordered to remain in its barracks and offer no resistance. Brave, angry crowds filled the streets of Prague, protesting against the invasion and telling the soldiers to go home. Dubcek was taken to Moscow and forced to abandon his reforms and accept an occupying force of Soviet troops. Less than a year later, he was ousted from office and Czechoslovakia became perhaps the most repressive regime of the Soviet bloc until the final collapse of Communism.

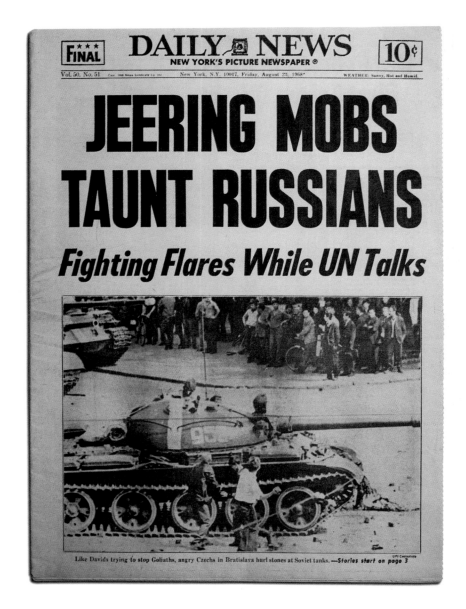

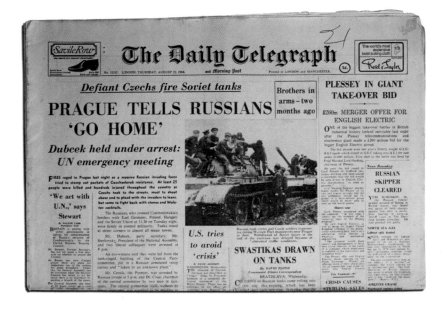

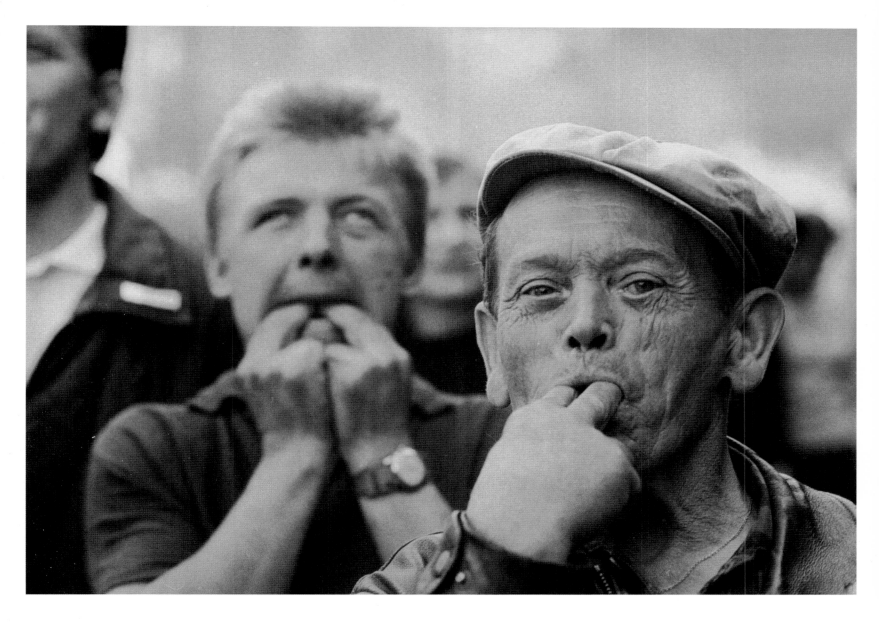

Off Message

Prague citizens whistle and jeer as the Russian troops occupy their streets. Soviet propaganda described the invasion of the Warsaw Pact armies as a rescue mission; most Czechoslovaks saw it differently.

Hulton Archive
Front pages courtesy John Frost Newspaper Archives

Two decades later, on November 24, 1989, Czechs and Slovaks massed in Wenceslas Square in Prague to celebrate the fall of the communist regime. Alexander Dubcek, architect of the Prague Spring of 1968, declared: "We have been too long in darkness. Once already we have been in the light, and we want it again." A year earlier, he had referred to the lost 20 years of "economic stagnation, sterility and incalculable moral loss" which his country had suffered after 1968. Dubcek's ideas became the model for subsequent reforms which ultimately led to the end of the Soviet empire. In 1987, Soviet President Gorbachev's spokesman, Gennadi Gerasimov, when asked what the difference was between perestroika and the Prague Spring, replied, "Nineteen years."

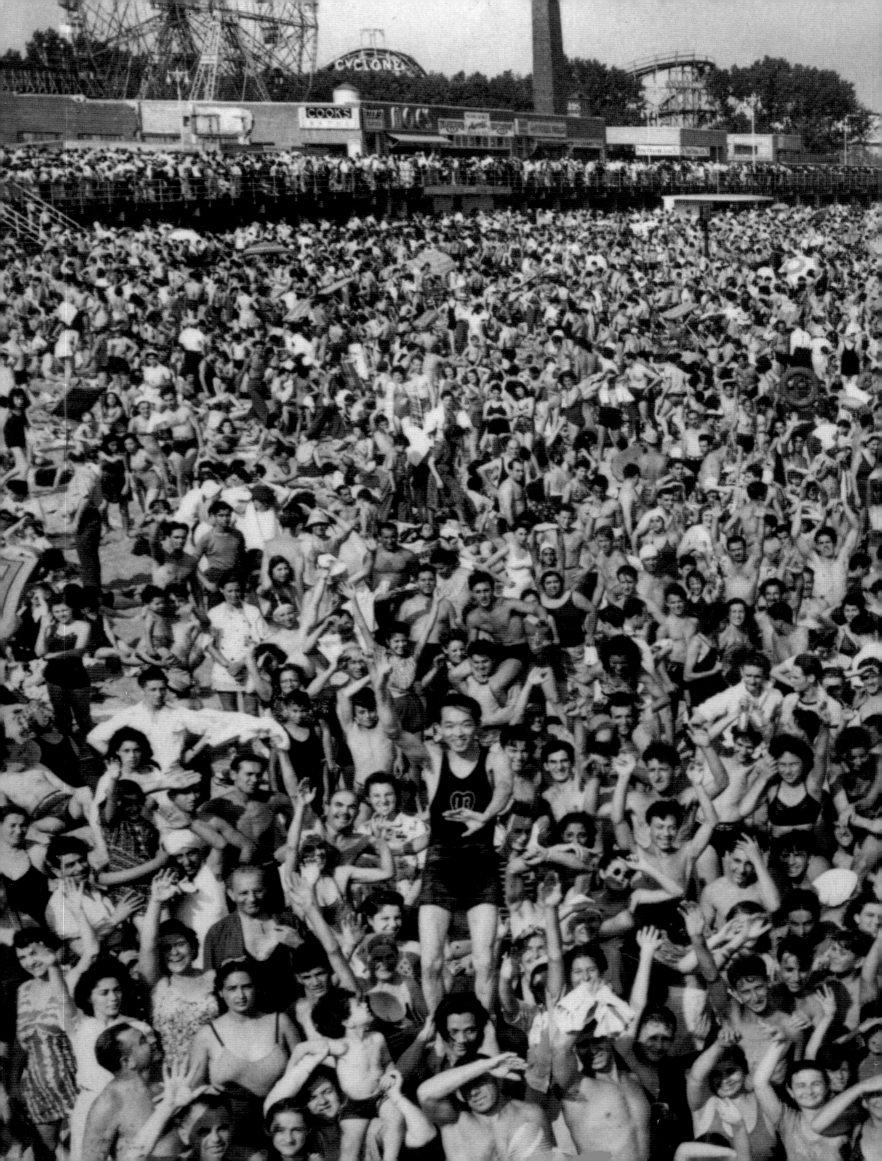

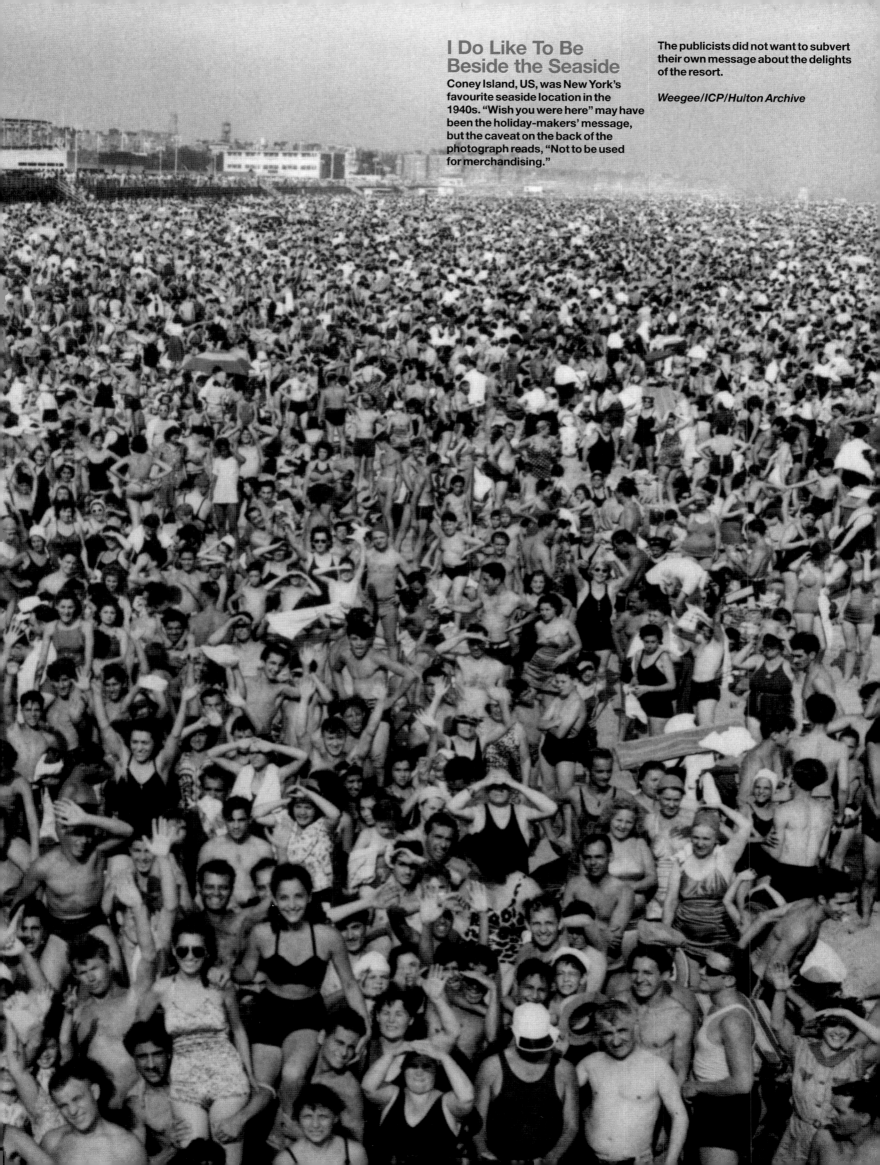

I Do Like To Be Beside the Seaside

Coney Island, US, was New York's favourite seaside location in the 1940s. "Wish you were here" may have been the holiday-makers' message, but the caveat on the back of the photograph reads, "Not to be used for merchandising."

The publicists did not want to subvert their own message about the delights of the resort.

Weegee/ICP/Hulton Archive

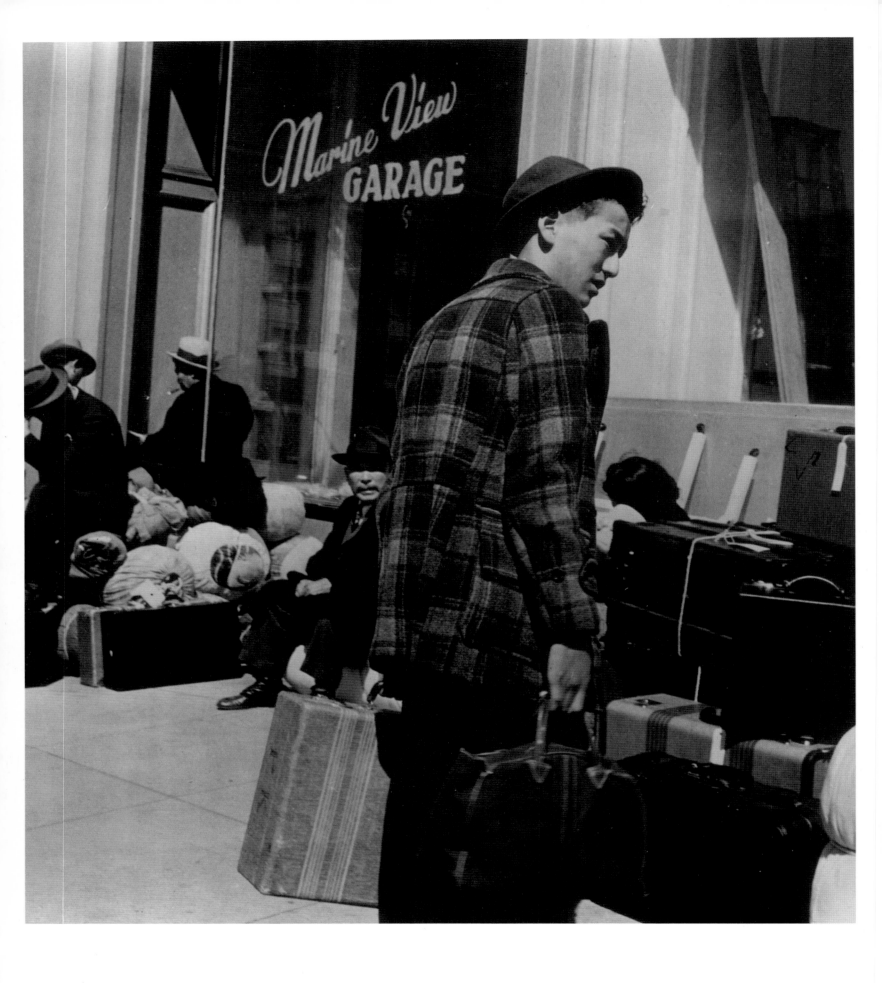

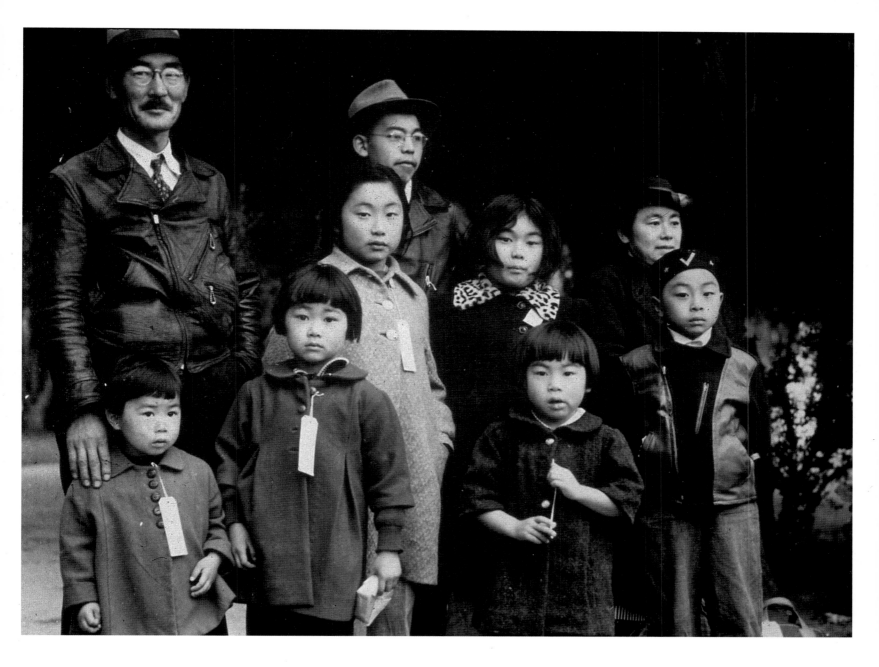

Second Class Citizens

(Left) San Francisco, US, April 1942. A Japanese-American resident alien waits to be taken to an internment camp.

(Above) Hayward, California, May 1942. The Mochida family, Japanese-American residents, about to be transported to a camp.

Hulton Archive

After the Japanese attack on Pearl Harbour in December 1941, anti-Japanese feelings ran high in the US. In February 1942, President Roosevelt issued an order decreeing that all Japanese immigrants on the West Coast, including some who were US citizens, should leave the area. The fear was that they might aid and abet any landing by the Japanese army. They were asked to leave voluntarily, but as many as 120,000 refused to go. These were rounded up by American troops and removed forcibly to isolated detention camps. Most of them remained there until late 1944. It was not until 1988 that the US Government formally apologised for this wholesale internment and agreed to pay $40 million in compensation.

Staying On

(Below right) Saipan, Mariana Islands, North Pacific, circa 1944. A young Japanese girl with a bottle of water carries her brother across an internment camp during World War II. The conditions in these camps were frequently appalling.

Hulton Archive

Two poignant anecdotes on the *San Francisco Examiner*'s website underline how shocked Japanese-Americans were at this treatment. Masaru Kawaguchi recalled: "It was really strange. Here I was, born in America. I was an American citizen. I had attended school in San Francisco all my life. When I was told I couldn't come to school none of my classmates said a word to me. No one said [they were] sorry. No one said they didn't want me to go. Our family had to live in a stable. The luckier ones got to live in barracks. The toilets and showers had no dividers. Family members were given two blankets each. They made their bedding by filling mattresses with straw. Items like cameras, radios, knives – and family heirlooms – were taken and never returned."

A student, Michi Kobi remembered that she had gone into a "serious, zombie-like depression" in the camp: "I lost my sense of identity. I had thought I was an American. When I was incarcerated, suddenly I wasn't an American. I didn't know what I was. When times are bad, human beings have to find a scapegoat to blame. That is human nature."

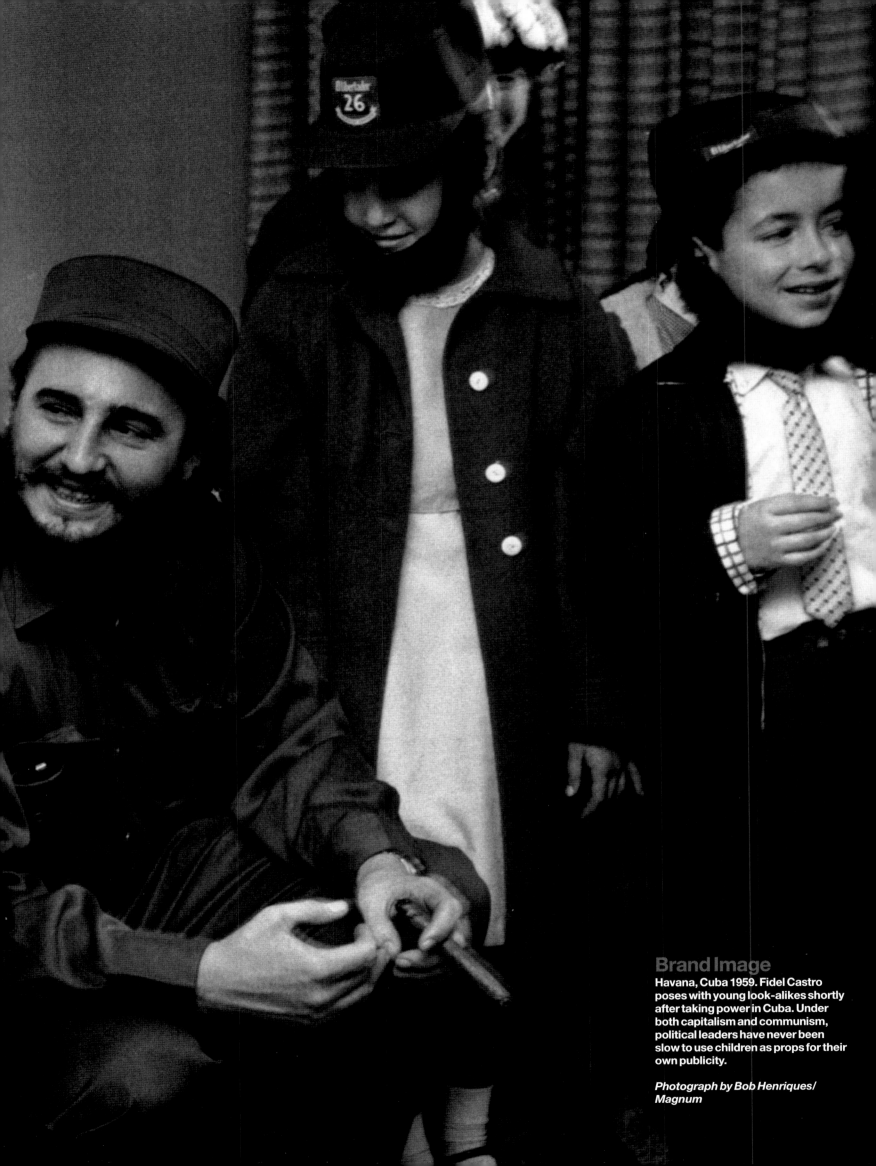

Brand Image

Havana, Cuba 1959. Fidel Castro poses with young look-alikes shortly after taking power in Cuba. Under both capitalism and communism, political leaders have never been slow to use children as props for their own publicity.

Photograph by Bob Henriques/ Magnum

Dubious Welcome

(Right) Washington DC, US, 1959.
Two months after Fidel Castro's
successful revolution in Cuba and
shortly before Richard Nixon was to
lose the US Presidential election by
the narrowest of margins to John F
Kennedy, the two politicians exchange
an uneasy handshake.

(Above) New York, US, 1959. Noisy
demonstrators outside the hotel
where Fidel Castro is staying object
to his presence in the land of freedom
and opportunity.

Hulton Archive

The US chose to view Castro as a
dangerous irritant 90 miles off the coast
of Florida, and effectively drove Cuba
into the arms of the Soviet bloc at
the height of the Cold War. Neither
President Kennedy's abortive Bay of
Pigs invasion nor the continuing 40-
year trade embargo placed by America
on her tiny neighbour succeeded in
bringing down Castro. In 1963, Premier
Kruschev tried to install Russian nuclear
warheads in Cuba to target the US, and
the subsequent Cuban Missile Crisis
brought the world to the brink of
annihilation. After the Soviet empire
fell apart in the 1990s, Castro's Cuba
remained true to its Marxist roots.
Generations of puzzled CIA oper-
atives from 1959 onwards may have
wondered how the US could be so
successful in destabilising potentially
hostile regimes in Central and Latin
America, yet Castro's Cuba continued to
survive as an unwelcome neighbour.

Friendly Fire

Saigon, 1968. During the Tet offensive by the North Vietnamese army, many civilians were caught up in the violence. The Saigon fire department was responsible for collecting the dead from city streets. This young girl's body had just been placed in the back of a fire truck when her distraught brother discovered her. She had been killed by gunfire from a US helicopter.

Photograph by Philip Jones Griffiths/ Magnum

Philip Jones Griffiths writes: "Editors were reluctant to introduce complexities that deviated from the naturally perceived 'truth'. Even after the great disillusionment of Tet '68 I found that old habits died hard. When the *New York Times* dared to publish a picture of mine showing a boy crying over the body of his sister killed by rocket fragments from a helicopter gunship, they hedged their bets by captioning the picture: 'Killed, alleges the photographer, by US helicopter gunfire.' The Vietcong, of course, did not possess helicopters."

Philip Jones Griffiths relates how difficult it was for the Western public to get a genuine sense of who the enemy were: "'Remember, the Viet Cong are everywhere but nowhere to be seen!' was the advice given to me on my arrival in Vietnam in 1966. We photographers became obsessed with seeing the great unseen. It wasn't only the American troops who grew frustrated at never 'eye-balling' the enemy. Every journalist in Saigon longed to see the faces of the other side. We fantasised about being invisible, about hiding in a tree trunk in a tropical Birnam Wood, photographing the Viet Cong in full battle through a knothole.

Tim Page and Sean Flynn went further; they wanted to out-Capa Capa by rigging a camera on the end of a rifle to capture the moment of death as the trigger was pulled. Trying to spot the Viet Cong became a pastime for some of us. I considered that anyone with eyes to see could recognise the 'Com-symp' among the Vietnamese civilians – they looked more intelligent. The gentle, helpful Vietnamese working for *Time* magazine had to be Viet Cong (he was a colonel, no less) and anyone with any sense would bet that lots of the locals working for the American military had a direct line to Hanoi (they did).

But what about the fighters? The real Viet Cong? Live ones! Dead ones didn't count – a dead Vietnamese could be from either side, and often were. Dickey Chappell's pictures for *National Geographic* of a 'Viet Cong being shot from a helicopter' looked like nothing more than an unarmed farmer chosen for target practice. Horst Faas of the Associated Press took a fleeting picture during the 1963 battle of Ap Bac of a startled face that revealed little. It wasn't until Catherine Leroy's pictures appeared in *Life* of the NLF [National Liberation Front] troops occupying Hue during the Tet Offensive in 1968 that we saw what marvellous sights we'd missed.

Applying for visas to visit the North was a waste of time. The handful of Western photographers who did visit produced, for the most part, predictable pictures reminiscent of a photo-op. In the South, no Westerner ever went out with the Viet Cong, except for the kindly Methodist in Marx's clothing, Wilfred Burchett, and he didn't take a camera. The dearth of images from the other side gave the impression that the communists never recorded their exploits. I remember how surprised I was when, in 1967, an American captain in Quang Ngai province showed me a handful of photographs. They were of groups of young men with shining eyes marching around a village with the NLF flag stretched out in the background. 'The other day we ambushed a Viet Cong platoon,' he explained. 'One of them had a camera, he was a PIO [Press Information Officer]! They have them just like we do!' He continued: 'We developed the film and sent men down to the market with prints. Rounded up six of the guys we recognised. When they argued we showed them their pictures!' 'What happened?' I asked. He looked at me, genuinely surprised, and replied with a shrug, 'We killed them.'

Two years ago, while browsing through the photo files of the VNA [Vietnam News Agency] in Hanoi, my colleague Greg Davis, a *Time* magazine photographer based in Tokyo, came across an interesting photograph of Ho Chi Minh and General Vo Nguyen Giap relaxing together on the bank of a river. Fascinated by the candid quality of the picture, he questioned the librarian, who explained that it had been taken by 'Ho Chi Minh's photographer'. Greg, who knows most of everything about Vietnam, was astounded that the leader had a personal photographer, and was even more surprised when the librarian asked, 'Would you like to meet him? He's still alive.'

Dinh Dang Dinh lives alone in a spartan one-room apartment with no running water on the outskirts of the city. Now aged 73, he recalled his life photographing the resistance, first to the French and later the Americans; from 1945 to 1965 he was Ho Chi Minh's personal photographer. He explained to Greg that in the early days Ho was camera-shy. Secrecy was the main reason – the French were everywhere. He recalled Ho saying at the historic meeting in Hanoi in 1945, when Vietnamese independence was declared, 'Don't photograph me, take pictures of the people!' This is probably the only time in recorded history that a president behaved this way.

Independence was short-lived. The British army armed the defeated Japanese, who helped the French regain control. Ho took the struggle back into the hills, and Dinh was there with his camera. He processed his films in what could well be the world's first ecologically sound developing tank – a length of bamboo made chemical-resistant with beeswax. Films and prints were washed in a bamboo basket lowered into a nearby stream. He showed Greg some prints made in this way and they still looked fine. To keep the negatives from getting mildewed in the sweltering humidity, he used little bags of dried rice. (I used to do the same in my room at the Hotel Royale in Saigon.) Later, during the 'American' war, Dinh went into training for a trip down the Ho Chi Minh trail. After months of travelling with 20 kilos of equipment on his back, his group was bombed one lunchtime by a South Vietnamese pilot. He lost everything, including 200 rolls of exposed film. The pilot, I'd like to think, is condemned to spend eternity trapped in a one-hour photo booth in Orange County.

On his next visit to Hanoi, Greg brought Dinh a suitcase full of photographic paper and chemicals so that he could go through the archives and print up his best pictures. Being unfamiliar with the competitive spirit of Western individualism, it didn't occur to Dinh to do anything other than print up pictures he liked taken by his colleagues, many now dead, for over half of the photographers of the VNA were killed during the war. They comprise a privileged view of what we seldom saw during the war. Why? Well, you are unlikely to have seen them unless you had a subscription to *Pravda* or the *People's Daily*. Pictures of the war seen from Hanoi's side trickled out to most communist countries, and they could have been 'picked up' and re-transmitted by Western news agencies based there to all the world's newspapers. This rarely happened, except for pictures with an American angle, such as captured airmen. (The Vietnamese preferred, of course, that the foreign pilot be shown being led off by a woman, usually half his size.)

Most of these pictures would have been dismissed as 'communist propaganda' 20 years ago, not rare in a time of war when everything is considered fair. The American policy of annihilating as much of Vietnam and its population as possible could only be sustained by relegating the people to the level of 'sub-humans'. Part of this strategy involved making sure that photographs showing the 'other side' were not widely circulated, on the grounds, I suppose, that it's easier to hate what you don't understand, or even see. The policy of dehumanising the Vietnamese included discouraging the dissemination of pictures showing barefooted, childlike soldiers to the Western media.

As the conflict continued, the 'war managers' in Washington did their utmost to defend the myths about Vietnam. Not only was the public slowly discovering the truth about the war; so too were the soldiers. Disenchantment was setting in. One soldier wrote to his Congressman complaining about the unreliability of his M16 rifle. He'd tried to shoot his commanding officer, he explained, but the weapon had jammed. And all those Marines who'd marched around countless parade grounds grabbing their 'full-metal-jacketed' gonads while trying to distinguish their 'weapon' from their 'gun' had to be considered. They could hardly be expected to react positively to photographs of planes being shot down, and the pilots being captured, by women with anti-aircraft guns hidden in their Bermuda Triangles. One solution I witnessed was the distribution of thousands of copies of *Life* magazine to Marines stationed near the demilitarised zone. Warriors were ordered off a transport plane while pallets of the magazine took their place for the journey north. The issue contained a photographic essay about the siege of Khe Sanh by David Douglas Duncan that extolled the virtues of the American Fighting Man. There were no Vietnamese in sight. This piece of 'journalism' was interchangeable with any recruiting advertisement, yet I'm sure no one at *Life* considered it propaganda. Judging by the discarded copies I later saw littering the fire-bases, the Marines seemed to have a better understanding.

What I think comes across strongly in the pictures is the David and Goliath scenario. The Vietnamese appear like Lilliputians under siege. They were, of course, rice farmers being attacked by the most powerful nation on earth with the most sophisticated weapons the world had ever seen. Planes costing millions of dollars dropped smart bombs on dumb targets valued in cents; 'We'll bomb Vietnam back to the Stone Age!' was the cry. And they did, over and over, at the rate of three Hiroshimas a week, exclaiming, 'We made the rubble bounce!' The average victim remained as hidden from the world's gaze as the women and children of Baghdad. They were the foreign 'other' summed up in General Westmoreland's telling comment: 'The Oriental doesn't put the same high price on life as the Westerner – life is plentiful, life is cheap, in the Orient.'

I'm sure that had pictures showing the Vietnamese as valiant and honourable human beings been widely published then, in all likelihood, the American people would have turned against the war sooner than they did."

© *Philip Jones Griffiths 2001*

The Great Unseen

Hidden moments from the Vietnam War. These rare photographs taken by North Vietnamese photographers show Ho Chi Minh's army in action.

(Right) Camau Province, Vietnam, 1963. Viet Cong guerillas drag a heavy rocket launcher along a river during a successful attack on the South Vietnamese outpost of Cai Keo.

Tran Binh Khuol/LNA/VNA/ Associated Press (photographs from Horst Faas and Tim Page, Requiem)

(Below right) Vinh Linh Province, Vietnam, 1972. A Soviet-made 130mm gun is loaded for action during a North Vietnamese offensive.

Luong Nghia Dung/VNA/ Associated Press

"Television brought the brutality of war into the comfort of the living room. Vietnam was lost in the living rooms of America – not the battlefields of Vietnam."
Marshall McLuhan,
Montreal Gazette, 1975

Truth and Fiction
(Above) Hill Timothy, Hue, Vietnam, April 1968. US soldiers take cover during an attempt to dislodge enemy troops from a stronghold, taken two months earlier during the North Vietnamese army's Tet Offensive. President Lyndon Johnson attempted to reassure America that this offensive had failed, but photographs such as this sowed seeds of doubt in an increasingly disillusioned nation.

Hulton Archive

(Right) Saigon, Vietnam 1970. American officers study IBM computer printouts about how the war is progressing. The surreal atmosphere in their air-conditioned headquarters in the Ton Son Nhut airport compared with the harsh reality of what was happening on the ground. This was an early sign of the US military's reliance on the infallibility of technology. Philip Jones Griffiths commented: "[This] is the computer that proves the war is being won. The Hamlet Evaluation System spewed out data proving that support for the government was increasing. Optimistic results on the my-wife-is-not-trying-to-poison-me-therefore-she-loves-me pattern are reliably produced, each and every month."

Photograph by Philip Jones Griffiths/ Magnum

Many commentators consider the Tet Offensive the turning point in US policy towards Vietnam, the time at which a majority of the American public started to turn against the war. At the start of the Vietnamese New Year, North Vietnamese soldiers launched attacks on most major cities in the south, attacking police barracks, radio stations and military headquarters. They also started a campaign of assassination against government officials in the South. The ancient city of Hue was captured for 26 days and Viet Cong guerillas even penetrated the grounds of the US embassy in Saigon.

No one seems able to agree on who won the Tet struggle. An estimated 37,000 North Vietnamese troops died in the first month and only at Hue was any captured ground held even briefly, but the press and pundits in the US refused to see this as a military defeat for the communists. President Johnson, trying to juggle the rising costs of social reform at home and the conflict abroad, began to lose enthusiasm for continuing the struggle. The American public sensed this political vacuum, this lack of will, and the pressures to withdraw from Vietnam increased. "Tet was one of the great ironies of history... It was the largest defeat the communists ever suffered in the field and was the greatest political victory externally," mused a CIA official who liaised with the White House during Tet.

Philip Jones Griffiths, whose classic book on the war, *Vietnam Inc.*, has now been reissued, rejects the assertion that the press and TV effectively undermined the US involvement in Vietnam: "It never did! What was allowed to be published and shown, with a few exceptions, followed public opinion. The military effectively needed someone to blame, so they spread this theory."

He maintains that there was little censorship on the ground in Vietnam: "The 'censorship' was by the TV stations and publication editors – the military attitude was 'We're doing the best we can under difficult circumstances – see for yourself'. Had the military attempted to resist access to journalists, then we would have naturally assumed they had something dishonourable to hide."

The tendency to self-censorship among US media towards dissenting voices meant that very little of his work was seen at the time. "None of my pictures of napalm victims was ever published, and in fact Magnum got very little of what I shot in Vietnam published – they usually blamed the editors."

A significant factor in this form of partial coverage, he believes, was that about 90 per cent of the newsmen covering the war believed in what America was doing there, both morally and tactically. Of the remainder, nearly all agreed with the morality but condemned the tactics. "You could count on one hand those of us who disagreed with both."

"It became necessary to destroy the town to save it."
US Army statement, Vietnam, 1968

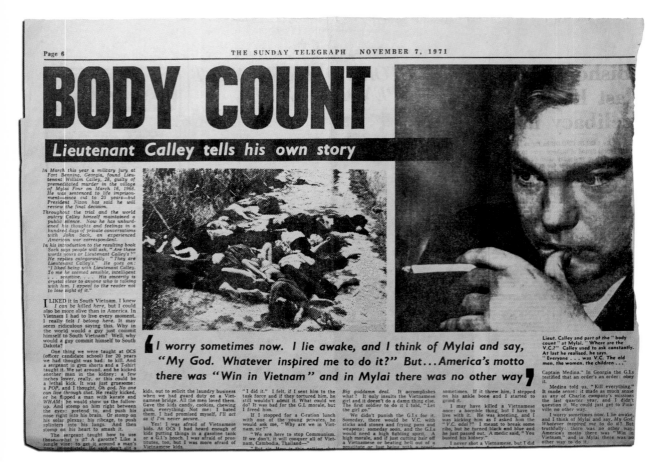

Fog of War

Vietnam, March 16 1968. Charlie Company, under platoon commander William L Calley Jr, wiped out old men, women and children in the village of My Lai. Estimates of the dead ranged from 100 to 500. Here was photographic evidence of an atrocity, yet it was over 18 months before the pictures were shown and the scale of the massacre was understood.

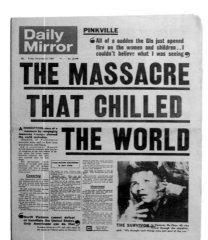

Front pages courtesy John Frost Newspaper Archives

My Lai revealed the difficulties of getting alternative perceptions of the American presence in Vietnam into print. Official releases after the event talked of the death of 128 enemy soldiers, and this was widely published in several American papers on March 17. Ron Haeberlee, an army photographer, had gone with the troops to My Lai. He took some routine black and white images for the army, but also took colour pictures around the scene of the killings with a separate camera. Soon afterwards, he left the Army and went home to Cleveland, US. He began to give lectures about Vietnam, with photographs, and he always put in a few of the My Lai images to gauge the reaction of the audience. By August 1969, a number of rumours were circulating about the incident, and when Haeberlee saw newspaper articles on the subject, he decided to go public with his photographic evidence. Black and white copies were published in the *Cleveland Plain Dealer* on the morning of November 20, 1969. Within days, My Lai had become a national sensation and the American people were stunned. CBS-TV interviewed a soldier who had been present, who admitted that the troops had killed men, women, children and even babies, and the transcript of his confession was printed in the *New York Times*. In December, *Life* magazine printed some of Haeberlee's colour pictures.

Not all of America was prepared to accept the evidence. "Your paper is rotten and anti-American," one unhappy reader told the *Plain Dealer*. Ex-Governor George Wallace of Alabama probably summed up the feelings of much of middle America: "I can't believe an American serviceman would purposely shoot any civilian… any atrocities in this war were caused by communists."

Willam Calley was found guilty of murder and sentenced to hard labour for life, but polls showed that almost 80 per cent of respondents were bitterly opposed to his punishment. After serving just three days in the stockade, President Nixon transmuted Calley's sentence to house arrest while appeals were being heard. Three years later, he was released on parole.

FINAL ★★★

DAILY ◉ NEWS

NEW YORK'S PICTURE NEWSPAPER ®

10¢

Vol. 52. No. 240 Copr. 1971 New York News Inc. New York, N.Y. 10017, Thursday, April 1, 1971★ WEATHER: Partly cloudy and cool.

CALLEY GETS LIFE TERM

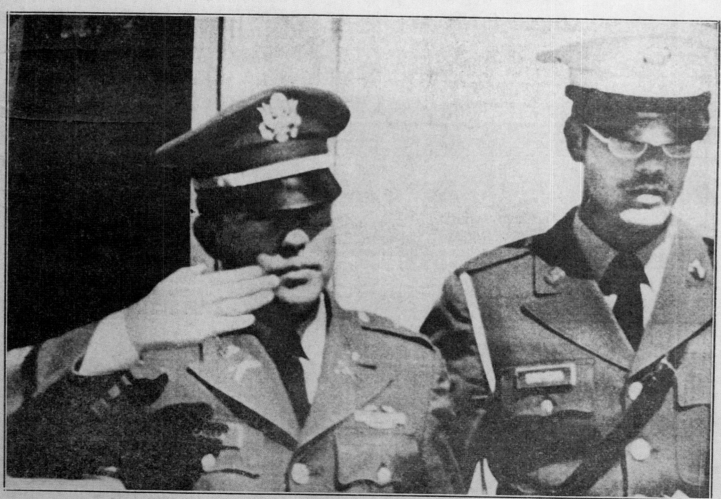

Lt. William L. Calley Jr. salutes as he leaves courthouse at Fort Benning after sentencing.—**Stories on page 3**

UPI Telephoto

Jimmy Hoffa Denied Parole

Story on Page 2

Hidden Persuaders

(Left) Nevada, US, 1952. A nuclear bomb test at Yucca Flats, closely observed by US marines. Using troops as guinea pigs was common at this time, in spite of evidence of the dangers of radiation and the lessons of the atom bombs dropped on Japan a few years earlier. In the atmosphere of the Cold War, images such as this may have helped to convince the American people of the need to stay ahead of the Soviet Union in the arms race.

Hulton Archive

American Pie

(Above) Nevada, March 1953. This reassuringly casual dinner scene in an average American home took place about two miles from the atomic test site, shortly before an atomic test explosion. Mannequins were used in houses, cars and experimental shelters for scientific purposes. The image may have been designed to soothe a population nervous about the dangers of radiation.

Bettman/Corbis

"There is no evil in the atom; only in men's souls."
Adlai Stevenson, 1952

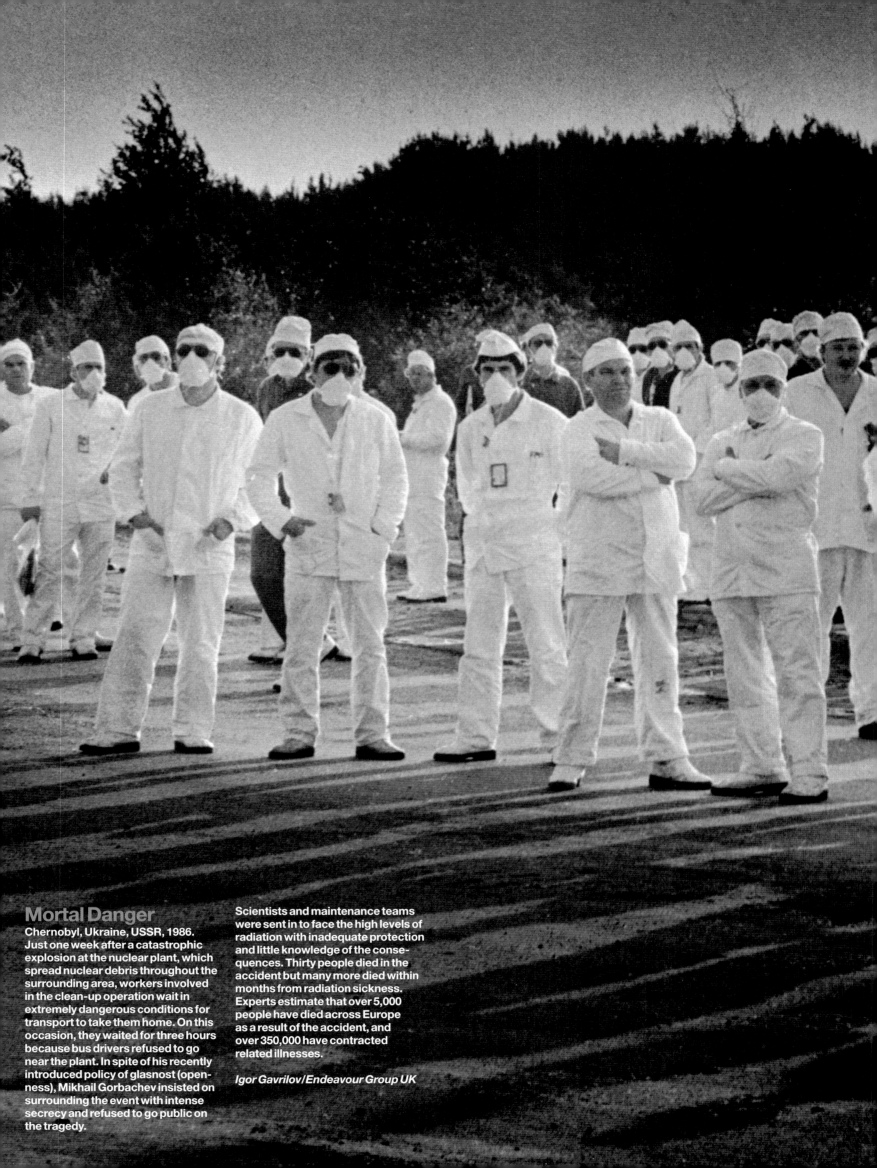

Mortal Danger

Chernobyl, Ukraine, USSR, 1986. Just one week after a catastrophic explosion at the nuclear plant, which spread nuclear debris throughout the surrounding area, workers involved in the clean-up operation wait in extremely dangerous conditions for transport to take them home. On this occasion, they waited for three hours because bus drivers refused to go near the plant. In spite of his recently introduced policy of glasnost (openness), Mikhail Gorbachev insisted on surrounding the event with intense secrecy and refused to go public on the tragedy.

Scientists and maintenance teams were sent in to face the high levels of radiation with inadequate protection and little knowledge of the consequences. Thirty people died in the accident but many more died within months from radiation sickness. Experts estimate that over 5,000 people have died across Europe as a result of the accident, and over 350,000 have contracted related illnesses.

Igor Gavrilov/Endeavour Group UK

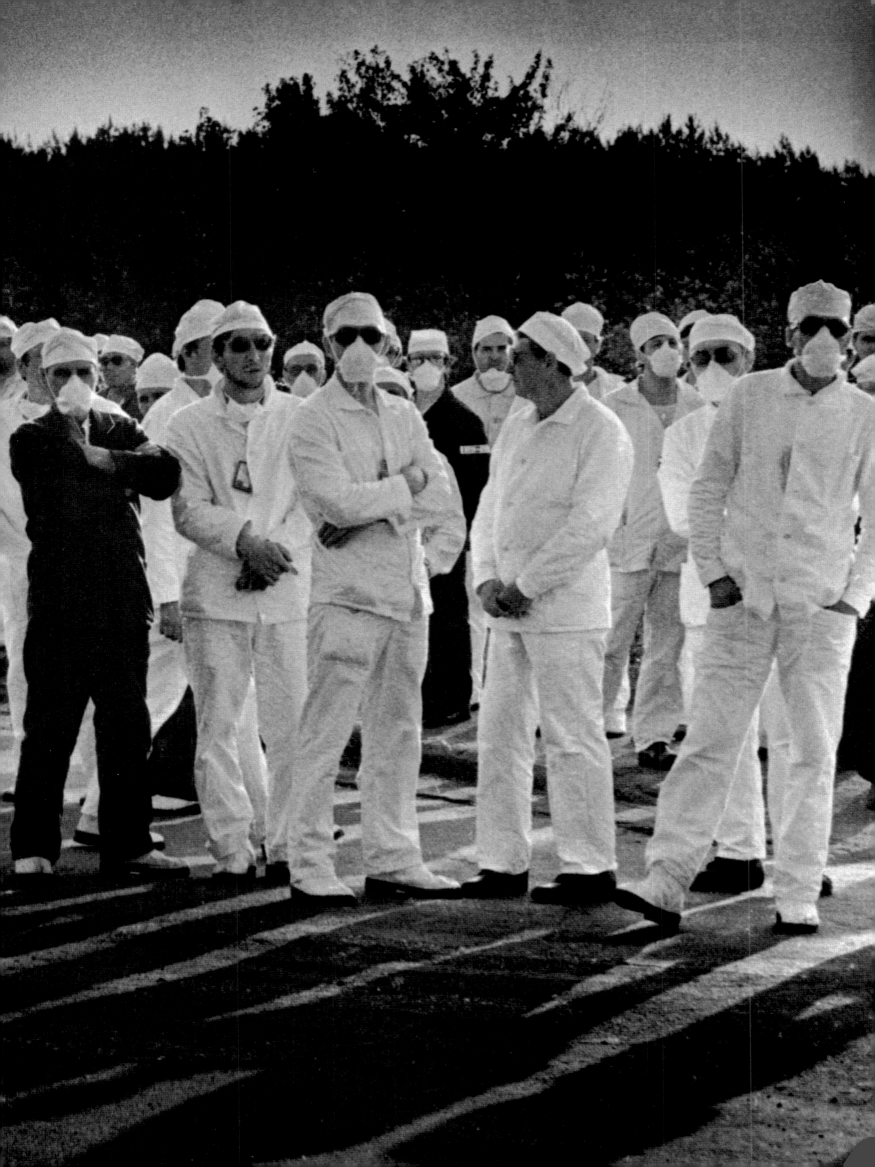

A Nasty War in a Distant Place

Falklands War, 1982. The British frigate HMS Antelope is blown up by an Argentine missile. The Argentine airforce carried out successful raids against a number of British ships by flying too low to be caught by radar and firing Exocet missiles from a range of 20 miles, where they were safe from attack.

Hulton Archive
Front pages courtesy John Frost Newspaper Archives

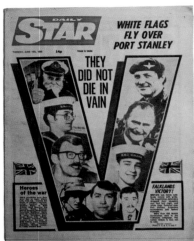

The British government found it easy to restrict press coverage of the war. The conflict was taking place on a remote island in the South Atlantic and it was the military that controlled access to communications channels. Just two photographers were allowed to accompany the British task force that sailed to the Falklands, one from the Press Association and the other from the right-wing *Daily Express*, neither of which were likely to pose a serious challenge to censorship during the war. The British Ministry of Defence was determined to avoid the kind of open access for journalists that had prevailed during the Vietnam War. As one Brigadier put it: "We would have to start saying to ourselves, 'Are we going to let the television cameras loose on the battlefield?'" To some extent, this policy backfired; when the Antelope blew up, the world's press splashed this picture of the British setback on their front pages, so starved were they of any genuine war images.

This lesson was not lost on the Ministry of Defence; when asked what had been learnt from the Falklands War, an official responded: "Next time, we'll cut down on the number of journalists."

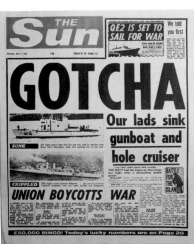

(Above) May 2 1982. The Argentinian cruiser, the General Belgrano, was sunk by a torpedo from HMS Conqueror, a British nuclear-powered submarine, drowning 368 sailors, most of them new recruits. In spite of the jubilation of the British tabloids, some opposition members of Parliament criticised this action because the Belgrano was attacked 36 miles outside the British-imposed exclusion zone.

FSP

The sinking of the Belgrano was condemned in many quarters as an irresponsible act which jeopardised any chance of a diplomatic solution to the conflict. Some political analysts suggested that British Prime Minister Margaret Thatcher was desperate for an outright victory in the Falklands to reverse her disastrous standing in the opinion polls.

Commander Jeff Tall, who helped to co-ordinate the sinking, is adamant that the attack was justified. Quoted on the website thenews.co.uk, he said: "Imagine it is dark and you have no night vision. You hear the enemy creeping towards you. For some reason he sneaks away. You see nothing. Then he comes back. It is your one chance to catch him. That is why the Belgrano was sunk. It was war. Of course there was sadness at the number of Argentinian sailors killed. We did not want that. The Belgrano was old. She was totally incapable of taking any hit. She was not taking even the most simple anti-submarine measures. But she was part of an aggressive act by the Argentinians. She was going about her legitimate war function of trying to hit the task group."

The controversy over the Belgrano rumbled on long after the conflict was over. In 1984, a senior civil servant at the British Ministry of Defence, Clive Ponting, leaked secret documents to an opposition member of Parliament which showed that the Argentinian ship had altered course and was returning home 11 hours before it was torpedoed. Ponting was sent to trial but was acquitted in 1985.

Port-au-Prince, Haiti, 1994. The massed ranks of the world's media wait for US peacekeeping forces to arrive at the airport.

(Overleaf)
The US Army takes on the press.

Photographs by Alex Webb/ Magnum

In December 1990, US pressure led to the first genuinely democratic elections in the troubled Caribbean country of Haiti. The winner, Aristide, was quickly deposed by a military coup and he fled to the US. President Clinton sanctioned a military intervention to restore Aristide to power in September 1994, but at the last moment the military junta agreed to give up control. On September 19, 1994, a peacekeeping force of some 15,000 US troops landed in Haiti to help restore order and establish an effective civilian police force. They were met by another invasion force: that of the world's media.

The PR potential of this military adventure was too much for the US authorities (and the media) to resist. The photographers and cameramen appeared to orchestrate the event for the Pentagon, prompting the unsettling thought that "it ain't news till it's on CNN."

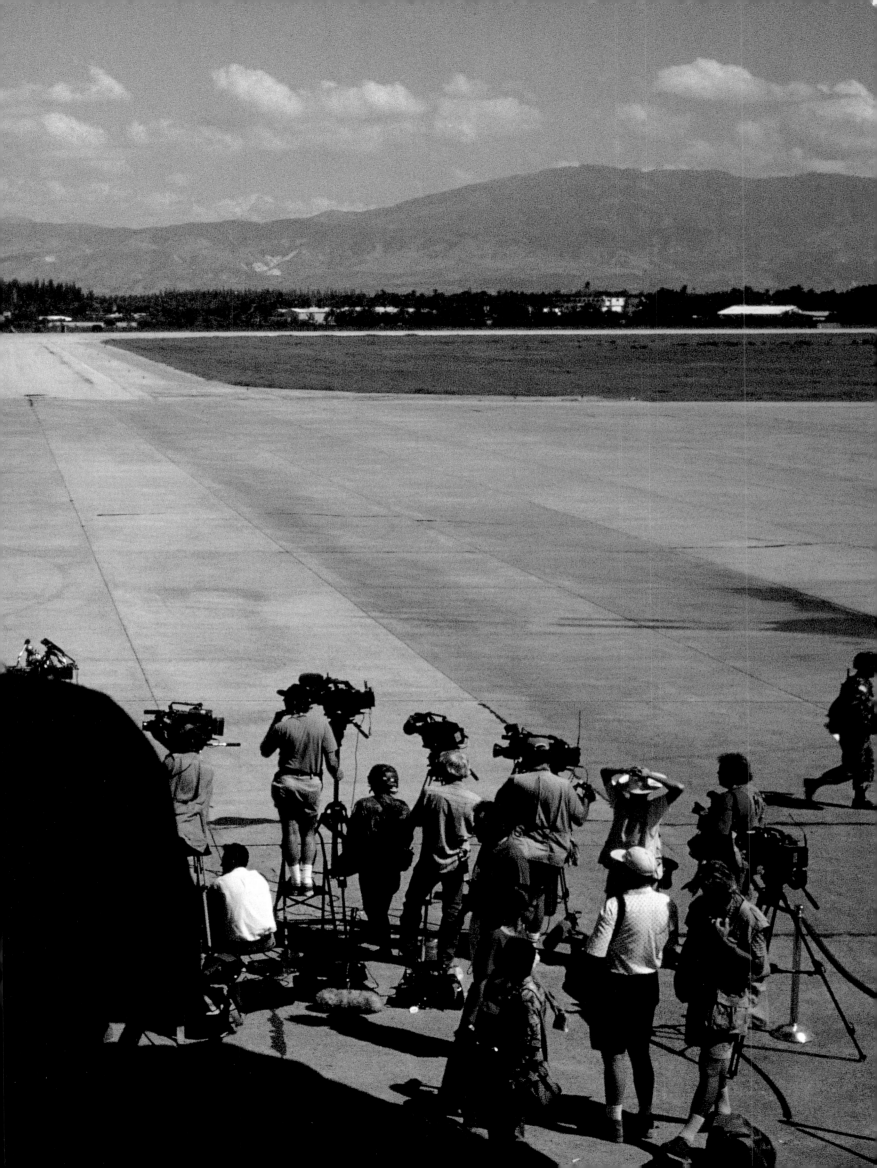

152 Recovered Memory
History revisited

"That men do not learn very much from the lessons of history is the most important of all the lessons that history has to teach."
Aldous Huxley, Collected Essays, 1959

Recovered Memory

Adam Phillips

Remembering is a form of madness. It would also be a form of madness – perhaps a particularly modern form – to believe that such a thing is possible; a form of madness plausible only by our increasingly sophisticated technologies for recording and retrieving the past. And yet when this striking remark is made in Brian Friel's play *Translations*, it also serves to remind us that we tend to think of memory as redemptive. As though remembering, in and of itself, were salutary, and that we suffer above all from forgetting. But whenever we privilege memory we are always, more or less covertly, promoting specific kinds of remembering. It is not, for example, Germans "remembering" their glorious Teutonic past in the 1930s that we even call remembering. But even if we call it mythologising the past to manufacture the future, we are unavoidably confronted with the selective nature of memory. We are not simply doomed to repeat what we forget; we are also enabled to repeat what we can remember. Our images of the past are our eye on the future. Remembering, that guarantees nothing, is unpredictable in its consequences. It only proves what we make it prove.

So, looking at these photographs – both the ones that we have chosen to forget, and the ones we may never have noticed – we may wonder what we are looking for, what use they are. If they are instructive, they force us to connect things we prefer to keep separate – the brutality of those on the "right side", on the side of freedom and democracy, abusing collaborators. If they are evocative we might find ourselves stirred, against our better judgement as it were, as though the images were a kind of pornography; we might find ourselves taking awkward pleasure in the insidious violence we are being shown. The photograph can "teach us" – can serve as a reminder that is also a warning – but it can also undermine us. It challenges our ways of seeing: if we refuse to be too easily recruited; if we take sides before we take thought. The photography is propaganda if we immediately know where we are with it. It is the complicity in voyeurism that tells us it's better to look, and yet without looking such complicities can never be undone.

In the dream, Freud suggested, the dreamer is all the characters. In the stilled life of the photograph, which has become so quickly an essential part of our cultural dream-work, we are at once invited and implicated. So it may be more revealing to think of these photographs – the ones that fascinate us and the ones we disown – along these lines. More revealing and more usefully disturbing, to see ourselves everywhere in the photographs – while unerringly acknowledging that these are real, other people living their predicaments – may be our best refuge from the worst refuge of all: righteous indignation. It's never enough now to be shocked by a photograph, and perhaps these daunting photographs are best seen as part of an attempt to get beyond shock, to think more promisingly about the uses of memory, and the trickiness of images.

If trauma is that which by definition we cannot bear, it is not surprising that we work so hard to make it seem unreal, to make it appear as spectacle rather than lived experience. The question becomes how one can reproduce, or record, or elaborate an experience – in these photographs, the horrors of what is still contemporary history – but keep it imaginably real. The unbearable has to be made bearable in order to be remembered. If the image is too terrible, we can only go on looking if we can in some way use the image to punish and/or excite ourselves. It is what we need to do with memories, with the images, to make them acceptable and therefore available for consideration – to aestheticise them, censor them, eroticise them, idealise them – that makes the act of memory fraught. So if these photographs remind us of what we would rather forget – or are a bit too keen to remember – they also confront us with a question: with what desire, with what kind of project in mind, are we going to take a look at them?

Pieties about the perils of forgetting have made it increasingly difficult to think differently about the purposes of memory, and indeed about the virtues of forgetting. When we say (or assume) that memory is selective, that forgetting is motivated, we imply that we are purposive beyond our knowledge of ourselves, that we only turn a blind eye with a view to our future. The photos we choose to recirculate, now at the end of the century, encode our wishes for the future. The picture of the past we choose – and there is, as always, more past than ever before – are conjectural politics. But they predict nothing, only tell us, more obscurely than we might wish, what it is we want.

© *Index on Censorship. Adam Phillips is a psychoanalyst and author. His latest book is* Houdini's Box *(2001, Faber and Faber)*.

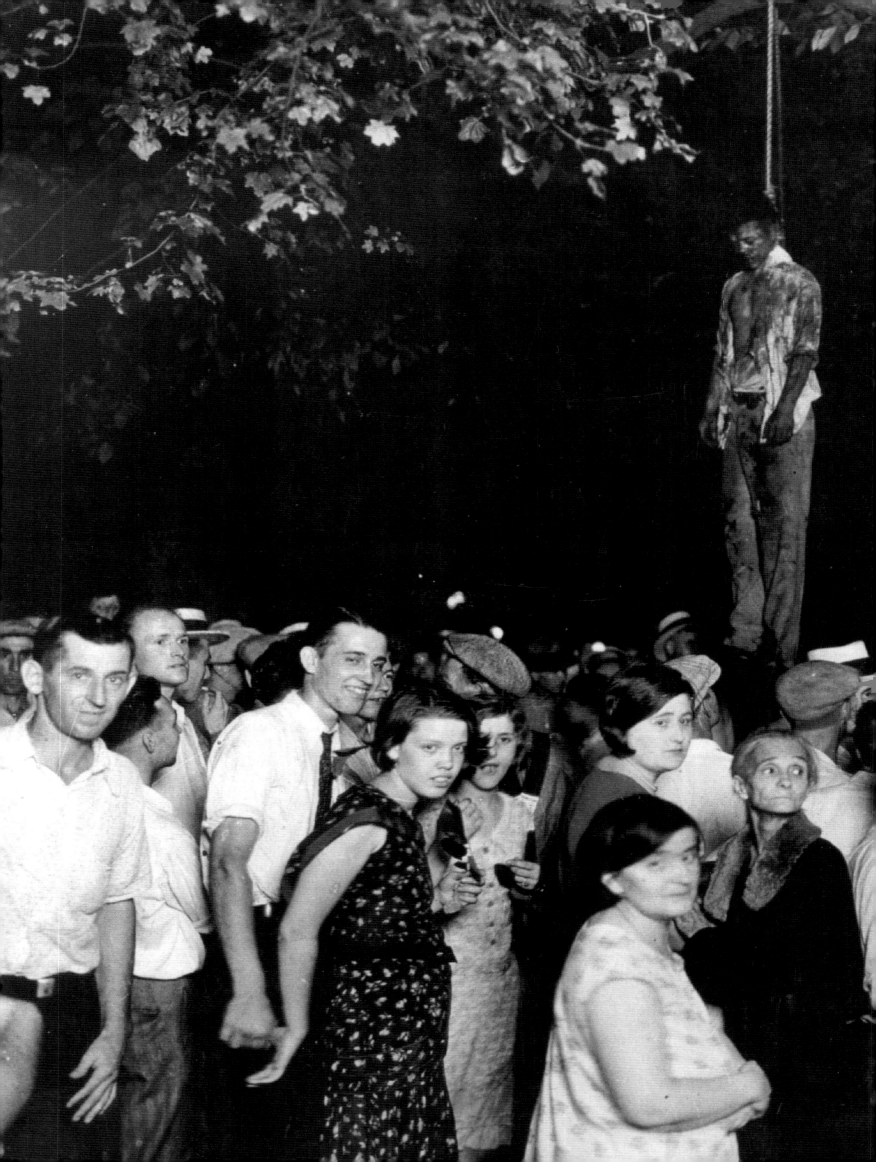

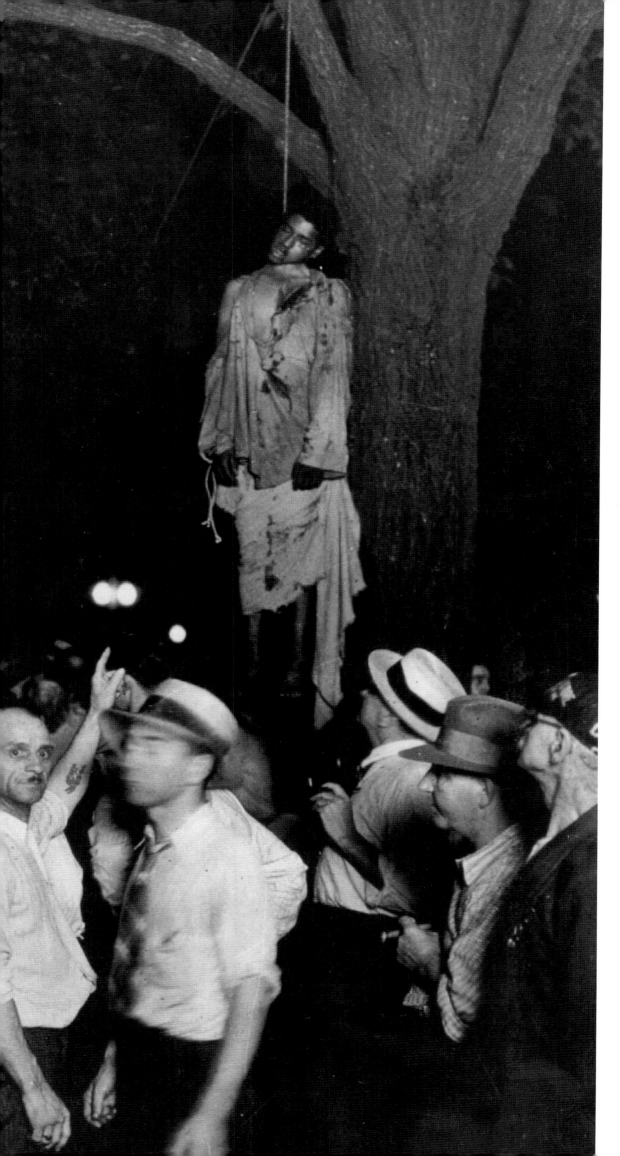

Hometown Hospitality

Indiana, US, August 7 1930. An enthusiastic crowd poses for the camera following the lynching of Tom Shipp and Abe Smith.

Hulton Archive

What was once an occasion for civic pride, in which the unfortunate victims were presented as trophies, is now an opportunity for catharsis. The *Independent* newspaper in Britain recently reported that Duluth, Minnesota was holding a week of remembrance for the lynching of three black men, which took place on June 15, 1920. A mob of hundreds of outraged white citizens pulled six black men from the city jail and hanged three of them from a lamppost. The men – members of the John Robinson Show Circus – had been accused by a white teenager of raping his girlfriend and forcing him to watch. This was subsequently found to be a lie, but by then it was too late.

Unbelievably, a photograph of this grisly event was turned into a popular postcard. Bob Dylan, celebrated son of Duluth, started his song "Desolation Row" with the words, "They're selling postcards of the hanging." Joan Crawford, the great-granddaughter of the only undertaker in the town who was prepared to bury the three dead men, said, "It makes you embarrassed to be a white person." One of the organisers of the memorial, Portia Johnson, maintained that the lynching had always divided the community. Many people chose not to acknowledge it, refusing to accept that one of the faces in the crowd may have belonged to a relative.

The legacy of the lynch mob mentality has not entirely disappeared. In June 1998, three white youths out driving a pickup truck in Jasper, Texas stopped to give a ride to a young black man, James Byrd Jr. They beat him unconscious, stripped him, chained him to the back of the truck and dragged him for two and a half miles so brutally that his head and one arm were ripped from his body. In February 1999, one of the youths, John William King, described as a white supremacist, was convicted of capital murder.

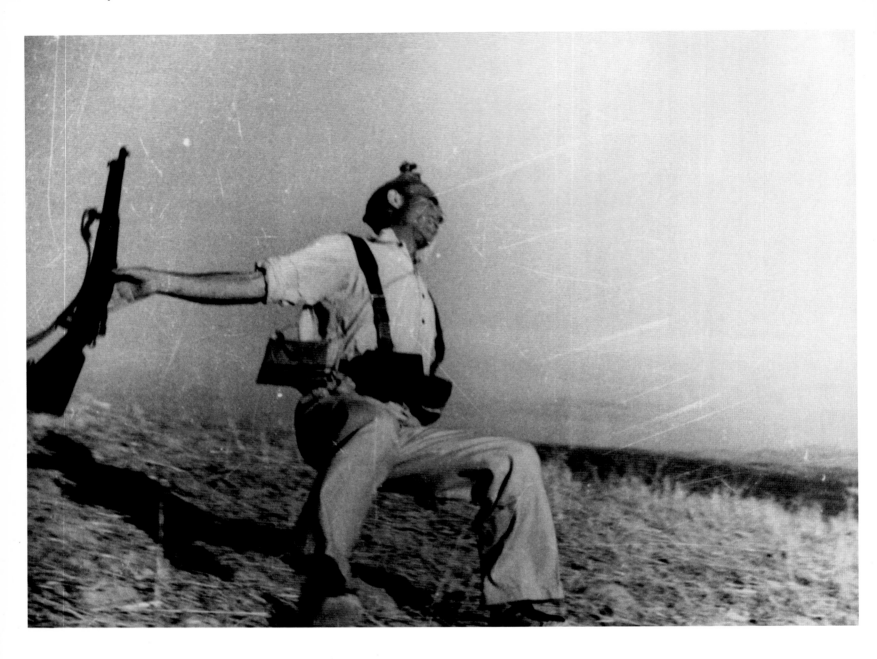

Double Vision

Robert Capa took this famous Spanish Civil War image of a Republican soldier falling backwards, an icon of the moment of death. It was first published in the French magazine *Vu* (left) in September 1936, but both the photograph and its author became internationally celebrated when *Life* magazine published it in July 1937.

Photographs by Robert Capa/ Magnum

Página de Vu con la foto del miliciano que cae muerto en Cerro Muriano (Córdoba). La foto fue tomada en agosto de 1936.

Capa was undoubtedly one of the greatest war photographers ever, but Philip Knightley, in his classic book *The First Casualty*, first raised serious doubts about the photograph's authenticity. He investigated the circumstances surrounding the picture, pointing out that, if genuine, Capa would have placed himself in great danger and might well have been shot himself.

Knightley continued the debate in an article for the British magazine *Night & Day* in 1998: "When, and exactly where, did Capa take it? The terrain in the photograph tells us nothing; it could be anywhere. Who is the man? His face is blurred, but there appears to be no trace of a wound, certainly not the explosion of the skull that a bullet in the head would cause. In fact, he is still wearing his cap. How did Capa come to be alongside him, camera aimed at him, lens reasonably in focus, just as the man was shot dead?"

Capa himself never wrote anything about this picture, even though it made him famous. Knightley tried to find out more from *Life* and from Magnum, the agency Capa co-founded, but without success. Cornell Capa, Robert's brother and himself a distinguished photographer, maintained that nothing had ever been said about the story behind the falling soldier.

Knightley talked to men who had been in Spain at the same time as Capa. Ted Knight, a Canadian playwright who was working there as a journalist, claims that he was told by another co-founder of Magnum, David "Chim" Seymour, that Capa never actually took the picture. Former war correspondent John Hersey claimed Capa told him that that the picture was a million-to-one fluke. Capa was sharing a trench with Republican volunteers who launched a series of brave but wild charges on a nationalist machine-gun nest. Many Republicans were mowed down. Hersey wrote: "Finally as they charged, the photographer timidly raised his camera to the top of the parapet and, without looking, at the instant of the first machine-gun burst, pressed the button. Two months later, Capa was notified that he was now a famous, talented and nearly rich photographer, for the random snapshot had turned out to be a clear picture of a brave man in the act of falling dead as he ran."

OD Gallagher, a former correspondent in Spain for the London *Daily Express*, was sure that Capa had posed the photograph. Gallagher was sharing a room with Capa, and things were rather dull at that stage of the conflict, so a Republican officer agreed to stage some manoeuvres for Capa to photograph. When the photograph was published, Gallagher complimented Capa on how genuine it looked: "He [Capa] laughed and said, 'If you want to get good action shots, they mustn't be in true focus. If your hand trembles a little, then you get a fine action shot.'"

The page reproduced from *Vu* shows not one but two "moment of death" pictures. The caption suggests that the photographs are meant to be symbolic: "Legs braced, chests bared, rifles at the ready, they stumble down the stubble-covered slope. Suddenly, the momentum of the attack is broken. Bullets whistle, fratricidal bullets, and their blood is drunk by their native earth." Knightley quotes Philip Gaskell, formerly librarian and a fellow of Trinity College, writing in *Journalism Studies Review* in July 1981: "Careful comparison of the two [pictures] shows first that both were taken at precisely the same spot (proved by the pattern of long grasses in the foreground) and also that they were taken at the same time (indicated by the clouds, and by the lighting and shadows).

Nevertheless, they are not pictures of the same event. The soldier falling in the less well-known shot is nearer the ground than the soldier falling in the 'moment of death', but he still clutches his rifle in his hand, whereas the soldier in the first picture has already flung his rifle away. The simple explanation is that neither of them shows an actual moment of death, but that both were staged, and have a soldier (or perhaps two separate soldiers) falling to the ground in simulation of being shot. For what follows if they were not staged? Can we really believe that Capa was able to photograph the actual moments of death of two separate soldiers, in quick succession on the self-same spot, the body of one having been removed before the second one fell? Or that one is of an actual moment of death, and the other one was staged immediately before or after the real one? Such suppositions are obviously absurd."

Capa's biographer Richard Whelan rejects the suggestion that the picture is fraudulent. He claims that the falling soldier had been positively identified by his family as Frederico Borrell Garcia, a 24-year-old Republican who was killed at the battle of Cerro Muriano on September 5, 1936. Knightley responds: "All this adds nothing to the debate. Frederico could have posed for the photograph before he was killed."

Only Capa himself would have known for certain the truth about this "moment of death", but the great photojournalist was killed in Indo-China in 1954, covering another war. It seems strange that no one at Magnum or *Life* ever claimed to have seen the negatives or contact sheets, since these could have solved the mystery once and for all.

The photograph remains a powerful symbol of that strangest and harshest of events, the Spanish Civil War. Perhaps the mystery is part of its power, but as Knightley asks, if we were to rewrite the caption to read, "A militiaman slips and falls while training for action", would history have treated this image with such reverence?

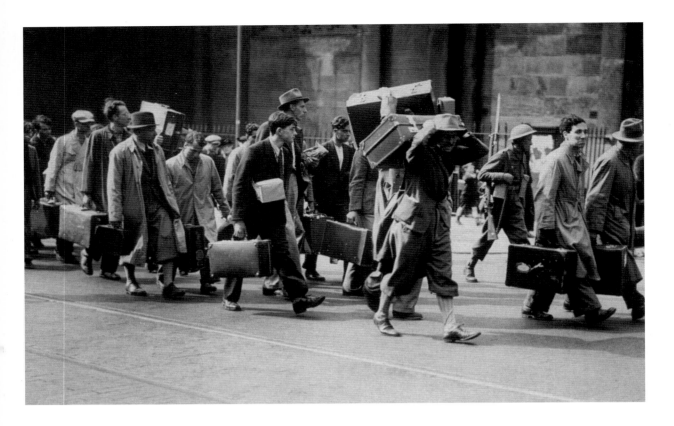

Friend or Foe

(Above) UK, May 1940. Several months into World War II, some 50,000 "enemy aliens" were rounded up because of their German origins. Many were Jewish refugees from Nazi Germany and passionately anti-Hitler, but were still sent away to camps. In one contemporary anecdote, a policeman in the north London suburb of Hampstead, home to many refugee intellectuals, went to the local library and asked anyone who could read German to step outside. Later, many of the detainees were released and participated enthusiastically in the Allied war effort.

(Right) Berlin, Germany, 1914. Ludwig Bornstein, a soldier in the German army, is seen off to the war front by his friends Fritz and Emma Schlesinger. This photograph was widely published at the outbreak of the Great War to bolster Germany's morale. All three of those photographed were Jewish and chose to emigrate to Israel after Hitler came to power.

Hulton Archive

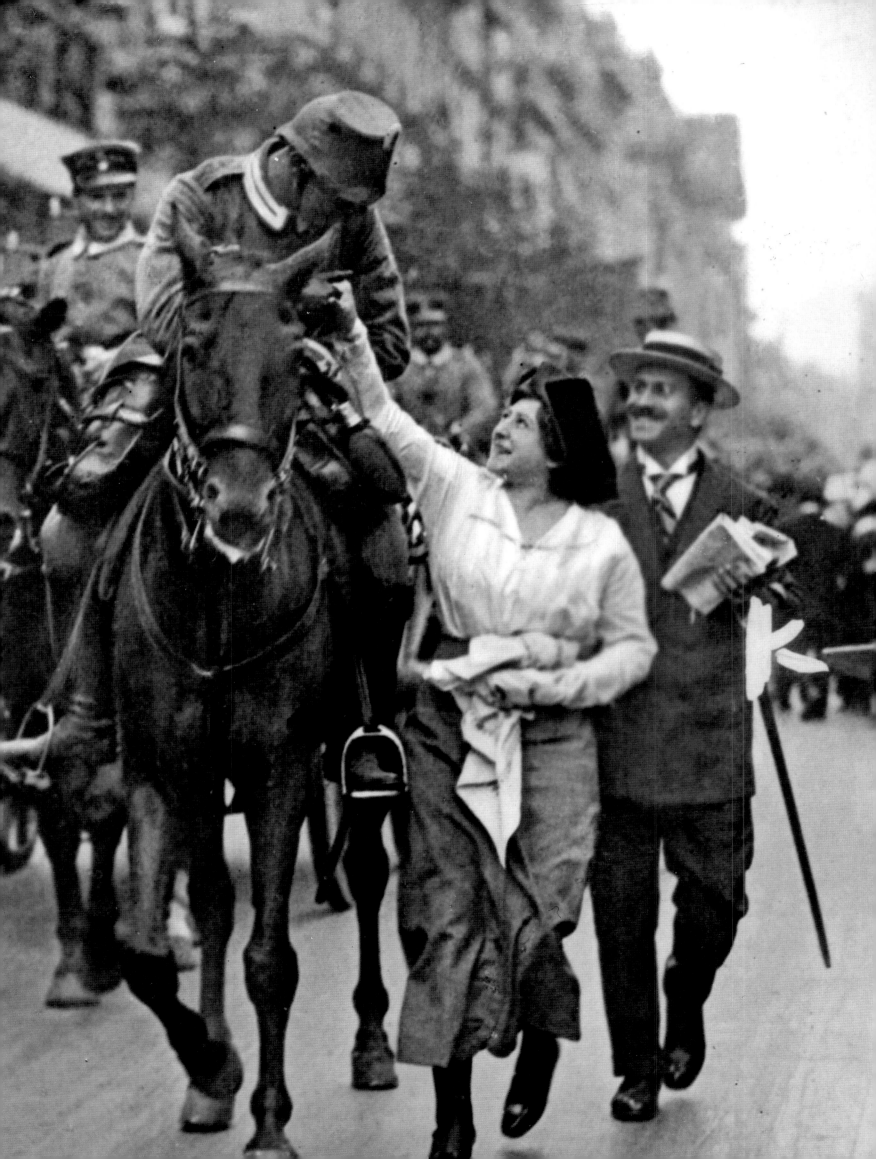

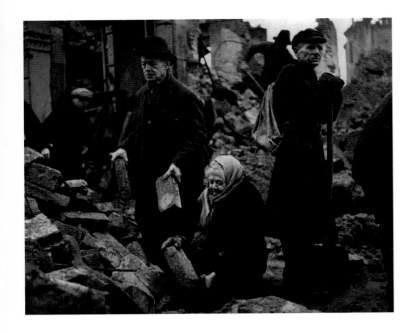

Britain's Blitzkrieg

(Above left) Dresden, 1946. Gustav and Alma Piltz participate in the reconstruction of their city a year after the destruction.

(Above right) Dresden, 1937. Soon after he abdicated from the British throne, the Duke of Windsor is seen with prominent Nazi leaders discussing a grand building plan for Dresden. The Duke made numerous pre-war visits to Germany, persuading many commentators that he was sympathetic to Hitler's ideas.

(Far right) Dresden, Germany, February 1945. The ruins of the historic city after a night of intensive bombing. Over 100,000 civilians were killed in this raid.

Hulton Archive

The British War Cabinet sanctioned bombing attacks on Germany's civilian population early in the war, while officially maintaining it was pinpointing only military targets. On the night of February 13, 1945, Royal Air Force planes, under the enthusiastic direction of Sir Arthur "Bomber" Harris, dropped thousands of tons of incendiary bombs on the historic city of Dresden, which was overflowing with refugees from the advancing Russian army. The bombs created a fire-storm with winds in excess of 100 miles an hour sweeping debris and human beings into its epicentre, where the temperature exceeded 1,000 degrees centigrade. The next morning, American planes flew over and machine-gunned survivors as they struggled towards the river Elbe. Estimates of the number of civilian dead vary from 100,000 to 130,000. This was considerably more than the number of casualties resulting from the atom-bombing of Hiroshima a few months later, and far exceeds the total of 51,500 deaths recorded in the entire London Blitz.

The airmen who carried out the Dresden bombing were under the impression that they were attacking German army headquarters, or destroying arms dumps and poison gas plants.

British newspapers bought the official line that Dresden was a major military target. In the US, the Associated Press put out a press release: "Allied air chiefs have made the long-awaited decision to adopt deliberate terror bombings of German population centers as a ruthless expedient of hastening Hitler's doom." This announcement was completely banned in Britain and it was not until three weeks later that the *Manchester Guardian* published a report suggesting that many civilians had died in a horrifying manner.

It took until the mid-1990s for the British and US governments to formally apologise to Germany for the savage and unnecessary attack.

"The Dresden catastrophe is without precedent. In the inner town, not a single block of buildings, not a single detached building, remains intact or even capable of reconstruction. The town area is devoid of human life. A great city has been wiped from the map of Europe."
Rudolph Sparing/German Overseas News Agency

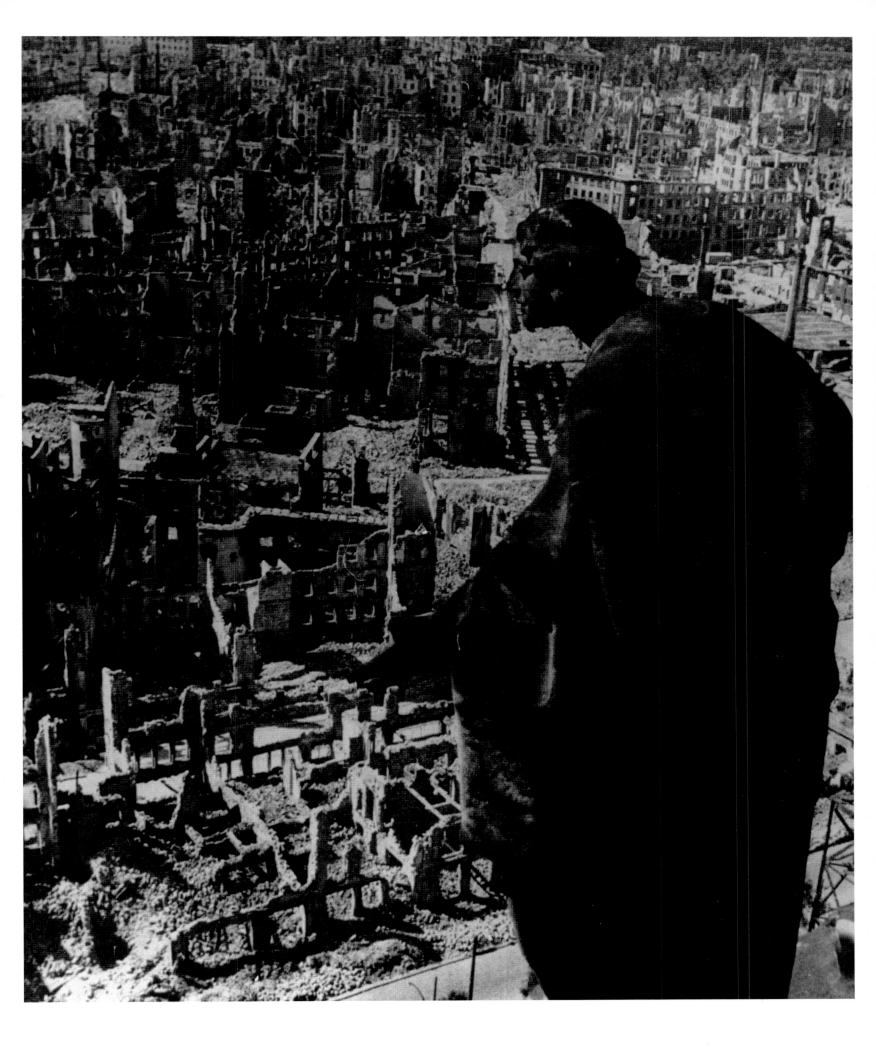

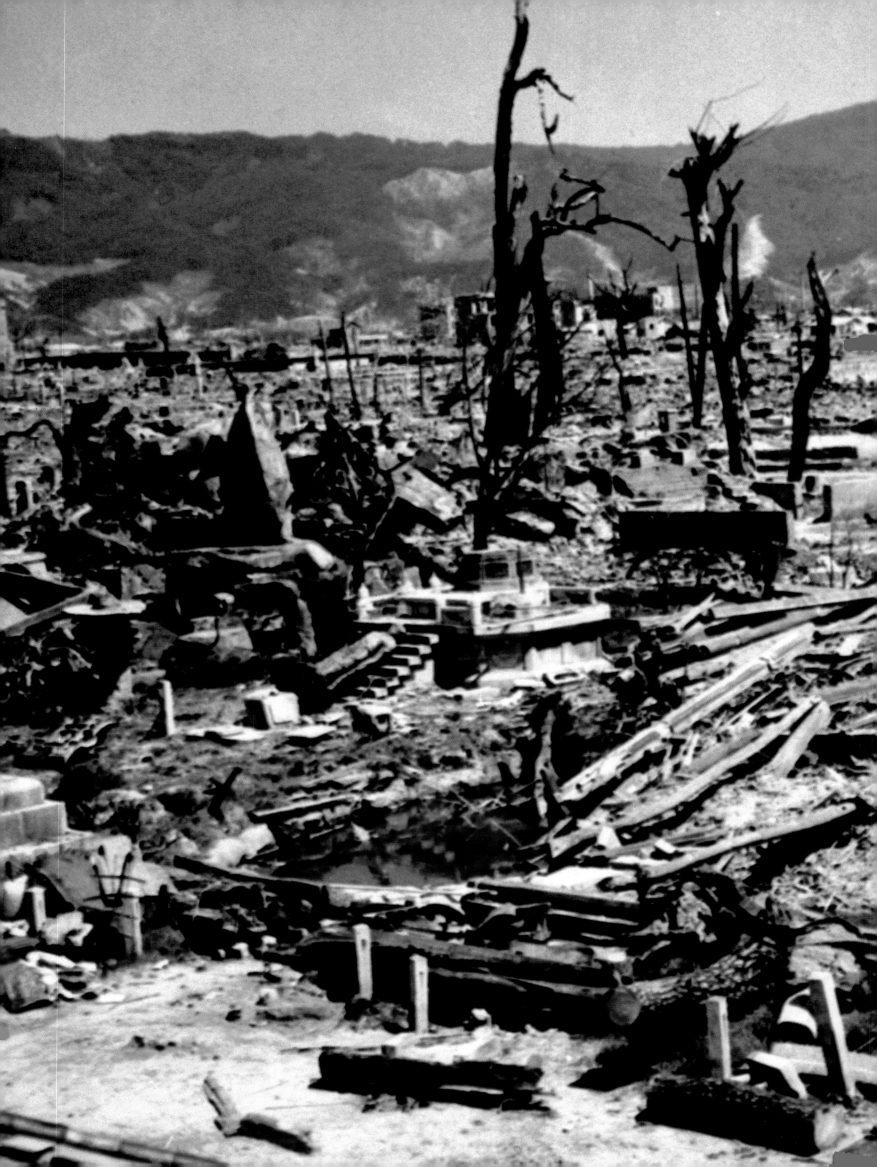

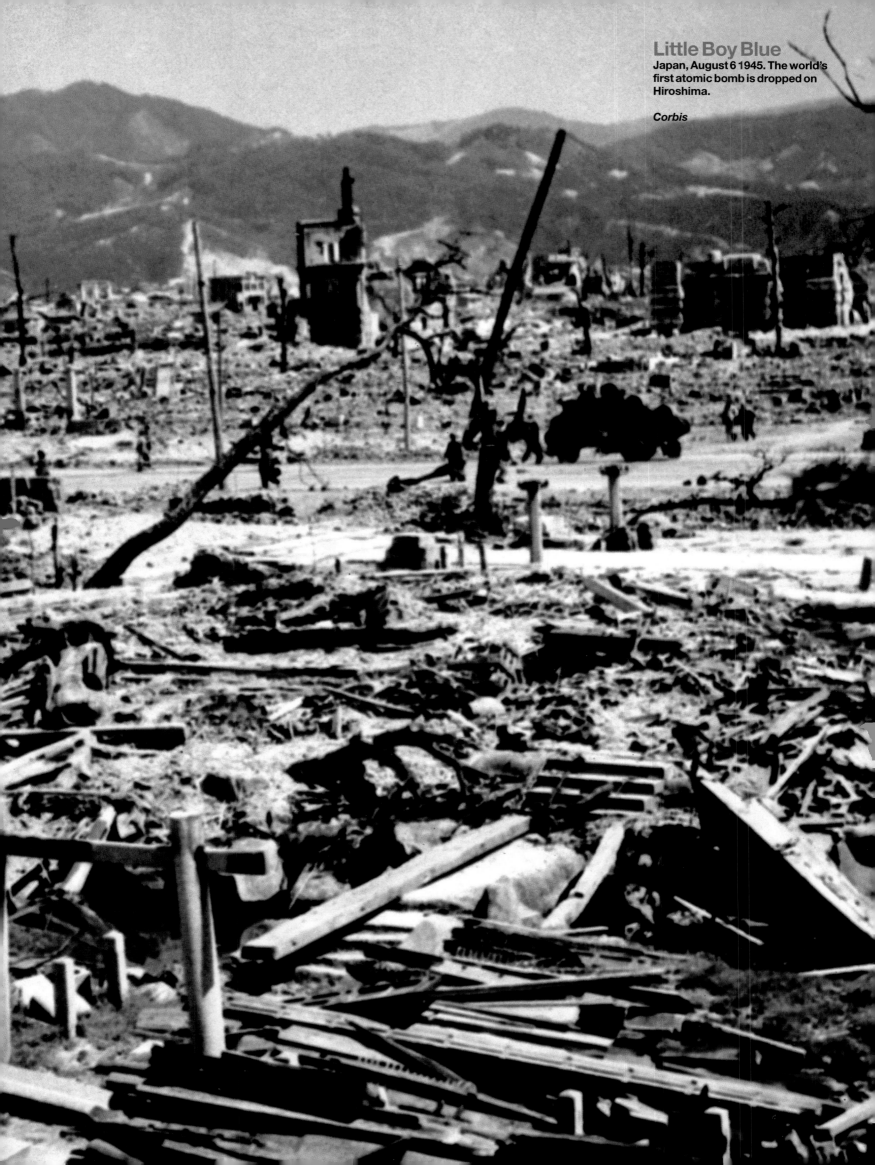

Little Boy Blue
Japan, August 6 1945. The world's first atomic bomb is dropped on Hiroshima.

Corbis

DAILY EXPRESS

No. 14,094 Lighting-up: 9.39 pm to 4.33 am TUESDAY AUGUST 7 1945 Weather: Cool, showers One Penny

Smoke hides city 16 hours after greatest secret weapon strikes

THE BOMB THAT HAS CHANGED THE WORLD

Japs told 'Now quit'

THE Allies disclosed last night that they have used against Japan the most fearful device of war yet produced—an atomic bomb.

It was dropped at 20 minutes past midnight, London time, yesterday on the Japanese port and army base of Hiroshima, 190 miles west of Kobe.

The city was blotted out by a cloud of dust and smoke. Sixteen hours later reconnaissance pilots were still waiting for the cloud to lift to let them see what had happened.

The bomb was a last warning. Now leaflets will tell the Japanese what to expect unless their Government surrenders.

So great will be the devastation if they do not surrender that Allied land forces may be able to invade without opposition.

In God's mercy we outran Germany

This statement was prepared by Mr. Churchill before he resigned, and was issued from Downing-street last night.

By WINSTON S. CHURCHILL

BY THE YEAR 1939 IT HAD BECOME WIDELY RECOGNISED AMONG SCIENTISTS OF MANY NATIONS THAT THE RELEASE OF ENERGY BY ATOMIC FISSION WAS A POSSIBILITY.

The problems which remained to be solved before this possibility could be turned into practical achievement were, however, manifold and immense; and few scientists would at that time have ventured to predict that an atomic bomb could be ready for use by 1945. Nevertheless, the potentialities of the project were so great that his Majesty's Government thought it right that research should be carried on in spite of the many

The men who knew

SIR JOHN ANDERSON
He supervised the work

SIR CHARLES DARWIN
He was called in

PLANE KIDNAPS SCIENTIST

20,000 tons in golf ball

ONE atomic bomb has a destructive force equal to that of 20,000 tons of T.N.T., or five 1,000-plane raids. This terrific power is packed in a space of little more than golf ball size.

Experts estimate that the bomb can destroy anything on the surface in an area of at least two square miles—twice the size of the City of London.

When it was tested after being assembled in a farmhouse in the remote desert of New Mexico, a steel tower used for the experiment vaporised; two men standing nearly six miles away were blown down; blast effect was felt 300 miles away.

And, at Albuquerque, 120 miles away, a blind girl cried "What is that?" when the flash lighted the sky before the explosion could be heard.

BLAST FELT 300 MILES FROM BOMB TEST

Steel tower turned to vapour

From C. V. R. THOMPSON: New York, Monday

THERE is reason to believe that the vital part of the atomic bomb with its almost incredible power of devastation is not much bigger than a golf ball.

We have not seen it; all that is given officially—and this from the War Department—is that it is "a revolutionary weapon destined to change war, or which may even be the instrumentality to end all wars."

But something is known about the first test, made in heavy rain at 5.30 a.m. on July 16 in a remote area of New Mexico.

We know that the blast was felt nearly 300 miles away. Imagine feeling in Piccadilly-circus the effect of a bomb dropped in Penzance.

And there is this account, given

THANKS, BRITAIN

Says Professor

From GUY AUSTIN

LOS ANGELES, Monday— Professor R. Robert Oppenheimer, director of the work on the atomic bomb, told me

DAILY NEWS FINAL

Vol. 27. No. 37 New York, Tuesday, August 7, 1945 32 Main + 8 Brooklyn Pages 2 Cents

ATOM BOMB ROCKS JAPS

More on Way, Truman Warns; Biggest War Secret Revealed

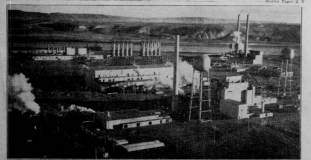

Home of Atomic Bomb. Thousands of Americans, working in secret, are producing atom bombs at this Richland, Wash., factory. The new bomb, first used against the Jap base of Hiroshima, was revealed yesterday by President Truman. One atomic bomb packs the wallop of 2,000 fully loaded B-29s.

Deadly Rain

(Right) Hiroshima, Japan, 1945. Young survivors of the world's first atom bomb attack wearing masks to combat the smell of death. The danger from radiation was still intense and decades later people were still dying from the after-effects.

Hulton Archive
Front pages courtesy John Frost Newspaper Archives

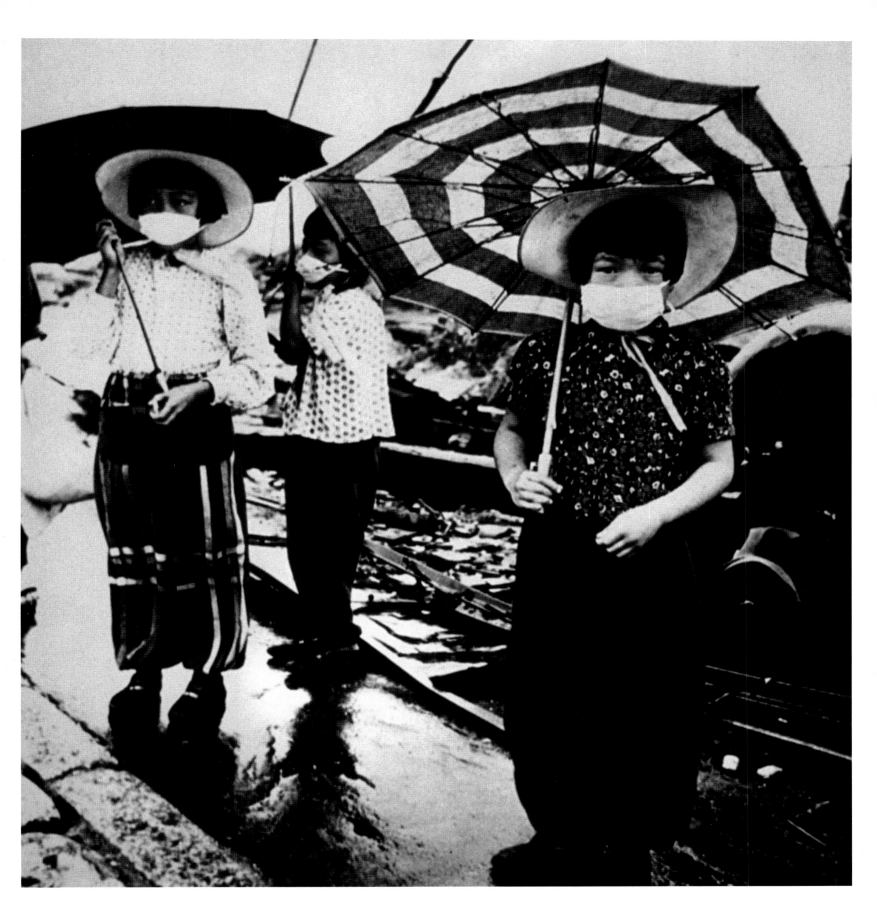

"The dropping of the bombs stopped the war, and saved millions of lives."
President Truman

◀ The atomic bomb, cosily named Little Boy, was dropped on Hiroshima by the Enola Gay, a Boeing B-29 bomber, at 8:15 am on August 6, 1945. A survivor, Takeharu Terao, recalled that "a bluish-white light flashed like an electric welding spark, gas welding torch, or magnesium burning. The world went white". 100,000 people were instantly killed and another 100,000 died from burns and radiation in the following months. Three days later, a second bomb hit Nagasaki, killing another 75,000 people. Within a week, the Japanese had surrendered.

The bomber crew returned to a ticker tape welcome in New York. Scant attention was paid to the havoc wrought on Japan's civilian population. Survivors were largely abandoned to care for themselves and deal with what is now recognised as post-traumatic stress. Few pictures of the awful injuries caused were published, so as not to upset celebrations at the end of the war in the Pacific.

Since 1945, many Japanese who survived the original bomb blasts have died slow, painful deaths from cancer. One man who died in 1967 recalled the atmosphere after the explosion: "Everything was still and quiet. There were young girls naked, not saying anything. Some of them had no skin or hair. I thought I was dead." (*Reporting the World, John Pilger's Great Eye-witness Photographers*)

Many historians and politicians did not share Truman's certainties, both at the time and subsequently. Even war heroes such as General Eisenhower and Winston Churchill had serious doubts about dropping the atom bomb.

Writing in *Newsweek* magazine in 1963, General Dwight Eisenhower recalled his response when told that an atomic bomb would be used against Japan: "I had been conscious of a feeling of depression and so I voiced… my grave misgivings, first on the basis of my belief that Japan was already defeated and that dropping the bomb was completely unnecessary, and secondly because I thought that our country should avoid shocking world opinion by the use of a weapon whose employment was, I thought, no longer mandatory as a measure to save American lives. It was my belief that Japan was, at that very moment, seeking some way to surrender with a minimum loss of 'face'." He concluded, "It wasn't necessary to hit them with that awful thing."

Churchill later wrote: "It would be a mistake to suppose that the fate of Japan was settled by the atomic bomb… Her defeat was certain before the first bomb fell…"

A curious figure to emerge at the heart of the debate about the use of the atom bomb was Henry L Stimson, the US Secretary of War. As Gar Alperovitz describes in *Atomic Diplomacy: Hiroshima and Potsdam*, Stimson was a staunch Republican, but he began to have serious doubts about what America intended to unleash upon the world. His memo to Truman makes it clear that politicians at the highest level had been kept in the dark about the secret development of the bomb:

"Dear Mr President,
I think it is very important that I should have a talk with you as soon as possible on a highly secret matter… [it] has such a bearing on our present foreign relations and has such an important effect upon all my thinking in this field that I think you ought to know about it without much further delay." (Henry Stimson to President Harry S Truman, April 24, 1945 – 12 days after President Roosevelt's death and two weeks before the US bombed Japan)

After the Hiroshima bomb, Stimson became convinced of the need to share atomic secrets with other powers, especially the Soviet Union, in order to save mankind:

"…I consider the problem of our satisfactory relations with Russia as not merely connected with, but as virtually dominated by the problem of the atomic bomb… For if we fail to approach them now and merely continue to negotiate with them, having this weapon rather ostentatiously on our hip, their suspicion and their distrust of our purposes and motives will increase.

My idea is… that we would be prepared in effect to enter an arrangement with the Russians, the general purpose of which would be to control and limit the use of the atomic bomb as an instrument of war, and so far as possible to direct and encourage the development of atomic power for peaceful and humanitarian purposes." (Henry Stimson, Memorandum for the President, September 11 1945)

The subsequent barren years of the Cold War show that Stimson's voice went unheard.

Bettman/Corbis

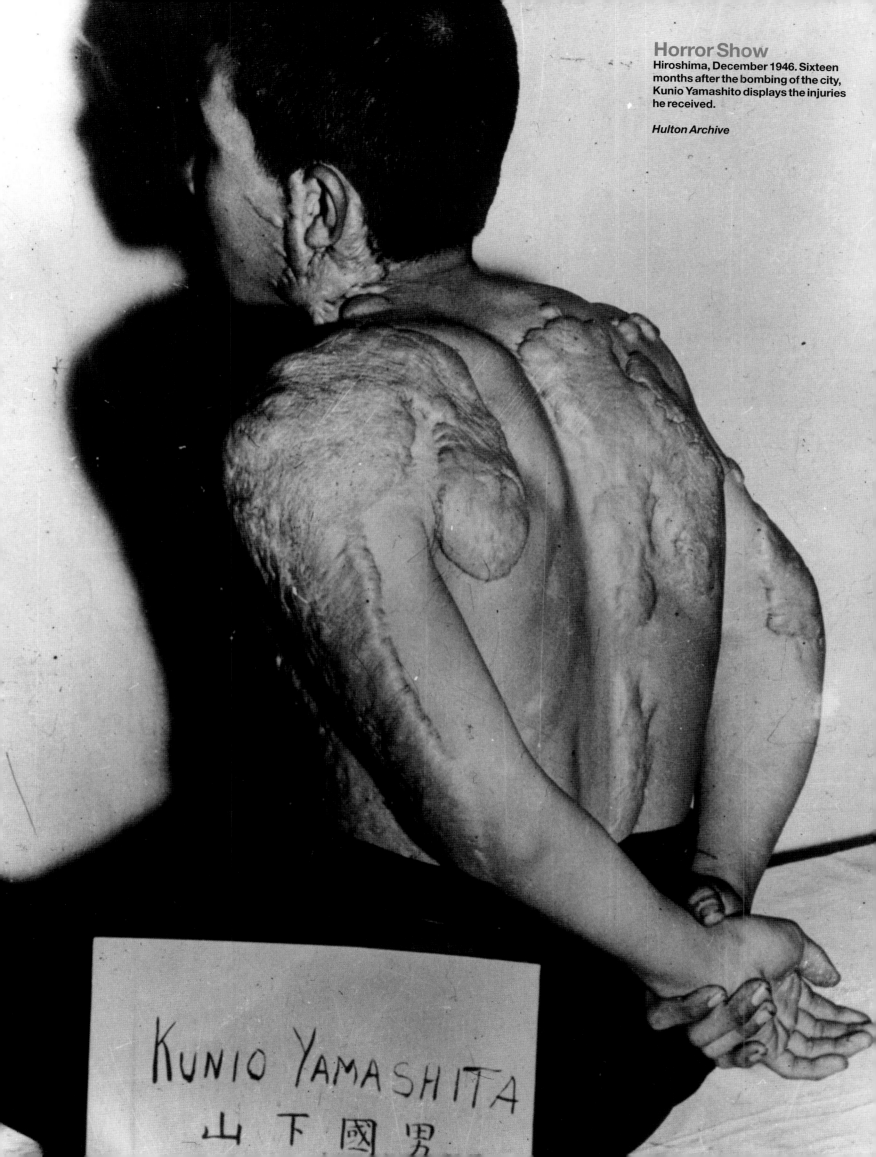

Private Army

(Above) Michigan, US, May 1937.
Henry Ford's "Servicemen" approach representatives of the United Automobile Workers with menacing intent outside the Dearborn factory. Seconds later, these security men assaulted the UAW activists in what became known as the Battle of Dearborn Overpass.

(Left) Michigan, US, 1932. A striker fighting with Ford Motor Company security men during a strike at the autoplant in Dearborn.

Hulton Archive

Henry Ford ran a tight ship. If a worker joined a union or expressed sympathy for the unions, he would be dismissed immediately. With poor wages, no paid holidays or vacations and no job security, employees were very vulnerable.

Ford appointed Harry Bennett to run the Ford service department. In this case, "service" meant running a gang of heavies, called "Servicemen", who controlled the factory through a well-informed spy network and employed intimidation and strong-arm tactics to keep the workforce in line.

In 1932, during the Great Depression, 3,000 hunger marchers who came to the River Rouge Ford plant looking for work were machine-gunned by the Service Department. Four marchers died and dozens were seriously injured. Ford's attitudes were as forthright as his industrial methods. "History is more or less bunk," he declared in 1916. He bitterly opposed US entry into World War I and blamed the conflict on international Jewish capitalists. His anti-Semitism became more pronounced as he supported the growth of the Nazi movement in America – Adolf Hitler was said to have kept a life-size portrait of Ford by his desk. Ford was one of only two non-Germans to be awarded the highest honour of the grand cross of the German eagle by Hitler. The other was Benito Mussolini, leader of fascist Italy.

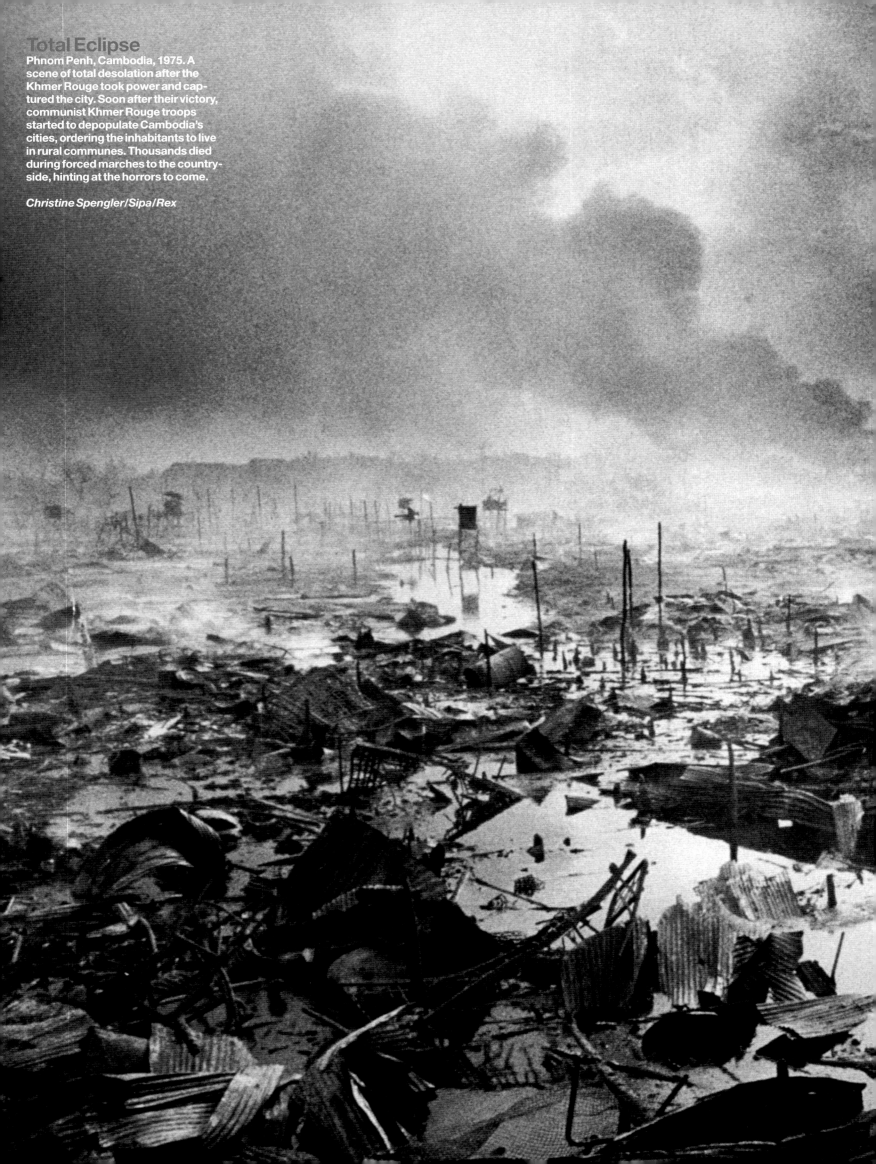

Total Eclipse

Phnom Penh, Cambodia, 1975. A scene of total desolation after the Khmer Rouge took power and captured the city. Soon after their victory, communist Khmer Rouge troops started to depopulate Cambodia's cities, ordering the inhabitants to live in rural communes. Thousands died during forced marches to the countryside, hinting at the horrors to come.

Christine Spengler/Sipa/Rex

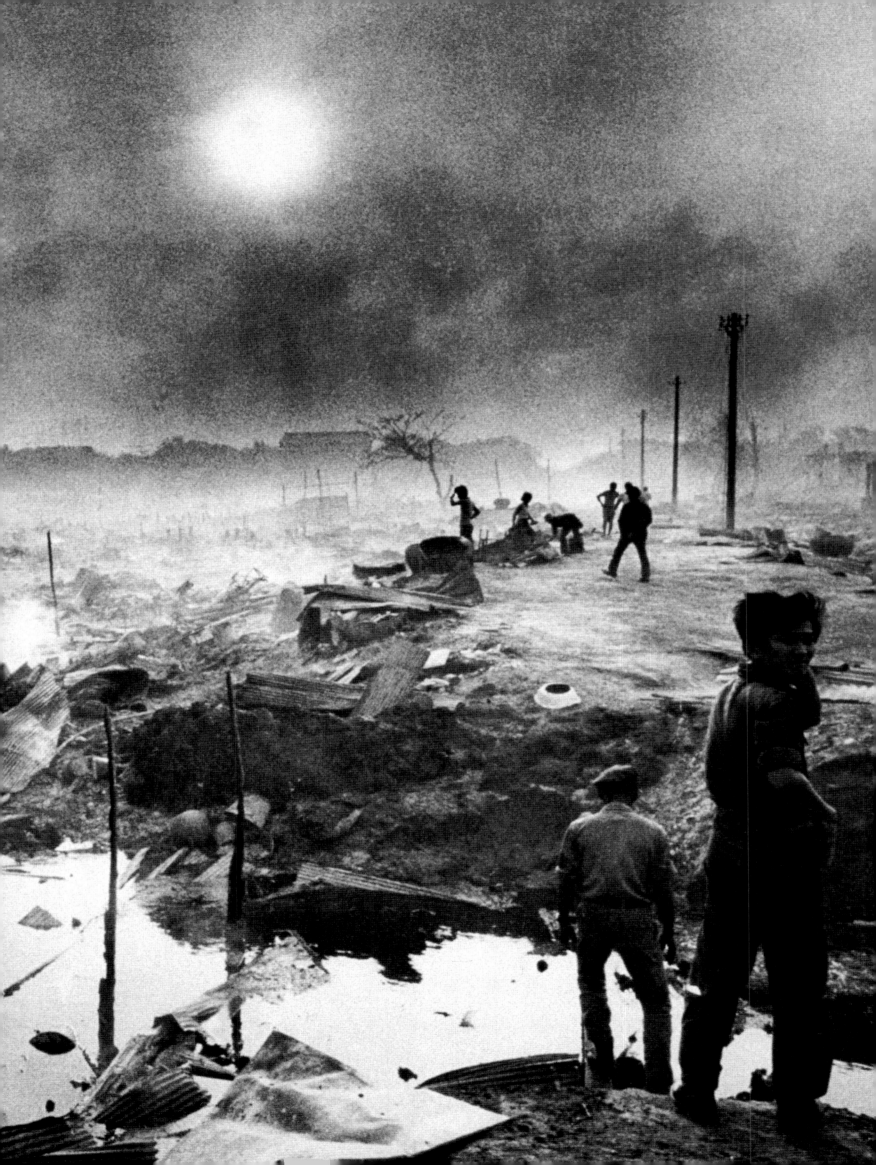

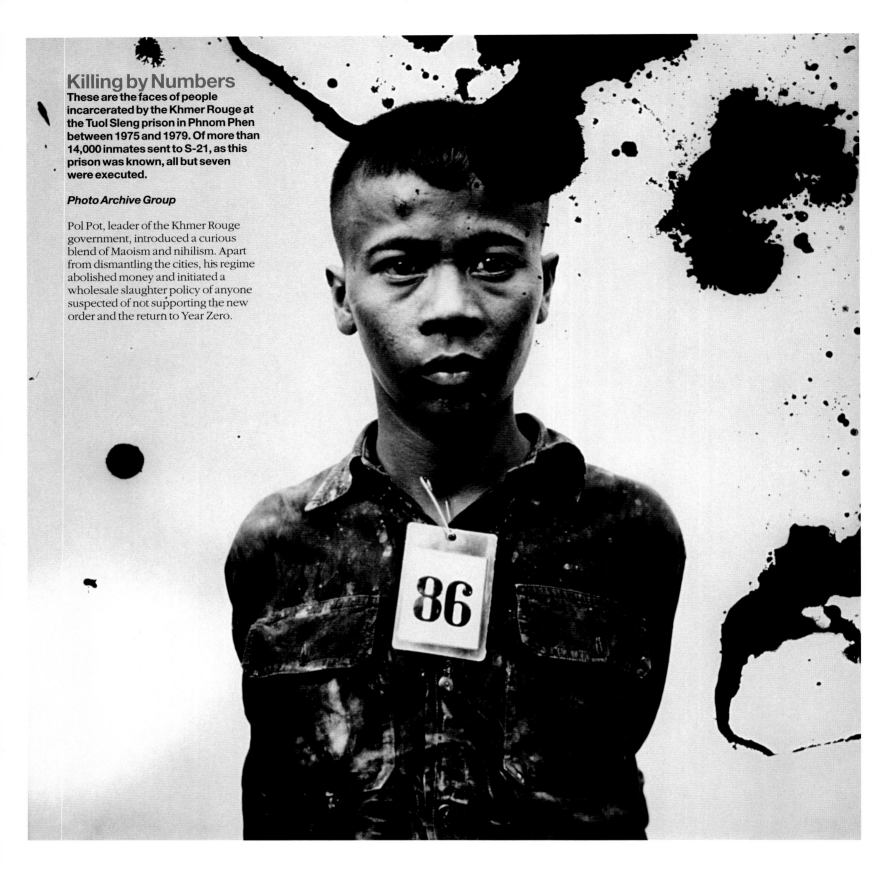

Killing by Numbers

These are the faces of people incarcerated by the Khmer Rouge at the Tuol Sleng prison in Phnom Phen between 1975 and 1979. Of more than 14,000 inmates sent to S-21, as this prison was known, all but seven were executed.

Photo Archive Group

Pol Pot, leader of the Khmer Rouge government, introduced a curious blend of Maoism and nihilism. Apart from dismantling the cities, his regime abolished money and initiated a wholesale slaughter policy of anyone suspected of not supporting the new order and the return to Year Zero.

When a confession had been forced out of the prisoners, they were taken in groups of about a hundred to the out-skirts of the city, made to dig their own graves, and were shot or had their skulls smashed with iron bars or hoes. The killers were military personnel assigned to S-21; one of them, interviewed later, said, "What else could I do? If I refused to kill the prisoners, I would have been killed myself."

The human cost of Pol Pot's revolution was catastrophic. In less than four years, it is estimated that almost 1,700,000 people died out of a total population of just under 8 million. Much of what went on was hidden from the gaze of the outside world, and it was only after Pol Pot's regime collapsed in 1979 and he fled the country that the visual evidence of his barbarities came to light. The new government sentenced him to death in absentia for genocide.

An artist who was sent to the notorious Tuol Sleng in 1977 recalls: "I was shackled at my wrists and ankles. Every time they tortured me, they covered my face. I don't know what they hit me with. They hung me upside down and lowered my head into water. They also kept pouring water down my throat. If I didn't keep swallowing I would drown. They put my hands in a box filled with scorpions after tearing my fingernails off slowly, a little at a time, until all were removed."

Another of the seven survivors, Vann Nath, interviewed while he was working at the Genocide Museum on the site of the former prison, described how he met a former guard of S-21 who came on a visit: "I recognised him immediately. When he saw me, he tried to cover his face with his scarf. But I grabbed him by the hand and pulled him into the cellblock. 'If you were me and you caught me like this, maybe you would kill me,' I told him. 'But I want to show you that not all people are evil like you. If you don't believe me, I'll take you out of here right now and tell all the people outside that you were a guard here. You will be killed immediately.'

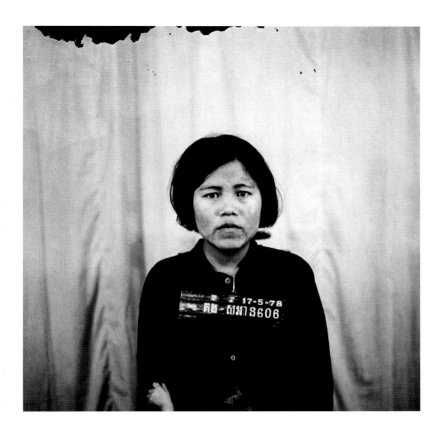

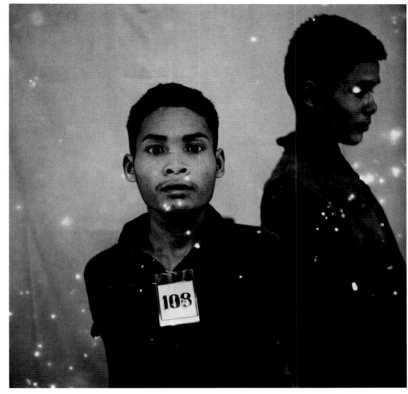

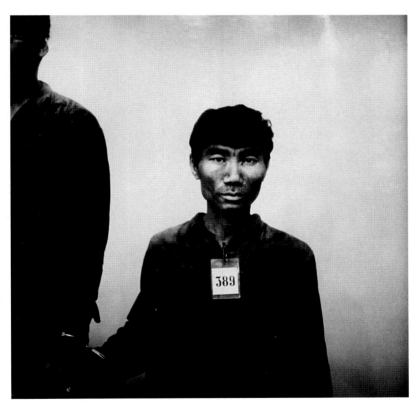

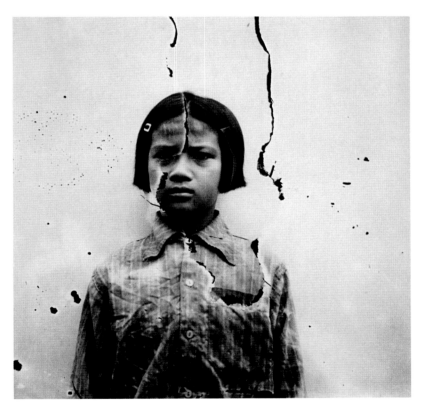

The guard had a blank look on his face, the look of an illiterate, unthinking man. He put the palms of his hands together and kneeled on the floor in front of me, begging me to spare his life. I looked at him for a long minute, and then I let him go." (Photo Archive Group, *The Killing Fields*)

The Khmer Rouge turned Tuol Sleng into a prison where anyone suspected of counter-revolutionary sentiments was interrogated, bullied, often tortured, forced into writing a confession and then, in any case, executed. The Khmer Rouge's blunt renaming of the school as "S-21" was unintentionally eloquent, echoing the way in which those who passed through the school gates and died inside themselves became just numbers. Their killers – the self-styled enemies of bureaucracy – turned out to be expert and meticulous bureaucrats, who kept not only a written record of each prisoner, including copies of confessions, but also a photograph of every one.

Following the chaotic retreat of Pol Pot's forces, much of the archive was looted and destroyed. Later, the US-based Photo Archive Group helped to salvage some 6,000 negatives, which are housed at the former school, now a museum commemorating the holocaust inflicted upon Cambodia.

A few years ago, the photographer responsible for these haunting images was discovered in Phnom Penh. Nhem Ein, now in his early 40s, joined the Khmer Rouge as a 10-year-old. He was sent to China for training and returned in May 1976 at the age of 16, when he became chief photographer at Tuol Sleng. Interviewed by Robin McDowell of the Associated Press, Nhem Ein estimated that he took about 10,000 photographs at S-21 and recalled seeing face after face filled with fear and deep sadness: "I knew that I was taking the pictures of innocent people, but I knew that if I said anything, I would be killed."

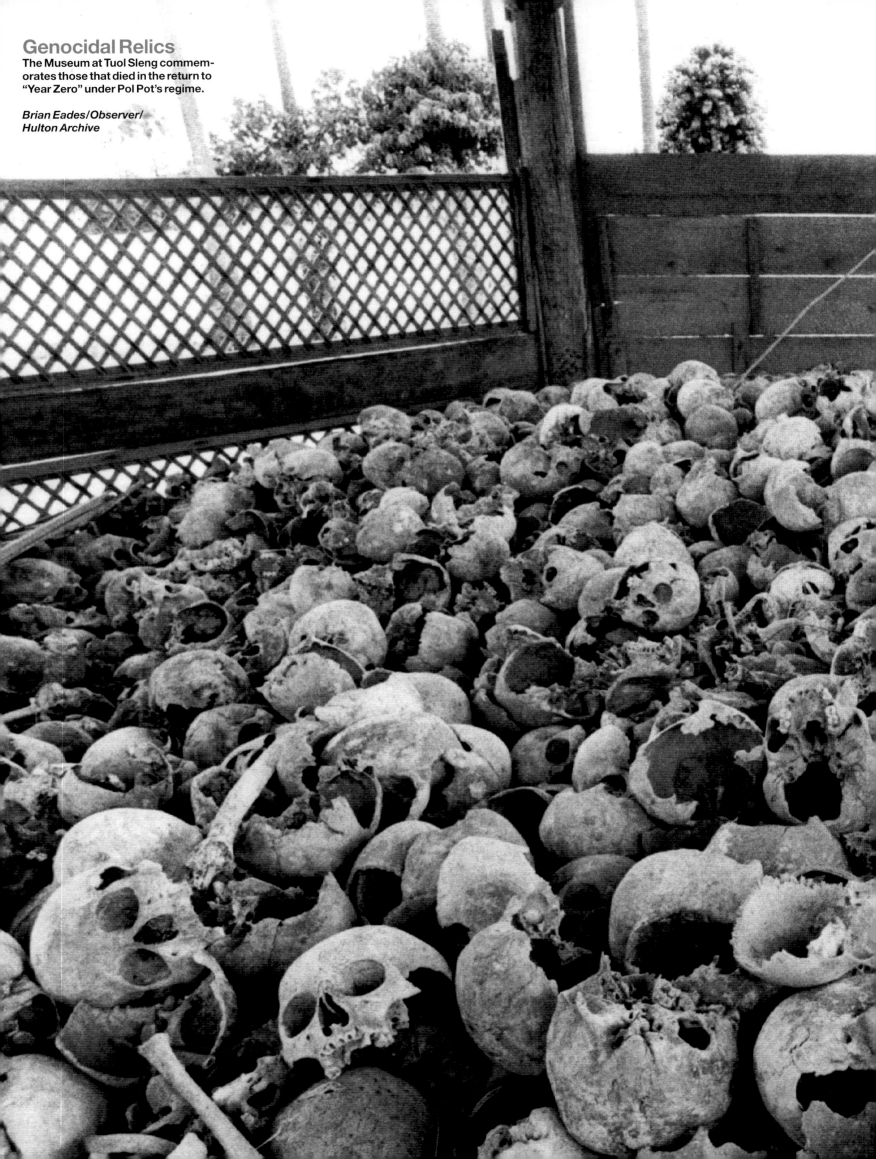

Genocidal Relics
The Museum at Tuol Sleng commemorates those that died in the return to "Year Zero" under Pol Pot's regime.

Brian Eades/Observer/ Hulton Archive

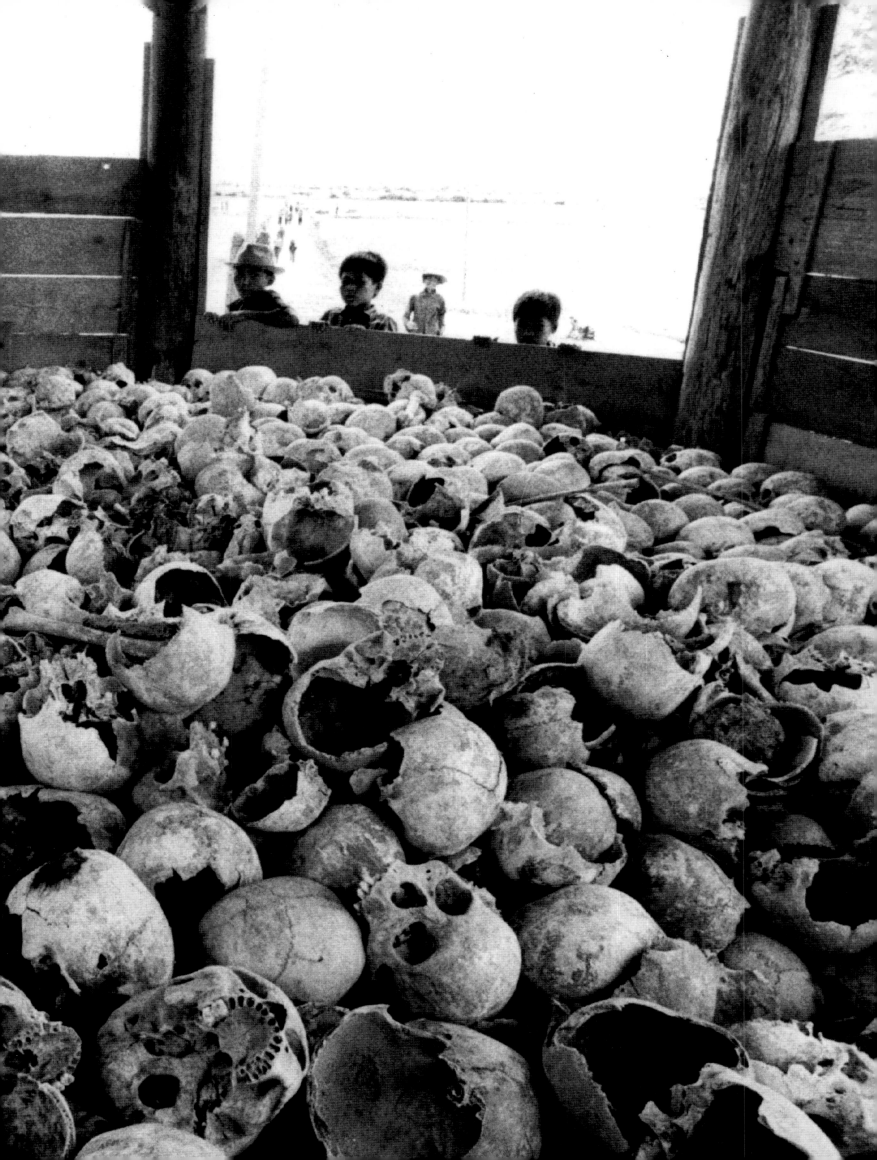

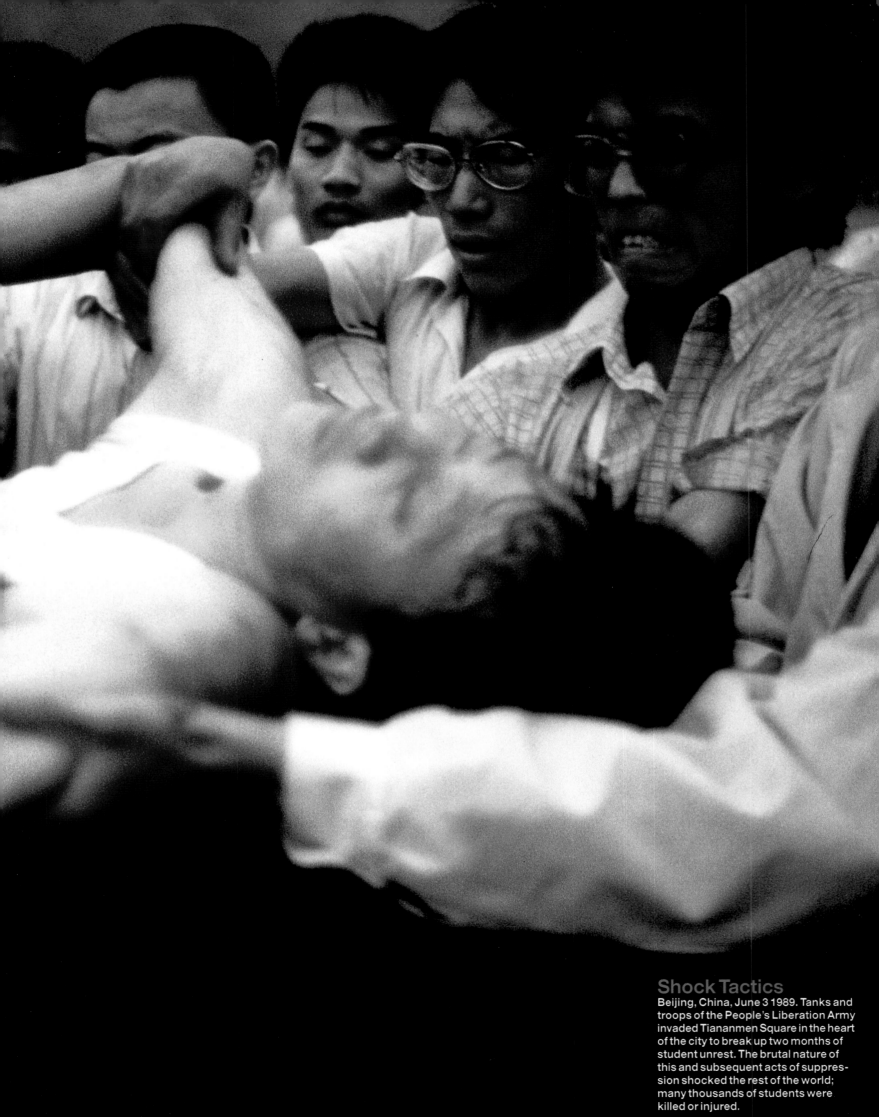

Shock Tactics

Beijing, China, June 3 1989. Tanks and troops of the People's Liberation Army invaded Tiananmen Square in the heart of the city to break up two months of student unrest. The brutal nature of this and subsequent acts of suppression shocked the rest of the world; many thousands of students were killed or injured.

Jacques Langevin/Corbis/Sygma

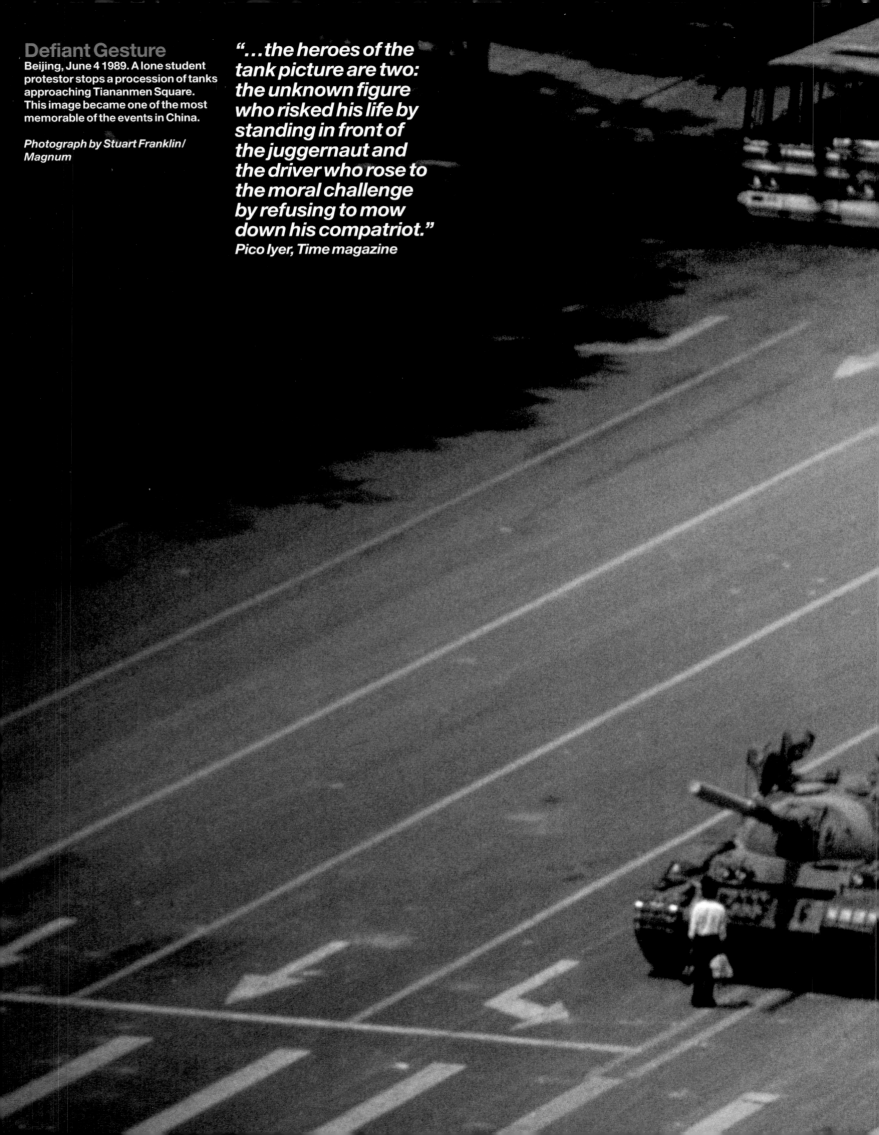

Defiant Gesture

Beijing, June 4 1989. A lone student protestor stops a procession of tanks approaching Tiananmen Square. This image became one of the most memorable of the events in China.

Photograph by Stuart Franklin/ Magnum

"…the heroes of the tank picture are two: the unknown figure who risked his life by standing in front of the juggernaut and the driver who rose to the moral challenge by refusing to mow down his compatriot."
Pico Iyer, Time magazine

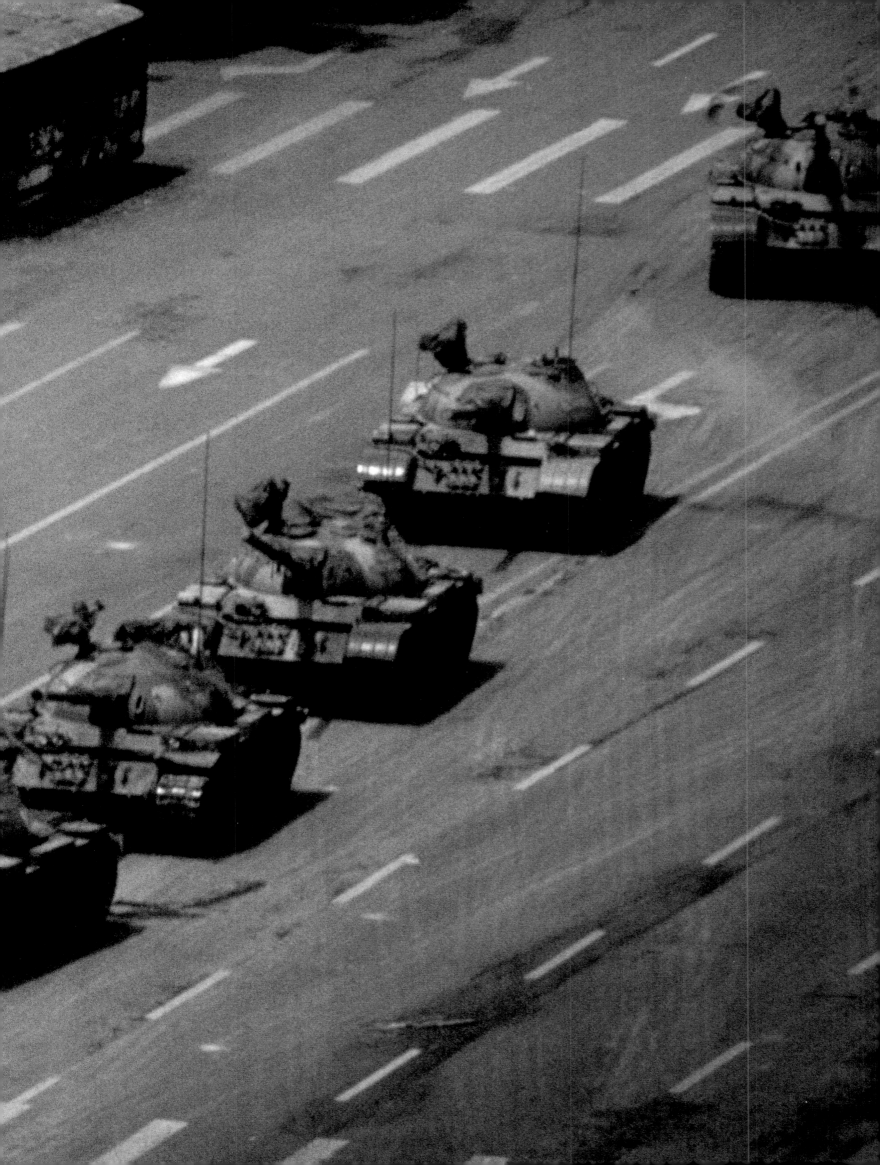

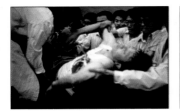 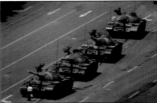

◀ As with many iconic photographs, the facts behind it are clouded in mystery. In his book *Photojournalism and Foreign Policy*, David D Perlmutter provides a comprehensive background to the image. When Wang Weilin, as he was subsequently identified, stood in front of the column of tanks on the day after the Chinese government's crackdown, he yelled, "Why are you here? You have done nothing but create misery. My city is in chaos because of you." The tanks tried to manoeuvre around him but he blocked them at every move, then climbed on the lead tank, trying to persuade the driver to turn back. Finally, his friends ran out and pulled him away. At least three photographers and several video crews were recording this scene from the windows of the Beijing Hotel.

Time magazine voted Wang Welin, the "unknown rebel", one of the "top 20 revolutionaries and leaders of the twentieth century". Tiananmen was the first media event in China covered by hordes of Western journalists and presented back home in easily digested, simplistic terms. "Chinese communism could liquidate more than a million Tibetans – yet this fact never seriously impaired China's prestige and inter-national credit. Why? There were no television cameras on the spot," Simon Leys pointed out in the *New York Times*. When news is not visually reported by Western photographers and camera-men, it fails to exist.

Perlmutter quotes Chai Ling, a student leader at Tiananmen, who gave a press conference on the first anniversary of the events and was asked what had happened to the young man who stood alone against the tanks. She replied she did not know but went on: "However, I know of a young woman [who] did exactly the same thing. She stood in front of a tank with one arm on her hip and the other arm waving in the sky trying to stop a tank, and the tank ran right over her. Even though she did the same courageous thing as [the man] but no – she didn't have the opportunity to be recorded by film or by photograph."

As Perlmutter points out, the Western consensus on the meaning of this photograph is challenged by pro-government Chinese spokesmen. "The tank did not crush him, or open fire on him. No matter how the American media distorted the facts by using this photo, anyone with any common sense would wonder how a man with nothing in his hands could stop a column of tanks. Isn't this proof that the martial law troops had exercised great restraint? It's all in how you look at it, and what you want to see… That famous picture … is seen around the world as the courage of one individual against military might and force. We see it differently. To me it is a symbol of the tolerance of the Army. The soldiers were very tolerant during most of the six weeks of the uprising until provoked in the streets at the very end."

Nothing is really known about Wang Weilin; indeed, even his name may be false. *Time* later referred to him as a 19-year-old student, son of a factory worker, and claimed he was sentenced to ten years' imprisonment for his non-violent protest. Other reports say he was a 26-year-old printer. A Hong Kong-based human rights group believes he is in hiding and was never arrested. Activists maintain he was executed without trial and does not appear in any records.

"It seems the fate of becoming an icon is to be stripped of identity. You become what others want you to become." (David D Perlmutter)

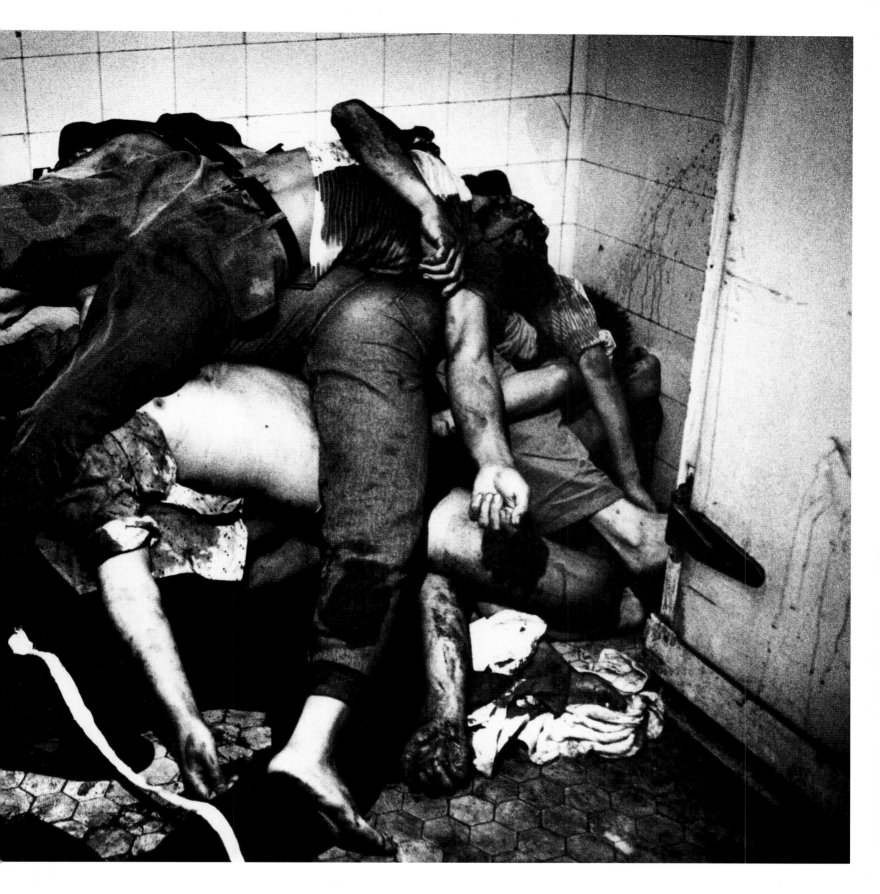

Lethal Response

The violence surrounding the events at Tiananmen Square peaked on June 3 and 4. Hundreds, possibly thousands of people were killed in the streets or in their houses by random fire from the People's Liberation Army. The Chinese authorities tried to downplay the violence, but photojournalist Dario Mitidieri was taken by a doctor to a room in a nearby hospital and shown these piled up bodies.

Dario Mitidieri

"The exact number of casualties will never be known, since a news blackout was imposed on the city, hospital records were suppressed, and families were forbidden to mourn those who had perished."

Jonathan Spence and Annping Chin, The Chinese Century

Last Orders

(Left) UK, 1954. Sir Winston Churchill, British Prime Minister, a year after he had suffered a serious stroke.

Hulton Archive

After 6 years in opposition, Winston Churchill became Prime Minister in October 1951. Many leading politicians in the Conservative Party had already begun to see him as an embarrassment after his vocal attacks on the Soviet Union and his refusal to accept that Britain should play a part in the growing movement for an integrated Europe. He was almost 77 and found it difficult to function effectively for long periods. He also had a heart condition and had survived three attacks of pneumonia, one almost fatal. He was increasingly deaf and suffered from a bad eye condition. Worse, he had suffered a minor stroke in Monte Carlo two years earlier. Nevertheless, his appeal to the country was still strong because of his wartime leadership. Whether the country would have voted him in as Prime Minister if they had had any real inkling of the state of his health is open to conjecture.

Cabinet memoirs from that time confirm that Churchill's mind frequently wandered and he "would talk about something for two and a half hours without once coming to the point".

In June 1953, he suffered a second, much more serious stroke that paralysed him down his left side and left him unable to walk. His memory began to fail and his speech became slurred. And yet the media, much influenced by the right-wing press baron Lord Beaverbrook, observed a blackout concerning his true condition, and politicians and advisers surrounding him continued to maintain he was Britain's "greatest asset". It was not until 1955 that he finally stepped down, but even then, he continued to stand for election as a backbench MP.

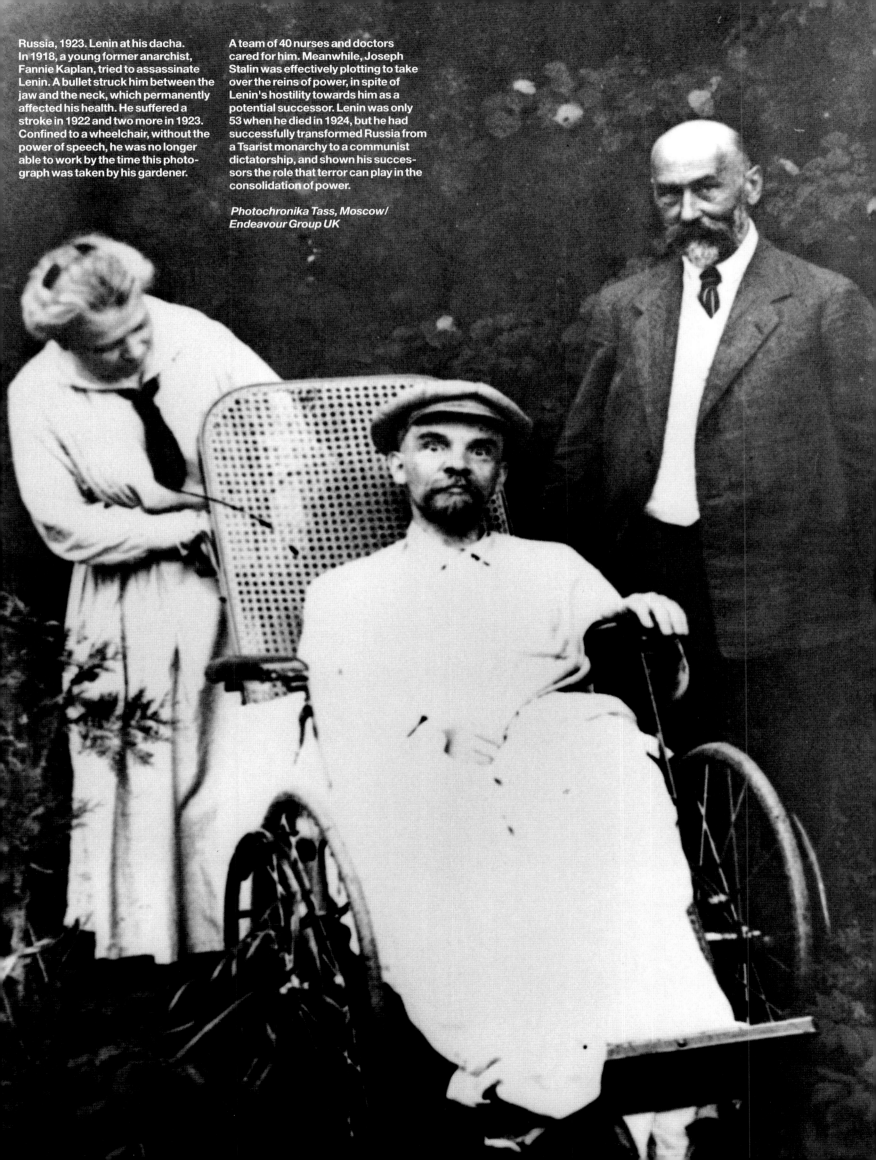

Russia, 1923. Lenin at his dacha. In 1918, a young former anarchist, Fannie Kaplan, tried to assassinate Lenin. A bullet struck him between the jaw and the neck, which permanently affected his health. He suffered a stroke in 1922 and two more in 1923. Confined to a wheelchair, without the power of speech, he was no longer able to work by the time this photograph was taken by his gardener.

A team of 40 nurses and doctors cared for him. Meanwhile, Joseph Stalin was effectively plotting to take over the reins of power, in spite of Lenin's hostility towards him as a potential successor. Lenin was only 53 when he died in 1924, but he had successfully transformed Russia from a Tsarist monarchy to a communist dictatorship, and shown his successors the role that terror can play in the consolidation of power.

Photochronika Tass, Moscow/ Endeavour Group UK

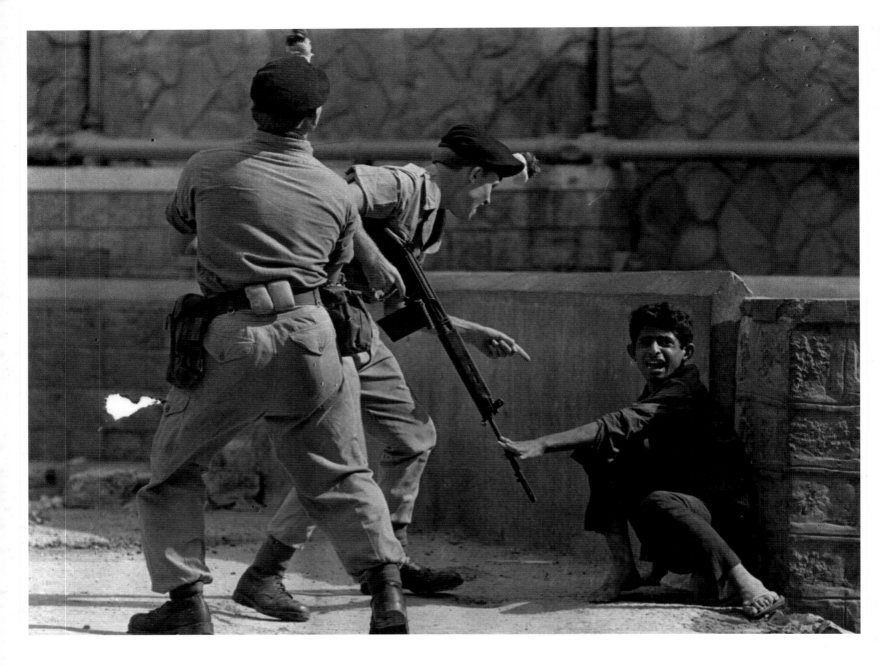

Last Gasps of the Imperial Dream

(Above) Cratev, Aden, 1967. British soldiers intimidate a young civilian during an Arab demonstration.

Hulton Archive

129 British servicemen were killed in Aden between 1965 and 1967 as Britain unsuccessfully tried to preserve the colony as part of the British Commonwealth. Arab nationalism was a growing force under the influence of Nasser's Egypt. Britain completed a humiliating withdrawal in November 1967. Aden became the People's Republic of South Yemen, and began looking to China and the Soviet Union for economic aid. These dying gasps of former British influence echoed the famous saying of the US statesman Dean Acheson in 1962: "Great Britain has lost an empire and not yet found a role."

(Right) Suez Crisis, Port Said, Egypt, November 1956. An Arab woman expresses her distress at the occupation by Anglo-French troops.

Hulton Archive

In July 1956, President Nasser of Egypt nationalised the Suez Canal Company, whose principal shareholders were the British government and French investors. Egyptians danced in the streets of Cairo at the news. Nasser's justification was that he needed the revenue from the canal dues to finance the Aswan dam on the Nile – just a week before, Britain and America had declined to finance this project. Nasser rejected compromise proposals, taking offence at economic sanctions imposed by Britain, France and the US. They could "choke to death on their fury", he proclaimed. And furious they were, especially since the Suez Canal was a vital lifeline for oil supplies to western Europe.

Tension was mounting at the same time between Egypt and Israel, and Israeli forces invaded the Sinai on October 29. With prior knowledge of this, the British and French airforces attacked Egyptian military bases on October 31 and landed airborne troops in a drive to capture the canal. This invasion provoked widespread condemnation around the world, not least from within Britain and France. The US and the Soviet Union were particularly incensed and within days, the Anglo-French operation was halted by international pressure and a UN peacekeeping force was sent to the region. The Suez crisis was a clear watershed in the post-war world – the value of sterling collapsed dramatically and France and Britain finally realised they could no longer act as a great power against the wishes of America and the Soviet Union. Nasser was driven further into the arms of the Soviet Union by the Anglo-French collusion with Israel, and the Western world's attention was deflected from events in Hungary, when Soviet troops invaded on November 4, ruthlessly suppressing the Hungarian National Rising.

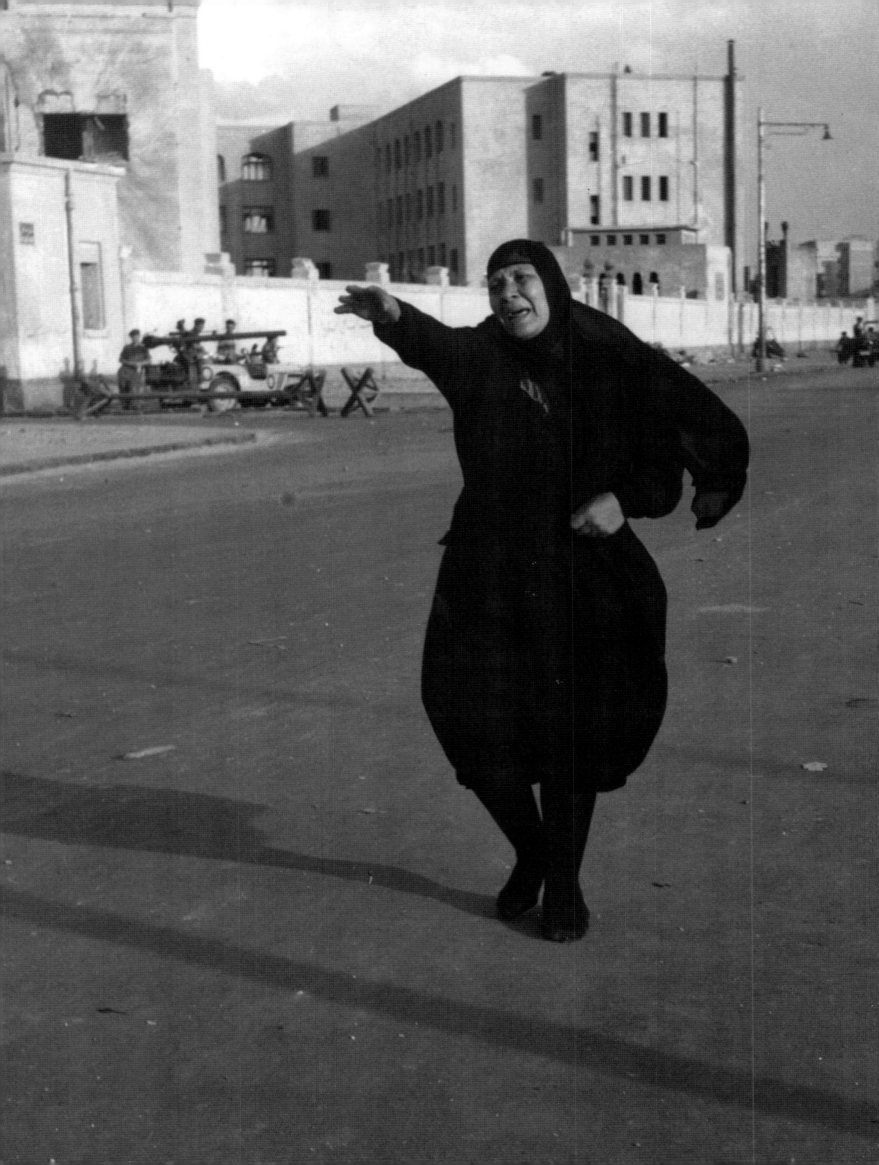

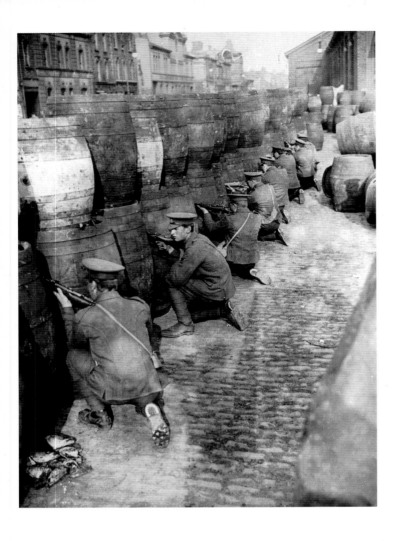

Making Martyrs

Easter Rising, Dublin, April 24 1916. While Britain was deeply involved in the Great War, a group of Irish nationalists called the Irish Republican Brotherhood took the opportunity to plan an armed rebellion seeking immediate independence from Britain. This image of British troops barricaded behind beer barrels did not send out an altogether convincing image of a government in control, but after a week of intense fighting, the insurgents surrendered.

Hulton Archive

Two years into the Great War, the German government were keen to encourage an Irish national uprising with promises of weapons and ammunition. 20,000 German rifles arrived off the Irish coast but the rebels failed to turn up to bring the weapons ashore. Led by Padraic Pearse and James Connolly, the uprising took place two days later than planned and only 1,000 of an expected 5,000 people joined in. The leaders read out a proclamation establishing a provisional government from the steps of the general post office, and this building became the rebels' headquarters. The British troops used heavy artillery to dislodge them, causing considerable damage to buildings and significant civilian casualties. Among the besieging British forces were some of the 100,000 Irishmen who had fought against the Germans on the western front and who were not happy about the rebels' German connections. 64 rebels died, as well as over a hundred soldiers and police. Support for the uprising was lukewarm at best and as the defeated nationalists were led away, many Dublin citizens greeted them with catcalls. Irish history is never simple. But when 15 of the rebel leaders were tried in secret and executed (an unwise move by the British), this immediately transformed public opinion in Ireland and gave the dead men martyr status. The botched uprising subsequently took on legendary significance in the annals of Irish independence.

Bloody Sunday

(Right) Londonderry, Northern Ireland, January 30 1972. British soldiers opened fire on a civil rights march, killing 14 unarmed men. Here, a bystander reacts with horror after Barry McGuigan was shot dead through the head.

Photograph by Gilles Peress/Magnum

At the beginning of 1972, the predominantly Catholic Civil Rights Association was planning a series of high-profile, peaceful marches to try to regain the political initiative from those intent on violence.

On January 30, a march in Londonderry came up against an army barricade and was diverted from the planned route. A small number of rioters started to throw stones at the soldiers. British paratroopers appeared on the scene and pursued the rioters to a block of flats. The troops opened fire, killing 13 Catholic civilians and wounding 12 others, one of whom died later. The world's press was in Northern Ireland at this time and the shootings provoked international condemnation. In the Irish Republic, protestors burnt down the British embassy.

Philip Jacobson and Peter Pringle claim in their book, *Those Are Real Bullets, Aren't They,* that the victims were killed "as part of a deliberate plan, conceived at the highest level of military command and sanctioned by the British government, to put innocent citizens at risk by authorizing the use of lethal force during an illegal civil rights march". The subsequent Widgery Tribunal admitted that "none of the deceased or wounded is proved to have been shot while handling a firearm or bomb", but in almost every other respect, the Tribunal report was a public relations cover-up and attributed no blame to the Army. Jacobson and Pringle maintain that the Lord Chief Justice, Lord Widgery, was directly lobbied by Conservative Prime Minister Edward Heath prior to what was supposed to be an independent public inquiry: "In his memoirs, Heath would insist that 'there was no attempt to interfere in Lord Widgery's deliberations'. But the official minutes record that he had one last piece of advice for the Lord Chief Justice. Heath urged him to bear in mind that in Northern Ireland, Britain was 'fighting not only a military war but a propaganda war.'"

In 1998, the Labour Government under Tony Blair tacitly accepted the inadequacy of the Widgery Report by appointing an entirely new inquiry under Lord Saville to establish the "truth" of what happened on Bloody Sunday almost 30 years before. Preparations for the Saville tribunal cost an estimated £15 million. By the end of 2001, more than 600 civilians and 500 soldiers had been interviewed.

The thoroughness of the Saville inquiry seems designed to arrive at an agreed version of the events of Bloody Sunday which people can accept as a truthful account of what took place. The whitewash of the Widgery Report made it difficult for moderate voices to argue persuasively for a constitutional solution to the conflict. Bloody Sunday and the Widgery conclusions significantly strengthened support for the Provisional IRA and drove many young people into the path of violence.

However, the best intentions of Lord Saville were challenged by a decision of the Law Lords in Britain in January 2002 that the former soldiers who carried out the shootings will not have to give evidence in person at the hearings in Londonderry. Moreover, earlier in the proceedings, a lawyer for relatives of one of those shot called for a separate hearing into the whereabouts of a thousand photographs taken by army photographers on Bloody Sunday. He alleged that the Ministry of Defence had failed to produce a single picture in spite of "maximum coverage" ordered that day and suggested there might be "a deliberate concerted policy" to prevent evidence reaching the inquiry.

To aid the memory of witnesses at the inquiry, conventional photographs have been used to reconstruct a "virtual reality walk-through" of the streets of Londonderry as they stood in 1972. On the website, www.source.ie, Sean Doran comments: "Talk of photographs being 'doctored' to assist in the preparation of evidence would in normal circumstances be anathema to the legal process; the deliberate distortion of reality does not sit easily with an objective search for the truth. There is surely some irony in the employment of this technique in the present context: a case of the camera lying in order to get at the truth?"

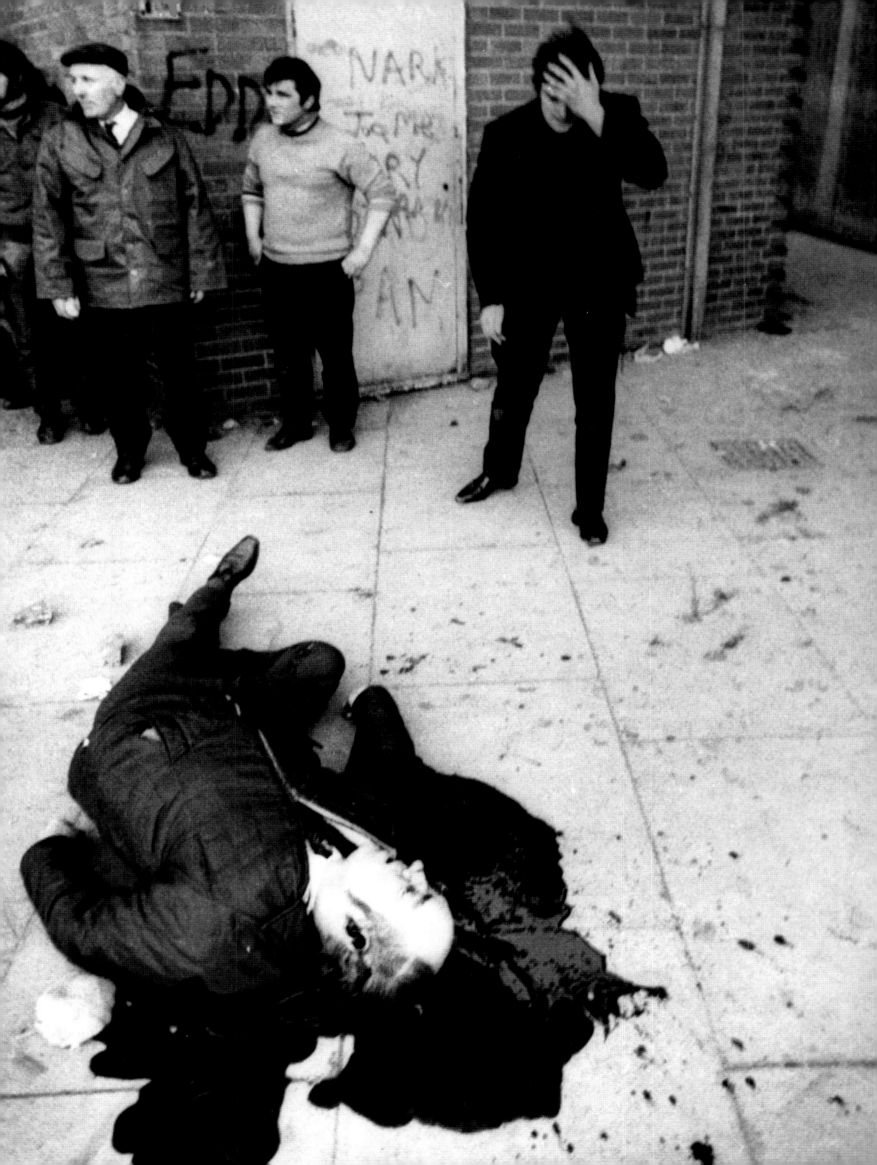

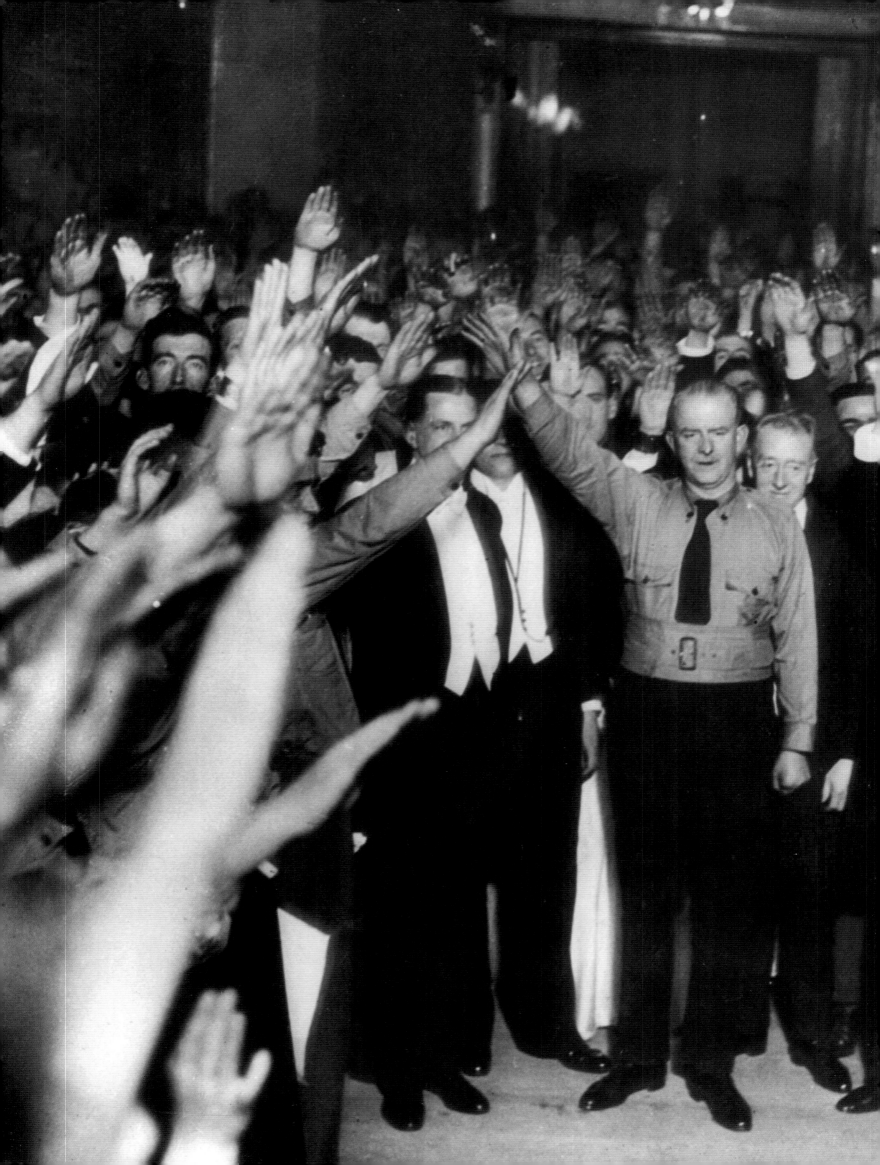

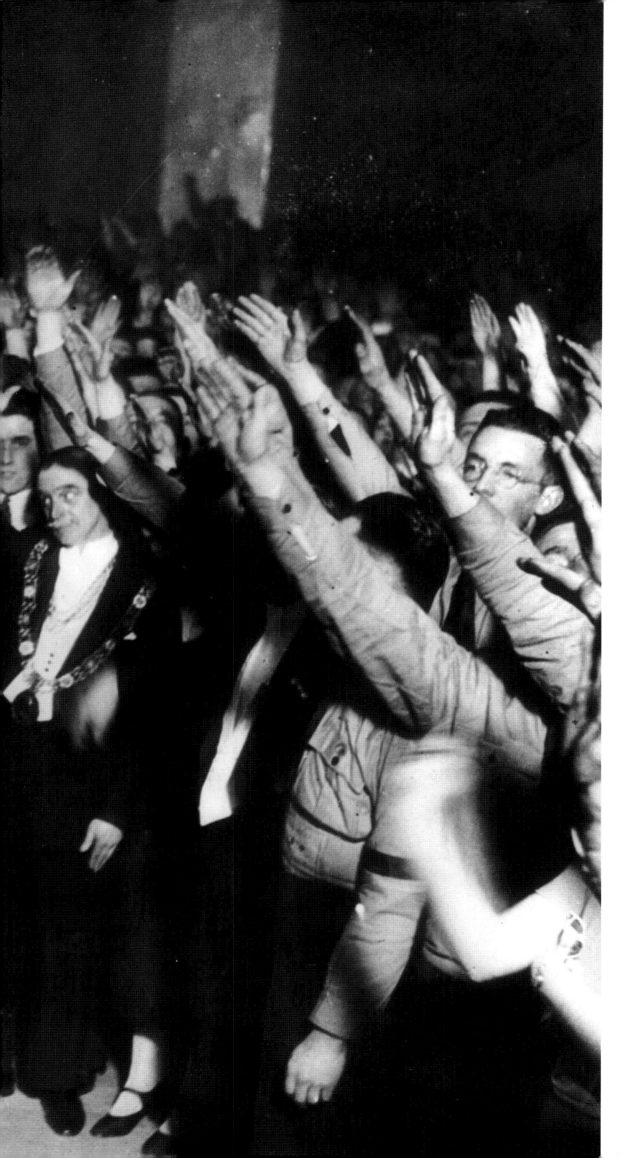

Green Fields and Blueshirts

Dublin, 1935. Irish fascist leader Eoin O'Duffy leads a rally of his Blueshirts. To his right is Alfred Byrne, Lord Mayor of Dublin.

Hulton Archive

A curious sideshow of Irish history was the Blueshirt movement in the 1930s, the Irish version of the Blackshirts of Oswald Mosley in the UK and Mussolini in Italy. A decade after the founding of the Irish state, the Blueshirts emerged out of anti-communist paranoia, strongly allied with anti-Semitism. A writer in the Blueshirt journal put it succinctly: "The founders of communism were practically all Jews. This can scarcely be a mere coincidence." The unlikely leader of the Blueshirts was an ex-police commissioner, Eoin O'Duffy, who had been a close colleague of Michael Collins during the war of independence against Britain and in the subsequent Irish civil war. In 1936, O'Duffy led a 700-strong Irish Brigade to fight on the side of Franco's fascists against the republican government of Spain. The Catholic Church in Ireland strongly supported the Blueshirt effort and after Franco's victory in the Spanish civil war, O'Duffy's little army marched through the streets of Dublin in a surprisingly well-attended parade.

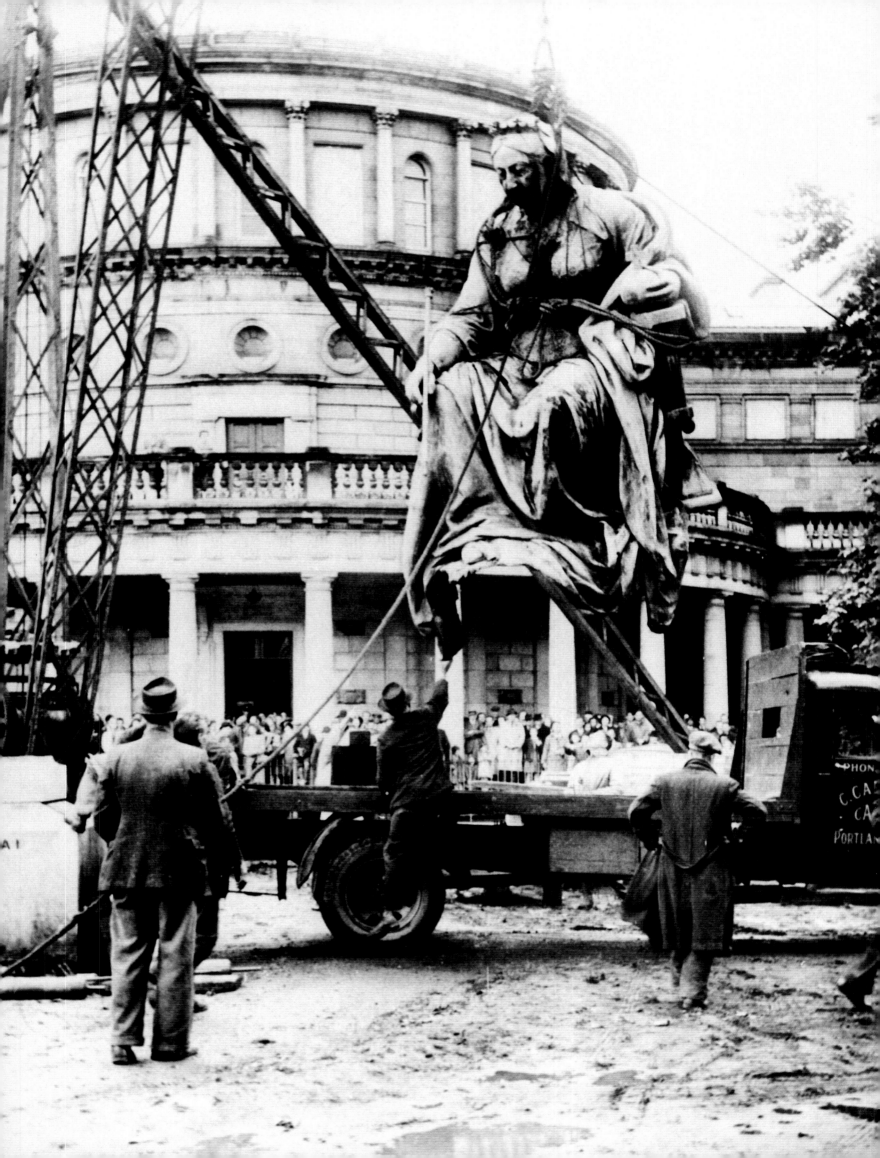

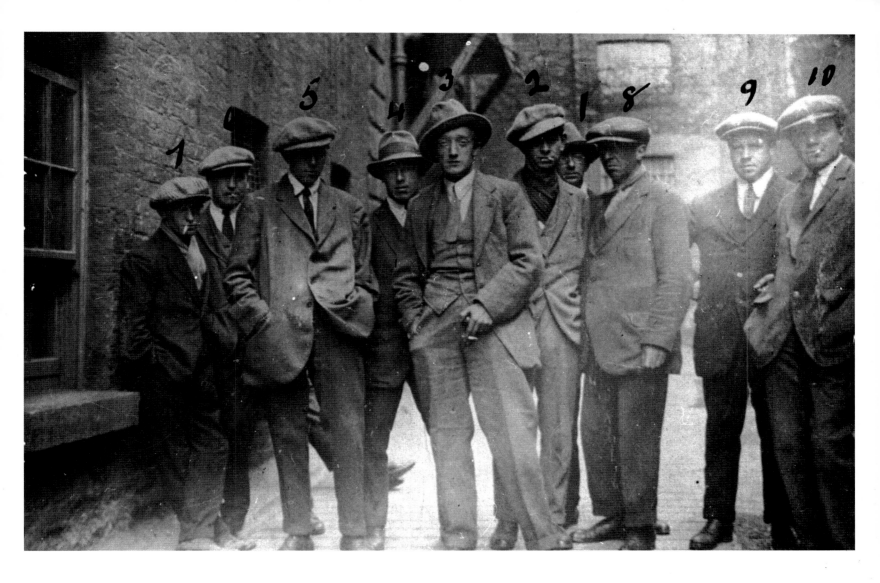

Deconstructing the Past

(Left) Dublin, 1948. The remnants of a troubled past. A statue of Queen Victoria is lowered from its pedestal outside the Irish Parliament. When communism crumbled at the end of the 1980s, former countries of the Soviet empire were quick to topple hated icons of Lenin and Marx; it took the Irish a quarter of a century to remove this potent symbol of British imperialism.

Courtesy Mrs GA Duncan

Biters Bit

(Above)The Cairo Gang were a group of British intelligence officers, so-called because of their wide experience in the Middle East. On November 21, 1920, shortly after dawn, they were murdered in their beds by IRA gunmen.

Hulton Archive

At the height of the Irish war for independence, terrible atrocities took place on both sides. Colonel Sir Ormonde Winter took charge of the British secret service effort in Ireland. When he brought in the Cairo Gang, the IRA moved to neutralise this threat.

The officers were living in rented rooms or hotels and the gunmen forced terrified maids to identify the relevant bedrooms. Some of the officers were dragged to other bedrooms so they wouldn't be shot in front of women and children.

Later the same day, in what seemed to be a clear reprisal attack, soldiers and the notorious Black and Tans special police surrounded the Gaelic Athletic Association's ground at Croke Park just before the start of a Gaelic football match. 12 people died as some of the crowd were shot, and others trampled to death when the crowd panicked. This became known as Ireland's first Bloody Sunday.

Dangerous Play

In March 1988, two British soldiers in plain clothes blundered into a republican funeral in Belfast and were beaten up and shot dead by IRA gunmen.

*Syndication International
Pacemaker Press, Belfast
Front page courtesy John Frost
Newspaper Archives*

David Modell, a freelance photo-journalist from London, was present at the funeral:

"The murder of the two British army corporals, Corporal Derek Wood and Corporal Robert Howes, came two days after three Catholics had been killed in Protestant Michael Stone's attack on another funeral, in the same cemetery.

An extremely tense procession was heading out of the dip in the Falls Road to start up the gentle incline toward Milltown Cemetery, the resting place of choice for most IRA volunteers, when a Volkswagen Passat began moving at speed backwards and forwards to our left. As the crowd panicked, fearing another loyalist attack, stewards and several other men descended on the car.

Some photographers and TV crews moved in with them. A shot was fired by one of the soldiers trapped in the car, and the crowd withdrew for a few seconds and then set on them again. Finally the corporals were pulled from their vehicle, beaten up and dragged across the road into a Gaelic football ground.

A few wiser photojournalists chose to leave immediately with the pictures they had taken; others, like me, continued on to the cemetery.

It soon became apparent that the men in the car were not loyalist paramilitaries but British soldiers, and the IRA had made the decision to kill them – they were shot and beaten to death, their bodies dumped in a nearby car park.

Just inside the cemetery gates, three or four other photographers and I were approached by two bulky-looking men in grey suits with shaved heads: 'We are from the PIRA [Provisional IRA]. One of us has a weapon. We want all the film you have shot today.'

We all handed over film from pockets and cameras and were briefly frisked. When they had collected several rolls from each of us they moved back to join the mourners.

This had been a bad PR day for the republicans – something they quickly realised. They were well aware that these images would portray a moment of real brutality and they wanted to stop the pictures making the newspapers.

As it happened, a number of photo-graphers did manage to release pictures – some of which have become the most disturbing and graphic images of the Irish Troubles."

It remains a mystery as to why the British soldiers made such a fateful mis-judgement and approached the IRA funeral in the first place.

The *Sunday Telegraph* in Britain was the only newspaper to publish these photographs prominently. In *War Photography*, John Taylor describes how the *Sunday Telegraph* printed fourteen letters under the headline "Should we have published lynching pictures?". One reader felt "horror, revulsion, outrage and hatred", and then became "increasingly calm and rational", finally deciding "it was an excellent piece". But another corres-pondent said: "The photographs of the slain soldier greatly distressed me. I was put off my Sunday worship, my Sunday lunch and had a disturbed night's sleep."

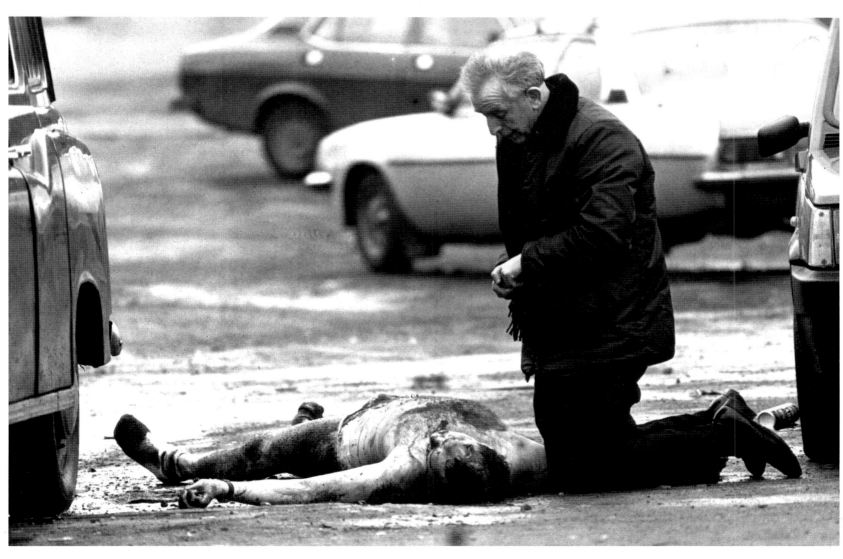

Truth Games

Ottoman Empire, 1915. Great controversy surrounds this photograph. It shows an Armenian woman with her two children who died in the genocide of 1.5 million Armenians during World War I.

Hulton Archive

The photograph was taken by Armin Theophil Wegner, a German lawyer and poet who was working with the German Army Sanitary Corps during the War. It now belongs to an historical archive in Germany.

The journalist Robert Fisk, writing in the British *Independent* newspaper, pointed out that when the photograph was published recently, the Turkish embassy in London objected to the use of the word "massacre" in the caption, claiming instead that the Armenians had starved to death and were not killed by Ottoman Turkish troops. As Fisk observed: "This extraordinary argument… would presuppose that Jews starved to death by the Nazis in the second world war could not be counted victims of the Jewish Holocaust."

Fisk described this as part of a concerted effort by the Turkish government to rewrite history and deny the Armenian massacres. "They have funded academic chairs at American universities with the purpose of questioning details of the genocide and they have threatened economic sanctions against European countries which accept the facts of the genocide. When President Chirac went public in February 2001 and accepted the massacre as fact, Turkey cancelled arms and construction contracts with France worth millions of pounds."

Turkey prefers to believe that the Armenians died in "civil unrest" in spite of eyewitness accounts by US diplomats and missionaries. They brush aside harrowing reports of mass executions by firing squads of tens of thousands of Armenian men and the forced deportation of women and children into the deserts to face rape and starvation.

Wegner took photographs at great personal risk after visits to Turkish concentration camps in the Syrian desert near Aleppo. Mrs Tessa Hoffman, of the Centre for Documentation and Information on Armenia, based in Berlin, confirms their authenticity: "The pictures are perfectly genuine. In his diary, Armin records seeing all these bodies of starved Armenians around the camps and taking their photograph. He wrote that many of the bodies had become 'petrified', stiff and unchanging after death."

Fisk also traced the first reproduced copy of the picture, in an American journal also called *The Independent*, on October 18, 1915. The article begins: "The most extensive, the most atrocious of religious massacres which the world has seen for centuries is now being perpetrated in Turkey."

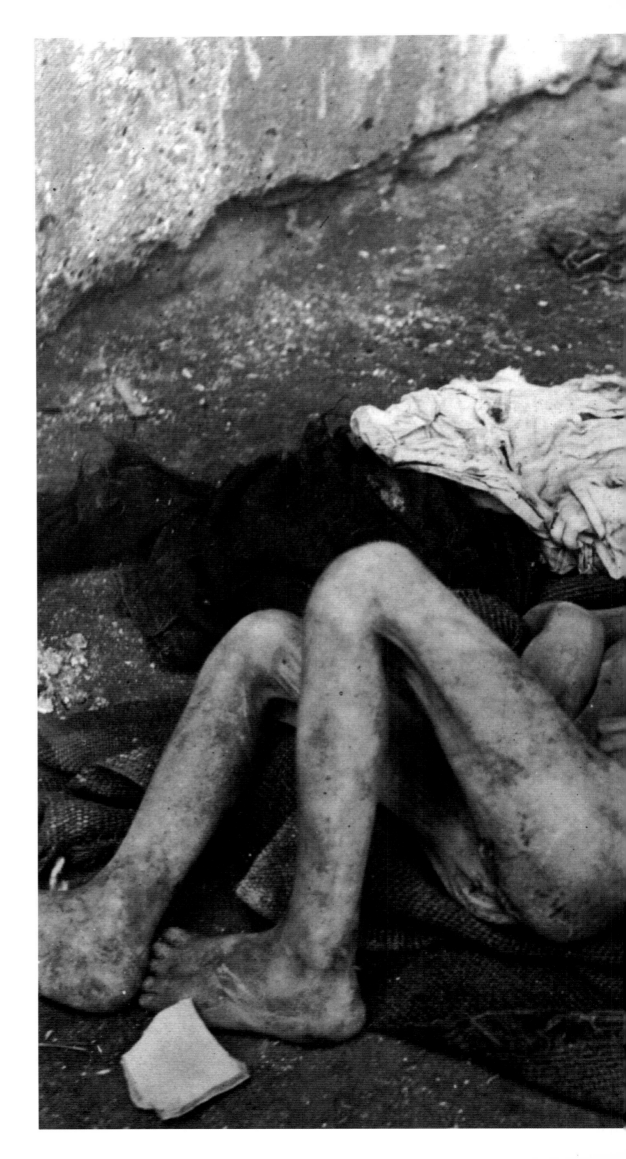

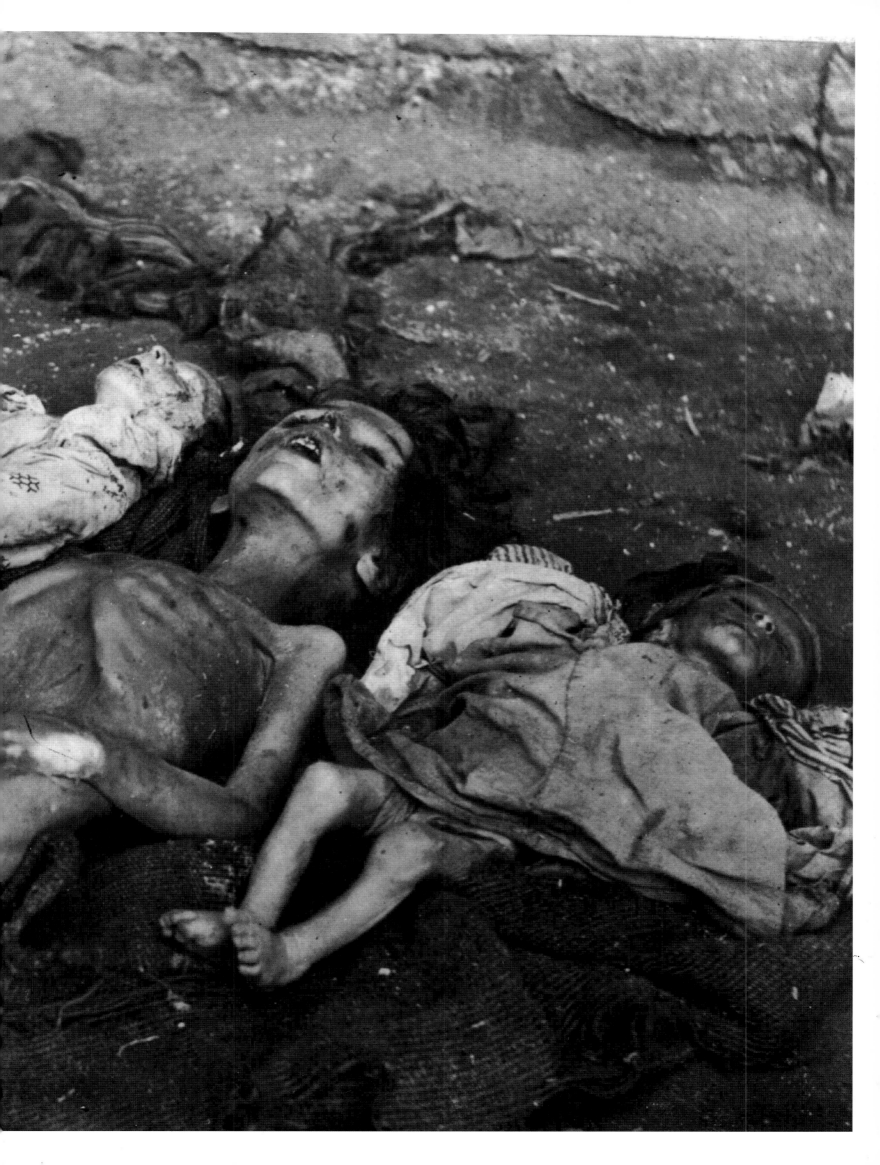

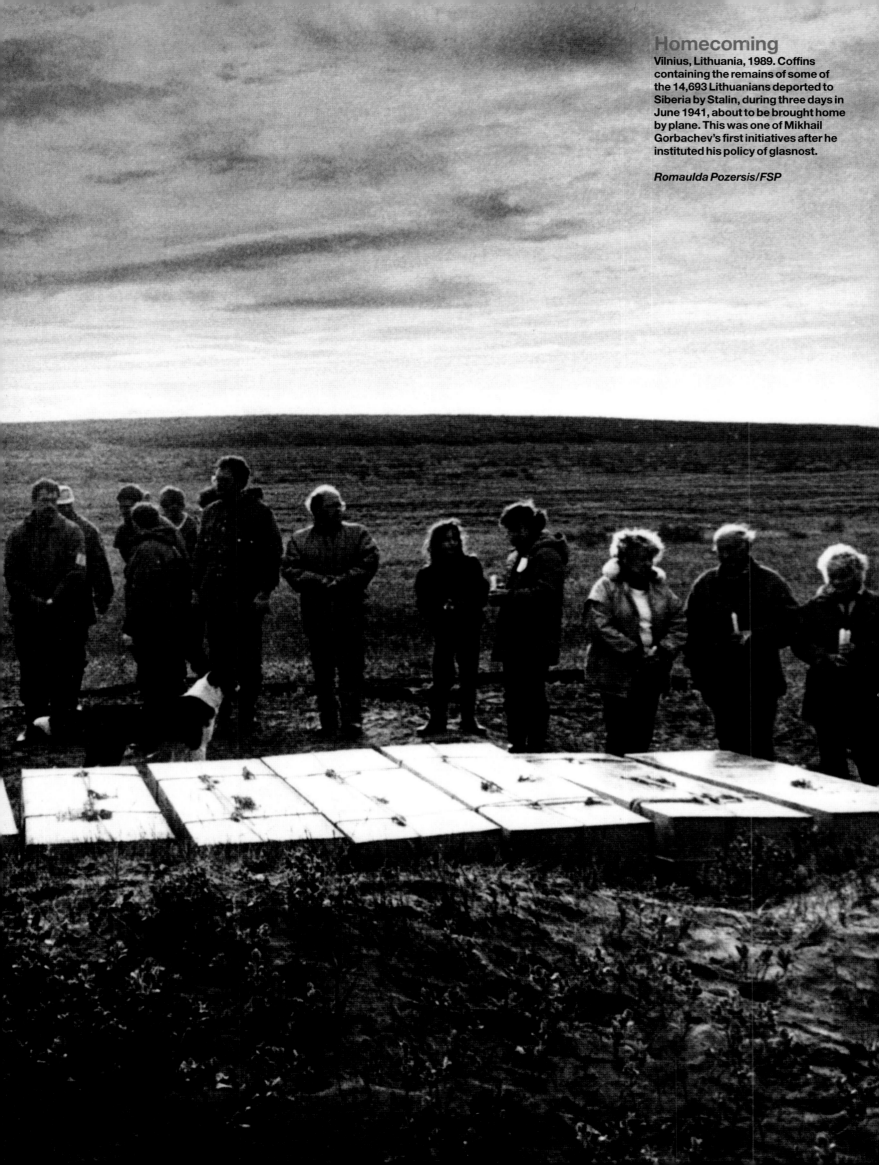

Homecoming

Vilnius, Lithuania, 1989. Coffins containing the remains of some of the 14,693 Lithuanians deported to Siberia by Stalin, during three days in June 1941, about to be brought home by plane. This was one of Mikhail Gorbachev's first initiatives after he instituted his policy of glasnost.

Romaulda Pozersis/FSP

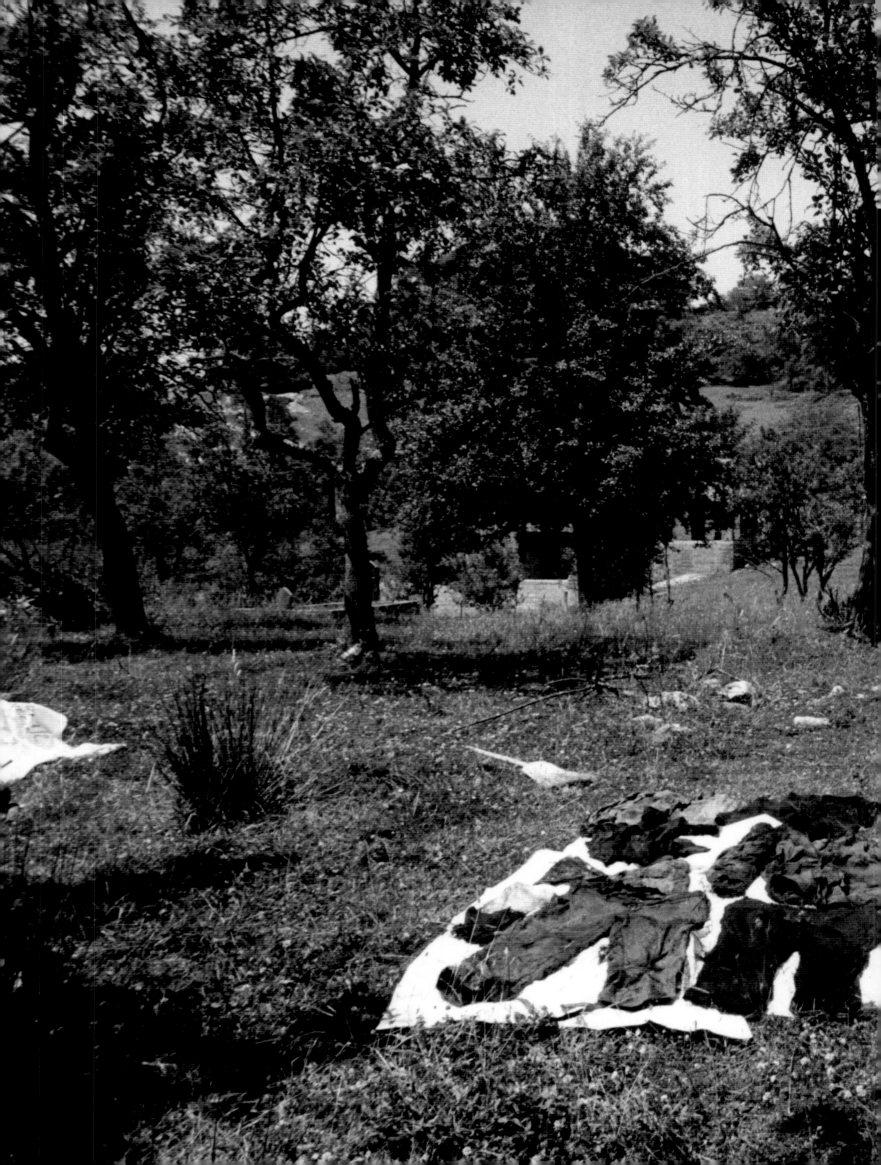

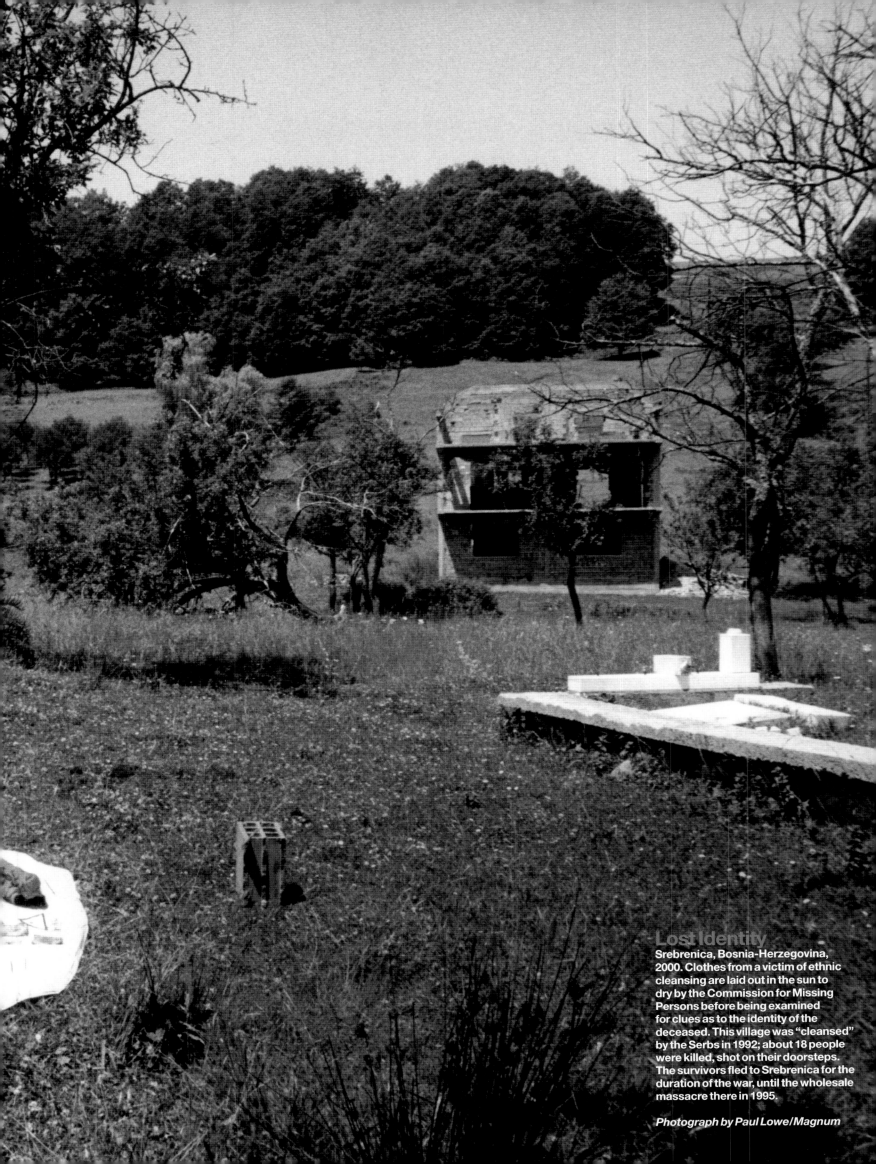

Lost Identity

Srebrenica, Bosnia-Herzegovina, 2000. Clothes from a victim of ethnic cleansing are laid out in the sun to dry by the Commission for Missing Persons before being examined for clues as to the identity of the deceased. This village was "cleansed" by the Serbs in 1992; about 18 people were killed, shot on their doorsteps. The survivors fled to Srebrenica for the duration of the war, until the wholesale massacre there in 1995.

Photograph by Paul Lowe/Magnum

When photography is unable to be present at, or is prevented from reporting some catastrophic event, it can only record the aftermath. George Rodger, co-founder of Magnum, was among the first photojournalists to arrive in Belsen concentration camp in 1945. Deeply shocked, he set about recording what he saw with calm detachment. Subsequently, he vowed never to photograph war and strife again, but his visual documentation formed part of the evidence which convinced the world of the Nazi leaders' crimes against humanity.

Photographs will undoubtedly feature prominently in the trial of Slobodan Milosevic, former Serb leader, for crimes against humanity at the Court of International Justice in The Hague.

Truth and Lies

The Truth and Reconciliation Commission was South Africa's attempt to come to terms with a tyrannical and violent past. The photographer Jillian Edelstein attended these hearings and took portraits both of those who had carried out atrocious crimes and those who had suffered the consequences. Amnesty was granted to those who were prepared to attend the hearings and fully disclose their deeds.

(Right) Dirk Coetzee commanded a "counter-insurgency" unit and was responsible for ordering the killing of many African National Congress activists. He was granted amnesty by the TRC. He told Jillian Edelstein: "I take my gun everywhere, even when I go to the toilet."

(Below left) Joyce Mtimkulu, Siphiwo's mother, holding a chunk of hair that fell out after he had been fed rat poison in prison. She kept it in a black plastic bag that she took to the hearings so she could hold it up, whenever needed, as evidence.

(Below right) Gideon Nieuwoudt (left), with a member of the witness protection team, testified that he had participated in the killing of Siphiwo Mtimkulu in 1982. He and two colleagues from the security police kidnapped Siphiwo and a friend, interrogated them, tortured them, shot them in the back of the head and burned their bodies.

Jillian Edelstein/
Network Photographers

The TRC was set up in 1993 to investigate the hidden secrets of the apartheid years as well as the alleged atrocities by the ANC during their liberation struggle. Hearings started in 1995 and were concluded in June 2001. Michael Ignatieff points out in his introduction to Jillian Edelstein's book *Truth And Lies* that, although the aim of the TRC was to achieve some form of catharsis of the legacy of violence, neither the former president, F W de Klerk, nor the current president, Thabo Mbeki, were prepared to accept all the findings of the TRC report. "Most senior figures in the apartheid era regime refused to accept responsibility for torture, killings and other abuses lower down their own chain of command." At the same time, senior figures in the ANC rejected the commission's standpoint "that human rights violations remain abuses even when the cause is just".

"What the TRC uncovered was... a system, a culture, a way of life that was organised around contempt and violence for other human beings."

Joyce Mtimkulu "pursued Nieuwoudt for 20 years – long before the Truth Commission began – and he even came to her house to threaten her, then to torment her by telling her what had happened, then to confess. It was a strange relationship. They could not leave each other alone, this perpetrator and his victim". (Michael Ignatieff)

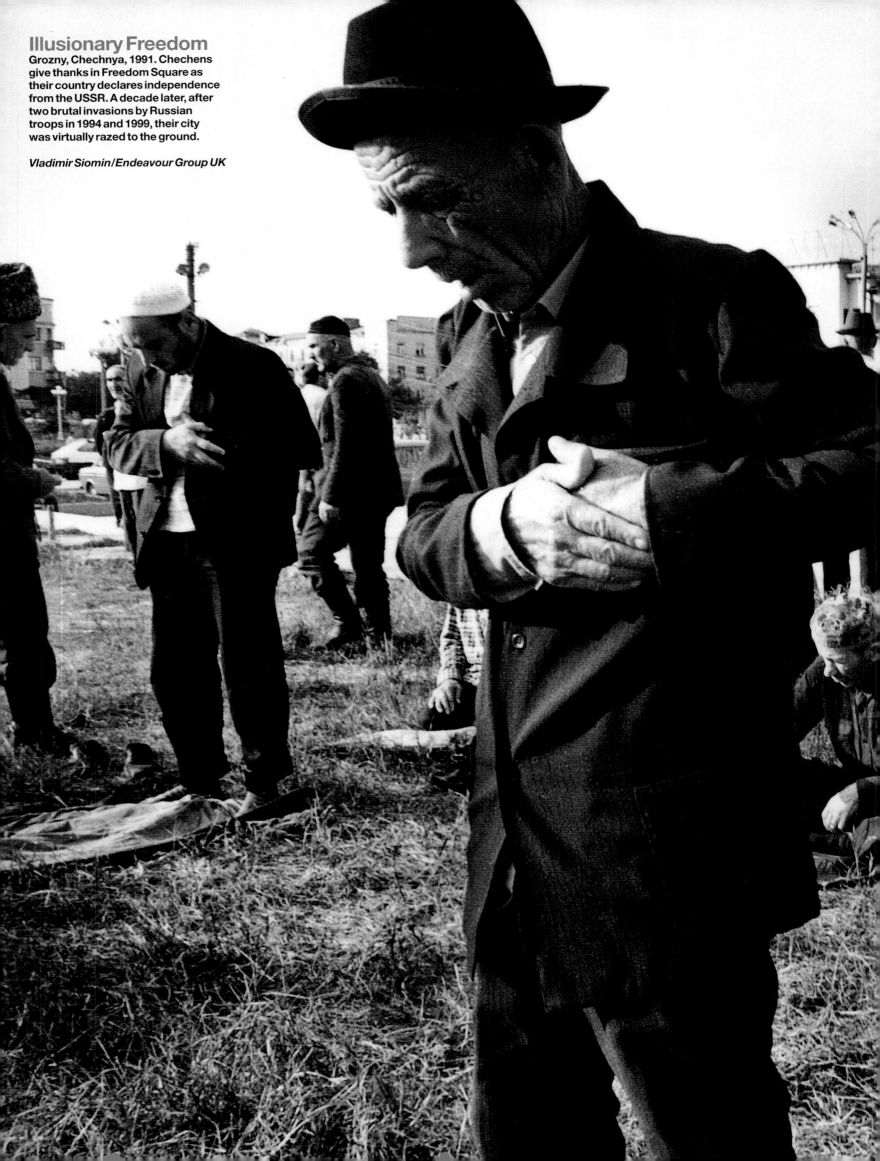

Illusionary Freedom

Grozny, Chechnya, 1991. Chechens give thanks in Freedom Square as their country declares independence from the USSR. A decade later, after two brutal invasions by Russian troops in 1994 and 1999, their city was virtually razed to the ground.

Vladimir Siomin/Endeavour Group UK

The Forgotten War

Early in 2000, the Russian army captured Grozny and other key Chechen cities "after the most ferocious artillery barrages in Europe since the Second World War". (Jonathan Steele, *London Guardian*, July 2001)

Anthony Suau/ Network Photographers

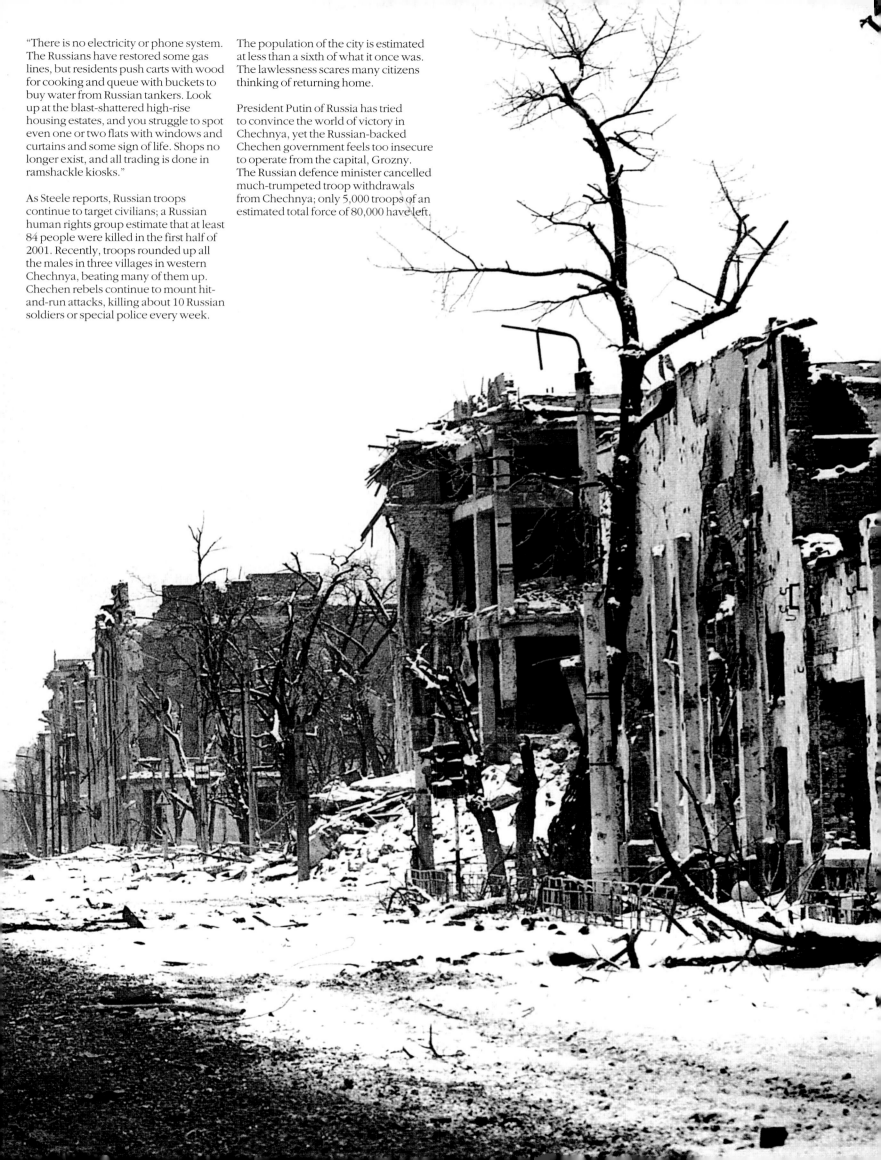

"There is no electricity or phone system. The Russians have restored some gas lines, but residents push carts with wood for cooking and queue with buckets to buy water from Russian tankers. Look up at the blast-shattered high-rise housing estates, and you struggle to spot even one or two flats with windows and curtains and some sign of life. Shops no longer exist, and all trading is done in ramshackle kiosks."

As Steele reports, Russian troops continue to target civilians; a Russian human rights group estimate that at least 84 people were killed in the first half of 2001. Recently, troops rounded up all the males in three villages in western Chechnya, beating many of them up. Chechen rebels continue to mount hit-and-run attacks, killing about 10 Russian soldiers or special police every week.

The population of the city is estimated at less than a sixth of what it once was. The lawlessness scares many citizens thinking of returning home.

President Putin of Russia has tried to convince the world of victory in Chechnya, yet the Russian-backed Chechen government feels too insecure to operate from the capital, Grozny. The Russian defence minister cancelled much-trumpeted troop withdrawals from Chechnya; only 5,000 troops of an estimated total force of 80,000 have left.

"When politicians and civil servants hear the word 'culture', they feel for their blue pencils."
Lord Esther, House of Lords, 1960

Jean Straker

The Story of a Maverick

The Academy of Visual Arts in Soho, London, was an unlikely centre for resistance to public censorship. It was the brainchild of a rebellious character, Jean Straker, a photographer who specialised in nudes. However, he frequently fell foul of the law in Britain because he insisted on showing pubic hair. He was prosecuted three times under the Obscene Publications Act and twice under the Post Office Acts, and 1,400 of his negatives were confiscated.

In 1929, a prosecution relating to drawings by the author DH Lawrence established that the portrayal of pubic hair was obscene in law. It was not until 1959 that Parliament established the right of artists, photographers and publishers to challenge an obscenity ruling. In 1963, Straker took on the Director of Public Prosecutions, conducting his own case, and won the right to regain his confiscated negatives. He also pursued an appeal against a magistrate court ruling and established that his unretouched photographs were not of themselves obscene in law. Straker's energetic pursuit of a campaign against "a bigoted minority" led indirectly to the introduction of the 1964 Obscene Publications Bill, which relaxed many of the restrictions on artistic freedom of expression.

Straker was born in London in 1913, the child of a Russian émigré and an English mother. At one point, the family moved to Paris, where both his parents appeared in the chorus line of the *Folies Bergère*. Straker recalled: "My earliest memories are of being surrounded by naked ladies in the dressing rooms. That was what made going to school in England so strange afterwards. All the mysteries were known to me. I had to keep quiet when the other boys talked about girls."

Amateur photographers came from all over the world to study at Straker's Academy and others received correspondence courses in the art of photographing nudes. The Academy had 100 members who came along to photograph nude models and use the club's social facilities. One member recalled: "A lot of the members came to be provoked by naked women, but the odd thing was that an air of fusty puritanism pervaded the place. There was nothing remotely naughty about it."

Staker condemned all forms of visual censorship because "visual censorship is rather different to word censorship. I regard the visual media as primarily media of understanding, not enticement… I don't think that anybody should be denied the right to look at anything he wants to look at."

Straker's early introduction to the female form led him to declare: "People are getting in their minds false concepts of the human body, which are bringing them into conflict with reality. So that a man who is brought up on a diet of retouched nudes, when he first sees his wife's pubic hair, is inclined to think she is a monster!"

Prophetically, Straker predicted: "I'm sure the law will be altered. Future generations will look back at our taboos and think that we were as crackers as the Victorians who covered their piano legs."

Subsequently, Straker gave up photography, tired of the threats of uncaring magistrates. He retired to a ramshackle Victorian mansion in the countryside where he took up cooking and founded the East Grinstead Current Affairs Society. Visitors to his home, Ashurstwood Abbey, were frequently surprised to be received by Straker completely nude.

A group of images, documentation and ephemera relating to the nude photography and state prosecution of Jean Straker is held at the National Museum of Photography, Film & Television, Bradford, UK.

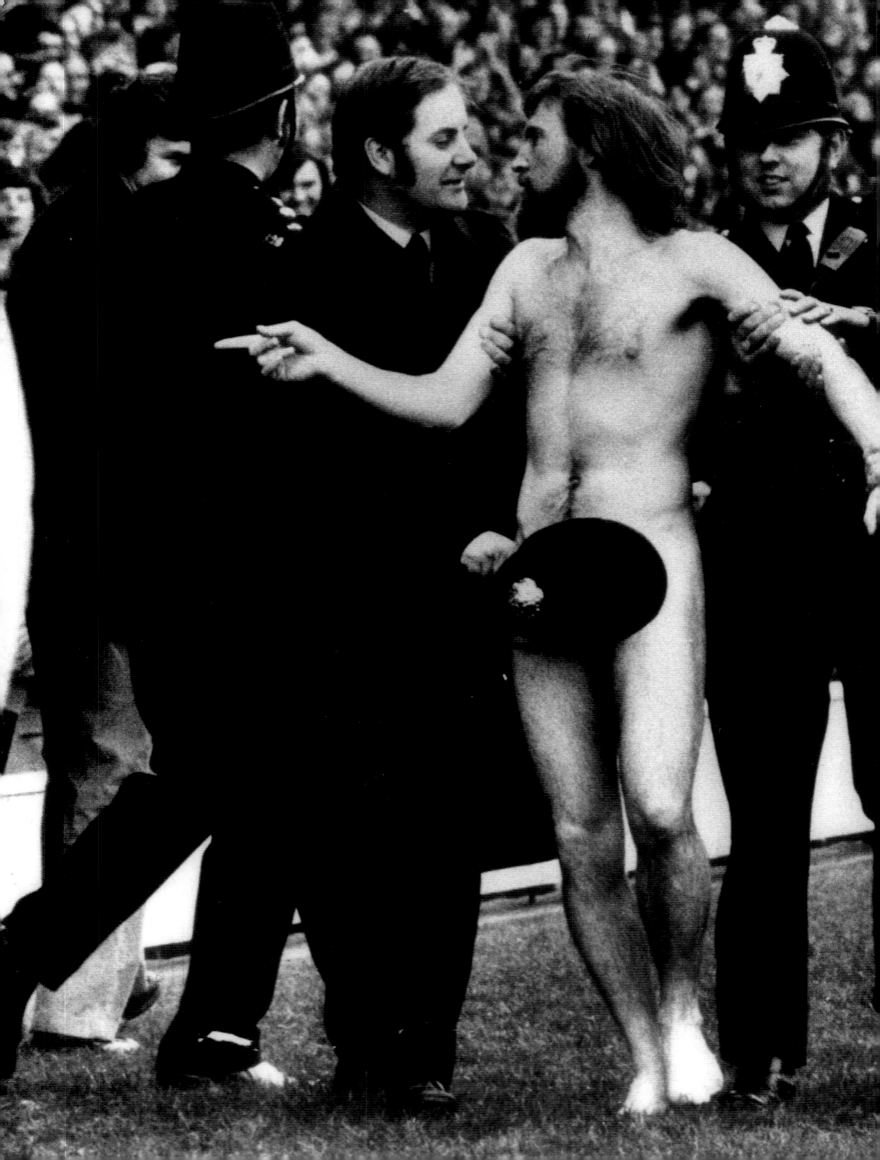

Basic Equipment

Twickenham, England, 1974. A mild form of sexual censorship as police arrest Michael O'Brien for an unscheduled interruption during an international rugby match between England and France.

*Ian Bradshaw/
Syndication International*

Naughty Bits

(Left) London, 1937. Controversial statues by Jacob Epstein are removed from the façade of Rhodesia House without the knowledge or consent of the artist. The excuse was that the stonework had become unstable and was endangering passers-by.

Hulton Archive

Sir Jacob Epstein came to London from his native New York City in 1905 at the age of 25. He wanted to be a painter but gave it up for sculpture because of poor eyesight.

At the age of 28, he was commissioned to create 18 modern sculptures for the second floor of a building in the Strand in central London. The building had been erected in 1908 to house the British Medical Association, and Epstein's figures represented men and women in various stages from birth to death. His work caused an outcry and most of the press attacked it. A religious society across the street even installed frosted windows to prevent their staff's morals from being corrupted.

In 1937, the building became Rhodesia House. Epstein used sandstone for his sculptures and when some small pieces fell off, it was a convenient excuse to remove some of the offending parts. Several Epstein statues ended up as a slightly titillating side-show on the sea-front at Blackpool. Meanwhile, time and bad weather assumed the role of censor and nothing of Epstein's work remains in the Strand that could remotely be called offensive.

Private Dancer

(Right) Poland, 1997. "The stripper picture was part of a story I photographed in 1997 on the Zulawy, a depressed rural area in the north of Poland, in the Vistula delta. I was commissioned to cover the story for the weekly magazine *Gazeta Wyborcza*, Poland's best-known newspaper. The photographs were never published because I refused to withdraw this picture. The editor's argument was that the publication would be lying on a table and children might see it. So I took the story to *Rzeczpospolita* magazine, where it was accepted. But when I saw the layout, this picture was not there and I discovered that the graphic designer had never even seen it. I threatened to withdraw the story but it was the day before the magazine had to go to press and I didn't want to leave the editors with a massive problem. So I let it go, but not before a big row."

Witold Krassowski/
Network Photographers

Gone Fishing

Spitzbergen, Norway, 1905. A whaling ship with its huge catch. The start of factory whaling at the beginning of the 20th century tolled the bell for many species. The annihilation process continues today as Japan and Norway attempt to resist international pressure to reduce the destruction of marine life. According to Greenpeace, since 1987 Japan has conducted an annual whale hunt in the Antarctic under the pretext of "scientific" whaling. In fact, the whale meat and blubber produced by this "research" is sold commercially in Japan at a value of four billion yen every year. Between 1986, when an internationally agreed moratorium on whale hunting came into effect, and 2000, Japan had killed 5,138 whales for "scientific" purposes. Norway resumed commercial whaling in 1993, using a whale population estimate based on distorted figures to justify this, says Greenpeace. There is little demand for whale meat in Norway and most of it is sold on to Japan at a large profit.

Hulton Archive

Monkey Business

(Left) Sussex, UK, 1991. Shamrock Farm, a primate breeding facility. Animal rights activists took this photograph as part of an undercover investigation into the conditions and treatment of animals at the farm.

British Union for the Abolition of Vivisection

Between May 1991 and January 1992, a BUAV investigator worked at the farm as an animal technician, obtaining video, photographic and documentary evidence of practices and conditions. The BUAV claimed that Shamrock's overriding concern was to satisfy customer demand for primates at the cost of the animals' welfare.

Their evidence revealed high mortality rates among primates caught in the wild and brought to the UK, often from pneumonia or enteritis; inadequate physical conditions; abnormal behaviour such as twisting, continuous rocking, self-mutilation and wailing; and rough handling by staff, with primates being caught by nets and hauled to the ground, causing distress, injury, cuts, bruises and loss of teeth.

Shamrock (GB) Ltd was licensed by the British Home Office as a primate supplier. The BUAV presented its evidence and demanded this license be withdrawn. The Home Office declined to do so, but did strongly criticise Shamrock.

Killer Instinct

(Above) Bolivia, 1932. A graphic illustration of the influence of culture on human behaviour and its photographic representation. Here a "great white hunter", Sacha Siemel, proudly displays his bevy of slaughtered jaguars. The plaudits he received for his sporting prowess ring hollow today, when so many species are threatened with extinction.

Hulton Archive

"About half the species now on earth are endangered, including most big mammals and virtually all cats and primates. Even some deep-ocean fish, like the bluefin tuna, seem all but scuppered… The next century could be like the present, only worse, truly the coup de grâce. Or we could turn the corner."
Colin Tudge, 1999

You're Going to Love It

China, 1998. In a gentle version of a photo-call, Chinese officials proudly display a map of the Three Gorges dam on the Yangtze river. When finished, the reservoir will be 40 miles long and will cover 28,000 hectares of formerly arable land, including thousands of square kilometres of unique forest.

Chip Hires/FSP

Almost two million people will be displaced and over 100 towns, as well as around 1300 ancient archeological sites, will disappear when the water begins to rise in 2003. The Chinese government does not appear to have made any plans to deal with the industrial poisonous waste that will be disturbed by the flood-water. Health experts predict a surge of endemic infections such as malaria, encephalitis and a parasitic disease known as schistosomiasis.

Unusually, the Chinese government faced criticism from its own citizens about this massive project. A journalist, Dai Qing, was jailed for 10 months in 1989 after writing critical articles; others have spoken out against environmental destruction and corruption and misappropriation of funds for rehousing displaced citizens.

A Boat to Nowhere

Aral Sea, Uzbekistan, central Asia, 2000. The first recorded death of a sea and the most dramatic man-made environmental disaster in modern times. Irrigation schemes have shrunk the sea by 50 per cent; fisheries have declined; clouds of salts, toxic herbicides and pesticides are blown over nearby towns; respiratory disease in the area is wide-spread and mortality rates have increased.

Photograph by Paul Lowe/Magnum

The Aral Sea in northern Uzbekistan was once the world's fourth-largest lake. Now it is disappearing. Since 1960, its level has dropped by nearly 13 metres and its total area decreased by 40 per cent. Here, abandoned boats lie at the edge of what once was the water; the shoreline is now over 100 kilometres away. If the drying continues, some experts predict that the sea could disappear entirely by 2015. These strange effects have been caused by a system of canals built in the 1960s by the former Soviet Union to irrigate the cotton fields of central Asia; as much as three-quarters of the water destined for the Aral Sea is diverted.

The region has experienced a drastic increase in cancer and kidney disease. It boasts one of the highest levels of anaemia in the world and a very high rate of tuberculosis. Life expectancy is falling fast. What was once a bustling seaside area, known for its clean air, thriving ports and fresh fish, is now a medical and environmental disaster.

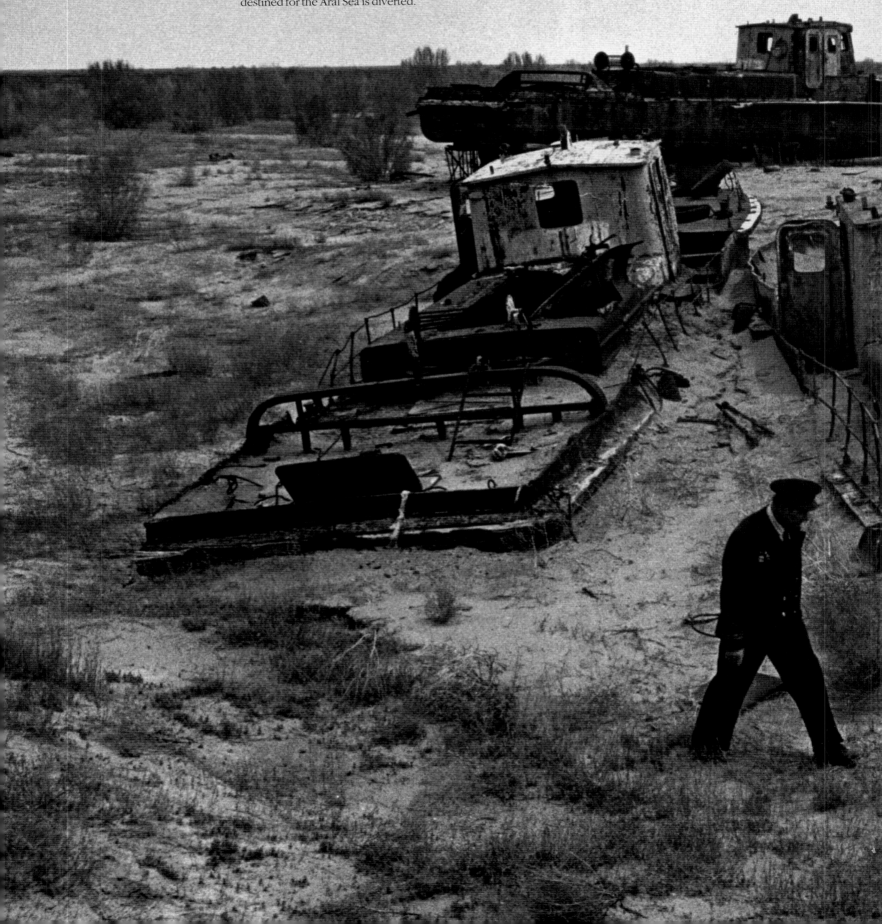

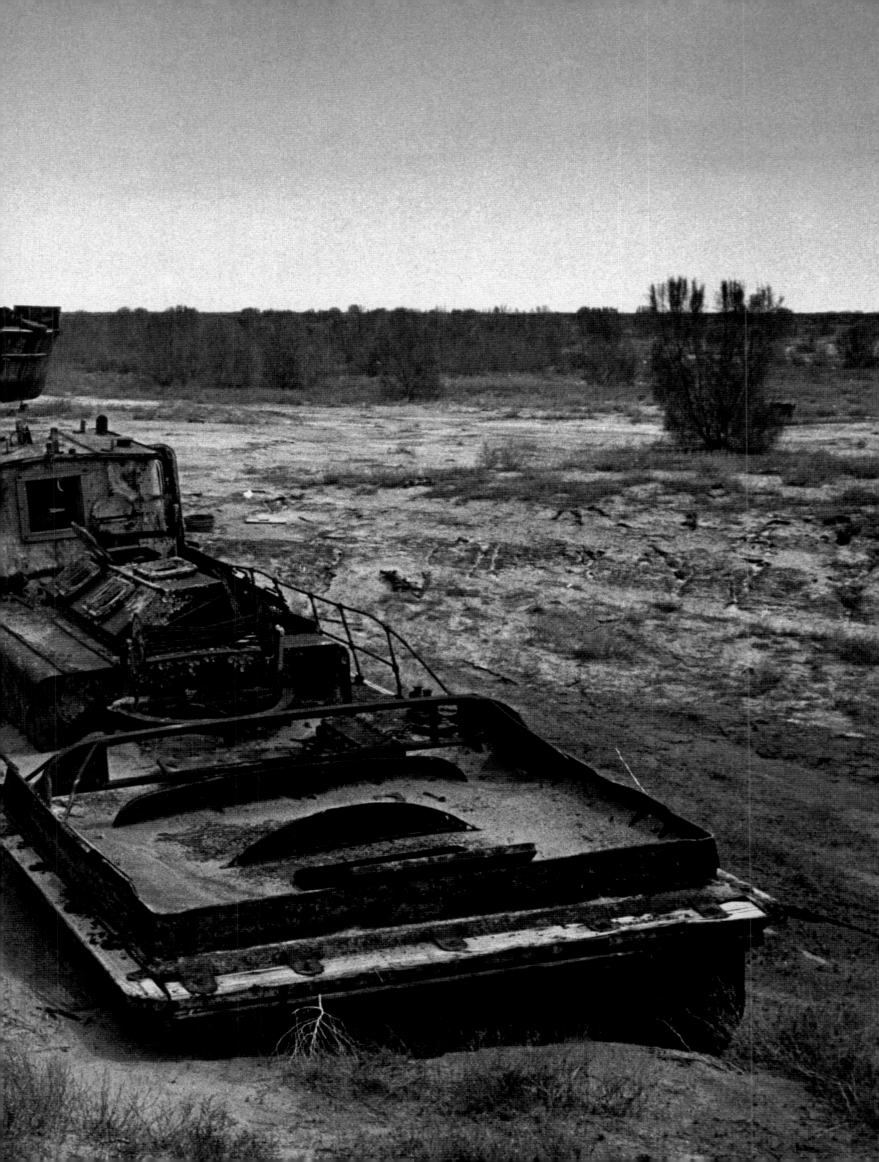

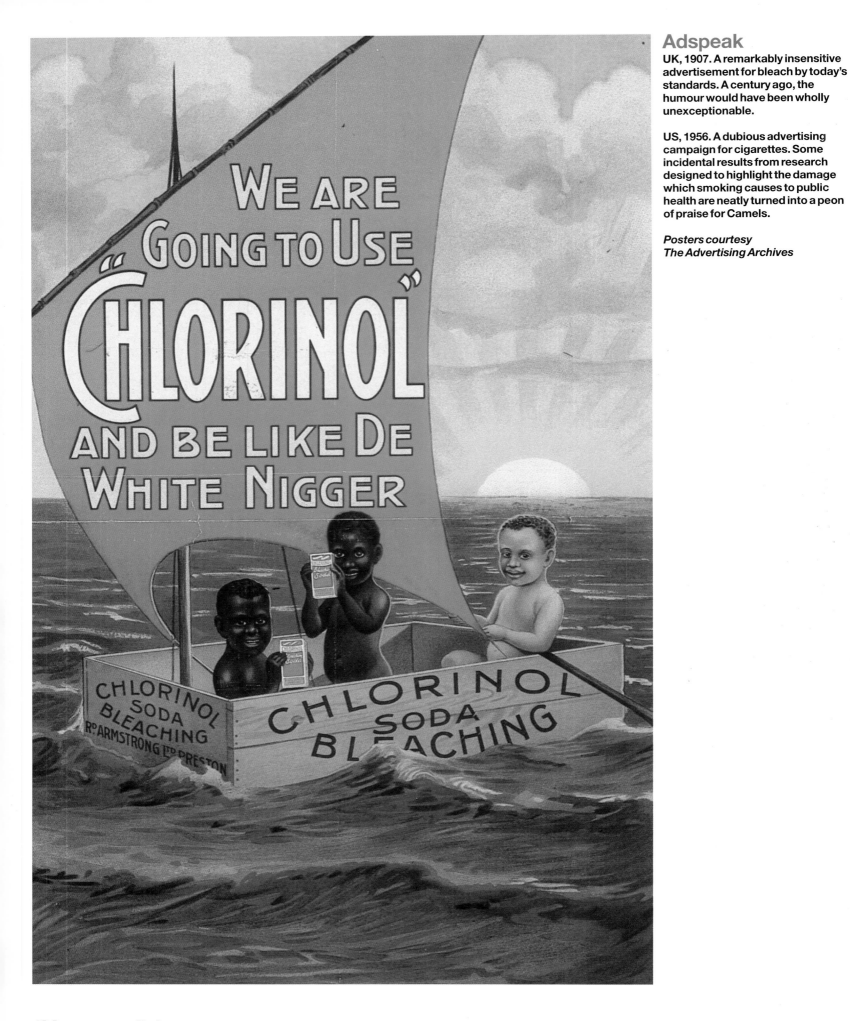

Adspeak

UK, 1907. A remarkably insensitive advertisement for bleach by today's standards. A century ago, the humour would have been wholly unexceptionable.

US, 1956. A dubious advertising campaign for cigarettes. Some incidental results from research designed to highlight the damage which smoking causes to public health are neatly turned into a peon of praise for Camels.

*Posters courtesy
The Advertising Archives*

"You can tell the ideals of a nation by its advertisements."
Norman Douglas

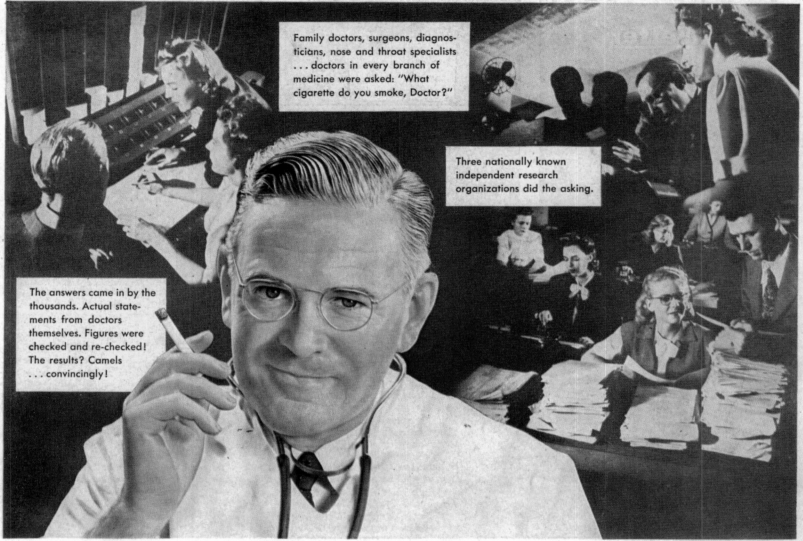

Family doctors, surgeons, diagnosticians, nose and throat specialists ... doctors in every branch of medicine were asked: "What cigarette do you smoke, Doctor?"

Three nationally known independent research organizations did the asking.

The answers came in by the thousands. Actual statements from doctors themselves. Figures were checked and re-checked! The results? Camels ... convincingly!

According to this recent Nationwide survey:

MORE DOCTORS SMOKE CAMELS THAN ANY OTHER CIGARETTE!

This is no casual claim. It's an actual fact. Based on the statements of doctors themselves to three nationally known independent research organizations.

THE QUESTION was very simple. One that you...any smoker ... might ask a doctor: "What cigarette do you smoke, Doctor?"

After all, doctors are human too. Like you, they smoke for pleasure. Their taste, like yours, enjoys the pleasing flavor of costlier tobaccos. Their throats too appreciate a cool mildness.

And more doctors named Camels than any other cigarette!

If you are a Camel smoker, this preference for Camels among physicians and surgeons will not surprise you. But if you are not now smoking Camels, by all means try them. Compare them critically in your "T-Zone" (see right).

CAMEL—COSTLIER TOBACCOS

THE "T-ZONE" TEST WILL TELL YOU

The "T-Zone"—T for taste and T for throat—is your own proving ground for any cigarette. Only your taste and throat can decide which cigarette tastes best to *you* ... how it affects your throat. On the basis of the experience of many, many millions of smokers, we believe Camels will suit your "T-Zone" to a "T."

CAMEL
TURKISH & DOMESTIC BLEND CIGARETTES
CHOICE QUALITY

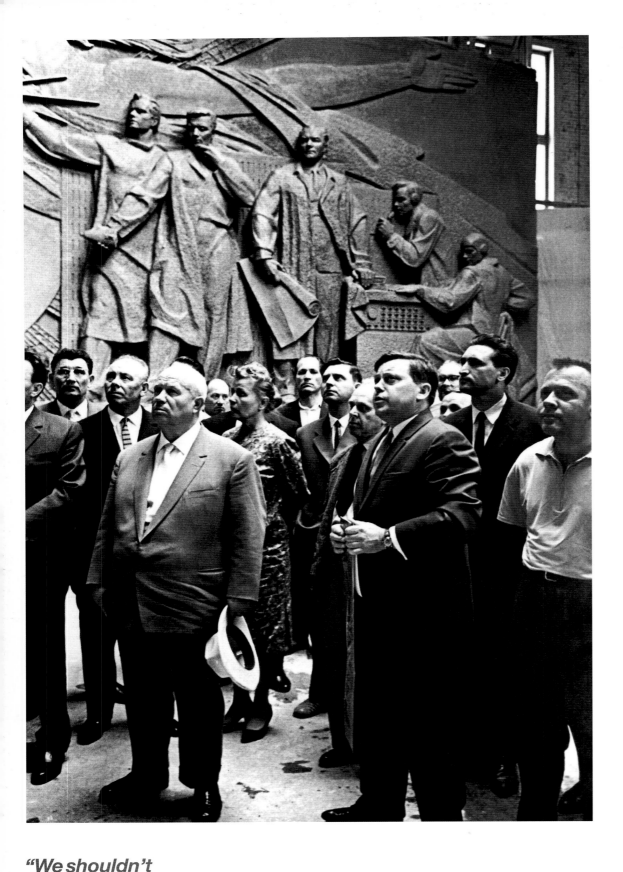

Thunderstruck

(Left) Moscow, USSR, 1954. President Nikita Kruschev was not known for his avant-garde philosophies. This photograph shows him about to storm out of an exhibition of modern art. "Any donkey could have done better," he raged, and ordered the exhibition to be closed.

*Alexander Ustinov/
Endeavour Group UK*

All Shook Up

(Right) New York, May 14 1957. Red-haired Gloria Parker, described as an 88-pound firebrand and owner of one share of CBS, parades in front of the RCA building. Gloria launched a personal crusade against rock and roll music and was making a stand against General Sarnoff, chairman of the board of RCA. She declared: "We must put an end to the obscenity that is inundating American music. We must exile the grunters and the groaners, the twitches and twitchers, the gyrations and the animal posturings from the airwaves." History does not record how Gloria coped with the increasing success of Elvis Presley.

Bettman/Corbis

"We shouldn't underestimate the cultural attraction of censorship, of creating an enemy out of ignorant authority… If no one wants to ban a contemporary art work, then it cannot be really avant-garde."
Edward Lucie-Smith

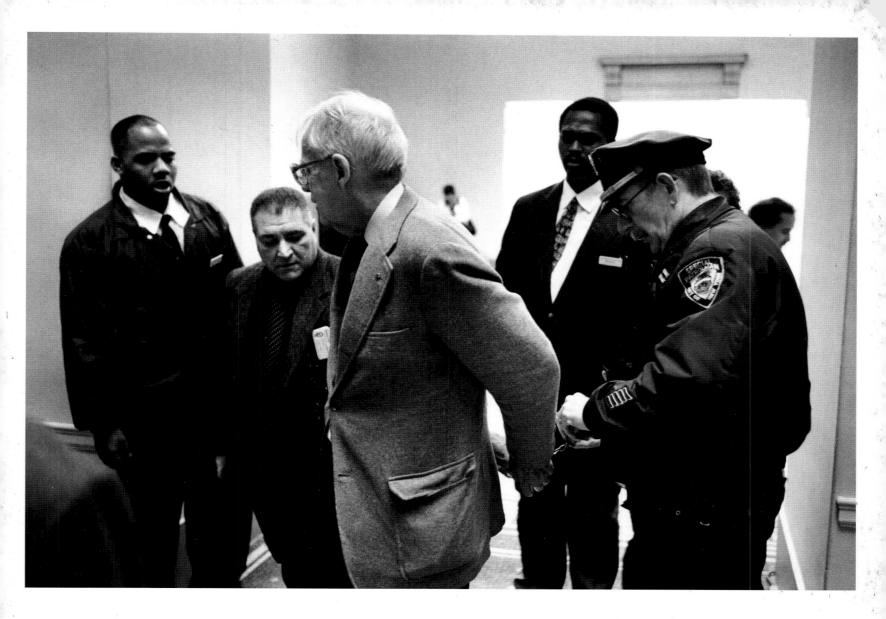

Guardians of Morality

New York, December 1999. *Sensation*, a show of contemporary British art, caused something of a stir in America. New York Mayor Rudolph Giuliani tried to have the show closed down even before it opened at the Brooklyn Museum of Art. Here (below), a 72-year-old man, Dennis Heiner, is seen vandalising one of the more controversial works, Chris Ofili's *The Virgin Mary* (with elephant dung), described by Giuliani as "sick stuff". Heiner evaded security and smeared paint from a tube all over the canvas. He was promptly arrested (right) while the photographer was escorted from the building.

Photographs by Philip Jones Griffiths/ Magnum

Mayor Giuliani's hostility sparked off a lively debate about the role of art and issues of public decency. In February 2001 he described a colour photograph of a nude black woman as Christ at the Last Supper as "disgusting", "outrageous" and "anti-Catholic". The photograph by Renee Cox, entitled *Yo Mama's Last Supper*, appeared in an exhibition of black photographers, also at the Brooklyn Museum.

Almost every museum in New York City receives money from City Hall. Giuliani announced he was setting up a commission to keep such offensive works out of museums that receive public money. He had "a few ideas" about who should serve on this committee: they should be "basically decent people". The Bronx borough president, Fernando Ferrer, who was himself running for mayor, said, "That sounds like Berlin in 1939."

Giuliani's attempt to shut down the museum over the *Sensation* exhibition was overturned in the courts. A federal judge ruled that the mayor had violated the First Amendment when he cut city funds to the Brooklyn Museum and started eviction proceedings against it.

Giuliani's attempts at censorship succeeded in attracting some 175,000 viewers to *Sensation*, close to a record for the museum.

"Written journalism can delude the mind and deaden the emotions. It is not redundant because it requires intelligence, knowledge, sensitivity and scepticism; and neither is photojournalism. It is just that photojournalism requires more of these qualities ... more critical analysis, more awareness ... To warn of the risks of being deceived by a photograph is not to admit that photography is symbolic, is not to deny its uniqueness as a contribution to understanding the world we cannot see for ourselves."

Harold Evans, Pictures on a Page

Reading Pictures

Alberto Manguel

"A photograph," writes John Berger, "whilst recording what has been seen, always and by its nature refers to what is not seen." Unlike a photograph, the world is not framed – the eye wanders and can take in what lies beyond the margins. We know the limits of a photographic document, we know that it shows only what the photographer has chosen to show and what light and shade have allowed him to show, and yet the factual mirroring overpowers such hesitations. On the contrary; photography's claim to faithfulness has allowed (and allows still) for it to be manipulated without protest, a manipulation that electronic techniques have now made even more seamless. From Stalin's infamous removal of every *persona non grata* from the official pictures to the selective portrayal of war scenes in everyday reporting, from the dressed-up representation of celebrities to the doctored depiction of fashion models, from the cropped documentary views to abstract or fantastical arrangements, photography allows, perhaps more than any other medium, for the presence of censorship as an integral part of its own creative process.

A text, a sculpture, a painting may suppress – does suppress – information from within the work itself, through the restrained hand of the artist, and also from without, through the restricted hand of an official censor. But all these forms of art deliberately define themselves as subjective, accept their own fictions, require in order to exist (as Coleridge pointed out) the audience's willing suspension of disbelief. Photography, however, though acknowledging in its criticism and its manifestos the subjectivity of the camera, nevertheless relies on the conviction that what we, the viewers, see what was actually once there, that it took place at a certain precise time, and that as reality it was captured by the eye of the beholder. Any photograph, whether deliberately censored or unconsciously manipulated, though it may offer itself as "fixed, rigid, incapable of intervention", wholly depends on this necessary deception.

© *Index on Censorship, excerpted from vol 28, 6/99. Alberto Manguel won the Prix Médici for* A History of Reading. *His latest book,* Reading Pictures, *is published by Random House.*

Bodies of Evidence

◄ Massacre in Ahmici, Bosnia, 1993. Gilles Peress' book *Farewell to Bosnia,* published in 1994, challenged existing attitudes to photojournalism. Presented without text or captions, the quiet, undramatic photographs relied on juxtaposition and a cumulative visual impact to establish a sense of revulsion at the violence of the Bosnian conflict. Here, what seems at first glance to be an innocuous arrangement of flora and plastic takes on a new and more terrible meaning when the visual context of the body bags becomes clear.

Photograph by Gilles Peress/Magnum

Trompe l'oeil

Germany, September 1947. The potential for confusion in the realm of visual memory is underlined by this photograph. It is eerily reminiscent of Nazi deportations, but the people at the windows of the train are German Jewish survivors of Nazi concentration camps and the soldiers guarding them are British. The refugees had sailed to Palestine on the ship *Exodus 1947*, but were sent back to Germany as illegal immigrants on the British troop ship *Ocean Vigour*. Here, they are being transported from Hamburg docks to Poppendorf detention camp.

Hulton Archive

The British government was in an uncomfortable position in 1947, trying to reconcile conflicting interests in Palestine. Tens of thousands of Jewish displaced persons were waiting to emigrate to Britain's Palestine Mandate. The British Parliament understood the feelings of Jewish survivors of the Holocaust, but was also sensitive to resistance from Arab nations to Jewish immigration. As a result, most of the refugees were prevented from entering Palestine. The Jews were herded into tightly guarded camps surrounded by barbed wire, a cruel reminder of what they had recently escaped.

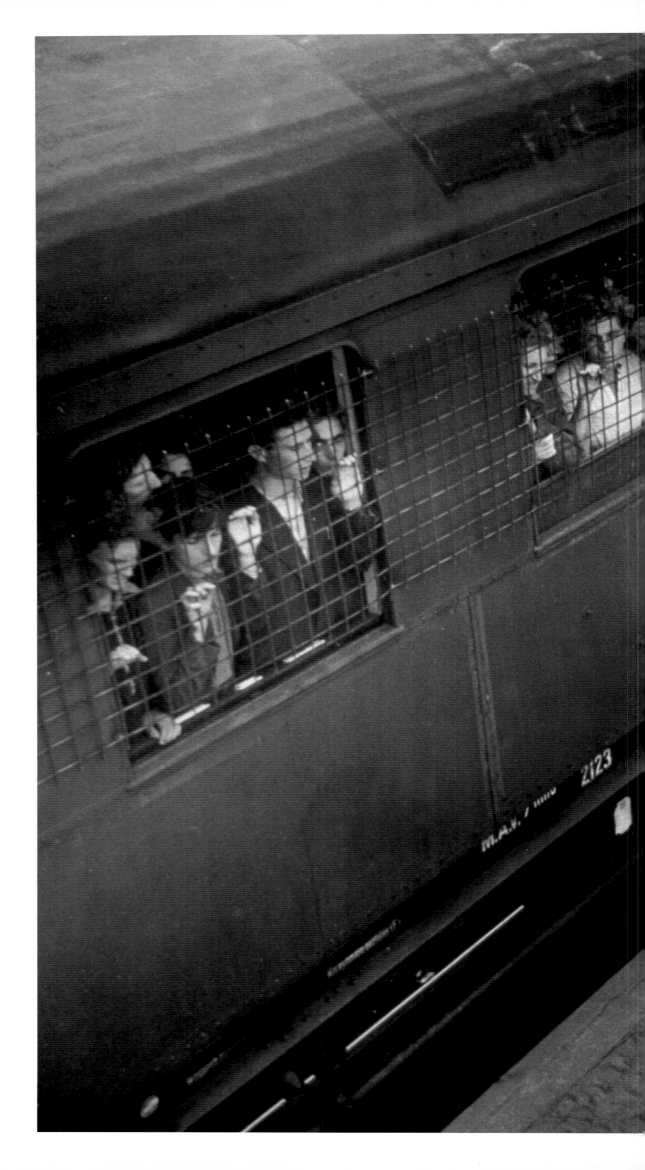

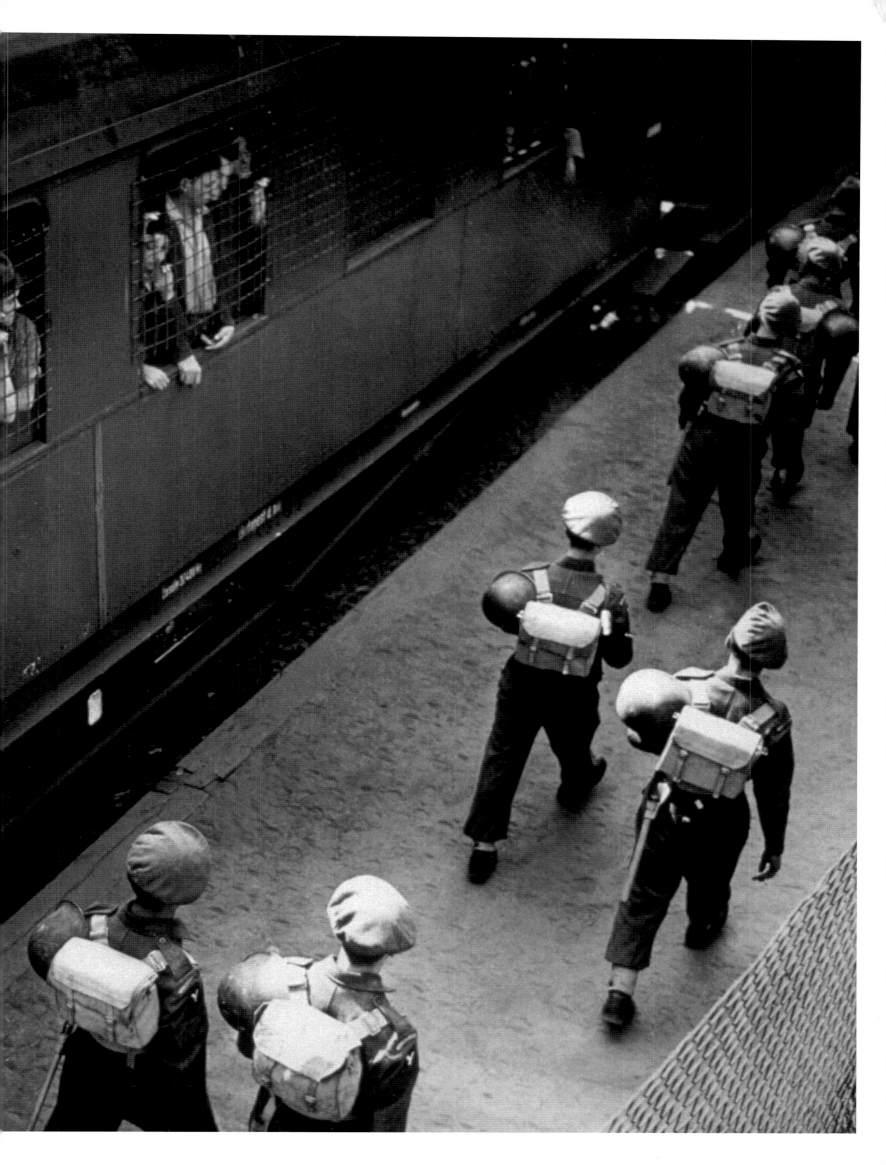

Mistaken Intentions

Dorchester Hotel, London, 1956. Hollywood star Joan Crawford appears to be stoically receiving the arduous attentions of an unknown admirer.

Hulton Archive

In fact, the photographer, Thurston Hopkins, who was on assignment for *Picture Post*, recalls that Crawford was actually waiting to go into a press conference and one of her minders was biting off a loose thread. The story was not published because, as Hopkins remembers, "the journalist did not turn up and so we had no interview."

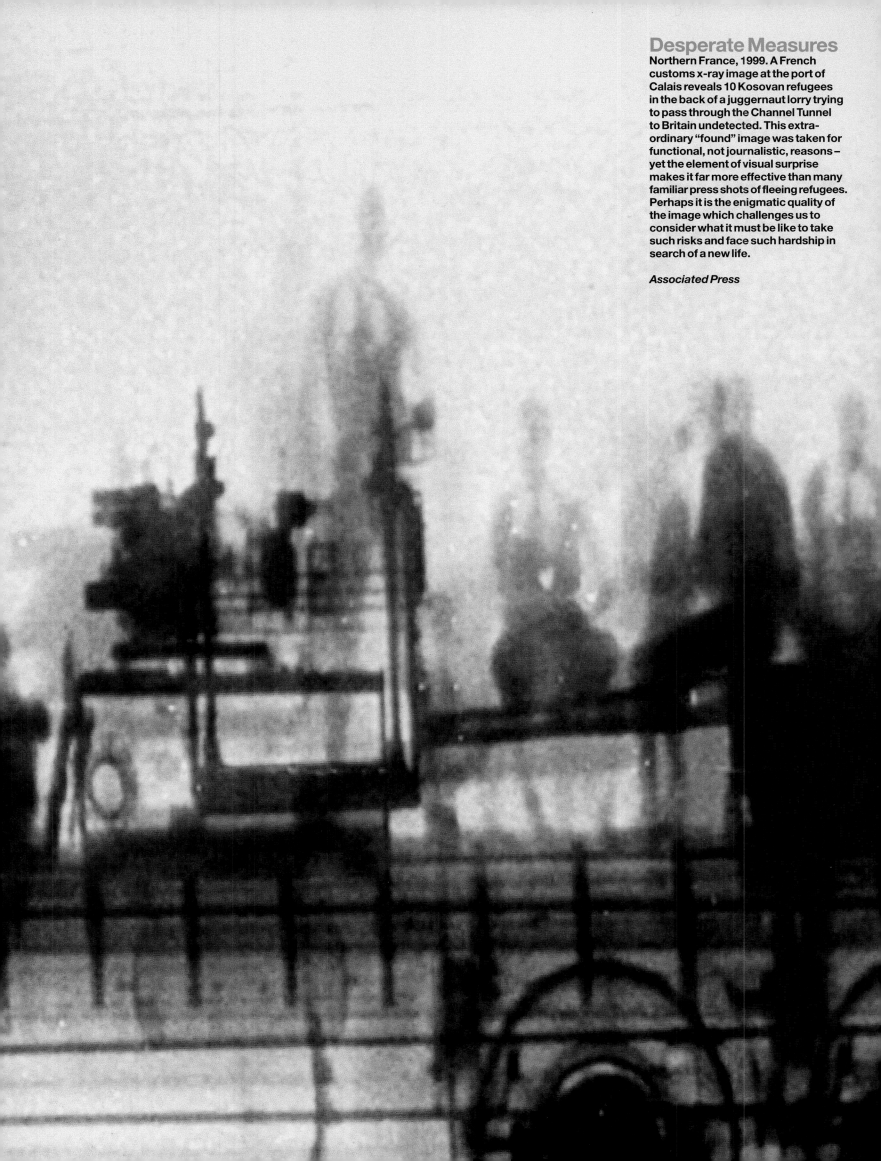

Desperate Measures

Northern France, 1999. A French customs x-ray image at the port of Calais reveals 10 Kosovan refugees in the back of a juggernaut lorry trying to pass through the Channel Tunnel to Britain undetected. This extraordinary "found" image was taken for functional, not journalistic, reasons – yet the element of visual surprise makes it far more effective than many familiar press shots of fleeing refugees. Perhaps it is the enigmatic quality of the image which challenges us to consider what it must be like to take such risks and face such hardship in search of a new life.

Associated Press

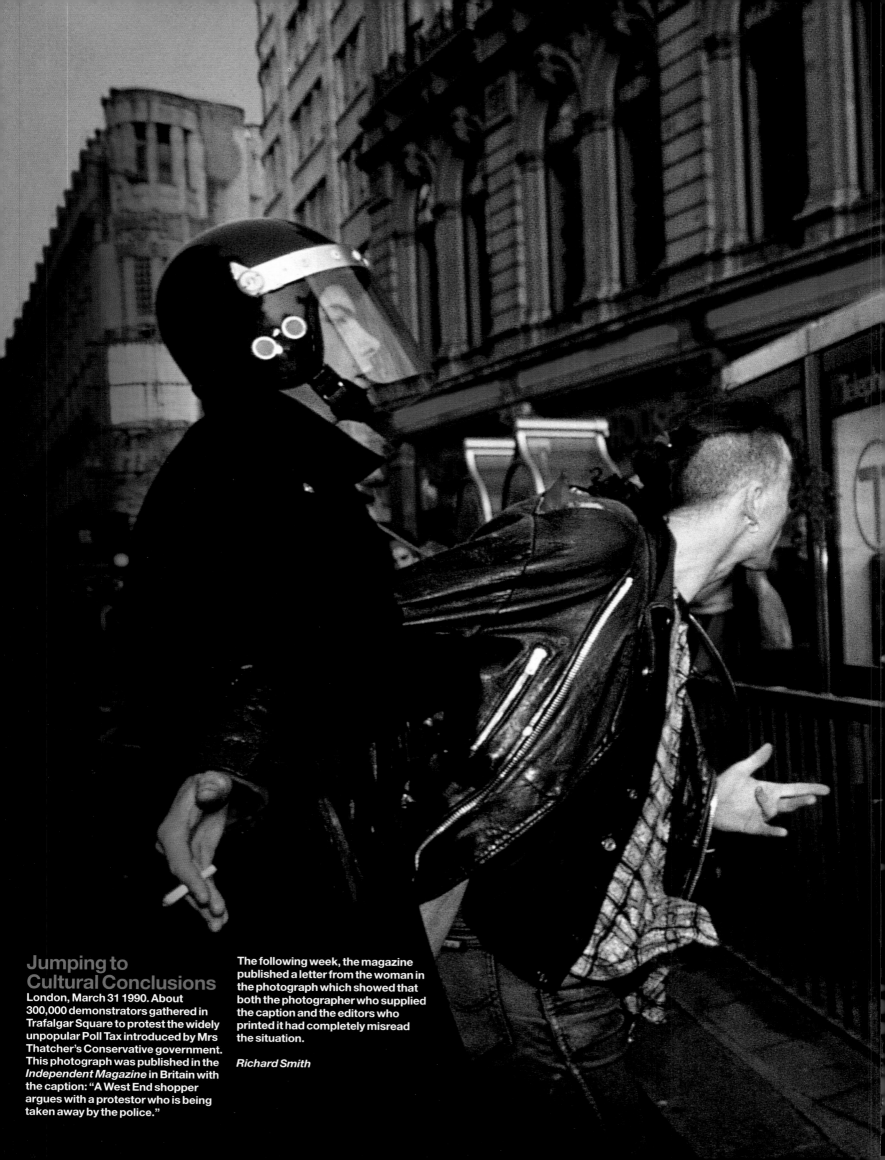

Jumping to Cultural Conclusions

London, March 31 1990. About 300,000 demonstrators gathered in Trafalgar Square to protest the widely unpopular Poll Tax introduced by Mrs Thatcher's Conservative government. This photograph was published in the *Independent Magazine* in Britain with the caption: "A West End shopper argues with a protestor who is being taken away by the police."

The following week, the magazine published a letter from the woman in the photograph which showed that both the photographer who supplied the caption and the editors who printed it had completely misread the situation.

Richard Smith

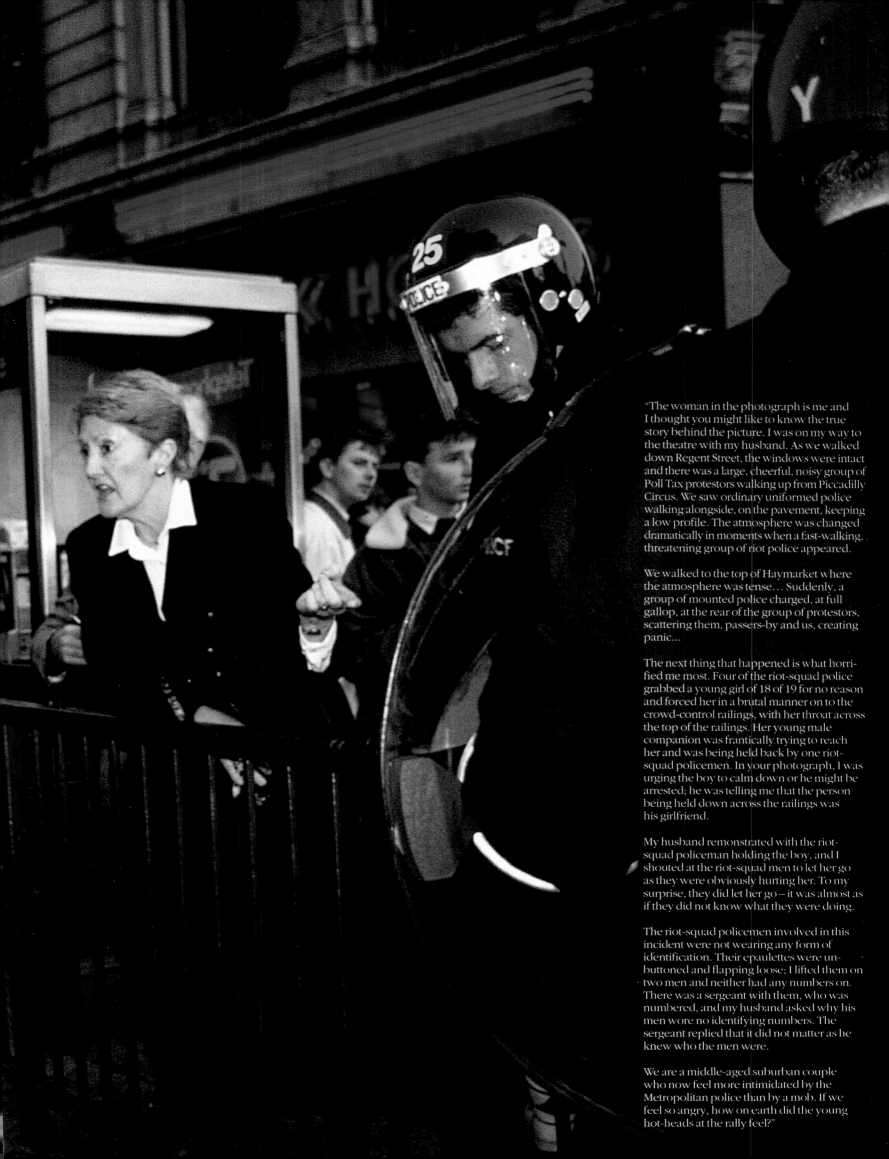

"The woman in the photograph is me and I thought you might like to know the true story behind the picture. I was on my way to the theatre with my husband. As we walked down Regent Street, the windows were intact and there was a large, cheerful, noisy group of Poll Tax protestors walking up from Piccadilly Circus. We saw ordinary uniformed police walking alongside, on the pavement, keeping a low profile. The atmosphere was changed dramatically in moments when a fast-walking, threatening group of riot police appeared.

We walked to the top of Haymarket where the atmosphere was tense… Suddenly, a group of mounted police charged, at full gallop, at the rear of the group of protestors, scattering them, passers-by and us, creating panic…

The next thing that happened is what horrified me most. Four of the riot-squad police grabbed a young girl of 18 of 19 for no reason and forced her in a brutal manner on to the crowd-control railings, with her throat across the top of the railings. Her young male companion was frantically trying to reach her and was being held back by one riot-squad policemen. In your photograph, I was urging the boy to calm down or he might be arrested; he was telling me that the person being held down across the railings was his girlfriend.

My husband remonstrated with the riot-squad policeman holding the boy, and I shouted at the riot-squad men to let her go as they were obviously hurting her. To my surprise, they did let her go – it was almost as if they did not know what they were doing.

The riot-squad policemen involved in this incident were not wearing any form of identification. Their epaulettes were un-buttoned and flapping loose; I lifted them on two men and neither had any numbers on. There was a sergeant with them, who was numbered, and my husband asked why his men wore no identifying numbers. The sergeant replied that it did not matter as he knew who the men were.

We are a middle-aged suburban couple who now feel more intimidated by the Metropolitan police than by a mob. If we feel so angry, how on earth did the young hot-heads at the rally feel?"

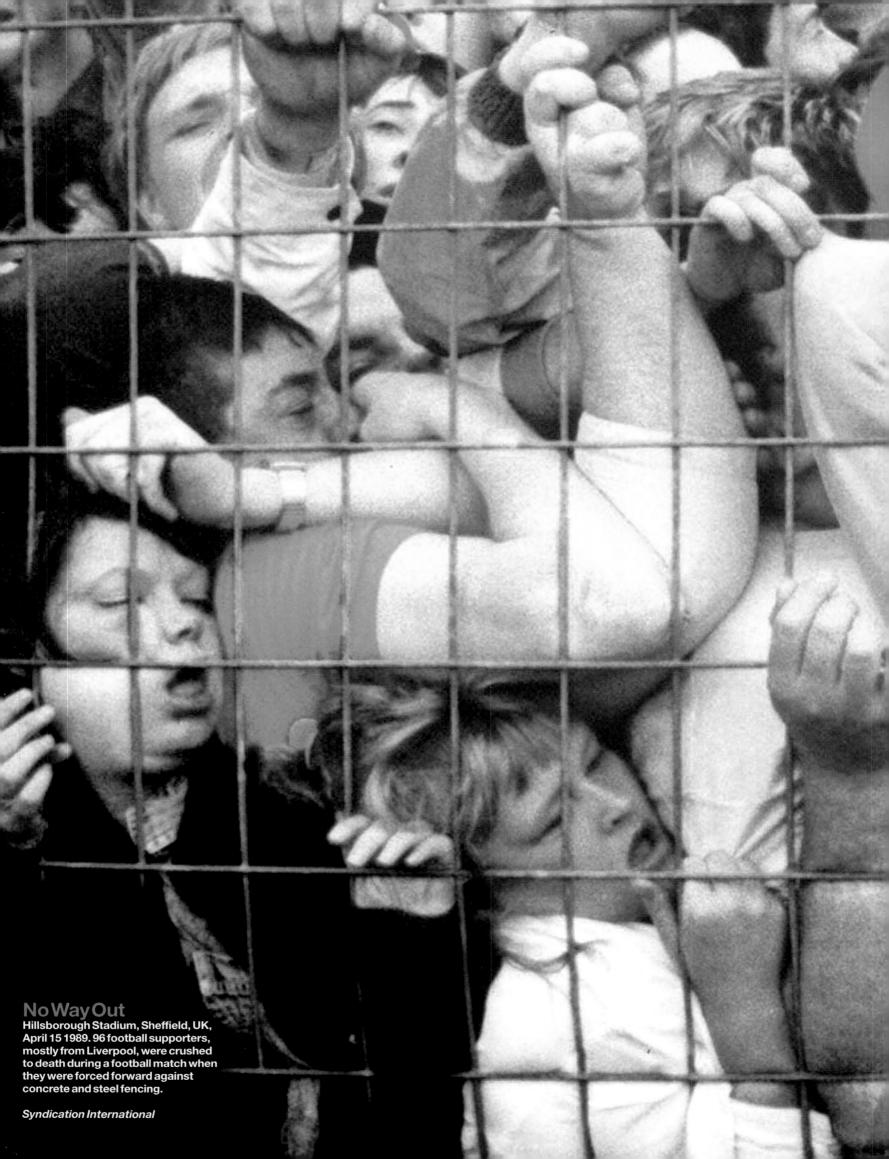

No Way Out
**Hillsborough Stadium, Sheffield, UK,
April 15 1989. 96 football supporters,
mostly from Liverpool, were crushed
to death during a football match when
they were forced forward against
concrete and steel fencing.**

Syndication International

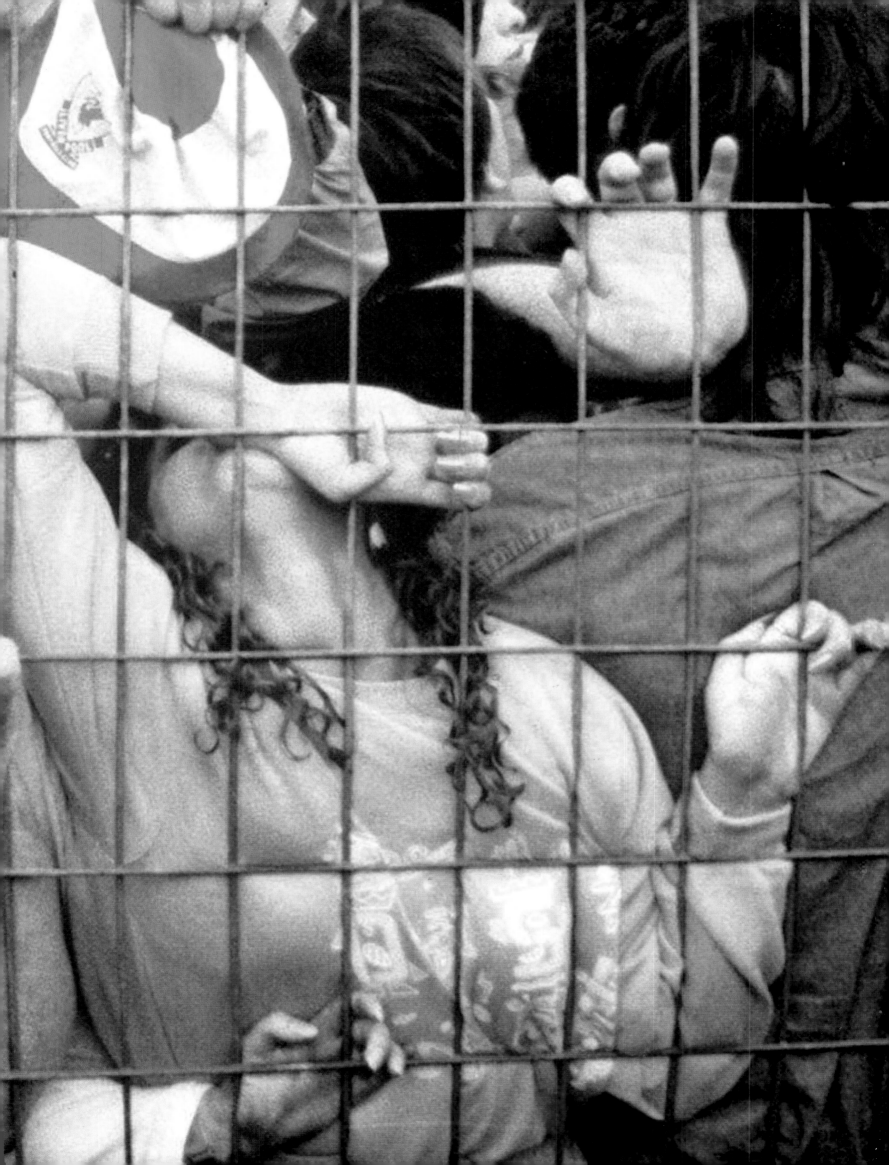

◄ Making Scapegoats A public inquiry under Lord Justice Taylor established that the police had ordered the gates to be opened after the start of the match to relieve crowd pressure outside the ground, against the advice of the gatekeepers. Excited fans who had been locked out surged forward on to the terraces, pushing those already at the front into the wire fences.

This image shows the moment at which many of those who died had just begun to suffocate. In that pre-digital era, Sunday newspapers had very early deadlines on Saturday evening, so few pictures of this tragedy were available for the news and sports pages. However, by Monday, the publications had masses of colour and black and white photographs from which to choose. Journalists from the tabloid *Daily Mirror* had done their homework and realised that the tragedy was caused not by crowd trouble but inadequate crowd control. The paper produced a dramatic wrap-around cover taking in the front page and the back sports page using this image. Later in the week, however, the rival tabloid, *The Sun*, leapt on the "hooligan" angle, based on the reputation of Liverpool supporters after a previous disaster at the Heysel Stadium in Belgium was blamed on their rioting. This was lazy journalism and the paper paid the price. It is estimated that *The Sun* lost up to 30,000 readers in the Liverpool area, and it is possible that they have not regained these readers over a decade later.

THE Sun

Wednesday, April 19, 1989 **20p** Yesterday's sale: 4,310,811 Thought: Kop of shame

THE TRUTH

GATES OF HELL

Tycoon Adnan thrown in jail

By SUN FOREIGN DESK

ARMS tycoon Adnan Khashoggi, once one of the world's richest men, was seized on massive fraud charges yesterday.

Police swooped in Switzerland after he flew in for "eternal youth" health treatment.

He was jailed awaiting a bid to extradite him to America, where an international warrant had been issued for him.

Khashoggi, 53, is accused of helping deposed Philippines president Ferdinand Marcos steal £100 MILLION from his country's treasury.

He could face 25 years' jail if convicted in the U.S.

FBI investigators say Khashoggi pretended to be the owner of sky-

Khashoggi . . . seized

scraper blocks in Manhattan which Marcos had bought with looted money.

The racket was allegedly set up to hide the sacked dictator's massive assets.

Khashoggi also arranged to sell millions of pounds' worth of art treasures filched from galleries in Manila which mysteriously "vanished" when Marcos and his wife Imelda fled in 1986, it is claimed.

America gave the pair sanctuary, but indicted them when they realised the scale of their massive swindling.

Much of the loot they

Continued on Page Nine

ATISH-OW!

A pillow feather made salesman Mark Meehan, 28, sneeze so violently he was taken to hospital at Dudley, West Midlands, with a suspected broken neck.

• Some fans picked pockets of victims

• Some fans urinated on the brave cops

• Some fans beat up PC giving kiss of life

Opened the gate . . . Superintendent Marshall

DRUNKEN Liverpool fans viciously attacked rescue workers as they tried to revive victims of the Hillsborough soccer disaster, it was revealed last night.

Police officers, firemen and ambulance crew were punched, kicked and urinated upon by a hooligan element in the crowd.

Some thugs rifled the pockets of injured fans as they were stretched out unconscious on the pitch.

Sheffield MP Irvine Patnick revealed that in one shameful episode, a gang of Liverpool fans noticed that the blouse of a girl trampled to death had risen above her breasts.

STUNG

As a policeman struggled in vain to revive her, the mob jeered: "Throw her up here and we will **** her."

Sheffield officers have been badly stung by criticism of themselves and their boss Superintendent Roger Marshall — who gave the order to open the gates because he was worried

By HARRY ARNOLD and JOHN ASKILL

about the crush OUTSIDE the ground.

And yesterday, as the death of a 14-year-old boy brought the toll to 95, they hit back.

One furious policeman who witnessed Saturday's carnage stormed: "To paint all the Liverpool fans as lily-white is wrong.

"As we struggled in appalling conditions to save lives, fans standing further up the terrace were openly urinating on us and the bodies of the dead.

"And as policemen on the pitch tried to save the injured they were

Continued on Page Two

DI GRIEVES FOR LEE, AGED 14: Pages 2 and 3

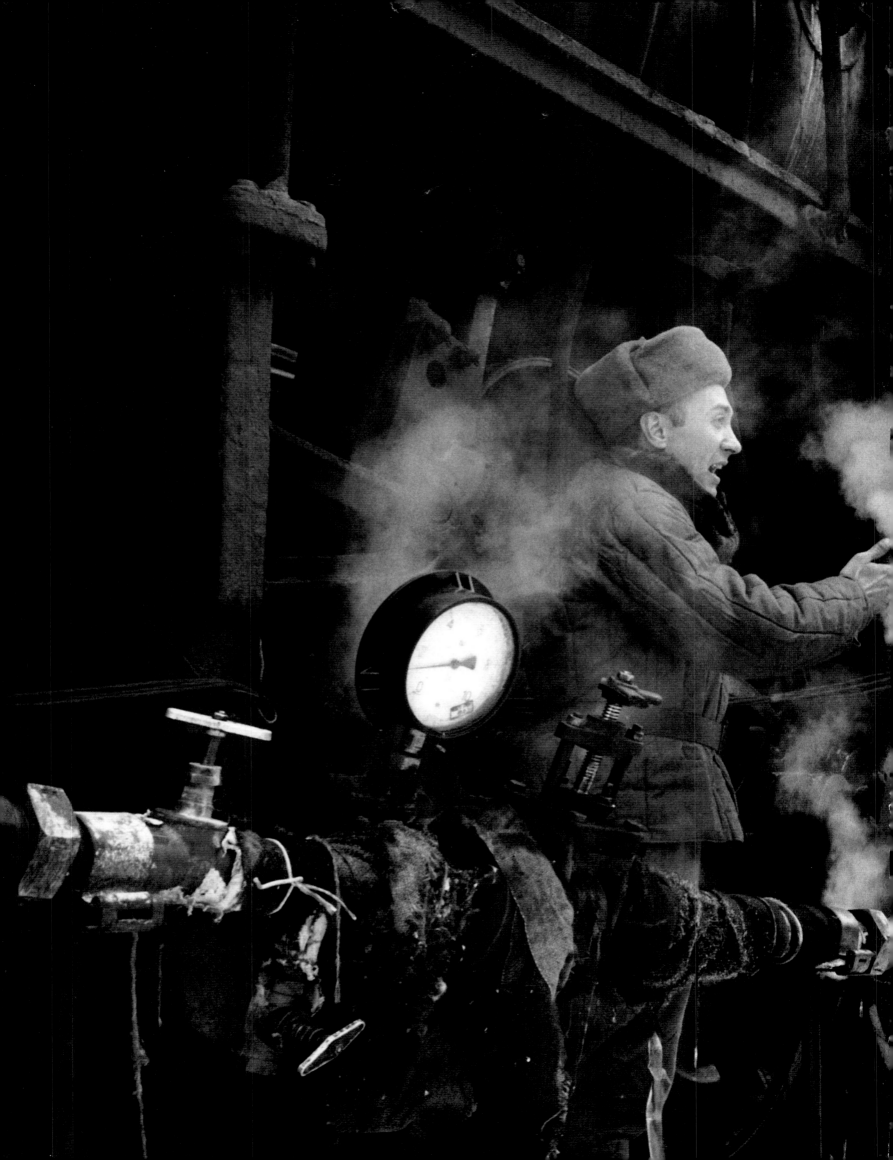

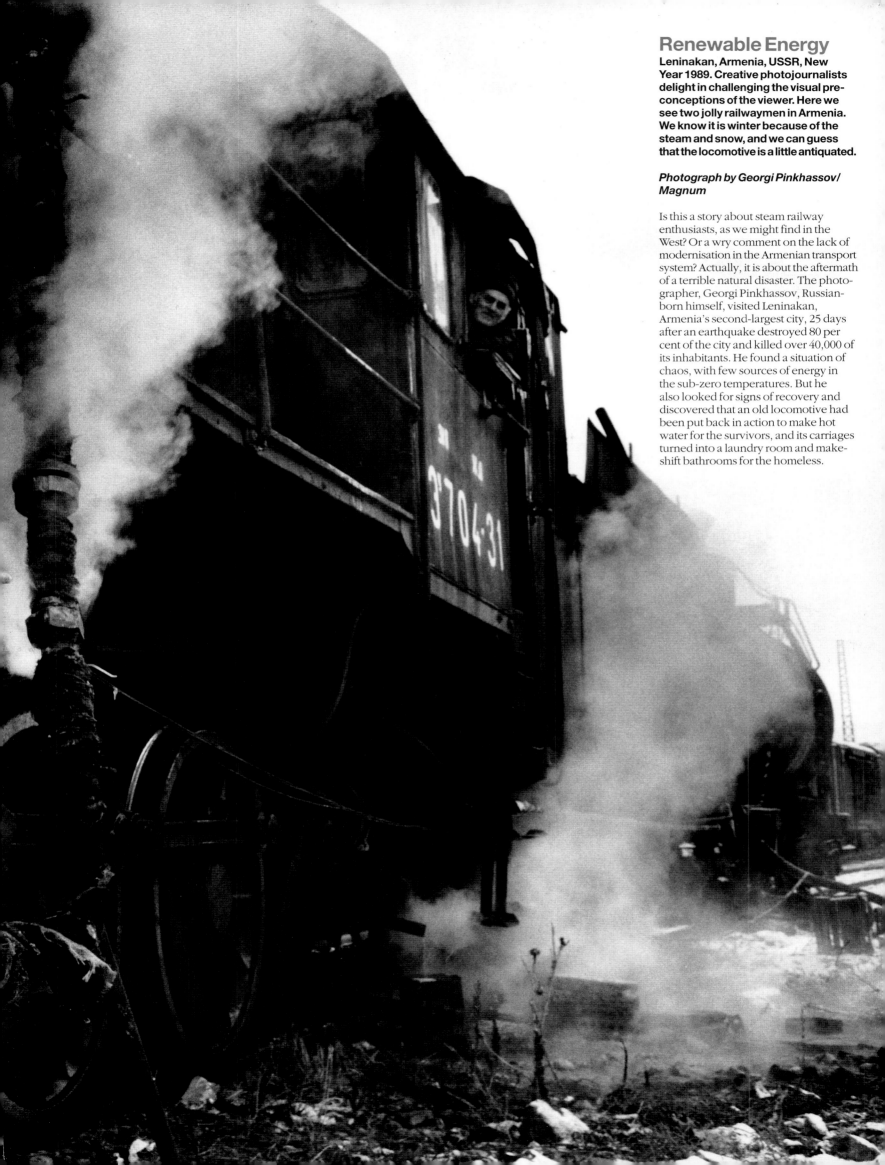

Renewable Energy

Leninakan, Armenia, USSR, New Year 1989. Creative photojournalists delight in challenging the visual preconceptions of the viewer. Here we see two jolly railwaymen in Armenia. We know it is winter because of the steam and snow, and we can guess that the locomotive is a little antiquated.

Photograph by Georgi Pinkhassov/ Magnum

Is this a story about steam railway enthusiasts, as we might find in the West? Or a wry comment on the lack of modernisation in the Armenian transport system? Actually, it is about the aftermath of a terrible natural disaster. The photographer, Georgi Pinkhassov, Russian-born himself, visited Leninakan, Armenia's second-largest city, 25 days after an earthquake destroyed 80 per cent of the city and killed over 40,000 of its inhabitants. He found a situation of chaos, with few sources of energy in the sub-zero temperatures. But he also looked for signs of recovery and discovered that an old locomotive had been put back in action to make hot water for the survivors, and its carriages turned into a laundry room and makeshift bathrooms for the homeless.

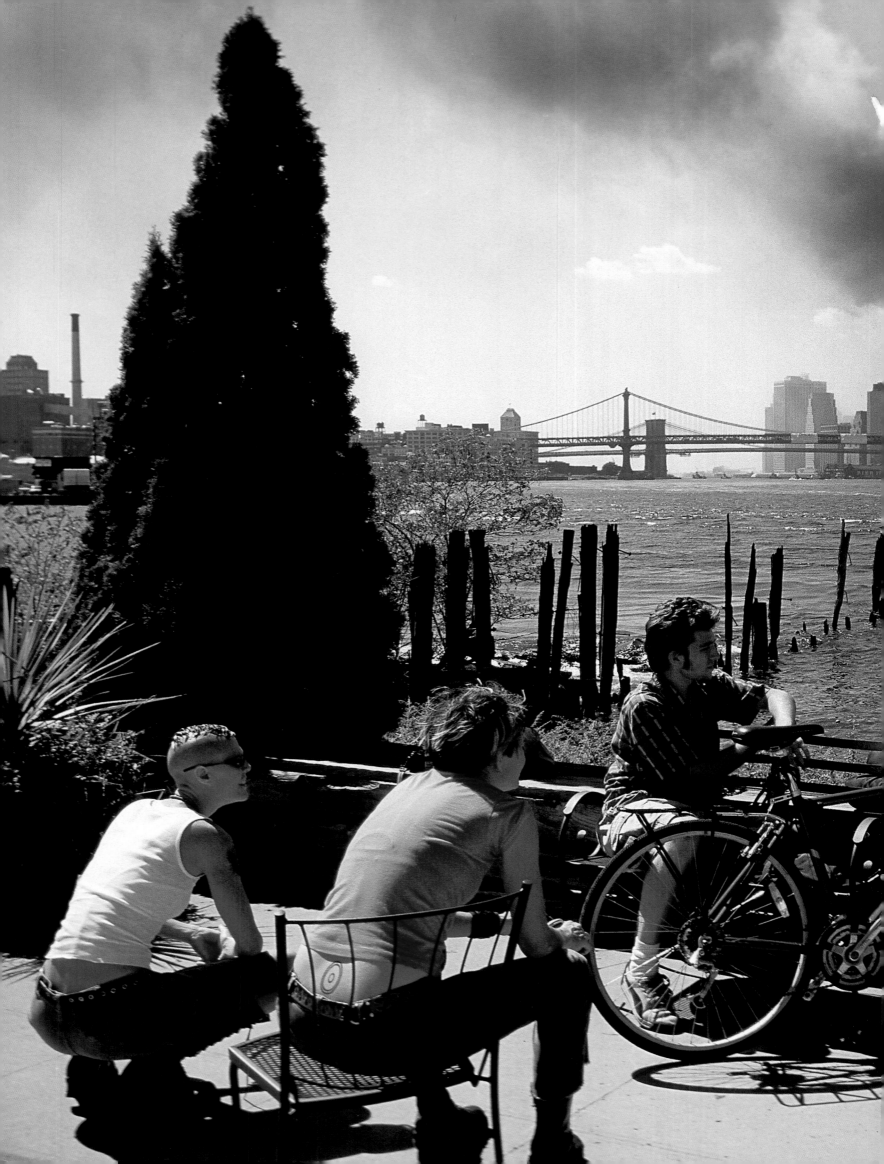

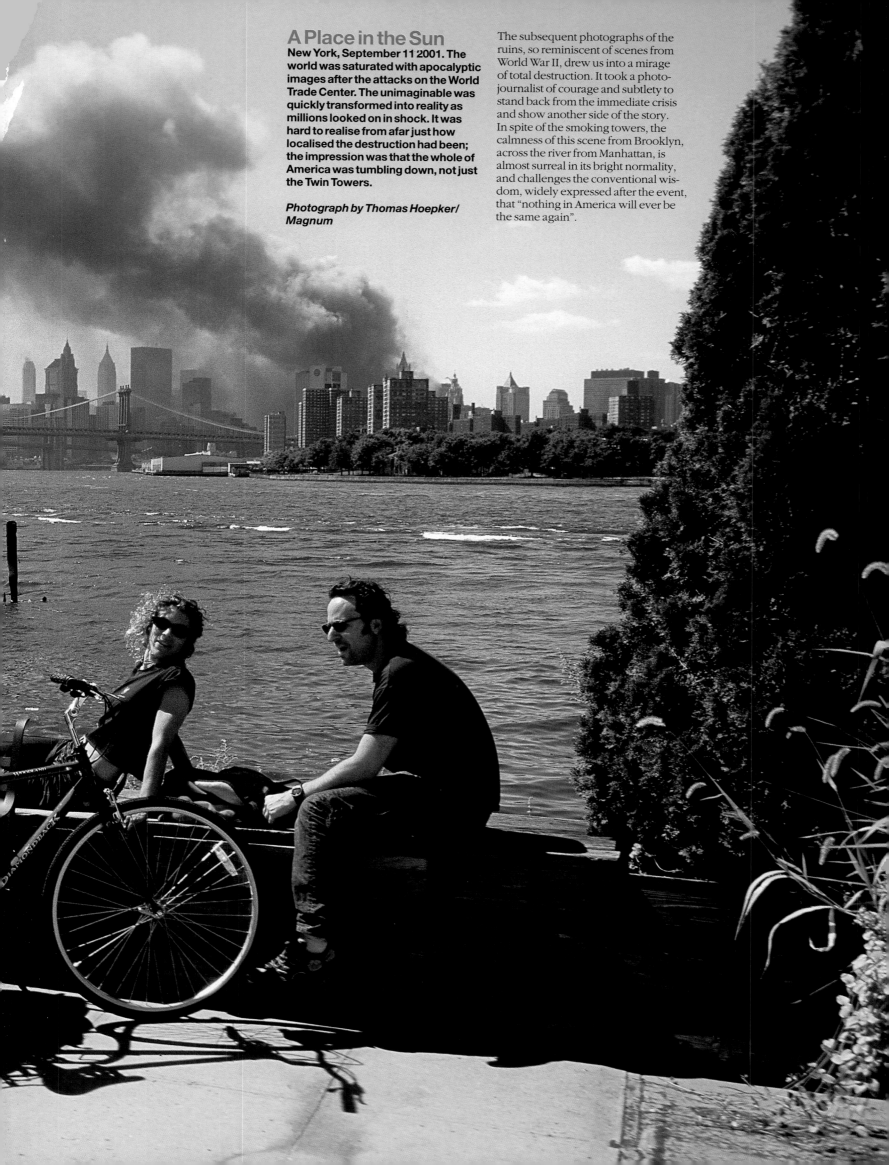

A Place in the Sun

New York, September 11 2001. The world was saturated with apocalyptic images after the attacks on the World Trade Center. The unimaginable was quickly transformed into reality as millions looked on in shock. It was hard to realise from afar just how localised the destruction had been; the impression was that the whole of America was tumbling down, not just the Twin Towers.

Photograph by Thomas Hoepker/ Magnum

The subsequent photographs of the ruins, so reminiscent of scenes from World War II, drew us into a mirage of total destruction. It took a photo-journalist of courage and subtlety to stand back from the immediate crisis and show another side of the story. In spite of the smoking towers, the calmness of this scene from Brooklyn, across the river from Manhattan, is almost surreal in its bright normality, and challenges the conventional wisdom, widely expressed after the event, that "nothing in America will ever be the same again".

Acknowledgements

Many thanks for the association provided by Charles Merullo, Liz Ihre and Joëlle Ferly at Hulton Archive, and Henderson Mullin and all at Index on Censorship. This project would not have been possible without their tireless assistance and invaluable support.

Getty Images is the world's leading visual content provider, with 70 million images and 30,000 hours of film footage held by the various brands. The archival collections are held by Hulton | Archive, who has provided many of the images for this book. With over 40 million images, Hulton | Archive is an unparalleled resource of unique illustrative material covering every facet of people's experiences and environment, recording history to the present day.
www.gettyimages.com

gettyimages

For 30 years, Index on Censorship has been the only international magazine devoted to defending free expression – a fundamental human right and the cornerstone of democracy.

Underexposed was originally conceived, by Index, in an issue of the magazine revealing the hidden history of the 20th century through photographs that were concealed, banned or manipulated. *Underexposed* reminds us of the continuing importance of free expression.
www.indexonline.org

INDEX
for free expression

Thanks also to Suzy Lewis, Nick Galvin, Hamish Crooks and Liz Grogan at Magnum Photos. Magnum has been at the forefront of reportage photography for over 50 years. With an ongoing powerful individual vision, Magnum photographers are both key witnesses and interpreters of the world's events, peoples, issues and personalities. This unique collection is gathered in the Magnum Archive.

The editor and publisher gratefully acknowledge the use of background information from the following publications. All copyright on material quoted is retained by the individual authors and publishers as indicated in the text.

Gar Alperovitz, *Atomic Diplomacy: Hiroshima and Potsdam* (Secker & Warburg)

Jane Carmichael, *Photographs of the First World War* (Routledge)

Jillian Edelstein, *Truth And Lies* (Granta)

Harold Evans, *Pictures on a Page* (Pimlico)

Horst Faas and Tim Page, *Requiem* (Cape)

Martin Gilbert, *A History of the 20th Century* (HarperCollins)

Martin Gilbert, *Descent into Barbarism 1933-1951* (HarperCollins)

Index on Censorship, *Underexposed* (vol 28, 6/99)

Philip Jacobson and Peter Pringle, *Those Are Real Bullets, Aren't They?* (Fourth Estate)

Philip Knightley, *The First Casualty* (Quartet)

Russell Miller, *Magnum* (Pimlico)

Dario Mitidieri, *Children of Bombay* (Dewi Lewis Publishing)

Brian Moynahan, *The Russian Century* (Chatto and Windus)

Alan Palmer, *The Penguin Dictionary of 20th Century History* (Penguin)

David D Perlmutter, *Photojournalism and Foreign Policy* (Yale University Press)

Photo Archive Group, *The Killing Fields* (Twin Palms Publishers)

John Pilger, *Reporting the World: John Pilger's Great Eyewitness Photographers* (21 Publishing)

Jonathan Spence and Annping Chin, *The Chinese Century* (HarperCollins)

John Taylor, *Body Horror* (Manchester University Press)

John Taylor, *War Photography* (Manchester University Press)

Peter Tweed, *Dictionary of 20th Century History* (Oxford University Press)

Chronicle of the 20th Century (Longman Higher Education)

ITV Visual History of the 20th Century (Carlton)

Editor Colin Jacobson
Book Design Lisa Ling
Project Co-ordinator Alasdair MacGregor
Reprographics AJD Colour Ltd
Printed in Slovenia
Underexposed first published in Great Britain in 2002 by Vision On Publishing
112-116 Old Street
London EC1V 9BG
T +44 207 336 0766
F +44 207 336 0966
www.vobooks.com
info@vobooks.com
All photography © the photographers and/or agencies listed.
"Banned" by Harold Evans, "Propaganda" by Danny Schecter, "Reading Pictures" by Alberto Manguel and "Recovered Memory" by Adam Phillips © Index on Censorship. "Death of the Photographer" © Philip Jones Griffiths. All other text © Colin Jacobson unless otherwise listed.
Book design © Vision On 2002.

www.vobooks.com

Vision On would like to thank the following people for their generous support for *Underexposed*: Helen Walters, Tanya Kiang, Josephine Jacobson, Daniel Meadows, Matt Herron, Dario Mitidieri, David King, David Hoffman, Wendy Wallace, Richard Smith, Ben ten Berge, Roger Hutchings, Philip Jones Griffiths, Ian Berry, Paul Watson, Penny Tweedie, Amanda Hopkinson, Horst Faas, David Modell, Shahidul Alam, Gideon Mendel, Mrs GV Duncan, Patricia Strathern, Sylvie Languin, Fiona Wilson, Kinga Kenig, Witold Krassowski, Maryanne Golon, Jim Belither, Stephen Mayes, Arpad Gerecsey, Alex Betts and Sophie Martin; Katherine Hallett and Graham Cross at Network Photographers; Val Baker and Carlos Reyes-Manzo at Andes Press; Giovanni Cafagna at Corbis; Dominique Deschavanne at Contact Press Images; Nigel Gibson at Associated Press; David McCormick at Pacemaker Press; Chris Riley at Photo Archive Group; Tarkan Algin at Syndication International; Franziska Payer at Endeavour Group; Janice Mullin at the Imperial War Museum; Glen Marks at Rex; John Easterby and Alyson Whalley at IPG/Katz; Della Green at BUAV; Martine Robin at Agence Vu; Jonathan Muller at FSP; Michael Regnier at Panos; and Andrew Frost and John Frost at John Frost Newspaper Archives.